STOP MOTION

PASSION, PROCESS AND PERFORMANCE

BARRY J C PURVES

STOP MOTION

PASSION, PROCESS AND PERFORMANCE

Focal Press
Taylor & Francis Group

NEW YORK AND LONDON

First published 2007 by Focal Press
70 Blanchard Road, Suite 402, Burlington, MA 01803

Simultaneously published in the UK by Focal Press
2 Park Square, Milton Park, Abingdon, Oxon OX14 4RN

Focal Press is an imprint of the Taylor & Francis Group, an informa business

Library of Congress Control Number: 2007938572

ISBN 13: 978-0-240-52060-5 (pbk)
ISBN 13: 978-0-080-55579-9 (ebk)

DEDICATION

My mother and father, Anne and David.

Thanks especially to my beloved Ma and Pa for, well, for so much; to Inigo, who sat on my shoulder for nearly every page; and to Amanda and all the chums I temporarily deserted while doing this.

To the large hairy primate who started it; to Ray Harryhausen who inspired us and to Mark Hall and Brian Cosgrove who actually made it happen for so many of us … thank you.

To all the artists, craftsmen, musicians, technicians, editors, commissioning editors and producers I've been lucky enough to work with, and particularly to Ian Mackinnon and Peter Saunders, without whose artistry we would still be twiddling our thumbs.

Contents

Barry J.C. Purves

Barry started his involvement with model animation at Cosgrove Hall in 1978, then went freelance in 1986, working with Aardman and others. With producer Glenn Holberton he worked through their company Bare Boards from 1990 to 1995. Since then he has been mainly freelance, animating, designing, directing, writing and teaching. He was involved for a period on *Mars Attacks!* and *King Kong*. His own films have won over sixty awards, including Oscar and BAFTA nominations. A lively website – www.barrypurves.com – is run by his brother-in-law, Peter.

Principal credits

Cosgrove Hall films

Chorlton and the Wheelies, 1979: animator
The Pied Piper of Hamelin, 1980: animator
The Wind in the Willows, 1982–1986: animator and series director
Stills: Joe Dembinski
Puppets: Peter Saunders, Bridget Appleby and others
Costumes: Nigel Cornford

Next: an Aardman Animation production for Channel Four television, 1989
Directed, written and animated by Barry J.C. Purves
Puppets: Ian Mackinnon, Peter Saunders, Colin Batty
Costume and props: Nigel Cornford
Photography: Dave Riddett, David Sproxton
Music: Stuart Gordon
Voice: Roger Rees
Editing: David McCormik
Producer: Sara Mullock, Aardman Animations

Screen Play: a Bare Boards production for Channel Four television, 1992
Directed, written and animated by Barry J.C. Purves
Animation: Barry Purves
Puppets: Mackinnon Saunders and Barrow Models
Photography: Mark Stewart
Costumes Nigel Cornford
Dialogue: Ernst Lube
Sets: Barrow Models
Illustrator: Barbara Biddulph
Editing: Flix Film Editing
Music: Nigel Hess
Voice: Michael Maloney
Producer: Glenn Holberton

Rigoletto: a Bare Boards production for S4C and BBC, 1993
Directed and animated by Barry J.C. Purves

Adapted by Wyn Davies and Barry J.C. Purves
Puppets: Mackinnon Saunders
Photography: Mark Stewart
Costumes: Maxim Stuart
Sets: Barrow Models
Editing: Flix Facilities
Music: Guisseppe Verdi, orchestra of the Welsh National Opera singers including Rosemary Joshua, Jonathan Summers, Anthony Mee
Music Director: Wyn Davies
Producer: Glenn Holberton

Achilles: a Bare Boards Production for Channel Four television, 1995
Directed, written and animated by Barry J.C. Purves
Dialogue: Jo Cameron Brown
Photography: Paul Smith
Editing: Flix Facilities
Music: Nigel Hess
Voice: Derek Jacobi, with David Holt, Simon Green
Puppets and Costumes: Mackinnon Saunders
Props: Liz Scrine, Barbara Biddulph
Producer: Glenn Holberton

Gilbert and Sullivan: The Very Models: a Bare Boards production for Channel Four Television, 1998
Directed and animated by Barry Purves
Adapted from Gilbert and Sullivan by Wyn Davies and Barry J.C. Purves
Photography: Jean Marc Ferriere
Editing: Flix Facilities
Puppets: Mackinnon Saunders
Art Direction: Nick Barnes
Sets and props: As and When Men
Music: Arthur Sullivan arranged by Wyn Davies, Northern Chamber Orchestra conducted by Wyn Davies
Singers: Steven Pimlott, Sandra Dugdale, Christopher Gillet, Anna Burford, Roland Wood
Producer: Christopher O'Hare

Hamilton Mattress: produced by Harvest Films, Bristol, UK, © Hamilton Mattress Ltd, 2001
Directed by Barry J.C. Purves
Written by John Webster and Anna Farthing
Animators: Jo Chalkley, Steve Boot, Will Hodge, Timon Dowdeswell, Andy Joule, Stefano Cassini, Susy Fagan, Dug Calder
Puppets: Mackinnon Saunders
Costumes: Aideen Morgan
Art Direction: Matt Sanders
Sets and Props: Farrington Lewis
Voices: David Thewlis, Henry Goodman, Lindsay Duncan, David Holt, Roy Hudd, William Hootkins, Maxine Peake, David Holt, Sue Jane Tanner, Clive Hayward and others
Photography: Paul Smith

Music: Steve Spiro, Wix, Ayub Ogada
Producer: Christopher Moll

Rupert Bear: a Cosgrove Hall production for Entertainment Rights, 2007
Directed by Barry J C Purves
Produced by Francis Vose
Various writers
Cameramen: John Duffy, Dan de'Giovanni, Richard Cockerill
Voices: David Holt, Claire Skinner, Morwenna Banks
Studio Director: Sue Pugh
Animators: Richard Haynes, Hayden Secker, Chris Tichborne, Susan Guy, Adam Farrish, Andrew
James Chapman, Malcolm Lamont, Jason Stalman, Andy Shackleford, Sam Turner and others
Sets: As and When Men
Puppets: Mackinnon Saunders
Costumes: Andrea Lord
Editing: Flix Facilities and Nibs Senior
Sound: Hullabaloo
Music: Karl Twigg, Mark Topham
PA: Steve Levinshon

Mackinnon Saunders

Of the many artists from Mackinnon Saunders, Graham Maiden, Pat Brennan, Stuart Sutcliffe,
Noel Estevan Baker, Joe Holman, Colin Batty, Darren Marshall, Georgina Hayns, Caroline Wallace,
Michelle Scattergood, Mark Thompson, Christine Keogh, Emma Trimble, Jonathan Grimshaw,
Ruth Curtis, Richard Pickersgill, Kevin Scilitoe, Graeme Hall, Dave Whiting, Carrie Clarke, Claire
Elliot, Bridget Smith, Geraldine Corrigan and Rose Hopkins have particularly contributed to the
success of the above films.

The Garrick Playhouse, Altrincham

The Ritz, *Communicating Doors*, *Snake in the Grass*, *The Turn of the Screw*, *Habeas Corpus* directed
and designed by Barry J.C. Purves; *Jekyll and Hyde* designed by Barry J.C. Purves; acted in *Lady
Windermere's Fan* and *One Flew Over the Cuckoo's Nest*.

Stills

I gratefully acknowledge all stills from the various programmes with the following credits and copyrights:

Cosgrove Hall Films
Chorlton and the Wheelies, *The Pied Piper of Hamelin*, *The Wind in the Willows*: © Fremantle Media
Rupert Bear®: © Entertainment Rights Dist Ltd/Express Newspapers Ltd 27 June 2007

Next: an Aardman Animation production for Channel Four Television, 1989
Stills by Dave Alex Riddett

Screen Play: a Bare Boards production for Channel Four Television, 1992
Stills by Mark Stewart
Rigoletto: a Bare Boards production for S4C and BBC, 1993
Stills by Mark Stewart

Achilles: a Bare Boards Production for Channel Four Television, 1995
Stills by Paul Smith

Gilbert and Sullivan: The Very Models: a Bare Boards production for Channel Four Television, 1998
Stills by Jean Marc Ferriere

Hamilton Mattress: produced by Harvest Films, Bristol, UK copyright Hamilton Mattress Ltd, 2001
Stills by Paul Smith

The Garrick Playhouse, Altrincham
Production stills by Martin Oldfield

Foreword

It's hard to deny that cinema is the most significant artistic innovation of the last century. While we've been telling each other stories since our ancestors lived in the caves, the ability to photograph a living event as a succession of still images and then recreate that event by successively projecting those same images has changed the way stories are told, and altered the very nature of human communication. A rich cinematic language has evolved, spoken eloquently by dramatists, documentarians, poets and propagandists alike. It's not a language of words but of images; images which can be juxtaposed in myriad combinations to divert us, educate us, enrage us, or stimulate our noblest, most human emotions.

All this from a simple, brilliant optical illusion.

The process which fools us into believing that these still pictures are alive has given birth to a parallel art, one which can only be perceived through the magic of the motion picture camera. It's come to be known by the deceptively simple word 'animation'.

Animation brings still images to life, too, but not just images which photographically record an unfolding real-world event. Hand-drawn characters or sculpted figures spring to counterfeit life and allow us to immerse ourselves in their imaginary worlds; characters and worlds limited only by the skill and inspiration of their creators.

Hand-drawn animation – cartoons, if you insist upon that too-dismissive term – has brought us the phantasmagoria (and breathtaking draftsmanship) of Winsor McKay, the heart warming fables of Walt Disney, the hilarious anarchy of Tex Avery. Stop motion animation has given us the sly surrealism of Ladislas Starevitch, the poetry of Jiří Trnka and Lottie Reiniger, and the thrilling, primal monster clashes of Willis O'Brien and Ray Harryhausen.

While the history of drawn animation has been heavily documented by scores of books, stop motion has received far less attention. In fact, many 'history of animation' texts seem only concerned with the cartoons, giving stop motion scant (and sometimes inaccurate) attention: an oversight probably attributable to a generation of animation historians who spent their childhoods snuggled up with Jiminy and Dumbo and Thumper and *that* crowd.

But Barry Purves seems to have spent his boyhood hanging out with the puppets, and he's written a book which, at last, gives stop motion its due. Barry is uniquely qualified to hold forth on the subject: not only an historian, he's one of stop motion's premiere practitioners, both as animator and filmmaker.

He not only writes passionately and digressively about his influences and inspirations – the *why* of his art – but holds intermittent colloquies with a panel of stop motion artists who offer their own insights into animation's intricacies. Among these is Jim Danforth, whose brilliant mind and seemingly limitless array of artistic talents bring him closer to genius than anyone I've ever known.

Barry writes from the heart, and his book isn't a typical 'how-to' craft manual, but rather an ardent valentine to an art form he truly loves. This love of stop motion is one which demands abundant devotion, as the creation of even a simple stop motion shot is a laborious and emotionally intense process.

A posable figure, fabricated to the most exacting standards, is set before the camera in a static attitude. Since the puppet will doubtless be required to move into postures which defy balance, it needs to be affixed to the stage securely and invisibly, through screws into its feet from below, or on wires, or on a mounting rod. The puppet is posed for the beginning of the scene, and a frame of film is exposed. Frame One: one 24th of a second's worth.

If the animator is performing a ten second scene, that's 240 separate movements of the character. These aren't *just* movements, but incremental components of a performance, a performance – pose, timing, expression, acting – which the animator must keep in his head until the shot's completed. A shot may take four hours, eight hours, sixteen hours, and all the while the animator must stay 'in the moment' if the performance is to communicate the animator's message and intentions.

Screen Play, one of my favourite Purves films, has multiple characters, complex staging and lighting effects, moving stages, moving Japanese screens (illustrated with animated birds), billowing cloth, even gushing blood - all in one beautifully conceived and executed shot.

A shot which runs, uninterrupted, for about nine minutes.

And tells a story, beautifully.

Obviously, this is the work of a man who loves his art. We are privileged indeed to have him discuss the love of that art with us.

Randall William Cook, October 2007

Introduction

The animated puppets.

Tell a tale of cock and bull,
Of convincing detail full,
Tale tremendous
Heaven defend us,
What a tale of cock and bull!

W.S. Gilbert, *The Yeomen of the Guard*

I have two dreams. They recur with alarming regularity, and are very predictable, reassuring, exciting and utterly credible, and say a lot about stop motion. The first dream is about circumstances forcing me to take over in some sort of performance, at the last minute, sometimes as the orchestra are tuning up. I'm always familiar with the plot, the set, the costumes, the choreography, from a lifetime of seeing the production, but I have never actually performed in the show. When I do, I fend off the confused glances of the other performers, winging my way through the show, adapting bits and doing what feels right. The cast's eyes glaze over with a panicked expression of 'this isn't how it's meant to be'. It's what neither the cast nor the audience expected, but I do deliver and the show wasn't cancelled and the audience had a good time. The other dream is the inevitable flying, but not so much with flapping arms, but more a willing myself to rise by lifting my body from within through sheer determination. Once up, there's a release and I glide considerable distances to a safe landing. I'm afraid that in the dream I tend to use this unique skill rather too regularly and no-one seems to notice or think it's unusual. With the flying (and oh, flying is a recurring image for me: it's possible in stop motion; most things are – that's why we do it) I'm actually tensing and relaxing

in my sleep, and I wake physically drained, with appropriate muscles aching. This is a confusing feeling as it suggests that I actually experienced something. Certainly my brain is recalling vivid images, and the body is recalling physical sensations of some sort. Something has strayed over, all too strongly, into my waking life. With the performance dream, I wake still feeling the rush of adrenaline, and recalling it all with alarming sensory detail. I go to work with the high that you get after coming off stage.

Flying, almost. A storyboard panel from *Feather*, an unproduced film.

Most confusingly, this is exactly how it feels to be a stop motion animator. The whole tactile, physical, arduous, detailed process involved in creating something that really doesn't exist can seem so concrete that the animator, certainly this animator, is often fooled. We can get the same highs as the character, and the same lows. Filming a joyously exhilarating scene does rub off on us, and later there's that odd feeling of having experienced another existence you can't quite pin down; of having lived some other life for a short time. Actors and dancers who perform a role nightly or in a long-running soap opera must feel the same.

Whatever does linger, and strays into real life, stays there. I still have the memory of being, or performing as a pencil from a commercial twenty years ago. I recall the day I stole a train, but oh no, hang on, that was Mr Toad in *The Wind in the Willows*. These are memories locked away in the brain, probably in the same place as many forgotten photos, or pages from a diary that can suddenly prompt all too clearly the events of the day decades ago. Maybe animators working intimately with a pencil feel something similar, but I'm not sure this experience happens for computer animators, as they are deprived of the actual tactile nature of touching and feeling something moving through an all too real space. Tapping away at a keyboard may not give you the same confusing muscle memory that puppet animation does. The results on the screen are often better, but I can't imagine other animators have as much selfish fun as we stop motion animators.

This isn't a book attempting to prove that stop motion animation is superior to computer-generated imagery, or any other form of animation – it isn't, simple as that. For pure realism

and convincing, moving performances, stop motion is no longer able to compete with such breathtaking CG creations as Gollum or Kong, but that's the point. It doesn't have to compete any more. It's doing something totally different, and maybe now that we see we each have different values, stop motion will blossom. In the 1990s we threw up our hands in horror, announcing that CG would kill stop motion, but actually both techniques have developed along different paths. There are those who love the sophisticated realism and detail of CG, and there are those who love the sheer oddness and tactile nature of stop motion. We won't see stop motion characters combined with and passing for live action again, as we can confidently leave that to CG, but I do think we'll continue to see films like *The Nightmare Before Christmas*, *Wallace and Gromit – The Curse of the Were-Rabbit*, *Max and Co.*, and countless children's TV series, that celebrate the quirkiness of the medium itself, presenting complete, wholly credible fantastical worlds, revelling in the glorious strangeness of stop motion. Puppets now look very uncomfortable in a live-action environment, unless put there with a heavy dose of irony, unlike CG creations that blend seamlessly. It's all about finding the right technique for the right story. This book tries to celebrate what we love about stop motion and what it does well, but not to the detriment of any other form of animation.

This is not a book about the theory of animation, as there are far more eloquent, intelligent and perceptive writers than me; nor is it a comprehensive textbook about how to animate, but there are enough tips, observations and behind-the-scenes hints to help most animators; nor is it a book exclusively devoted to stop motion and its history. It is, though, a book about a shared passion for a strange craft, and all the elements of design, storytelling, performance, movement and so on, that make it. These elements often overlap with other arts and practitioners. Animation does not, and certainly should not exist in an airtight bubble, cocooned from the other arts. I have tried, sometimes unsuccessfully, and sometimes successfully, to drag animation kicking and screaming into the other media. Stop motion has certainly been influenced hugely by the other arts, and I hope that, however negligibly, the reverse may apply.

Above all, though, this book is about the very personal experience, not just mine but others', of being an animator, working laboriously with puppets, and why so many of us still get so much from, as the late Paul Berry described it, 'dolly waggling'. Just what is satisfying about bringing puppets to life that, for all the hard work, the tedium and the backaches, keeps us doing it and keeps so many people watching it? It's not the most prolific of jobs. Other directors make many hours of film in the time it takes us to do a short film. Actors perform the same role several hundred times in the months it takes us to perform our role just once, but even so, there is something deeply satisfying about bringing a lump of latex, metal and cloth to life. At every level, it is a performance, and for those who have never delicately held a puppet, squeezing it gently and sensually into life, that can be a strange concept.

Already I'm talking of acting and performance, and of a confusing relationship between the puppet and the animator, and that's where this book is heading. It's a bit easy to say all animators should be actors, but acting probably has certain connotations of the theatre and film, and is maybe too defined by scripts and human personae. These days I prefer to say that all animators need to have the sensibilities of a performer, as that widens the field, and brings in dance, mime, singing and a million related skills. We are performers who happen to be telling big stories on a small scale. What makes us different from most performers is that we are called upon to perform a truly extraordinary range of characters, and with more detail and control than they can dream of.

I certainly have an obsession with storytelling – the act of storytelling, tales within tales looks behind the scenes, and looks behind icons – so it's no surprise that my favourite pieces of film and theatre are such pieces as *Cabaret*, *Shakespeare in Love*, *Some Like it Hot*, *Noises Off*, *Sunday in the Park with George*, *The Boyfriend*, *La Nuit Americane*, *Les Enfants du Paradis*, *Finding Neverland*, *Follies*, *Rosencrantz and Guildenstern are Dead*: they all use the backstage story to inform the onstage story; they all use play-acting to reveal more about themselves; they all use artifice to uncover some deeper truth; they all use the metaphor of art and performance to look at what's really going on. Give a man a mask and he'll tell the truth. This is really how I see animation, in particular stop motion. It is so artificial, and revels in its artificiality, but somehow manages to say something more directly in a way that a straight live action film cannot.

Writing a book now, it seems that I should, Prospero like, be breaking my staff and abjuring my rough magic (and 'rough magic' is certainly apt for us). Not just yet. My ramblings may be hubristic folly, but my qualification for writing this book is that I'm passionate about animation. This book is about the decisions and developments that are made, many wrong, mostly right. It's about the problem solving; it's about the joy of bringing a puppet to life and the definitely odd relationship; it's about other puppets and strange art forms that inform what we do; it's about a strange, but gloriously addictive way of earning a living. I hope some of this passion rubs off and encourages others to enjoy the craft that I, and so many of us, love.

Feather

In the corner of most pages is the complete storyboard of *Feather*, one of many films yet to be made. It's a film about learning to adapt, and something at its heart feels so right to me that I'm not giving up on it. (Boards drawn by Peter Williamson.)

For this book I am most grateful to the following friends and artists (from seasoned professionals to new enthusiasts) who have generously contributed either illustrations or personal thoughts about their love of animation. These chats took place through e-mails, some of which I have edited for economy. I much appreciate their welcome involvement, honesty and wit. Thank you.

Guests

AC: Amanda Clarke, author/teacher, Ireland
ACZ: Andy Cadzow, animator, Australia
AE: Adam Elliot, animator/director, Australia
AFS: Anthony Farquhar Smith, animation director, UK
AJP: Andrew James Chapman, animator, UK
ALS: Alasdair Saunders, sound mixer, UK
AS: Anthony Scott, animator, USA
AW: Adam Wyrwas, animator, Poland
AWD: Aaron Wood, animator, UK
BB: Barbara Biddulph, art Director, Designer, UK
CH: Charlie Hopkins, animator, UK
DC: Dug Calder, animator, UK
DH: David Holt, voice artist, UK
DS: David Sproxton, producer, UK
EM: Ethan Marak, animator, USA
FL: Federico Landen, animator, Argentina
JC: Jo Chalkley, animator, UK
JCB: Jo Cameron Brown, dialect coach, UK
JCL: Joe Clarke, art student, UK
JD: Jim Danforth, animator, USA
JK: Jessica Koppe, animator, Germany
JW: Jason Wishnow, animator, USA
KC: Ken Clark, animator, New Zealand
KD: Kerry Drumm, animator, UK
KP: Ken Priebe, animator/author, Canada

MH: Mark Hall, animation producer/director, UK
MHolt: Matt Holt, sound editor, UK
MS: Matt Sanders, art director/designer, UK
NR: Nola Rae, mime, UK
PC: Paul Campion, computer graphics artist/director, New Zealand
PF: Paul Flannery, animator, UK
PP: Petros Papadopoulos, animator, UK
PRW/MG: Pat Raine Webb and Margot Grimwood, ASIFA, UK
RB: Ronnie Burkett, puppeteer, Canada
RC: Rick Catizone, animator, USA
RH: Richard Haynes, animator, UK
RK: Rick Kent, set builder, UK
RWC: Randy Cook, animator/director, USA
SB: Steve Boot, animator, UK
SG: Susan Guy, animator, UK
SK: Sayoko Kinoshita, festival organiser, Japan
SKopp: Sandro Kopp, artist, New Zealand
SP: Simon Partington, CG artist, UK
ST: Saemi Takahashi, artist/doll maker, Japan
TA: Tim Allen, animator, UK
TB: Tom Brierton, animator, USA
TD: Teresa Drilling, animator, USA

Most of all I am grateful to the generous foreword by Randy Cook whose career spans stop motion, CG and live action. His animation, effects and direction are distinguished by astonishing innovation, physically detail and complexity, all with a real sense of showmanship.

A great animator, friend and raconteur.

Some of the Guests

PASSION

Jack Point in *The Yeomen of the Guard* (Richard Haynes).

I've wisdom from the east and from the west
That's subject to no academic rule
You may find it in the jeering of a jest
Or distil it in the folly of a fool.
I can teach you with a quip if I've a mind
I can trick you into learning with a laugh;
Oh, winnow all my folly and you'll find
A grain or two of truth amongst the chaff.

W.S. Gilbert, The Yeomen of the Guard

Smoke and Mirrors

I have long since been enthralled by magicians. I watched the charming David Nixon on TV (who introduced the glove puppet Basil Brush to the unwitting world), and loved the ease of his performance. I was never keen on the over-glitzy presentation of Siegfried and Roy (their magic inseparable from a distracting camp element), or the smarm of David Blaine, as these performers tend to have too much show, with plastic assistants and unnecessary technology, detracting from the trick itself. A magician's audience know that a woman is never likely to be actually sawn in half; they like to flirt with believing but no more. There is a complicity. If a woman was sawn in half, the whole event would lose its point and the woman her life! We are willing to be tricked and fooled, and the more fooled we are the more satisfying the experience. What makes the trick better is the element of doubt, where the audience's perception of what is real and what is not is pushed to an uncomfortable limit.

This is like countless TV detective shows and Agatha Christie novels: if we knew whodunnit on page one, there would be little point in reading on. The fun is trying to work out what happened or who did what to whom. We want to be tricked and gulled, and misdirected, with the final unmasking of the murderer bringing a complex feeling of being angry for not having seen it coming and a glorious fulfilment at having been so deliciously deceived.

Having watched dozens of magic shows, there is one inescapable moment essential to every trick: there has to be a moment of misdirection, and it's in this split second that the mechanics of the trick happens unseen. Misdirection could be the puff of smoke as a genie appears on stage, or the shutting of a cabinet, or the elaborate swishing of a black cape, or the pulling of a ubiquitous curtain, or the blindfolding of the eyes, or the closing of a fist, or the sealing of an envelope, or the shuffle of a pack of cards or a glamorous assistant innocently tinkering with something. There is an instant when something is concealed from the audience, and the magician's art is to make this moment as brief and as subtle as possible. Usually it involves some element of black or darkness, where the trick is able to be carried out unseen.

The animation trick

For animators, that moment of misdirection is there twenty-fives frames a second (in the UK at least). It's a black frame that does not register with the audience, and allows the animator, acting as both magician and glamorous assistant, to step in and tinker with the puppets, rearranging everything before stepping out again, as if nothing had happened. The audience hasn't seen us, but they see the trick. The puppet appears to have moved.

Stop motion is, using an appropriate Tommy Cooper segue, just like that. We know it's a trick, and enjoy going along for the ride, seeing that these puppets or drawings have the credible illusion of life. We give them that illusion. I was confused when I saw Disney's *Snow White*. The dwarves were a huge hit as they were obviously animated in being exaggerated, stretchy and squashy, but they still had a recognisable truth that came through the caricature: a lie that told a truth. Snow White herself, with much of her animation being as a result of rotoscoping, had an unsettling effect on me. I didn't like it, and didn't want to watch her. She belonged in a different film (though I appreciate she was meant to be different from the dwarves), and her realistic timing and movements so out of place next to the animals and the dwarves. I didn't want to see realism in a totally elastic world. In this situation and with the conventions of the dwarves, her naturalistic movement destroyed her credibility.

An essential part of a magician's trick is his costume, and which is often black. Black is not there for pure sartorial fancy, but because most things can disappear against black. I love the distracting cod mysticism and theatrical flim-flam that magicians dress their tricks up with, but I want to challenge them to perform some tricks naked in a bright white room, where nothing could be hidden. Houdini often did exactly that. The tiny picks necessary for his escape were, well if he had nothing up his sleeve, they were probably up somewhere else. Even under these naked circumstances a magician is still able to use his own body to hide things. My barber, Edward, is a magician at night, and often does tricks whilst cutting hair. He has no black cloak but cleverly uses the back of your head in the mirror to block out his moment of deceit. As he stands behind you, your own reflection prevents you seeing his palming of cards. This, with the disorientation of looking in a mirror, makes for some effective trickery … and he's a great barber. We animators couldn't do our tricks if our black cloak, the black frame, was taken away from us.

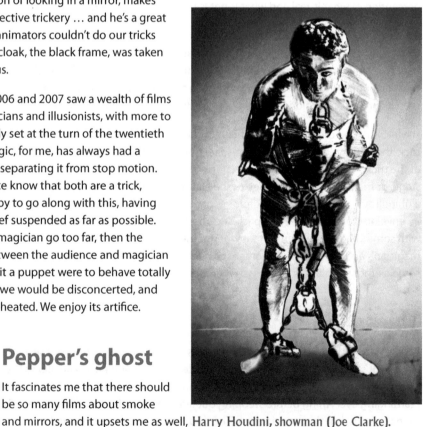

The years 2006 and 2007 saw a wealth of films about magicians and illusionists, with more to come, mainly set at the turn of the twentieth century. Magic, for me, has always had a blurred line separating it from stop motion. The audience know that both are a trick, but are happy to go along with this, having their disbelief suspended as far as possible. Should the magician go too far, then the contract between the audience and magician is broken. If it a puppet were to behave totally realistically, we would be disconcerted, and would feel cheated. We enjoy its artifice.

feather.

Pepper's ghost

It fascinates me that there should be so many films about smoke and mirrors, and it upsets me as well, Harry Houdini, showman (Joe Clarke).

as a film about the legendary Pepper's ghost has been in my head for some time. The influential trick, a sheet of glass angled across the stage, reflecting the transparent image of someone brightly lit off stage, had a fascinating story behind it. The trick was not developed by Pepper at all. He brought it from another, somewhat struggling magician, Henry Dircks, when it was called, rather clumsily, the Dircksian phantasmagoria (detailed beautifully in Jim Steinmeyer's book, *Hiding the Elephant*). As in recent times, when a new effect, or a new technology, is developed and films are written to incorporate the innovation, so Pepper's ghost appeared in all manner of stage productions adapted to show off this illusion. Literally, ghosts were popping up everywhere. Not just ghosts, but lit properly, the figure could appear to be flesh and blood, and disappear in the fraction of a second it took to turn off a light. Sometimes, the nature of the trick was reversed, so the set that was the illusion and real characters appeared to be walking through solid architecture.

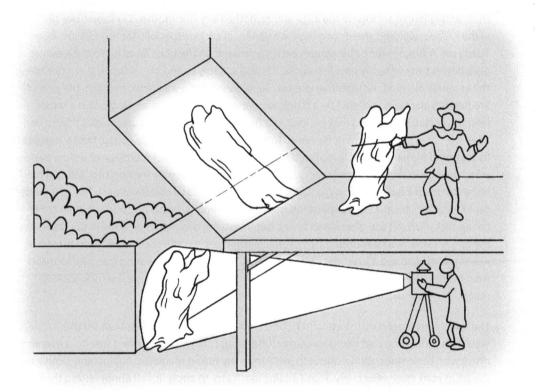

The Victorian stage effect Pepper's ghost, ancestor of our blue screens and mattes (Richard Haynes).

As the nineteenth turned into the twentieth century technology was letting the arts run riot. Stage spectacles of ships sinking and chariot races twice nightly at Drury Lane, competed alongside the less literal miracles of the illusionists and magicians. In France the Grand Guignol was providing macabre entertainment, all the more macabre for its taking place in front of a live audience. The stage spectacles tried to compete with the developing cinema, and they were not afraid to meet in the middle. The marvellous Georges Méliès, a man I definitely

admire, was mixing theatre, film and brilliantly inventive and witty special effects, developing techniques that are still applicable today. Throw in dozens of leggy beauties and he had a box-office success. It is hard to say whether Méliès was a film-maker, a magician, a great theatre technician or what, but he was a dazzling showman with a prolific imagination, using smoke and mirrors to make money. He developed many ideas and techniques that we still use in stop motion. We still stop the camera and replace an object with a different one to suggest something shrinking; we use false perspective; we superimpose and matte floating objects against a background, with either invisible black or blue screens. He was a giant in the development of special effects, and brilliantly light hearted and giddy with it. Pure entertainment, and one day I would like to pay homage with my own film.

Before computer graphics (CG) and when postproduction budgets were reasonably realistic, I used Pepper's ghost many times in animation, mainly to add insubstantial elements such as smoke, falling glitter or, rather clumsily, in a film of *Cinderella*, where a shimmering ball of light tried, and failed, to anticipate the appearance of the Fairy Godmother. On shows like *The Wind in the Willows*, we used sheets of glass for a variety of tricks, especially for the exhaust from Toad's car. A simple white chinagraph pencil animated on the glass lined up to the exhaust pipe beyond would easily pass for smoke if it was suitably lit and out of focus, this latter being the essential element. An effective use saw Toad dressed as a washerwoman (ah, the joys of animation!) and being conned by a barge woman to wash some smalls, including a rather fetching corset. I wanted to make it look as if he was unfamiliar with such menial things, and have the bar of soap slip out of his hand. Toad held a prop bar of yellow soap, but to suggest it flying out of his hand, I simply replaced it on the glass with a matching piece of yellow paper, which being nearer the camera was out of focus, giving a welcome motion blur. Many times I have animated a falling leaf on glass, and then replaced it for a matching prop leaf as it landed on a character's head. Leaves, splashing mud, balls, balloons, butterflies and a million other cheap tricks. We still use glass shots today, but in general this would be done in CG. It pleases me to use something developed by Victorian illusionists. It is still used regularly in theatre. It was interesting to see a legendary stage effect of an orange tree bursting into blossom and then bearing fruit demonstrated in the recent film *The Illusionist*, except the trick, looking magnificent as it did, it appeared to be performed through CG.

The great early magician, the elegant Robert Houdin (b 1805–1871), cut back on the superfluous dressing that had previously cluttered the stage. He appeared simply in evening dress, with basic stage props, one step away from my naked magician. Against this simplicity, the tricks read more effectively. That's an approach I try to apply. It's all about letting the trick read, and making the story clear.

All stop motion animators are magicians, or at least we think like magicians. We are working with a great trick; the impossible trick of the inanimate being animate, of natural laws being defied, has been part of the magician's trade for many centuries. Alongside developing

technology tricks have become more sophisticated, but whether it's a glamorous assistant disappearing, or a fakir climbing a rope, or Mary Poppins flying over a live audience twice nightly, or the most dazzling CG dinosaur, they're just illusions put before happily susceptible and knowing audiences.

Animation has been part of cinema since James Stuart Blackton made toys move in 1896 and Georges Méliès' camera accidentally jammed briefly, transforming

an omnibus into a hearse on the developed film. Cinema is basically a form of animation in itself. One static image is replaced by another and creating the illusion of movement. As early as 1895 Alfred Clarke staged a beheading of *Mary Queen of Scots*, stopping the camera, and replacing the actress with a headless dummy at the crucial moment. Stop motion happens to use puppets more than actors to do much the same.

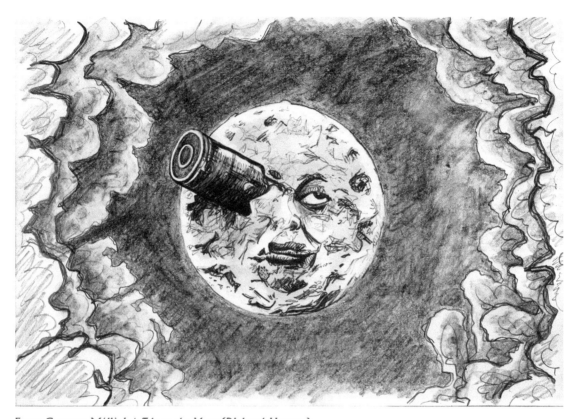

From Georges Méliès' *A Trip to the Moon* (Richard Haynes).

Evolving into Stop Motion

'Stop motion' …. That's a daft couple of words, and an oxymoron. I wonder where this expression came from, as animators are not stopping motion. We are not creating any tangible motion either, but creating an illusion of movement, and with it, life. We are dealing with objects that have 'stopped', giving them an illusion of 'motion'. Are we creating motion through stopping and starting? We are sometimes called 'stop–go' animators, which may be accurate, but is an ugly expression. The right word is not 'cartoons', although I like the idea that a cartoon is a sketch representing something bigger, the essence of something. Cartoons didn't always have comedy connotations, as there are not many laughs about Leonardo da Vinci's cartoons. We were called '3D' animators, as we animated objects around in three dimensions, but the computer guys took that name. People remain confused as to what we should be called. 'Film-makers' is easier, but if we have to be labelled in animation terms, I prefer 'model animator' or 'puppet animator', as that is pretty obvious. We work with models and puppets and we animate them. Simple.

'Stop motion' could apply to any animation, as the process is basically the same. Something is manipulated, moved incrementally by hand, and the image captured, whether it's a puppet, a pencil drawing, a pile of sand, some clay, a computer image or paper cut-outs. Another increment and another image. When the images are strung together at an appropriate speed, the eye is fooled into thinking something has moved in a continual manner. It has not.

'Stop frame' is nearer to what happens, as when we work the frame has definitely stopped moving through the camera (or the digital frame is not being recorded). The movement that is perceived to have happened in a piece of stop motion film happens between the frames, when we cannot see it, and in fact it simply doesn't happen at all. What the audience sees is what happens, or doesn't, when we stop working briefly. A movement is created by nothing moving. Time carries on in a moment where time stops. They are topsy-turvy paradoxes that Mr W.S. Gilbert would have enjoyed.

With so much happening between frames, unseen by the audience, this is another reason why I warm to backstage stories. The skill of the animator and the amazing work done by the eye and the brain filling in the gaps, constructs the impression that something has actually moved. An animator's job is to convince the viewer that there is a fluid continual performance happening, when the reality is a clumsy and disjointed affair. It's such a con. When an animator manipulates the puppet, he may not necessarily immediately move the puppet a consequential increment forward. A model eye may accidentally fall out of a puppet onto the floor. It can be replaced in

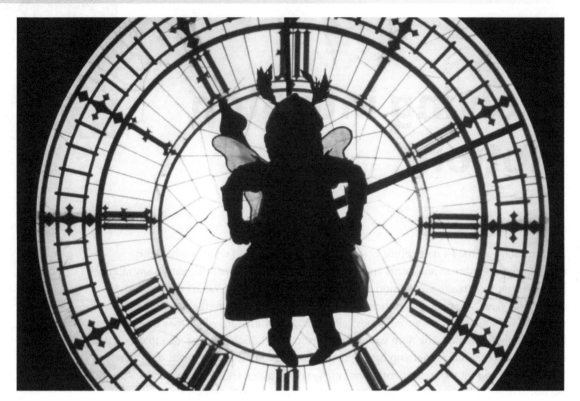

Mr Sullivan as a fairy in front of Big Ben. Ah, animation!

a position that resembled its original position, perhaps moved a millimetre along. The brain, or rather the audience, didn't see the eye fall and roll around; instead, it makes a connection between the two positions of the eye and assumes that it has moved the shortest distance between them, and physically moved from the first position to the second. The phenomenon of persistence of vision, where the eye/brain holds onto an image for one-eighteenth of a second, helps to link the old and new images, especially if the objects overlap. It connects them, and makes the presumption that the object has moved. We ignore or confuse this presumption to our cost: it needs all the help we can give it.

Messing with time

The mechanics of a puppet's arm may fold in on itself during the action of a long scene, so needs to be straightened out, or maybe the puppet itself needs to be physically removed from the set altogether and maintenance work done, or the original puppet may have to be replaced by an identical one, all in between the exposed frames, but as long as the next frame suggests a movement forward, and a close relationship to the previous frame, then the audience is none the wiser to the behind-the-scenes trickery and activity that has taken place. In *Screen Play*, most of the film took place as one long continuous take, so I had to engineer it that the main puppet would walk behind an on-set screen, and then be removed, repainted and have any maintenance done. It would be replaced on set, walking out of the other side

of the screen a couple of film seconds later, as if nothing had happened. The audience sees these two sequences next to each other, appearing to be in the same time scale, but minutes, maybe hours, have passed between those two frames. There are always at least two time scales going on at one moment. The animator, looking at his barsheet, measures time in inches, like a conductor measures time from the bars on a music score. An animator's day is structured around the few seconds he will shoot, and a day is judged to be a long one if it is about twelve seconds, or maybe an easy day if it is only four seconds long … little wonder that animators are a delightfully strange breed, often existing in their own world.

An animator is an actor, just a rather slow one. An actor goes on stage to perform, and when he's done all manner of real life happens in the wings. He returns to the stage to carry on a scene that will have progressed in stage time. If his performance relates to his previous scene, there will be a continuity of action and character and the audience will be unaware of the fact that the actor's had time to phone his agent. Likewise on film, a character is seen to walk out of a door, onto a street in one apparently continuous movement; in reality, the street scene may have been shot months later, many miles from the interior location, but as long as the movement and continuity details relate the two scenes, no-one will notice. Stop motion often uses identical puppets of the characters, and the viewer is unlikely to notice that a puppet used in the first shot is not the same used in the second shot … if the acting is similar. When the musical *Starlight Express* opened in a hot summer, the performers were not used to the physical demands of singing and roller skating in heavy rubber costumes, and often passed out from exhaustion. There were always identically dressed standby performers ready in the wings. With the constant through line of the visuals and the choreography, often the audience was none the wiser, though hopefully they were told of different performers. Getting sidetracked, but on the theme of continuity, when I saw my first cycle of Wagner's four *Ring* operas, I was naively disconcerted by Brunhilde being sent to sleep surrounded by fire at the end of Tuesday night, only for her to wake up on Thursday several stones lighter, a few inches taller, dressed differently and with a different voice. My demands for continuity were overruled by being told that it was a convention and that I could not expect one performer to sing the whole role. Well, actually I could … convention or no convention; I did make a mental note about keeping the integrity of a piece.

This is about seamlessly linking the pieces of the story (in our case the frames), making the action flow dramatically, regardless of the trickery in the gaps. An audience looking at the actor is seldom aware of the behind-the-scenes effort and expertise that have got him there. The stage or screen is all they need to believe the illusion. It's harder for stop motion to keep this continuity and flow of action, as the production process simply does not flow. Months often separate neighbouring shots, and several animators may have worked on the same piece of action. Juggling all this and giving it a unity is the hard, unsung job of the animation director.

Stop motion needs more frames to explain the action than most animation. The brain has to work to put in the missing information, since there is, generally, no blurring of the image, helping to suggest the weight, the direction and the speed of a move. We need to help the eye, and the ear, to relate every frame to the following and previous frames. A live-action film shows a limb moving forward with the trailing part of the limb blurred, making it clear which way the limb is travelling. We have to tell the story of a movement more clearly. A wrist trailing behind a forward-moving limb would emphasise the movement. This is not necessarily realistic, but

it indicates direction and implies weight and resistance. Animation is about not the duplication of life, but the suggestion and illusion of it, and especially imposing that illusion onto things that would not otherwise have life.

Physicality

Bambi was the first film and animation to register with me, and what an impact. For so many, the death of Bambi's mother was traumatic. Even today that scene can devastate a viewer. I cried with *Dumbo*, hissed Cruella, felt confused at *The Three Caballeros*, felt queasy at *Fantasia*, but I cannot think of the first model animation film I saw. It must have been on children's TV, or the title of *I Love Lucy*, although *Kong* on television and *Jason* in the cinema made the most significant impact. All manner of possibilities started to appear about puppets, storytelling and imagination.

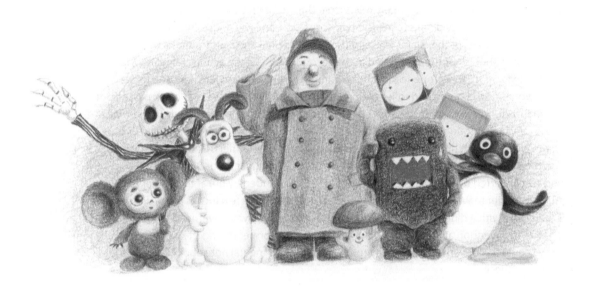

Different stop motion puppets (Saemi Takahashi).

Apart from Ray Harryhausen's great creations, I saw glimpses of stop motion in B-movies on TV, used mainly as a last resort. A horrendous, tentacled, brain-sucking creature animating badly with no performance or skill across the floor in some black-and-white British movie did not impress. Hammer Horror films used elements of stop motion, time lapse and frame-by-frame adjustments to disintegrate or resurrect various vampires, mummies and other beasties. They were pretty poor after Harryhausen's work, but whetted the appetite and interest, even

if, arrogantly, it made me think that I could do better. *Clangers*, *The Herbs* and *The Wombles* had quirky charm but little actual performance. Something about stop motion appealed to me, but the films and programmes disappointed. I love stop motion more each day, but only a few films arouse any interest in my 52-year-old head. We haven't scratched the surface of stop motion's potential. There are ground-breaking, challenging, provocative, meaningful, inspiring, sexual, tragic, intelligent, witty, honest films screaming to be made, and darn, I want to be part of them.

What was the first stop motion film of which you were aware?

JD – Trnka's *The Emperor's Nightingale*, particularly two translucent swans swimming on a mirror-like surface.

TB – *Jason and the Argonauts*. I'd seen the Rankin–Bass stop motion, *Rudolph the Red-Nosed Reindeer*, but it didn't make me want to animate, as Jason did.

RC – *Mighty Joe Young* or *Son of Kong*. I knew it was somehow animated, but I only knew cel animation, and these characters had shadows and details one could never draw.

KD – *Bagpuss*, or *The Wombles*, or *Paddington Bear*? *Nightmare Before Christmas* stopped me in my tracks. I stood in the living room thinking 'this is amazing!' *Wallace and Gromit* made me aware of animation.

DC – *Trumpton* and the *Clangers*. *Mosschops* later.

AW – A Polish children's series – I ended up making two episodes myself.

SB – The skeleton fight in *The Seventh Voyage of Sinbad* scared me s**tless.

KP – My first stop motion was *Sesame Street*, stuff like the Queen of Six and King of Eight and abstract psychedelic stuff. I saw 16 mm screenings of Will Vinton's *Martin the Cobbler* and Co Hoedeman's *Sandcastle* in class, and was rather intrigued by them. The first behind-the-scenes was a TV special on *The Empire Strikes Back* demonstrating the Hoth sequences. I was blown away particularly by was Vinton's *Meet the Raisins*.

TD – The *Gumby* TV series in the USA (Art Clokey).

RH – *The Wind in the Willows*.

TA – *Nightmare Before Christmas* blew me away and in many ways woke me up, especially the scene of Jack Skellington in ragged clothing lying on a statue singing. Such an emotional and visually powerful sequence. I wanted to do this! I later animated on *Corpse Bride*, alongside Anthony Scott, who did that sequence. I was the age Anthony had been on *Nightmare*. I felt very complete. Determination to chase your dreams really can make them come true.

JC – I watched most of Ray Harryhausen's films as well as shows like *Chiggley*, *Trumpton*, *Clangers*, *Morph*, *Paddington* and many others. The first moment I realised what 'stop motion' was came during a 'Making of …' documentary about *Return of the Jedi*. The scene where Luke had been put in a pit to fight a monster, eventually killing it by shutting a 'portcullis-type' gate on it. The documentary showed how the creature was animated. I was amazed at the finished result. It looked like everyone was having a good time. I thought … 'that's a great job'.

FL – *Clash of the Titans* on TV when I was 7. I didn't know it was stop motion, neither what 'stop motion' was … I was very impressed at the time, but I never saw it again.

DS – It must have been on *Watch with Mother* or an east European film in the *Tales from Europe* series. I was intrigued by the way things could magically move in stop motion and I found this more interesting than the drawn animation, because it was more magical.

AC – *Jason and the Argonauts* – the skeletons were pretty scary.

What seemed so different about stop motion?

JD – My awareness of technique was minimal but I was excited by the 'look' of the puppets.

TB – The effects animation that I saw in *Jason*, particularly the skeleton sequence, I knew was something far from a person in a suit. I knew it had to be some trick, but I didn't know how it was done. Through publications like Forest J. Ackerman's *Famous Monsters of Filmland*, I found out about stop motion and the work of Ray Harryhausen, Willis O'Brien and Jim Danforth. *Jason* hit me so hard emotionally because two years before, I'd researched and presented a book report on the Greek myths for class. I became fascinated by the Greek myths, and read everything I could. When I saw *Jason* on TV, I was smitten and in shock, and, coining a famous quote from Mr Harryhausen, I haven't been the same since.

KD – 100% fantasy and storytelling, something was more magical about stop motion. I never questioned what was different from say a Disney animated film to stop motion; only that it was telling me a story.

RC – There was something about the look … a solidity missing from marionettes, and a strange life quality different than a man in a suit.

DC – I knew it was different to drawn animation and liked how more accessible it was. It was like having your toys come to life!!

SB – I had no idea how it was done. That's what made it scary. I didn't like it at all. *Clash of the Titans* was the first time I was mystified by an animated character, I liked the robot owl – oh the shame. I hate it now, spoils the film; he was probably only there because of *Star Wars* and they wanted an R2D2 type thing. I was blown away by Phil Tippet's 'go-motion' dragon effects in *Dragonslayer*.

TD – I knew there was a perceptual illusion in place, and I liked some of the stories and characters portrayed. I was more fascinated by the magical aspect of inanimate objects being filled with life. I understood the perception that life was dependent upon a successful illusionary process. It seemed that something was coming through the process from somewhere else, the way a gifted actor can 'channel' an authentic personality out of the thin air. The shamanistic elements that stirred quietly beneath the whole process captured my attention. Gumby and Pokey were especially prone to evoke that response, what with all their shape-shifting and walking into and out of books and all.

RH – Stop motion was in a league of its own because it had that wonderfully realistic three-dimensional look. Those puppets were real objects you could touch, and this made them believable as characters. I was aware of how it was done by looking and taking it all in, but this didn't spoil the illusion for me. I was fascinated at how well it was done! *The Wind in the Willows* and *Postman Pat* were always the most appealing to me, but I still have fond memories of *Portland Bill*, *Cockleshell Bay* and *Bertha*.

JC – I didn't make a connection between drawn animation and stop motion. I loved cartoons, particularly *Tom and Jerry* and their contemporaries, but felt that the puppets were more 'real'.

FL – Those great monsters, my eyes overloaded with those fantastic images. I wish I had that sensation again. I actually did, a few times. …

DS – It appealed because I didn't know how it happened. The fact that the sets had a more tangible nature appealed to me more than those of the 2D animated films as they were clearly a different technique

AC – No, I had no thoughts about how it was made, it was totally believable.

Texture

For mainly economical reasons, short films look like an endangered species these days, but ideas for such films keep tumbling out of my head at an alarming rate. I have thought about using whatever computer method is accessible, just so the ideas don't wither away. But I look at Flash and it doesn't excite me. I have seen many brilliant films in Flash, some with deep characterisations, beautiful designs, with witty or provocative ideas, and tremendous storytelling, but I cannot seem to structure my ideas to the particular qualities of Flash. I have a huge pile of cels at home waiting to be used, but I can't get started. There shouldn't be a blockage, as I consider myself a storyteller and should jump at any chance of making a film, whatever the medium. I am not short of ideas, but what's stopping me is one word: texture. Or several words: texture, richness, space, depth, movement, shadow, lighting, physicality. They are all qualities stop motion has in abundance. It's about textures that move in a credible spatial environment. I am not a fan of flat colours, or shapes that exist without shadows, with little contact with their environment. Richness engages me.

I'm not sure I'd seen anything so beautiful or atmospheric as the backgrounds for *Bambi*, but at the age of six, I was aware that the characters were flat by comparison and often had little shadow or texture. I understood it was a necessary result of cel animation, but I still felt a little cheated. The characters did not seem to exist in the same space as the backgrounds. The other moment that upset me (other than *that* scene) was when the skunk meets the female skunk, and changes into a stiff, sharp-edged version of himself, and an obvious blush travels up his body with a clear edge. It broke for me the credible convention (if talking animals can be credible … well they were mostly on all fours) they had set up in the film. To have animals talking, and with unnatural proportions, was fine, as they were still animals, wonderfully drawn with roundness and softness, but this gag with the skunk just didn't fit the rest of the film. It is odd that in the world of animation, especially stop motion, where everything is possible, you have to be careful not to push things too far, as even by these concepts they can become no longer credible. My wanting to pull my Shakespeare puppet's head off for 'Yorick' worried me. If I'd done so I would have destroyed all credibility.

But *Bambi* contains one favourite sequence, which is 'Drip drip drip little April showers'. This is so full of texture and atmosphere, with the drips glistening freshly.

We are lucky that puppets have such physicality; some sort of created flesh and blood. Puppets are less interesting when they have been sculpted without any detail or texture, in pastel colours straight off the most basic of computers, wearing costumes that do not respond unexpectedly to lighting. I feel cheated of

interaction with light and shadow, and the resulting flatness might as well have been drawn. It seems a waste to make puppets that do not celebrate existing in their solid and spatial world. Seeing *King Kong*, I didn't connect his fur crawling with the animator's touch (I thought it was probably large fleas!), but I did want to touch it.

Texture is one of the ways in that stop motion scores over other animation. It can be bettered with a whole team of computer graphics (CG) artists, but it just happens naturally with us. Texture was a late development with CG. The early films were all inherently shiny and plastic looking, with cloth, fur and hair taking many years to develop, but I confess the first time I saw the CG Martians from *Mars Attacks*, I did feel that finally one could reach in and touch those amazing characters. Perhaps Gollum and the new Kong have to be the benchmarks for such texturing.

Jan Van Eyck's fifteenth-century masterpiece *The Arnolfini Marriage* is now generally reckoned not to be an enigmatic painting full of symbols witnessing a marriage, but an artist's calling card, showing off a mastery of the new technique of oil painting. Into this picture he crams every possible texture, shiny surface and lighting effect, all unseen until then. The history of the early CG features similarly shows the artists mastering each new texture in turn.

The magnificent stop motion films of Sjankmayer and the Brothers Quay are stuffed full of every conceivable texture. Sjankmayer mixes the seductive textures of clay with the organic materials of real livers and wet offal. The Quays fill their screens with the beautiful textures of rust, sawdust, wood and feathers, making you feel every frame as though through your fingers.

It's a neat journey to watch Pixar go from the shiny simple shapes of the lamp and ball in *Luxor Jnr* to the hugely complex shiny surfaces of *Cars*, having taken in absolutely every surface on the way. The visuals, the colours and the lighting of *Finding Nemo* are hard to beat. The great CG films managed to make the story come first and used the leaps in technology as a means to realise that story. The less great films get it the other way round, with the story being the means to realise the technology.

I have often animated two characters talking to each other, and one accidentally gets in the other's light, causing the other to move to catch the light again. These little spontaneous gestures surprise an audience, and give life to the performance, making it totally believable. As with so many things in stop motion it's the flaws that make it credible and special. Other techniques might have the scene lit with no danger of a shadow getting in the way, making it a little sterile.

Approaching a new puppet, I try to think how the show might be lit. It would be as foolish to light a character with heavy brows from directly above as it would to light a heavily sculpted

figure from the front, losing all detail. Ignoring the worthier reasons for making *Achilles*, I wanted it to be a celebration of male flesh, an idea not disagreeable to the ancient Greeks. I encouraged Mackinnon and Saunders, the puppet makers, to sculpt the puppets with appropriate bulges, curves and textures. I knew this film was going to be lit dramatically with strong shadows; I didn't want to use the lighting traditionally used on children's television, where fill light and little shadow give a comfortable softness. I wanted *Achilles* to glorify in every muscle and vein

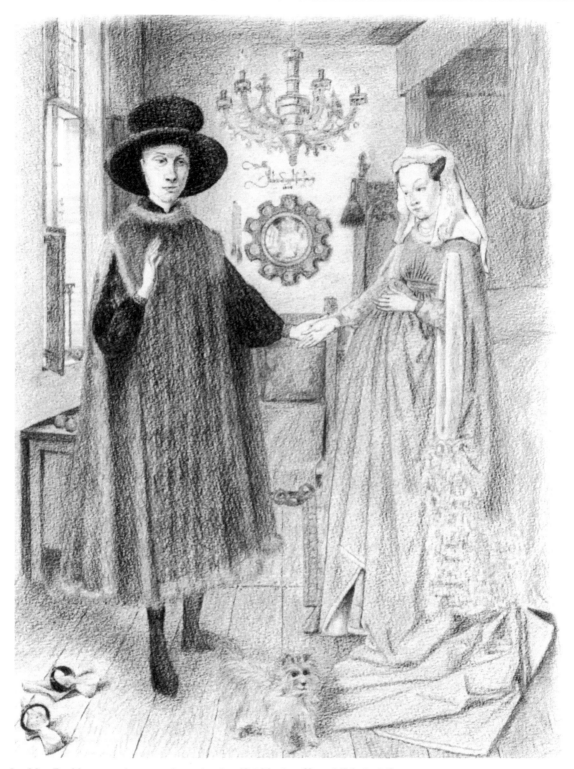

Jan Van Eyck's textural masterpiece, the *Arnolfini Marriage* (Saemi Takahashi).

of these astonishing puppets. Harsh side lighting with a gentle key light from behind picked up every sensual shape in the puppets. When animating, I could feel myself gently pushing the puppet a little further into or away from the light to make the shadows more effective. The shadows were as much a part of the film as the light.

Paul Smith's dramatic lighting for *Achilles*, emphasising the textural sculpting.

I tried to reference the Greek friezes and how they rely on a strong side lighting to make the relief stand out most effectively. I asked the excellent cameraman Paul Smith not to use fill, so some of the puppet was unseen, echoing they way that the puppets themselves stepped out of the darkness. The idea of using darkness is often a forced economy. I had used darkness in *Next* to play various theatrical tricks, but with *Achilles* I had ten puppets to walk: a time-consuming feat by any standards, and where would they have walked to when not needed in a scene? They couldn't walk off the set, as the set comprised just a stone circle. So the puppets evocatively emerge in and out of the dark, being physically removed when possible. This has become something of a signature trick. A cheap trick, but an effective one.

Puppets

What is this need to have such curious things as puppets? Why do we respond so deeply to a puppet? All great art forms, both high art and low culture, have at least one major dalliance with a puppet, or at least inanimate characters impossibly coming to life. Literature has *Pinocchio* and *Frankenstein*; myths have the *Golem* and *Prometheseus*; Opera has *The Tales of Hoffman*; dance has *Petruschka* and *Coppelia*; cinema has simply dozens ranging from *Metropolis* through *Dead of Night*, *Chucky* and *Mannequin*, to *The Iron Giant*. The appeal of *Chitty Chitty Bang Bang* (and *The Love Bug*) is based on an inanimate object supposedly having life, and that the best present for Baron Bomburst is a couple of living dolls.

Dick Van Dyke and Sally Ann Howes as the living puppets in *Chitty Chitty Bang Bang* (Richard Haynes).

Likewise in *Mary Poppins*, the most exciting day out is spent in the company of animated characters, making it a 'jolly holiday'. The equivalent scene in the glorious stage musical has

the chorus as statues brought to life. The potential was there for something exciting that blurred the line between the inanimate and the animate, making the audience unsure of what they were watching. The film has Dick Van Dyke seeming to dance with drawn penguins, in the same space, and beautifully directed to react with each other. With the stage statues there is little magic or surprise as the effect is so straightforward. Act One ends with Jane and Michael attacked by the toys and dolls they have mistreated. Again these are actors in effective costumes, and some are designed to look as if a limb is missing. Again, blurring the line between actors and puppets might have intrigued the audience more.

That puppets, dolls and objects with life feature in so many cultures should not be surprising as, basically, storytelling and drama are about bringing inanimate characters to life. Animation, and particularly stop motion, is an extreme version of this, but the tools we use are not singers, dancers or actors, but are literally inanimate objects. The popularity of video games shows not just a need for exciting role playing, albeit from a safe distance, but also that the players enjoying manipulating other characters in far more exhilarating situations. The puppet and the puppeteer.

Did imagining your toys coming to life kickstart all this?

JD – Several educational films using puppets by Bill Baird and others were shown in my school. My father made 8 mm home movies and had a book that mentioned animation of toys, etc. Aged five, I found a jointed wooden doll belonging to my aunts and mother. It could be posed like a stop motion puppet. Very intriguing, but I didn't give it adventures. I was more interested in how it worked.

TB – My friend Kent and I made stop motion films of anything we could get our hands on: GI Joe dolls, Johnny West dolls, model cars, airplanes, action figures, and so on.

RC – I used the family 16 mm camera for my first animation. I took two toy horses sculpted in two poses ... running and rearing up. I slid the running one along frame by frame until he got to a fence, then replaced him with the rearing one that I manipulated over and down in a few frames, and then back to the running one. When I got the film back, I was hooked.

DC – Star Wars figures were my thing! Adventures all the time!!!

RH – I had many He-Man, Ghostbusters and Thundercats toys with which my brother and I acted out our own adventures. My first piece of animation was with He-Man figures and a camcorder – in the garden, using a table-lamp for lighting and a watering can for rain!

TA – I was mad on playing with toys and creating adventures – usually a big fight. I choreographed fight scenes with macho dialogue; 'I'll get you'. 'No, I'll get you'. 'Well I'll get you first'. Playing with toys until I was far too old, my eyes lit up when learning I could do this for a living. Making toys come alive felt magical. We use 'magical' too much to describe stop motion, yet that felt true for this excited art student who'd found his niche. I actively try to keep that feeling going.

JC – I had an active imagination with teddies, dolls and 'Sindys' to play with. With my three brothers we put character into our toys, sometimes being a little cruel. My toys would often be kidnapped and tortured.

FL – I had He-Man action figures, and I did many stories with them.

DS – I played with marionettes but animation didn't hit me until later. I saw myself going into live-action camera work but got stuck in the stop motion world.

AC – I had a Sindy Doll and several Barbies – they were always being dressed up in flower petals or being draped in leaves. My brother was very fond of his Action Men!!

Response to stop motion

My gut response to stop motion isn't of trying to keep a sentimental childlike imagination in a harsh adult world, or about creating characters to make up for the lack of children or relationships of my own, or because I can't draw (I can't very well), and it isn't about having monstrous egos massaged by playing God on a film set. It's not even about trying to escape from the day-to-day world. One animator said that he does it because otherwise he would have to get a real job and what on earth could he do? We live in fear of being found out like this, and exposed for having no concrete skills. There are elements of all this, and the desire to leave some mark, but I do it because of the satisfaction coming from the storytelling and performance aspect of animation (however removed it might be). Though, I am aware that in what we do, however trivially, there is something primitive and basic, and that's probably no more than pure storytelling, with a bit of mythmaking thrown in. A young student wrote on my website that what we do, in a complimentary way, is witchcraft! I'm happy with that, and the choice of word is not irrelevant, bearing in mind witches and dolls with spirits.

It is a strange profession, but it's that peculiarity I love. It's almost a private world where those with a slightly distorted or eccentric imagination can function so well. I am pleased that I make my living doing something totally bizarre and different. I get paid for being sublimely silly and that can't be bad. Stop motion, in spite of so much information, still has a mystery and mystique about it. There is still an element of an animator being a shaman and conjurer and, shamelessly, I'm sure we're happy to play up to that image.

Sayoko Kinoshita, organiser of Hiroshima animation festival, Japan

Puppet animation is fascinating – it makes me feel something special, which cannot be found in other various animation techniques. The images constructed within the mind of an animator are brought to life with the warmth of his or her hands, frame by frame, and I always feel as if such embodiments start talking to my heart directly like the real living things in our world. It is also one of my pleasures to see that the film-maker's creativity and personality are clearly expressed as the original style aesthetics. We can say this characteristic differs significantly from that of 3D computer animation. At times, the animated puppets show devilish enchantment more than real human beings, and at times, the animated puppets invite the audience to a world of comfort, which is often beyond words. Moreover, I believe it is not only myself who feel the theatrical attractiveness in puppet animation. Because we not only sense the roots of puppet show represented by the Czech marionette, but also the unique 'timing' or 'breathing' which reminds me of Japanese Bunraku, Noh or Kyogen, and also, we find dance-like expressions as well as dramatic expressions of William Shakespeare. We can see these aspects within various kinds of puppet animation – from those

works aimed for adult audience, describing philosophical theme, to those fantastic works aimed for children – I feel as if I am appreciating a high-quality one-act play.

Puppet animation is a dynamic art form which allows us to do something closest to the gods, or perhaps, even more than the gods, as it gives life to things without life. As such, I well understand the feeling of the film-makers who become captivated by puppet animation. And, I am happy that, today, there are many artists who create puppets professionally and enthusiastically aimed for puppet animation, and also, that there are so many fans around the world who love this art form profoundly.

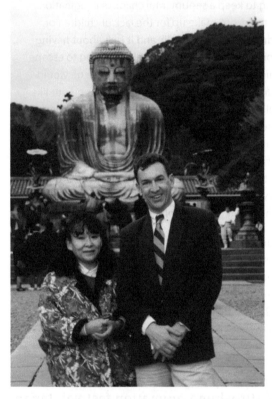

Sayoko Kinososhita and me, Tokyo, 1992.

Exciting and imaginative stories have always been told, sometimes to make sense of or to justify things not understood, sometimes to boast, sometimes to escape a harsher reality, sometimes to seduce, sometimes to flatter, sometimes to record, sometimes to caution, sometimes to pass on or sometimes to excite with the simple pleasure of a darn good yarn. Inevitably these stories get elaborated and embroidered, with the boring details left out. Most of them are told with relish, the success of the story more often depending on the telling. The stories can wander so far from the actual events that they become almost abstract, or symbolic, although the flavour, the point and intent of the original are still there, albeit in a heightened, more stylised and dramatic form.

This is where animators come in. My immediate reaction to animation is of a good story, a good idea, told with complete and utter joy for storytelling taken to imaginative extremes, using all the elements of sound, music, movement, design and character. Using animation to tell a realistic story would seem to be a waste of its potential. Using animation to tell a credible story with flamboyant relish is another matter. I get the same satisfaction from good animation as I do

from watching an orchestra play a glorious, complex piece of music that takes me somewhere sublime, or a piece of dance that has me marvelling at the stamina and agility of the dancer while a narrative or idea engages me. I can see the physical mechanics of the pieces, the orchestra fiddling away, the dancers sweating, but it doesn't stop me enjoying them. Both music and dance are a celebration of artifice, using sounds and movement in ordered deliberate structures, and none of what I'm watching or listening to is meant to be an exact replica of real life, but that is its appeal. I like seeing the craft, the construction, and then marvelling at how it manages to communicate with me. The best review I've had came from Allison Pearson in *The Independent on Sunday*, who summed up by saying about *Screen Play*, ' ... out of balsa came something infinitely weighty, infinitely sad'. Now replace the word 'balsa' with any word like movement, song or colour, and you have the appeal of arts such as animation. In spite of, or because of, knowing that it is a marvellously crafted trick, it manages to convey all manner of emotions.

Even if I don't understand the theories and technicalities behind performance and performances, I know when they work, and what makes them good or bad. I have seen my share of performances, and often my pleasure is derived from watching the craft. So it is with animation. I do not know about the theory of animation, or its political significance or resonances in popular culture, but I do know how to let a gesture read, and why to move a puppet at a certain moment and where to put a camera to make the most of a certain staging. I know how stop motion works, and what it is good at and, equally, what it is bad at. To spend thirty years working with puppets, and still be passionate about the craft, is an odd life.

Is animation a strange job for an adult? Has it affected your life at all?

JD – My friend Roger Dicken said, when someone derided his work because it was for children: 'yes but children can't do it'. Animation has affected my life, but I don't know if it's enriched my life or not. Some backaches. I sometimes enjoyed doing it, but received enormous abuse for my interests, even from those who were employing me to apply those interests. I got to travel a little. I received some notoriety, I rarely made any money to speak of, and I experienced personal gratification from my mastery of various skills, yet found that same mastery or awareness set me apart from others.

TB – Accounting is a rather strange profession. Is playing with dolls a strange profession? It depends on what is being done to the dolls. Each time I study a new character, I learn about another person. Learning about human behaviour is one of the most fascinating things about life, and should be for the performance animator.

KC – I've not met a pessimistic animator. Frustrated, yes, but always there seems to be optimism in their outlook on life. There seem to be no inhibitions when it comes to having a bit of fun.

RC – Strange? In the sense of compared to saving lives, I suppose so. As an art form, it's superb. Animators look at the world differently ... we seldom view anything without analysing it or being fascinated with its motion. It's affected my life by allowing me to perform and still stay 'behind the camera'. You can't hide all that much; your work is on the screen. You can't sit there and say, 'Yeah, that character should have had more punch in that action', as if the character was responsible instead of me. When I question students about something which isn't working, they often answer 'Yeah ... it seems to be doing this', as if they hadn't created the motion, and the character wasn't performing right on his own.

As for enriching my life, how do I even measure that? It has given me the chance to express myself, to bring life into all types of characters, attain some small notoriety, work on some feature films, earn a living doing something I love, and learn so much … mostly, how much more there is to learn.

DC – Definitely, and I'm glad I'm not like everybody else. Who wants to be a grown up? There are all sorts of things I can get away with 'because I'm an animator'. I wore a suit once! And now I'm married so I'll be careful before doing that again!! At a friend's wedding however, I saw an ornament that I thought looked like one of the Muppets! A Redcoat soldier stood sternly. His hat badge became a big funny nose and his brim became the wide characteristic toothless grin of a Muppet!! Everyone thought I was on drugs! I am! … And it's called imagination!!

AW – No I don't think it's a strange career. I see the world in 24ths of a second, doesn't everybody else??!!

SB – Yeah it is kinda strange. It's like we're not growing up and we want to stay playing with toys all our lives.

RH – Animation is a huge part of my life, and I love it more the older I get. In other people's eyes it seems a strange profession, but to do it well it is hard work – like any other job. We are much more observant than many other people, and are true perfectionists.

JC – A strange career but a rewarding one. We're lucky that we generally enjoy it so much. The stresses are more about schedules and continuity of employment. There a few staff jobs in this industry and most contracts are for six months or less. The money is quite good but you're always saving for the blocks between contracts. Animation has kept my imagination growing. You can work with truly inspirational creative talents, encouraging you to strive to be better. It's a difficult career for a woman if you have family. I've done well due to my lack of ties. I can go where the work is. Being tied to one place is more difficult. The hours can be difficult. On features, you can work fourteen-plus hours a day six days a week. Man or woman – in this industry you need an understanding partner.

FL – In some part of my soul I feel like strange for doing this thing. It's because I feel uncomfortable talking about animation (when the 'what do you do' question arrives) with people who are unrelated to any form of film-making or art. I've defeated myself (my hardest adversary) by actually starting to animate.

Generally, I have had an uneasy relationship with puppets … some I adore and some leave me cold, and the clever trick is not always enough. Not all of the stories I enjoyed as a child were all related to puppets (I'm already making an assumption that puppets are essentially connected with children), but often there was the common thread of inanimate things coming to life. *The Nutcracker* has been a constant source of pleasure, but I always lost interest when the nutcracker doll became a handsome prince; the doll character, doing dynamic things, seemed much more interesting than the dull prince.

Maria in *Metropolis*, coming to life out of the cold glistening technology, haunts me, primarily because of the iconic, beautiful design of the robot, and that something so cold and mechanical and dead can be sensual and expressive at the same time. My book of Greek myths was ever open, and the story of the original animator, Prometheseus, charged by the Gods with the task of bringing man to life through clay figures, well thumbed. I nearly named a company 'Prometheseus', but the clay connotations were misleading.

Being too bucolic for me, with its constant sunshine and jollity, and folksy, bland doll coming to life, *Coppelia* lost out in my affection to the other ballet puppet, the darker, rejected and tortured puppet *Petruschka* from Stravinsky.

Inspired not by the story but by that brilliant, lyrical, dangerous and exhilarating music, I have wanted to film this for ages. This story has appealing different layers; the character set apart, troubled but still having to dazzle the audience. The hubristic wish of a lonely puppet to feel real human emotions, and the fact that although he dies, his spirit still dances relentlessly and undiminished continue to excite me. It's a multilayered, deeply sexy tragedy about a puppet treated seriously, appealing to adults and children. Little wonder that *Petruschka* appeals.

Like the Nutcracker, I wanted Pinocchio to stay a puppet: his movements were more interesting and his world was more eccentric. I wonder what it was I feared that characters lost when they became human. Did they lose their naivety and have to face the real world and its responsibilities? Perhaps life was more colourful, or at least more carefree and less complicated as a puppet. Perhaps real life just looked dull. Perhaps this life was way too traditional, predictable and sensible, none of which appeals to me. Life as an animator has none of those qualities.

A dancer as the Nutcracker puppet (Richard Haynes).

Are you excited more by a CG film where Peter Pan flew with convincing realism, or see a stage production, where there's a complicity to use your imagination?

JD – It would depend on the production. Absolute realism has never been important to me. I like theatrical stylisation, even in films. However, I do think there should be an attempt to suggest reality. So good dramatics and style with wires showing wins out over lesser dramatics and style with flawless flying. But good dramatics and style with flawless flying would be even better.

TB – I enjoy stage productions more than movies, but I love animation more than anything. My late wife's sister, an actress here in Chicago, turned me on to the stage in ways that I never had seen before. I love theatre.

KD – With CG it has to be done well. Harry Potter, now that's done well … I want to go to that school and it's all so believable – to me anyway. However, something about theatre, about nearly being able to touch the scene and hear the voices is magical. I like both, if done well!

DC – I would enjoy not seeing the wires in a stage production. Seeing the rigging feels old fashioned and amateurish, but CG is too easy a cheat nowadays. The real magic comes from not knowing how it's done but knowing it is incredibly simple with no Heath Robinson involvement or computer trickery. The Ooooohh factor.

JC – It's hard to compare films with live performance. Realism isn't always important … something can be 'believable' without being realistic.

The puppet family

Impressionists

The word 'impression' is probably the reason why these performers do not work for me … an impression doesn't seem as committed as an illusion. It seems a bit half-hearted. Too often a loose approximation of the voice was seemingly enough. Not for me, and neither was I won over with elaborate costumes and make-up, clearly trying to convince where the voice failed. The only impressionists I have enjoyed are those who do it raw, transforming their whole face and body in front of us into the character, unaided by props or costumes. We are back with my naked magician. It's about overcoming the apparent limitations, and seeing the trick. Too many impressionists rely on the skill of the make-up artist, but those who can walk onstage and assume character after character and many at the same time get my attention. Steve Martin's physical performance in *All of Me* is a masterclass in transformation. He plays a man with a female spirit inhabiting one side of his body. With no special make-up or wardrobe effects, he walks down the street clearly as both male and female. This physicality definitely appeals to me, and drives much of my work. This would have been such a glorious animation challenge, but would the control of animation have been cheating? The Scottish character actor Stanley Baxter has the uncanny knack of overcoming a huge physical build to portray an astonishingly recognisable Queen Elizabeth II. Although he had wigs and great costumes, the performance is not about accuracy or finding the impression, but about looking at all the body language, the rhythms, the way of moving, the bearing, the physical and vocal tics of his character, and using the ones that tell the story of the character most clearly. This is what animation is all about. It's not slavishly copying real life, but it's about playing up observations and details that define a character, the essence of what makes a character, and simplifying things, throwing out the unnecessary clutter.

Ventriloquists

The voice and the face, perhaps because my own are a constant source of disappointment, have never been the primary factor for my interest in a performance, show me something moving and I am immediately interested. I never warmed to ventriloquist puppets. Originally I was

unsettled by the operator and the puppet often being dressed identically, but now I can understand the osmosis of the personalities too well. Again, here is a complicity with the audience. The experience of ventriloquism only works if the audience is aware of and enjoys the trick: if you remove the visual trick of the performer trying not to move his lips, and the constant placing of obstacles to make the trick harder (gottle of geer, anyone?), then ventriloquism falls to pieces rather quickly. To build a whole career about trying not to move one's lips, of trying to make a hard trick look

easy, is pretty odd, but hang on, an animator's career is pretty strange.

Ventriloquism on the radio has worked, on occasion, owing to the strength of the puppet's character, but that is one bizarre idea. I am mainly cold towards ventriloquist puppets, apart from the reliance on the voice, because of the lack of movement, and it is this movement that drives me. I'm not always interested in facial expressions, but more interested in body language, and a doll with a man's hand up his back, and limply swinging, scarily dead legs and loose floppy arms doesn't work for me. The big detailed head, the invariable glass eyes, and the noisy open or shut mouth never appealed. The nature of a forced voice thrown with a tight closed mouth, resulting in usually unattractive voices, didn't help either.

Kermit, from the Muppets, works much better for me as he does have those amazingly expressive arms and a face which, while deliberately lacking the detail of a carved ventriloquist's puppet's face, does have the

A ventriloquist and his puppet (Saemi Takahashi).

human spontaneity and subtlety element of which only a real hand-in-a-glove puppet is capable. Simplicity is probably Kermit's greatest visual strength as our imagination comes into play. The operators find the most basic essence of the expression and we supply the rest.

There is a hugely popular, but unsettling, comedian in the north of England, Frank Sidebottom, who is never seen with his real face exposed. He wears a large, obvious papier mâché ball-shaped head, with a fixed painted manic expression, and from the safety of this head he can say things he would never get away with otherwise. His identity is a closely guarded secret. To some extent he has become the ventriloquist's puppet without the intruding arm. I like they way that while his face is totally motionless, his body and voice do all the performing.

Although I am uncomfortable with them, the imagery of ventriloquists has popped up in my work (and that of many other animators). Mr Toad, from *The Wind in the Willows*, often play acted, and in one episode he used his hands as a mouth inside a white sheet, scaring Mole with a ghost story. My Shakespeare puppet used his hands to suggest the mouth of the chattering dummy puppet while acting out the Beatrice and Benedict moment in *Next*, but in *Rigoletto* I nearly went much further, by initially giving Rigoletto a folly stick that he could use to voice the insults he hurled at the court; the distance lending acceptability. This seemed to be the idea of animation itself: using a puppet to say things that could not be said by anyone else. I love the brief scenes Mary Poppins has with her talking umbrella, in essence a folly stick itself, which speaks its mind regardless. The parrot talks about the family's ingratitude, and Mary gently closes

Mary Poppins and her 'folly stick', a talking umbrella (Richard Haynes).

her fingers round its mouth, as if the parrot were voicing Mary's inner feelings which she had to suppress to keep up a respectable exterior.

Folly sticks

I wanted to develop the same relationship with Rigoletto and his folly stick, but it got complicated. I had already given Rigoletto a crutch, remembering Anthony Sher's agility and use of his crutches in the legendary Royal Shakespeare Company's 1984/1985 production of Richard III, where they became instruments of seduction and violence, as well as suggesting the imagery of a six-legged insect mentioned so often in the text. Rigoletto with a crutch and a folly stick was getting messy. But a crutch that was also a folly stick …? I had marked the score with the lines to be delivered by the folly stick, and had planned to echo Mary Poppins by

The original design of Rigoletto with his folly stick and crutch.

The final version of Rigoletto.

having him clamping his fist over the face when he sang things he should not have. In the end this was abandoned, as essentially, as it would have meant losing the use of one of Rigoletto's great long arms and expressive hands. Using both his hands would communicate more. Also, the practical detail of making sure the crutch stayed in firm contact with the floor would have been unnecessarily time consuming. So a nice idea, but that went because of simple practicalities. We shot a pilot using the folly stick, but it did not feature in the film.

In *Achilles*, folly sticks transmuted into masks on sticks that the chorus hold, reminding Achilles of his situation. The chorus itself is an artificial distancing device. It's becoming all about using something artificial, to say something far more directly.

My favourite character from the Gilbert and Sullivan operas, Jack Point, is a jester who usually has a folly stick. In my film of *Gilbert and Sullivan – The Very Models*, I tried to have Sullivan playing Point, saying something sincere to Gilbert through the distance and security of the folly stick, but again it got complicated, mainly because I did not want to lose the use of Sullivan's hands. Out went the idea, but I have always been fascinated by a folly stick. It is a puppet after all. I designed a poster for my school's production of *The Yeomen of the Guard*, and made an unsubtle parallel between the prongs of a halberd and the prongs of Point's folly stick. Not great art, but I do like giving objects an emotional weight. A folly stick can send audiences running, as jesters, in general, can be so unfunny, but this notion of putting the truth into the mouth of an inanimate object (or through the 'mask' of a heavily made-up jester, as in the opera *Il Pagliacci*), is essentially what we do. Having that distance from reality gives animators enormous licence. It's this distance from the truth that can bring us closer to the truth. Disembodied graphic heads appearing out of the darkness, prodding both Gilbert and Sullivan's conscience, act as a sort of folly stick.

Along with Rigoletto and Jack Point, the great Shakespearean fools such as Feste, Touchstone and Lear's Fool are characters telling the audience and the characters exactly what is going on. Lear's Fool, particularly, in a play so full of lies and blindness, straightforwardly tells Lear the truth. King Lear is a play that uses all manner of distancing devices to give the characters a perspective to see the truth when the truth is hard to discern. Here characters are blinded, so that they can see. Others embrace madness to become sane, and the Fool, often clutching his folly stick, is among the wisest. It is this distancing that we can exploit so much with puppets in stop motion.

Fools have their folly sticks, but so often clowns need some small token to hide behind: a red nose, huge flat shoes, an odd hat, white faces, a tear drop, baggy trousers and the like, all allow them the licence to get away with plain speaking.

Drag

Another example of how something so fake can be so truthful are two brilliant actors, Patrick Fyffe and George Logan (it would cheapen their craft to call them drag queens), who for nearly thirty years had audiences in hysterics with their creations, Dr Evadne Hinge and Dame Hilda Brackett, two genteel ladies of an uncertain age who sang and reminisced about the golden days of Noel Coward, Ivor Novello, and Gilbert and Sullivan. Their beautifully researched characterisation was on the surface all innocent and affectionate, but underneath lay barbed satire about theatre, those in it and their sexualities, full of joyously smutty jokes. Two dear

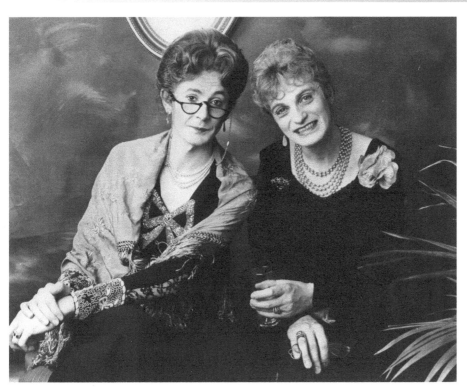

Hinge and Brackett, aka George Logan and Patrick Fyffe.

ladies getting away with salacious gossip, done with such craft, accuracy and love that even those in the audience were sometimes unaware that the joke was on them. To be unaware that these ladies were men must have made for a strange evening indeed. But once again, a little distancing, as with puppets, allows for the hitting of direct targets.

My films are usually criticised for being overtly theatrical, as though there is a set genre for puppet films. I have in my defence been trying to put more focus on the puppet as performer, building a stronger connection between the puppets and the audience, by cutting out all the clutter. Being so separate from the audience is my main disappointment with stop motion. In theatre these days, the most satisfying experiences are when there is little barrier between the performer and the audience. My heart sinks to see a curtain, with the emotional removal that instils. Most companies are encouraging spaces where it's not 'them' and 'us', separated by the straight line of the edge of the stage, but where the actors spill out into the auditorium. Great spaces such as the Royal Exchange in Manchester, the Courtyard and Swan Theatres in Stratford-upon-Avon, and the Cottesloe at the National Theatre put the emphasis on the performer and the direct shared experience of storytelling with the audience. This could be letting the cinema do the spectacle part, while theatre concentrates on actors communicating immediately with the audience. I have tried with my films to focus on the performance of the puppet. Budgets, schedules and brave commissioning editors allowing, I strive to make a film with puppets that communicate with the emotional responses I experience inches from a live performer. I know it can be done. Live puppets are being used more and more in theatre and opera, and I hope that stop motion becomes part of this cross-over.

The tangible relationship between Pinocchio and Geppetto (Saemi Takahashi).

Although having rather dismissed ventriloquism, those brilliantly made ventriloquist films, *Dead of Night* and *Magic*, still strike a chord of excitement with me, especially for the moment when the puppet, physically disconnected from its operator, appears to have life of its own. Every so often ventriloquists leave their puppet on a chair, and it carries on chatting (though little else). Suddenly I am interested, as I hope the puppet might walk with the ultimate illusion, but I'm usually disappointed. All animators can respond to giving life to a puppet, knowing it's a trick and an indulgent piece of psychology, but when the puppet starts to respond by itself, it is both exciting and unnerving. This element is an essential part of stop motion. The puppet often provides much of the performance, separate from us.

When the creation starts to have its own life then we are definitely into Frankenstein's monster territory. He, like Maria in *Metropolis*, the Golem (and how ripe this story is for animation, especially with its clay creation), the Nutcracker, Petruschka and a million other icons, are essentially large puppets given life by a puppeteer. Often the story centres on the troubled relationship between the puppet and the puppeteer, the creator and the created, or whatever roles we like to give them. Most of these stories come with inherent warnings about the responsibilities of creation, especially when the two characters are separated or fall out. Do these constant battles embody an eternal battle in us between the more attractive free spirit and the rather regretful staid conventional persona? Puppets seem to represent a huge range of emotion, from wide-eyed innocence through tragic incompleteness to downright sinister. Often puppets

are used to show some sort of rite of passage, where the puppet is a naughty, carefree spirit unrestricted by social conduct, which is then forced to grow up and conform to more socially acceptable behaviour. Such puppets are feared by grown-ups as a reminder of what has been lost. Clara's journey with the Nutcracker, at its most basic, is that she learns to stop playing with a toy man and welcomes the attention of a real man, but I cannot help feeling that marrying a bland prince is far less interesting than the adventures with fighting mice, wooden soldiers and kingdoms of sweets. Just as we can be deeply perturbed by puppets, as we can never quite be sure that they are just a lump of wood, they do hold forbidden pleasures. We may be unsettled, but secretly we are probably jealous of their non-conformity. Creating an image in substantial three dimensions or in a credible likeness cannot help but give it some suggestion of life, especially if it is done intimately by hand, and with this life we can project all manner of fantasies and character.

The puppet and puppeteer

Most puppets are inextricably linked to the puppeteer, or at least a presence, with the puppet often having the freer life, ironically. In *Thunderbirds* we can see the strings of the operator; Pinocchio is much a part of Geppetto; the Monster forever confused with Frankenstein; Punch and Judy linked to the operator by the presence of the operator down below in the booth; the doll in *Coppelia* part of Coppelius as much as Olympia is part of Dr Coppelius in *Tales of Hoffman*; Petruschka owned by the fairground barker, and so on, but in stop motion, the performer is removed, even if their personality is evident in the performance. In most cases the audience has no desire to know about the performer to enjoy the work. Names such as Trinka, Harryhausen, Nick Park, Tim Burton and George Pal will lead to expectations because of a history, but generally the audience is happily oblivious of who is animating a specific stop motion puppet. However, like actors playing roles differently, animators perform puppets differently. This can be a strength, but when several animators are working together on a series, this can be difficult. Each animator will interpret something differently, and have their own quirks, responding better to some situations than others, and thank goodness for that.

Do you think that you animate in a particular way? Is something of your personality in every shot?

JD – I hope so.

TB – No. If I am animating a sad princess, I know my approach to her performance will be different to animating a ferocious Minotaur. The character is the most important thing, not my own personality.

RC – I can't say that I do something different. But I try to give a sense of weight, which is important, and somewhat of a flow, as rhythm is important.

DC – Yes, everyone has their own technique and style and a favourite palette of work to choose from that they know will work. You're your own best reference.

SB – Each animator brings something different and has different strengths. I can tell other people's shots. Some have a fluid, smoother style; some are crisper, cleaner.

RH – I have my own style, but it's difficult to describe. I have developed a good mix of soft, flowing movement and snappy action. The real challenge is to balance not too much or not too less in every shot, while cutting corners and compromising for time constraints. I consider the secondage, and work out how I can make each shot read and tell the story, with still a good quantity of frames, within a reasonable timeframe.

JC – We each have a little of our own style but, as a jobbing animator, you must be able to copy the style of a show. There must be a sense of continuity. A lot of projects I've worked on, although the look is similar, you can pick out shots and know who has done them. A good director will play to his crew's strengths. Some people like the action shots, running, sliding, flying … others like the more subtle emotional stuff. Your personality can shine through a puppet if that puppet has something about it that you can empathise with.

DS – If you look at all the people who have animated Morph you can see the differences.

Can you see yourself in your work? Do certain themes keep cropping up, and what do they say about you?

JD – Not necessarily. Sounds shallow to me. One will have a tendency to find some themes more appealing. I like 'the neurotic hero' – one who does the right thing for the 'wrong' reasons, rather than the chap who is macho and never doubts his course of action. One fan could tell my work by the type of live-action set-ups I designed, but I'm too close to be able to see that.

TB – That I'm an incurable romantic. I tackle many different genres and topics, and that because of this, I cannot be pegged into a particular hole.

KD – That I enjoy the dark side and nearly always do something related to death.

DC – Characters often take on the mannerisms of the animator animating them because you're your own best reference and that can be a bit weird when someone notes 'that sheep walks like you!!'

RH – My film *The Typewriter* says a lot about me – the character is the mirror image of me – not only physically, but the way he acts. This is exactly how I would act if I were on stage or entertaining. It represents my optimistic views on life.

JC – I find my own ideas are probably aimed at people like me. I have explored themes that interest me. Some ideas are a more extreme version of something in my life.

DS – Themes do recur. I'm sure although the more you work with others the less obvious they seem.

Marionettes

My wish for more complex movement from ventriloquist puppets also applies to marionettes. I am full of admiration for the craft and the dynamic storytelling of such shows as Gerry Anderson's brilliant *Thunderbirds*, but I wanted more from the puppets themselves. By their nature, marionettes have a more lyrical, smoother movement, with gestures flowing and overlapping into each other, lacking the sharp precision of stop motion. Gravity and the natural bounce and momentum in the strings do not always allow sudden moves with dramatic instant pauses. Some marionettes can get a bit syrupy without the clarity and energy that stop motion can provide.

The animator animates: Anthony Scott drawn by Chris Butler.

Thunderbirds was an exciting series about a family providing a catalyst for the vivid action scenes involving Derek Medding's astonishing model work and special effects, with the flamboyance of Lady Penelope and Parker thrown in. The show made up for limited movement in the characters by using the old standby we have all relied on: put the characters in a vehicle (but what sensational machines) and have the vehicles race around, not only providing great pacing, but also speeding up production. In *Rigoletto*, lacking the necessary time to animate as much walking as I would have liked, the camera provided much of the movement. This also suited the film, as the camera became illustrative of the music itself. There are always ways to fool the audience into thinking they have seen a puppet running into shot.

Seeing the strings on these marionettes was part of the trick, and never worried me. The brilliant stage show, *Thunderbirds are Fab*, a loving homage to the Gerry Anderson oeuvre, reversed the trick of seeing puppets act like humans and imagined stringless actors behaving like marionettes, with beautifully observed detail. The audience knows how a human walks, but these actors appeared weightless, responding with that recognisable slight lack of coordination. The moment the actor, with his spectacular *Thunderbirds 2* model worn as a hat (like my Shakespeare puppet and his *Tempest* hat), moved through a succession of tiny palm trees worn on his fingers will stay with me for a long time.

I didn't have a history of seeing marionettes. I had a Pelham Puppet (a badly sculpted witch), but my mastery of the technique never got beyond jiggling about most inelegantly. This being not very beautiful, nor controlled nor weighty movement tempered my affection for marionettes. Any performance was haphazard to say the least, and stop motion animators certainly like precision. The arms waved around a lot, while the legs flopped nastily beneath, making a puppet walk almost impossible, lacking the essential convincing contact with the ground.

One of the world-saving Tracy family puppets from Gerry Anderson's *Thunderbirds* (Richard Haynes).

The Sound of Music

That, and so much more, changed with *The Sound of Music*. The puppets in the Lonely Goatherd sequence have had a profound influence on me. Even today, it is a beautifully executed and dazzlingly performed sequence. The actual performance by the puppets is rather economic, with most of the energy created through the editing. Aged ten, to me the naughty nuns seemed fun, Julie Andrews was luminous, the scenery breathtaking, and Eleanor Parker and Christopher Plummer … well the film is too full of so many gloriously guilty pleasures, but I just need to hear that opening music to Lonely Goatherd and I have watch the whole sequence with complete and utter attention and respect. I suspected that Julie Andrews and the kids were probably fronting for the real hidden puppeteers and that the sequence was not filmed in real time. The manipulators gave the characters much life, especially with the eyes, but it wasn't just the gorgeous design, the exhilarating song or the choreography that had me entranced.

I knew that something else was going on, although I couldn't quite articulate what. I knew that this puppet show wasn't there as a charming diversion to keep the kids, on screen and off, happy. I was aware that the puppets were echoing the main triangular relationship of the film, and this struck me as most agreeable. I noticed how the relationship between the lovers and the mother was reflected in the goat puppets, through use of colour (especially that ravishing purple), and with eye movements of the 'mother' character. This was the moment that semiology planted a seed in my head. I began to realise that other elements could tell the story, not just the more obvious and literal plot. It was these echoes and parallels that fascinated

Shakespeare as Prospero controlling Ariel controlling the Tempest, from *Next*.

me. Chatting about *mise-en-scène* probably made me an odd ten years old, but this puppet sequence was a eureka moment. The continuous musical through-line makes you unaware that filming has compressed real time. This film was so groundbreaking in its use of editing. The Do-Ray-Me sequence jumps locations and time in the same musical phrase, but the flowing movement and choreography drive the action through without jarring any logic.

Although the filming of the puppet sequence most likely took a good couple of weeks and Dame Julie probably wanted to strangle the kids with the puppets' wires by the end, it feels absolutely spontaneous. This was no doubt achieved by the most unsponatenous of planning, rehearsal and strict continuity. When the numbers is finished, you feel the same high that the characters do. That was another appealing element: not that these kids use the puppet show as an emotional release, making an unspoken point with their father, but it was a group coming together to produce something, however small, with everyone contributing, that also struck me. What's more, the 'performers' are having such fun. If that's what puppets can do, count me in. This short sequence, with its backstage story, the onstage story and the story out front, manages to sum up succinctly the state the characters' relationships at that point in the film. To have done so with characters literally chatting away revealing their inner thoughts would have been very uninteresting.

Most marionettes, though, pale next to the sophistication and content of Ronnie Burkett's *Theatre of Marionettes*, which supply the depth and detail of performance I have missed in other marionettes. Single handedly, and performing the voices live (the multiple voices alone would defeat most performers) he operates up to thirty different puppets in a single two-hour show. He is deliberately in view the whole time, as are the other waiting puppets, and Ronnie's own physicality is as much part of the performance as his puppets. Watching him in action, the relationship

The Bɪʟ Baird puppets from *The Sound of Music* (Richard Haynes).

between the puppets and the puppeteer is so strong that he seldom needs look directly at the puppets beneath him. The puppets often have fixed faces and hands, expressing so much through their whole bodies, using stillness just as expressively. They interact in ways that belie the spaghetti of strings, and at a recent performance of *10 Days on Earth*, the small detail of a puppet stepping out of a pair of slippers drew a gasp from the audience. These puppets walk, making solid contacts with the floor. The plays are complex, rich and utterly moving, taking the art to its most sophisticated and most direct level, with the puppeteer inseparable from the puppets. When I met Ronnie we were both rather humbled about the other's work, each thinking we were lower down the puppet pecking order, but what Ronnie does in one evening has taken me my whole career, and I've hardly begun to tackle his range of emotions. He was also transformed by the Lonely Goatherd sequence, and swapped stories with Julie Andrews after one of his performances. There is something about puppets that keeps linking people. With Ronnie's performances, there is no hiding, and the audience shares the event. I've not yet found a way for stop motion to break out of its glass wall and communicate directly to the audience. I'm trying.

Ronnie is so right about the roles that puppets allow us to play. No ordinary actor's repertoire can match our wide range of characters, and the necessary rethinking of approaches to a part tests and excites us. Ronnie's shows work by seeing the strings and the performer. The distance of created artifice in a supposedly realistic situation is such a brilliant device, as Shakespeare knew from Hamlet's *Mousetrap*.

This is when animation works so well: when it glories in its artifice, its filmic language, its theatricality, it is able to say so much more. Since the goatherds I have been a sucker for plays within plays and films and pieces that simple revel in their medium. The idea that something as artificial as an innocent-looking puppet can say something more honestly than a human character is my main preoccupation. Look at Gromit, who is hardly a realistic dog, but you recognise real character, real thoughts and real emotions. All the extra distracting details have been stripped away, and you know exactly what Gromit is thinking. Of course, it helps that he is so beautifully animated.

There has been a tentative revival of marionettes on the big screen. Parker and Stone's *Team America*, with the Chiodo Brothers' gloriously dynamic puppetry, was laden with so much irony, but still managed to get detailed performances out of the puppets, and hysterical and affectionate

Ronnie Burkett and Darrell from *10 Days on Earth*, 2007 (photograph by Trudie Lee).

Ronnie Burkett

I suspect many people think I work with puppets as a way of controlling the world, albeit a smaller world; a power-hungry Geppetto gone mad at least, a sort of God complex at worst. It's actually nothing to do with that, for one learns quickly and harshly how futile and immoral is the act of manipulating people, even jointed icons on strings masquerading as people. As a child I was first drawn to puppetry because it allowed me to play by myself in the various art and craft realms that interested me: play making, performing, sculpture, painting, costumes, and perhaps most importantly, a total escape into the world I imagined, and in the service of the voices I heard in my head. Later on, acting teachers pronounced that I would only play certain types or within a prescribed age range or limited to roles based upon my gender, my height or my skin colour. Performing with puppets has never held me to those limitations and I freely play men and women and children of all ages and types. The main connection between my initial fascination with puppetry and the work I do now is a sense of complete bafflement and wonder with my species. I simply do not understand people, but I find them the most glorious, devious, hopeful, destructive, mysterious, sad and hilarious subjects. I know many puppeteers and animators who create other worldly characters, aliens and monsters and mythical beasts and elves and such. But for me, the source material and inspiration for all my work are humans, for within us are truly angels and demons and infinite variations in between. So I make and perform puppets not as a way of controlling a disorderly world but simply to shrink my species to a manageable size to investigate, illuminate and ruminate upon my own kind.

Ronnie Burkett and a character from *Happy* (photograph by Trudie Lee).

observations about puppet behaviour, especially in the spectacular opening scene. Sometimes the traditionally disproportionate heads disconcert me as the small bodies then struggle even more to supply interesting movement, but here the sheer athleticism was astonishing. Anders Klarlund's *Strings* is very different, being earnest, exquisitely shot and designed, and containing some breathtaking puppet choreography, with some surprisingly subtle expressions and body language. I loved the notion of featuring the strings themselves, with an old puppet starting the film by committing suicide by literally cutting its own strings. This extravagant film contains many beautiful metaphors involving strings and their effect and significance on the characters. There is little attempt to deny the presence of the operators. This film is a glorious celebration of artifice and illusion, with the trick not just visible but also its justification. I wonder whether the marionette puppeteer is able to feel the same direct connection as the stop motion animator, or whether the several metres of strings has an alienating effect, especially as a puppet often needs more than one puppeteer. I was pleased to note that the principal puppeteer gets almost the first credit on *Strings*, a suitable acknowledgement that puppets perform, and perform differently with each puppeteer. Both films make different points through the strings themselves, and I wonder whether we would enjoy a film or performance where the strings and the puppeteer's presence were not acknowledged. The suicide by strings brings to mind a recent stop motion film where the puppet kills itself. *Aria* by Piotr Sapegin takes a puppet, Cio Cio San from *Madama Butterfly* and, to a Puccini aria, has her commit sapuko by first stripping off her kimono, then dismantling her armature, piece by piece. It is surprisingly moving.

I endured watching the Royal Variety Performance, primarily to see *Wicked* (another look behind a familiar icon, and thus appealing to me) and *Avenue Q*. As the puppeteers strutted their stuff with legless puppets singing about how 'it sucks to be me, when you're the sort who irons his underwear', I was embarrassingly ironing my underwear at that exact moment …

whoops. I was intrigued to see the operators at work, and happy to see them wearing black clothes, not as all encompassing as the operators in Japanese Kabuki and Bunraku theatre, but black all the same, throwing most of the focus, but not all, onto the colourful puppet. Even though they are basic legless puppets, they still command attention and express amazing emotions. One character retorts that another 'is so frigid that when you open your legs a line shines out'. The other responds with a painful look of hurt at her lack of legs. A great show with puppet

A puppet and its operators from Japanese Bunraku: the senior puppeteer, the dezakai, is uncovered (Saemi Takahashi).

performances aimed at adults, with songs and comments about relationships echoing the relationship between the puppet and the puppeteer. But once again, there is the puppeteer with his hand clearly up the puppet's back, and does it matter, not one jot. The trick is part of the show. It would be interesting to see this filmed with the puppeteer hidden. The show would be limp indeed, and lose its point.

The hugely influential show *The Lion King*, directed by Julie Taymor, now running all over the world, has opened eyes to puppetry of all descriptions. The show is innovative for using puppets on a big commercial stage, although most of the techniques are borrowed and jazzed up from different cultures and histories (*Screen Play* used many of the same techniques). There are nods towards Bunraku, Javanese shadow puppets, rod puppets and all manner of techniques, mixed with a colourful dose of Broadway. Beyond some dazzling stage tricks and illusions, audiences seem to have responded to the line between performer and puppet pretty much disappearing. It is hard to tell where one finishes and another starts. The actors performing the zebras, for example, have an animal-like structure built around their bodies, and move the legs of the zebras with rods. You see a seamless blend. With some of the main characters, such as the meerkat, the operator, rather than being dressed in the convention of invisibility, black, is a character in his own right, with a colourful costume that contrasts vividly with the meerkat puppet strapped to his front. Children seem to have no trouble grasping this convention of watching the puppet giving a tremendously detailed performance, while watching the performer giving

A zebra from *The Lion King* (Saemi Takahashi).

ENNIO MARCHETTO © Manuel Bergamin.

a different performance at the same time. Complicating the convention even further, the puppet turns round to face the operator, and they acknowledge each other, adding layer upon layer. Another character, the bird, gets excessively chatty and is danger of saying too much. The operator simply reaches up and clamps a hand round his beak. Rather than break the world of puppet and puppeteer, this reinforces the link between the two, much as Mary Poppins silenced her parrot. Working in stop motion I envy the spontaneous relationship there. It must be hard for those performers casually to put their puppets to one side when they are so physically a part of them.

Another artist who totally blurs the line between performer and animation is Venetian mime, Ennio Marchetto. He is literally a living cartoon, wearing outrageously observed paper cutouts of cultural icons ripe for caricature. He dances around the stage with astonishing dexterity, miming to appropriate songs, animating and transforming these cutouts into image after image, the juxtaposition of which are telling and hysterical. Living origami is too inadequate a description. The instant and inventive segues are as much a part of the fun as the methods in which he surprises the audience with the lively animation. However dazzling the cartoon drawings, his body, most especially his arms and face, are integrated into the design and movement. He is both puppet and puppeteer. His hour long one man show, with many dozen characters, is my NEXT take to manic colourful extremes, and it's glorious.

Recurring Images

Bodily transformation is probably my most common obsession (Petros Papadopoulos).

I tend to use flat imagery somewhere in most of my work. It is a satisfying mix of techniques and a statement of the artificial nature of illusion. I enjoy contriving to trick the audience, playing with scale and illusion. The first film, on Super 8 mm, was a clunky piece of irony. Near my flat was a huge advertising hoarding hosting a picture of a field of dazzling yellow sunflowers. With the opening frame of my film composed within the poster itself, and the fortunate fly-past of a bird, this could have been a sunny afternoon in the countryside, until the camera pulled back revealing that the poster was in the bleakest part of Moss Side, then a frightening place. Hardly breaking new cinematic ground, the irony of playing with real and fake has stayed with me. Most of my stage sets have been quite flat with graphic imagery; characters burst forth from numerous hidden doors. I do not like, or am not capable of designing architecturally accurate sets, and I prefer to find an apt image that comments on the piece rather than creating a literal space. I see being literal as some sort of curse.

I designed Alan Ayckbourn's *Communicating Doors*, which is set in three time periods at the same time and occupying the same space. Some productions become bogged down with literally presenting the different periods on stage, but it seemed to me that Ayckbourn was

The cast of *Communicating Doors*, Altrincham Garrick, 2001.

talking more about the past, the present and the future, or about three potential states of a life. I didn't have the time to design the hotel apartment suggested in the text, with all its detail. That seemed a dull way to go, and not theatrical for what was a theatrical piece. I came up with a space suggested by Magritte's painting of a curved wall painted blue with white clouds, and framed by painted red theatrical curtains. One piece of furniture doubled for every piece of furniture, and in the curved wall were hidden eight invisible doors. The past, present and future were differentiated by the primary colours worn by the characters, and this became a stronger visual clue as to who was where and when. Seeing a character in primary red sitting next to a character in primary blue was a more exciting way to show characters separated by twenty years than by relying on literal costumes and big hair. This concept liberated the actors, who made the most of the theatricality of the play. As with everything, I find the constraint of a simple visual conceit more creative. *Next* would not have been effective had I had the many characters I'd wanted, nor would *Gilbert and Sullivan* or *Achilles*. Less can be so much more.

Birds

Birds feature heavily in everything I do, right back to *The Pied Piper*, where some simple cut-out birds fly overhead as the Piper leads the children away. My school art teacher showed me how Breughel used birds in the midground to give depth to a painting. That's stuck with me, and they are in every sky. On *Pied Piper* we used large gauzes to soften the painted skies and distant hills, and onto these were stuck a few simple replacement black paper shapes in a cycle, with perhaps a white line separating the body from the upstage wing or one wing painted a lighter grey to give depth. In *The Wind in the Willows* there was a whole flock, from swallows darting about to a rather grand and stately heron flying away from Toad Hall. I showed off by

having these cut-outs in effect, turning corners. In one episode these birds appear to travel towards the camera through a series of larger replacements. Birds have a great resonance for me, but in their most basic function, they give life and a spatial dimension to an otherwise dead space of flat sky. Today we add them with computer graphics, but huge satisfaction comes from something so simple and so effective. Of course, Willis O'Brien was doing this effectively with his cut-out sea birds stuck to glass seventy-five years ago in *King Kong*.

Birds flying around will conveniently set a location, and give you licence for some equally atmospheric sound effects. Birds are hugely significant to me; they appear as bird masks or some more developed transformation. In *Next*, Shakespeare wears bird masks in the *Romeo and Juliet* scene, and an eagle mask in the final scene from *Cymbeline*. In *Screen Play*, the two birds are forever commenting on and paralleling the central relationship, hinting at the transformation to come. In *Rigoletto*, bird masks at the orgy quickly set out the hierarchy of the society in a visual shorthand. The Duke looks magnificent in a bird of prey mask, while the foolish Rigoletto is a cock and the cuckolded Ceprano is seen as a turkey. The women wear more exotic masks of swans. In this scheme of things, the assassins appropriately wear skulls. Two crows, beautifully made by my mother, peck at the hanging corpses – lovely!

Romeo and Juliet in bird masks.

In *Achilles*, the birds became bulls, as the image of men jumping through a bull's horns is a recurring one in Greek and Mycenaean art, especially at Knossos, and signifies a transition to full male adulthood. The Minotaur has enthralled me since I first read the Greeks, and although not exactly related to this myth, it is a masculine and virile image. I had referred to Achilles and Patroclus training together, killing a bull. There is symmetry in Achilles killing another 'bull' at the end, Hector in his bull helmet.

I always look forward to seeing how the serpent and the animals will be represented in *The Magic Flute*, and a rather space-age production recently saw the serpent as a spectacularly built muscleman in the smallest of jockstraps but with a splendid bull's head. The three ladies danced round, killing him with absurd glittery ray guns. The bull collapsed ungainly to the floor, and the scene carried on. Even when the scene changed he seemed happy on the floor, fast asleep. I have seen an audience asleep before, but never a performer.

The Gilbert and Sullivan film did escape my obsession with characters playing animals and birds, although at one point Gilbert came close to acting out *Tit Willow* as a bird-themed shadow puppet scene. Again, with Gilbert trying to show respect for Sullivan, puppets would have been used to say something the protagonists could not. It would have also been a moment of different visual storytelling and I'm always up for that.

Hamilton Mattress is populated with characters as birds, although here they are fully fledged birds, not some strange, role-playing hybrid commenting on the story.

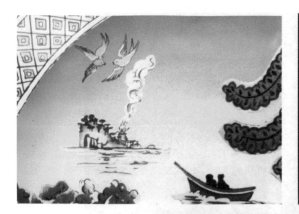

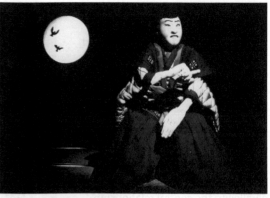

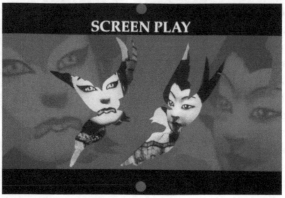

More birds, all from *Screen Play*.

Some of the significant bird masks in *Rigoletto*.

Two versions of the bull theme from *Achilles*.

The beautiful Beryl from *Hamilton Mattress*, voiced by Lindsay Duncan and animated by Joanne Chalkley.

Even so, birds do get everywhere. One of the many stop motion projects that have got away is Aristophanes' *The Birds*, in which two Athenians leave the city looking for Cloudcuckooland, an idyllic society free from man's laws, populated by birds and half-birds. Of course, the men arrive and change everything. It sends up interfering buffoons, bureaucracy and the arts, and would be a perfect vehicle for animation, being self-conscious, full of gloriously eccentric characters, music and great opportunities for interesting movement. Aristophanes knew the trick of distancing his characters as avian or animalistic equivalents of humans, allowing them to say something they could not in human form. His choruses are full of birds, frogs and even wasps.

This recurring theme, almost an obsession, of humans with animal and bird heads, may stem a little from dissatisfaction with my own face, and it is definitely an erotic image, but it is more about transformation and seeing things from a fresh perspective. Transforming into characters that we are not is a huge part of stop motion's appeal. Another project that got away features characters with bird heads, with the particular bird informing their movements and character more than dialogue could.

Somerset Down, Major Fly McNaughton and Commander Hugh Featherstone from my unmade *Toucan Tango*.

Swan Lake

The ultimate piece about transformation must be *Swan Lake*, something that has inspired me for so many reasons. The music is rich in drama, and even without knowing the narrative, clearly something powerful, sexual and emotional is going on. The music in the last five minutes has the power to reduce me to tears. I love the marathon that the show demands of the prima ballerina and the company. Each

performance is an event. I love its sheer standing as a great cultural icon, but probably I love it for being about transformation, not just in its narrative but in its performance. That we can give the illusion of being something else is what drives me, and stop motion goes some way towards realising that idea. Delicate positioning of a dancer's arm to suggest a swan's neck is what keeps me doing what I do. Seeing the swan and the human, the performer and the performance, the puppet and the puppeteer, strikes a strong emotional and artistic chord in me.

Swan Lake is rooted in tradition, and the original is breathtaking, but I wish that such pieces were freer to move with developments in staging and production. I can identify with Matthew Bourne's innovated reinventions of pieces, especially his *Swan Lake*. Freeing it from tradition, while still respecting the music, he has created an astonishingly powerful piece of modern dance theatre. I would like to approach animation in the same way as he has reinvented dance. It may be grand and tantamount to hubris, but I would love, as a result of my films yet to be made, to be responsible for a child's enthusiasm for classical music, or culture or myths. Just to get a child excited, stimulated, challenged, inspired and transformed through art … that would be satisfying. I'm not sure that I've achieved any of those; entertained perhaps, or kept them out of mischief for a while, but I doubt I've given anyone the rush I experience at a great production of *Swan Lake* or those other epics milestones of culture … now I've used that word 'culture' and hear tongues accusing me of being lofty. Not at all. I'm not for making art élitist, but I am all for creating something powerful, sublime and transforming. I know that animation has the power to do that.

With the sheer passion of the music reflecting something of Tchaikovsky's own torments, the icon saying something about the creator, *Swan Lake* brings together all the themes that interest and excite me.

Puppets elsewhere

Opera

Julie Taymor has often introduced puppets into opera, but I am sure this is primarily about a theatrically interesting way to tell a story. In the *New York Times* (20 November 2006) she says, 'Only when a human being in its simplest form cannot do what is suggested in the libretto should you use a mask or puppet. Unless a piece requires it, why bother?' Her production of *Magic Flute* had visible puppeteers operating the animals. A recent London production by the film director Anthony Minghella introduced puppets into a Kabuki-influenced *Madama Butterfly*, and in that context, a puppet for Cio Cio San's son seems appropriate, although in the same article he says 'The puppets in "*Madama Butterfly*" emerged from my resistance to seeing young children onstage, moving under direction and incapable of course of conveying an inner life; treated, actually, like puppets. Whereas it seemed to us that a real puppet can appear to listen, reflect and engage with complete focus and innocence'. That puppets can be more expressive than human actors is certainly true, but young boys in the role in Butterfly can perform amazingly. Serious productions such as *Oedipus Rex*, *Hansel and Gretel* and *A Midsummer Marriage* have all used puppets. *A Midsummer Night's Dream* has seen the fairies as puppets operated by Oberon and Titania, which has some theatrical logic to it. This year all of the major theatrical companies are building productions around puppets. I hope that it won't be long

Matthew Bourne's reinvention of *Swan Lake*, with a more traditional dancer (Saemi Takahashi).

before a more creative union happens between the other arts and stop motion. That this does not happen is probably a lack of awareness of our potential and that we have the same skills, although we apply them differently. I am pleased to see Suzie Templeton's *Peter and the Wolf* often being screened accompanied by a live orchestra.

Ballet

Ballet somehow manages to capture the essence of characters in a way that other mediums cannot. It is so fake and unrealistic, but manages to speak with directness. It is this distillation that stop motion, also, does best.

All the great classics of children's literature, such as *Beatrix Potter*, *The Wind in the Willows*, *Alice in Wonderland* and *Peter Pan*, have all been animated, some drawn, some stop motion, but the closest to the spirit of the books have, for me, all been ballet productions. This is particularly true for the Beatrix Potter characters. There have been some splendidly realised drawn versions, but surprisingly no stop motion treatments. The characters are perfectly drawn, in every sense, and so rounded with proportions that would make great puppets. Maybe it's a copyright issue, or the stories are too slight for the big screen, or the drawings are so delicate that a solid puppet might be too substantial; or perhaps a complex expensive puppet could not justify a short screen appearance. I have long since wanted to film these stories, particularly *Jeremy Fisher*, who is so resilient, charging on regardless of what life throws at him. (With him and Toad, what is it about amphibians that strike such a chord with me?). However, nothing brought these characters to life better than the 1971 Royal Ballet film. Christine Edzard designed the costumes, and although they are all built around human proportions they capture the animal quality perfectly. All the character comes from Sir Frederic Ashton's glorious and inventive choreography, rather than from any voices or facial expressions. The spirited dance for Jeremy Fisher catches his energetic optimism suggested by the book better than words could. The luxury of the Royal Ballet workshops and great dancers helps, but what an inspired yet strange idea. A wordless ballet on film of delicately illustrated stories should not work, but it does. It freed the characters, finding the essence rather than the literal interpretation. That notion is true for stop motion.

The Wind in the Willows has always been a tricky one to adapt. Shepherd's illustrations for Grahame's book do not help, as the characters change scale from one drawing to another (as Kong changed scale when his environment needed him to). They work magnificently as drawings, but when stuck with an inflexible scale, things can be tricky. One minute Toad is proportioned as an infant, the next he is happily driving a car. Cosgrove Hall was successful in finding the right balance between animal and Edwardian gents. The worst realisation of these characters was with real actors given solid unmoving masks, but behaving naturalistically as real humans without the ballet to give a convention. The production failed on all accounts. The most successful versions have blurred this line between animal and human to create something new. Most actors wear large green goggles as Toad: these suggest not only his passion for driving, but also a toad's characteristically large eyes. Similarly, his Edwardian suit and plus-fours are often tailored to emphasise a puffed out chest and chunkier upper legs, satisfyingly suggesting the essence of the two worlds without being explicit. Productions where the characters were performed by actors with no hint of make-up and straight clothing left me feeling cheated unless the body language suggested the animal.

A recent dance production, designed by the Brothers Quay, came closest to the spirit. The performers were clearly Edwardian gentlemen, but their dance and costume provided the animal characteristics that make-up would have made redundant. The set suggested a distorted nursery, with an old wardrobe quickly becoming the caravan, and then spilling out metres of blue silk for Ratty's river. Tea chests became the tunnel under Toad Hall. Cars and boats were represented by large tin toys worn by the characters, echoing perfectly Toad's state of mind. As Mole and Ratty sat having their picnic, other members of the cast hovered with their fists tight shut in long black gloves. Opening their hands revealed a dazzling flash of colour suggesting a butterfly or a dragonfly. All so inventive and more satisfying than a straightforward approach, and in keeping with Grahame's imaginative storytelling.

Peter Pan has yet to fly in stop motion. The practicalities make drawing Peter flying much easier. Although I find the Pirates and Indians tedious, the relationship between Peter and Wendy never fails to move me, but it is the relationship between Peter and his shadow that intrigues me. This echoes the relationship between the creator and the puppet, both wanting independence but actually dependent on each other. I have seen the shadow successfully performed with a silk cut out, and by a dancer in black, and by puppets.

I have yet to see a ballet involve any puppetry, although probably the exercise is generally pointless, as the success of dance lies in pushing the body into doing things we thought were impossible. To disguise the body or distract with puppets defeats the object. We need to see the body clearly to appreciate the extremes of movement and the transformations. The tradition of dressing male ballet dancers in tight period jackets, but with acres of thigh and much more showing can look ridiculous in harsh daylight, but it's not about costumes, but the legs. There is little point in hiding such tools of storytelling. Tutus may look slightly absurd, but they do not get in the way of the body's lines. Choreographers such as Busby Berkeley and Flo Ziegfeld used their performers not so much as dancers but as moving puppets, transforming the body into huge pianos, harps and other objects, or just massed ranks of flesh. So often, as in Disney's *Beauty and the Beast* musical, humans are turned into objects, and objects into humans.

A script arrived for me from Hollywood in which a strolling puppeteer in eighteenth century France (*Dangerous Liaisons* was big at the time) was able to pass on the truth about the corrupt courts he performed in, stirring the lower classes into action, while the courts were none the wiser. It was never made, but it had everything: a good plot, great costumes, heaving breasts, lashings of decadence … and puppets! A glorious combination, but above all, it took puppets seriously and acknowledged their power for conveying the unspeakable. This so excites me. Confusingly, the idea was to perform the marionette puppets as stop motion.

Spitting Image

A retrospective of *Spitting Image*, the hugely popular UK topical puppet show, suggested when the politicians were satirised on the show the public were considerably more aware of the actual politics.

Spitting Image was an extraordinary show that managed to make politics sexy and cool, but most importantly, here was the ultimate version of puppets getting away with saying the unspoken. The immediacy of the show was impressive, with the most topical elements being recorded during the afternoon of transmission, which gave it rawness. Even with these extremes of caricature, there were boundaries

crossed that caused even the tabloid newspapers to rant and rave. I'm not sure how a viciously pilloried Margaret Thatcher was acceptable, but an affectionate poke at the Queen Mother was not. Celebrities queued up to 'appear' on the show, sending in voice tapes for guidance, or offering to do the voices themselves. To offer oneself must surely miss the point. Many of the politicians were upset that they were so mercilessly depicted, yet would have been upset had they not been included.

The Queen Mother à la *Spitting Image* (Richard Haynes).

Owning the original puppet of oneself becomes the ultimate trophy, as does a figure in Madame Tussauds so what does that say about puppets? The website for puppet-makers Mackinnon Saunders tells that Sylvester Stallone happily owns the puppet they made of him for a tea advert. Does the puppet prove that attention has been paid? It's a flattering accolade. Mind you, I am in no position to pontificate as our *The Wind in the Willows* was the subject of a cruel sketch on *Spitting Image*. Toad was represented by a shapeless lump of green plasticine sitting in a plastic boat in a washing-up bowl of water, shoved along by an all-too-visible hand, while an equally visible fan blew through some cheap-looking leaves. How pleasantly ironic that one form of puppetry could criticise a different form of puppetry. I'm still smug, though, at being part of a show that deserved the *Spitting Image* treatment.

I was lucky to be on the *Spitting Image* set on a few occasions and, as to be expected, I was far more interested in the operators than the actual content. As they worked hunched under the set, the operators were giving a convincing

performance, unable to stop themselves echoing the puppet on their arm. The skill and dexterity were astonishing, but the concentration on just the face and not the whole body stopped me totally loving these puppets.

The show's directness could not be achieved with stop motion. There is no way we could animate anything to an acceptable standard and then broadcast it within a matter or days, let alone hours. If we did, it could only be for a matter of seconds. This immediacy is one of the things that I miss about stop motion. It is a continual struggle to achieve any form of here and now about animation, but then maybe that is one of its strengths, in giving it an undeniable timeless feel.

The Turn of the Screw

I recently directed Henry James' *The Turn of the Screw*, using puppets resembling some of the characters and manipulated by the children, Miles and Flora, to suggest the horrors they witnessed but could not articulate. This is a gloriously enigmatic piece that does not provide answers, referring obliquely to the demise of the previous governess. Our children innocently played with the puppets, but only as the back-story of Miss Jessel and Quint began to spill out did the audience realise the children were acting out the torrid back-story, and that the same fate might befall the new governess. Our unsettled audiences watched these children playing unpleasant games with the puppets, with an uncomfortable recognition. Most satisfyingly to me were the gasps as the children suggested Quint and Miss Jessel's affair, before dramatically but rather casually drowning the puppets in a toy sea of silver fabric.

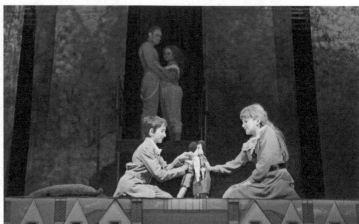

Holly and Adam as Miles and Flora being beastly to the puppets in *The Turn of the Screw*.

Most of the sex and violence was in the audience's mind, as I had left it vague when directing the children, but I was thrilled that the audience gave life and resonances to these simple puppets, only to have that life destroyed with a bump. Children operating and, in effect, abusing these puppets discomforted the audience, perhaps revealing their own rather eager imagination. '*Screw*' deals with ideas of manipulation and suggestion, but through using puppets I could take these ideas and make the audience question who was manipulating who with a clear visual metaphor. Not having watched any previous productions I assumed I was being

wildly innovative, but was disappointed to see a television version that used puppets in the same way, although here it was more ritualistic, with burning replacing my drowning. Still, I thrill at seeing puppets being used to disconcert and to say what human characters cannot. Puppets can do evil so well, and I wish there was more of this dark side represented.

Doctor Faustus

A memorable encounter with puppets, which whetted my ravenous appetite, was the Royal Shakespeare Company's 1973 production of *Doctor Faustus*, with Ian McKellen as Faustus. Mephistopheles fluidly appeared out of the shadows of the study, and tempted Faustus with the deadly sins, gathering up some blankets which became puppets operated by Faustus. A shape for a head and a sleeve suggested an arm, but the audience saw another person on stage. Most amazing was Helen of Troy: just rags, but manipulated by McKellen as if the world's most beautiful woman was seducing him, his own sleeved arm caressing himself. When spent, he dropped these blankets and 'Helen' lay there as a soiled sheet, brilliantly exposing the emptiness of his desires. This is a pertinent illusion, which I acknowledge in the *Midsummer Night's Dream* sequence in *Next*, where Bottom gets carried away with a length of blue silk, imagining it to be Titania. As he loses his ass's head it becomes a piece of limp cloth as insubstantial as his tryst with Titania. Look, there's a man with an animal head again.

Shakespeare as Bottom with Titania.

Shockheaded Peter

This hugely popular stage show arrived as *The Lion King* was dazzling audiences with its blend of puppetry and live actors. *Shockheaded Peter* did the same on a smaller budget, but shocked audiences. Built around several cautionary tales and set in an off-kilter toy theatre, it had disturbing songs from *The Tiger Lillies*. One story, poor Tom Suckathumb, climaxed with a vocal audience reaction such as I had never witnessed before: one of pure horror, brought about by the mutilation of a small basic puppet, manipulated by visible operators. So many people were willingly taken in by an astonishingly simple illusion. Tom was a three-foot puppet with one of the visible operator's hands operating a gash for a mouth in its head. His 'mother' warned him what would happen if he continued to suck his thumb and left Poor Tom alone on stage, gently sucking his thumb, at the mercy of an actor bearing huge fake scissors. With a well-timed look out front, Tom's button eyes conveyed so much dread that the audience shifted uncomfortably in their seats, collectively thinking 'surely not …?' Sure enough, the scissor man advanced, and snip snip! Tom's thumbs fell to the floor. I haven't before heard such a scream from an audience. Tom tried to retrieve his severed thumbs, made of potato, in his fingers. His mouth

quivered in shock, provoking a release of laughter from the audience. A few sniffs milked the moment, then the puppet was bundled away and we were into the next shocking scene. But how could a raw puppet, with a visible operator, manage to shock an audience more than a boy actor with prosthetic thumbs and lashings of Kensington Gore? Good staging, direction, performance and storytelling are crucial to such a scene working, but it was probably the simple look from the puppet to the audience that engaged their sympathy. The puppet was doing only the most contained of movements, pulling the audience in. Perhaps the audience felt safe with a puppet, assuming a certain cosiness, or perhaps they had gone along with the suspension of disbelief and then found themselves shockingly out of their depth. Whatever, it's a treasured moment out of many in the theatre.

There have been several attempts to film this show, including with stop motion, but it needs a live audience, as recording it removes the danger and the shared experience. A different approach would certainly work.

Oscar Wilde was more succinct.

'Give a man a mask, and he'll tell you the truth'.

For 'mask' any number of distancing devices can be used from make-up, to ballet, opera, and, yes, stop motion.

Getting Personal

Early animation

For others, it was dinosaurs or Action Men. For me, my early attempts at animations were less ambitious. They were a succession of drawn films, wittily called *To Bee or Not to Bee*, *Top Cat*, *White Tie and Tails* and *The Eleven Days of Christmas*, so called as, stumbling blindly in animation, I overreached myself and never managed to film the twelfth day. Of all the things I wanted to be (actor, vet, dancer, pilot) I'm not sure how I ended up as an animator, but it seemed to make sense.

Have dinosaurs been a huge part of your animated life?

JD – I did my first stop motion shortly before the re-release of *King Kong*, but Kong definitely jump-started my interest in getting involved in filming and animation. My first 'homage' was a hand-puppet show about explorers and dinosaurs. I didn't do any dinosaur animation until later. I still respond to dinosaurs, but much of the fun went out of them when they became 'codified' in the 1980s. Now everybody's T-rex looks like everybody else's T-rex, etc. – boring.

TB – Dinosaurs didn't (and still don't) interest me all that much. I'm into fantasy creatures, such as the Greek and Roman myths. There are so many wonderful fantasy stories and legends that would make fantastic movies.

RC – Dinosaurs were a large part! My aunt worked in a museum, and I got to visit her on Saturdays. I'd roam for hours, studying. She took me into the sculpting shop. Dinosaur Hall was uniquely arranged. You'd come around a darkened corridor, and confront a 25-foot-high painting of T-rex. It gave you an uncomfortable feeling as a kid. This was Carnegie Museum, renowned for its collection of actual skeletons. Ray was the first to give us 'real' dinosaurs on the screen.

DC – I've never worked with dinosaurs but was aware of them in Ray Harryhausen's films. I was into space and the future. My toys had a futuristic quality and the much-envied ability to fly.

SB – No dinosaurs. I was a robot man. I'm a child of the Star Wars generation.

TD – I had a long period of fascination with dinosaurs. Strangely, I was never drawn to animate them. I was more intrigued with the Canadian National Film Board animation.

RH – I loved dinosaurs since collecting models of them after visiting the Natural History Museum in London. As a Cub I got a 'Collecting' badge for my collection of dinosaurs. I loved them in the original *King Kong* and *Fantasia*. I'm still thrilled by them today, although I've never animated one.

JC – I had no dinosaurs and wasn't interested in them (though my little brother knew all the names before he could read).

FL – I always loved natural history museums, but never thought about dinosaurs as characters for movies. Recently I did my first 'artistic' approach to a dinosaur, trying to follow a tutorial on making a T-rex armature.

DS – I don't recall being a dinosaur freak or having any model dinosaurs or being insistent on seeing them in a museum, but I loved the schools radio programme where they took you back in time, especially those that went back to prehistory and the dinosaur age. Pete (Lord) and I might have animated the odd scaly dinosaur.

Paul Berry animating Arnold.

King Kong and dinosaurs

In a way, even dinosaurs are about animating inanimate objects, giving life to that which has no life – now. What put me off dinosaurs is the presentation of them as munching machines. Very few stop motion dinosaurs exhibit much psychology or motivation beyond eating and surviving, and while the animation challenge and endless possibilities of bringing these creatures to life must be hugely exciting, there wasn't much chance of acting, and it's acting that drives me. We've seen dinosaurs full of detail, but I am more satisfied when dealing with complex emotions. We were all looking forward to Paul Berry's *Arnold; A Million Sequins BC*, a film that would have shown dinosaurs in a very different light.

Paul's early death prevented this film being made but, from the short, exquisitely animated pilot, it was clearly going to be a hysterical, moving and very personal film. Arnold was a dinosaur whose taste for cocktails, make-up, high heels and the fine things of life innocently, but ultimately brought about the extinction of the dinosaurs. There were moves to get the film made after Paul's death, but it simply would not have been the same. Paul's animation is astonishing, being complex and clear at the same time. You understand exactly what the movement is about and what the character is thinking. His many years of working on series such as *The Wind in the Willows* and *Truckers* at Cosgrove Hall probably gave him the ability to focus on only what was important. There is no clutter in his animation, an aspiration for us all. I can only imagine what great work Paul would be directing now.

I have never animated a dinosaur (although working with dinosaurs on the previz for the recent Kong was great fun), other than a pterodactyl made out of potato chips for a commercial in which the creature chased a live-action boy and wrestled him for his potato chips … hmm, thinking about that, that's odd, even by our standards. Even though it was a totally imagined shape it was fun working out how the thing would fly with that anatomy.

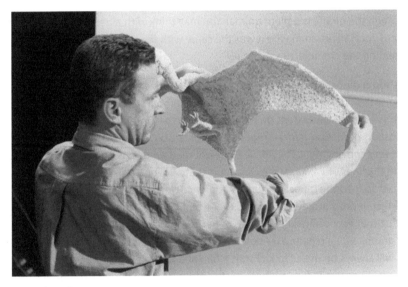

A crispy pterodactyl.

To animate a dinosaur, giving the impression of necessary size, would be a challenge. Looking at Willis O'Brien's footage for *The Lost World*, there is some impressive movement, but little account of the mass and scale of the creatures, betraying them as miniatures. It's hard to believe that these huge creatures could flick their long necks and tails from side to side in the passing of a few frames. A small model needs only a few frames to move its head an inch or so, but when multiplied to the imagined size of a dinosaur this movement equates to fifteen feet or so, and needs more time and thus more frames to suggest the creature's scale. A recent commercial spoofing *One Million Years BC* had a stop motion dinosaur doing exactly these quick movements. I hope this was a loving homage, not just weak animation, as it did advertise that it was a tiny model.

Dinosaurs have always been associated with animation and linked with new advances in technology. To have been the first to see Gertie moving, and apparently reacting to a live actor, must have been extraordinary. O'Brien's creatures, and subsequently those from Harryhausen and Danforth, probably took the skill of animating them as far as possible. The sublimely realistic creatures in *Jurassic Park* have undoubtedly changed dinosaurs and animation in general. Audiences will hardly accept a stop motion creature masquerading as reality in a live-action film now, unless done with a huge tongue in a huge ironic cheek, as in *The League of Gentlemen's Apocalypse*. However, it is clear that the public has an insatiable appetite for a wholly stop motion world, as in *The Nightmare Before Christmas*, *Corpse Bride*, *Max and Co.* and *Wallace and Gromit*. To mix the two techniques is a little uncomfortable, as invariably the seams show.

So many theories exist of how these dinosaurs walked and how agile they were, and credibly reconstructing their movement would be a fascinating detective story. The stop motion shot in preproduction for *Jurassic Park* by Phil Tippett shows creatures with real energy and dynamics, but still looking heavy: they look utterly credible. After a test screening of footage from *King Kong*, Merien C. Cooper was called by a natural history museum suggesting that is was unlikely that dinosaurs could have roared, as they seemingly didn't have any vocal chords. It's probably a good thing that film-makers often ignore the facts, but it's hard to think of those creatures as silent, although the giraffe is a silent animal. You may think with a neck that size there would be all manner of vocal tricks, so maybe it was the same with the dinosaurs. However, film-making is about creating the credible, not the real.

Most films about dinosaurs need human characters to drive the film, certainly making the contrasting scales work, and demonstrating the archetypal story of man versus monster, with the dinosaurs' success dependent on how seamlessly they interact with human actors. The digital dinosaurs of *Jurassic Park* stampeded across the big screen, chasing and eating the live-action cast very convincingly. They have since gobbled up television audiences with so many series along the lines of *Walking with Dinosaurs* that we'll get *Walking with Zimmer Frames* soon. Excuses to feed the dinosaur-hungry audience grow feebler as the dinosaurs get more credible. A recent programme speculated that we might have tamed them as pets had they not died out. Cue that especially skilled group of performers acting against beautifully animated computer graphics (CG) creatures; a skill that stop motion animators have, incidentally. Dinosaurs will always be useful to kickstart a film and to project any manner of subtext. Unlike the real thing, dinosaurs in film are here to stay, although I am happy to see that the dinosaurs of films like *Journey to the Centre of Earth* (real lizards with stuck-on fins doing gruesome battle and being submerged in 'lava') and *At the Earth's Core* (men in rather dire rubber suits) are an extinct breed. I'm not sure that we will ever see a stop motion dinosaur fighting live actors again, but dinosaurs seem to be a benchmark for each generation's technology and reinvented for their own purposes. Animated skeletons run a close second here, from Georges Méliès, through Harryhausen, to *The Corpse Bride* and beyond.

Ray Harryhausen

So much has been written about Ray's work, and whatever I say will be an inadequate appraisal of this extraordinary and innovative body of work. Naturally, I am a besotted admirer of his work, responding more deeply to the creatures that are inherently inanimate. Talos and the various skeletons thrill me more than the natural history-themed creatures. This is not surprising, as a huge bronze statue

coming to life appeals directly to the imagination, and exploits the craft of stop motion. If an elephant could be trained to act as dynamically as required then, possibly, a real elephant might have been easier, but bringing Talos to life through stop motion is so appropriate. Today, a sophisticated CG model might convey the scale better and fit him into the environment more seamlessly, but I doubt that CG would have given Talos the quirky, ponderous movements that define him one of the greatest animation characters. Thanks to the perfect marriage of sound effects, design and Ray's restrained animation, you feel the metal straining as Talos begins to move. The pacing of the sequence gives you time to see the performance. The editing doesn't tease you or apologise with glimpses, but there is Talos in all his glory, in an uncluttered environment, mostly shot full length, in dazzling daylight. It is breathtaking animation laid naked and looking stunning. The performance is full of little touches, he feels heavy and stiff, and in spite of the eyeless head, Ray manages to suggest some thought process going on. Important moments of stillness show decisions being made. Seeing Talos on the big screen caused many doors to open, and I thank Ray whole-heartedly that these doors have never shut. I am humbled that my puppets are sitting next to a cast of Ray's Talos in the National Museum of Film, Television and Photography in Bradford. Smaller than I imagined, Talos is testament to Ray's performance of a convincing giant statue.

Interviewing **Ray Harryhausen and Medusa.**

Musicals are a passion, and to some extent the films featuring Ray's creatures are much like musicals. Chunks of plot slot in between physical and musical set pieces, where the actors hardly speak as their combatants seldom have language. Talos, brilliantly, has no deafening roars, just that hollow creaking. These set pieces

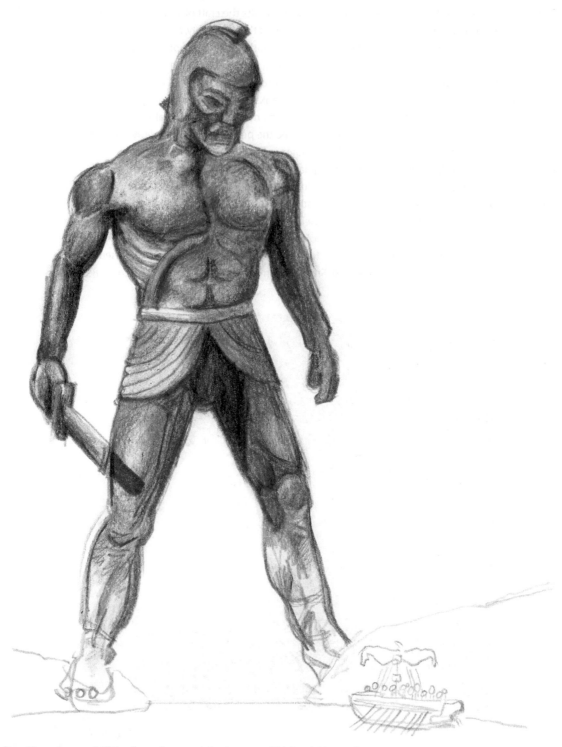

Ray Harryhausen's Talos from *Jason and the Argonauts* (Richard Haynes).

develop in dance-like sections, choreographed, usually, to Herrmann's astonishingly apt and colourful music. I'm not sure when the music was developed, but it's an integral part of the scenes, perfectly complementing the animation, especially the skeleton fight in *Jason*; it is just right using rattles and cacophony alongside moments of stillness and tension.

Toys

I had cuddly toys, teddy bears and Action Men as a kid, and gave them adventures most definitely different from other kids. They were imbued with strange and complex characters. My sister was more sensible and grounded in the real world, but the house was full of stuffed toys and wonderful pets. None survived the way that Pooh, my teddy, has loyally stayed with me for over five decades. There, it's easy to say 'loyally', giving a lump of squashed battered cloth a personality and character traits, but I'd be mortified to lose him. Alright, there's a history associated with him and he has travelled as much as I have, but it's not sentimental nonsense that keeps me looking after him, happily and naturally chatting to him. He has been a companion and, I feel, has absorbed part of my life and my experience, through some misty-eyed osmosis, so that he's forever part of me, or an extension of me. To not have him around is odd. It's not a security-blanket idea, but more a way of externalising thoughts, and by projecting ideas and character onto him, I can help make sense of what's rattling around in my head. In this respect I understand the relationship between Pinocchio and Jiminy Cricket. I have always found it terrifyingly easily to give inanimate objects a persona. Pooh is inanimate, but with a huge persona.

The indefatigable Pooh and similar sentiments from *The Mitten* by Katchnanov.

Many people think nothing of having apparently solid invisible friends. I didn't, but perhaps puppets fulfil this role. I understand anyone who makes friends with a six-foot invisible rabbit (*Harvey*) or a balloon (*The Red Balloon*). This French 1957 short film of a bullied child befriended by a red balloon has been hugely influential for many animators, and both Mark Hall and Brian Cosgrove cite it as an inspiration.

The Red Balloon – Richard Haynes.

It's not hard to see why. A devastatingly simple story, told mainly by strong visuals, and at its heart a moving and private relationship between a boy and an inanimate object. What's amazing is the amount of expression derived from that most simple of objects, a balloon. Its movements or lack of them convey more feeling than pages of dialogue. Surely this is what most animators strive for. Mark Hall remembers that 'the intense emotions generated by an inanimate object in its death throes and the final triumph so simply expressed have stayed with me for life. I was in tears then and would be now if I saw it tomorrow. I only learnt later how many people in our industry were influenced by that film. Brian Cosgrove was at the same showing at Art College.

Did you have an invisible friend or object as a child, that you imbued with personality?

JD – No for invisible friend, and yes for the inanimate object, because all my puppets had personalities of some sort. I could say that my puppets were taken from me like 'Rosebud' and my life was damaged, but that wouldn't be true. Actually, they got lost. There was a teenage moment when I burned my animation puppets due to my parent's incessant apprehensions about my interests in films and animation. I then decided that my parents shouldn't tell me how to live my life, and started rebuilding the puppets.

DC – I had an imaginary daredevil stunt acrobat spaceman type guy who raced next to our car on long journeys coping dramatically but effortlessly with whatever obstacle was thrown at him. Based on a toy I had with magnets on his feet, he had all manner of contraptions to help his travel.

JC – I still have 'Pink', my extremely faded, threadbare little teddy. She looks after me.

Most boys were busy building Airfix kits of planes and tanks, or collecting stickers about Bobby Charlton. I was collecting the Airfix Historical Figures, such as Henry VIII, Oliver Cromwell and especially Joan of Arc. This seven-inch figure got painstakingly assembled, with a small firework inside her. Shamefully, a pyre was built and she was tied to the stake, and as I challenged her about the voices, she met a spectacularly messy and noisy end. In *Next*, the Henry VI plays are represented by the small gruesome section of Joan, rather than the wider sweep of the histories. My limited knowledge of history was as dangerous as my limited knowledge of special effects. My enthusiasm for acting out dramatic scenarios was not so limited.

Joan of Arc leaves the stage.

Stop motion and me! – Simon Partington, CG visual effects artist

When I was young I had a book about a tortoise that got lost in the woods and had to ask the other woodland creatures for help to find his way home. I owned quite a few books, but this was special because the illustrations were photographs of little model worlds. There was a depth to this book that the others didn't have and I'm sure I thought that these photographs were real, taken by someone documenting this little tortoise's adventures. Although the images were obviously not moving, this was the start of my love for stop motion animation.

I vividly remember watching Cosgrove Hall's *Pied Piper of Hamelin* in the school holidays. It frightened and excited me in equal measures. The puppets in the film looked so real to me. It was mysterious and magical. There were rats that spoke and strange lights in mountainsides, and for a young boy with a wild imagination this was all quite incredible.

The *Flumps*, the *Wombles* and *Chorlton and the Wheelies* also fascinated me as a child. I was desperate to visit Wimbledon Common, convinced that the Wombles must exist and that if we could only go and look under the bushes we'd be able to meet them. My love of making things began to kick in. I remember someone bought me some little Womble miniature models and I set off on the quest to build my own Womble burrow, keeping me quiet for several days one summer. I remember a certain frustration that my Wombles didn't move like the ones on TV. My Granddad suggested that we should make a Womble of my own using his pipe cleaners as a kind of bendy skeleton and some Plasticine. I quickly set about emptying all of the local stores of Plasticine and pipe cleaners as the characters began to come thick and fast.

Schoolwork suffered as I thought of getting home to create more of these characters. I'd already made some flick books and although seeing the little stick men jump about was fun it did seem pretty primitive. My parents, who have always been a huge support in my endeavours, had a book about cine photography and for my thirteenth birthday I was bought my first cine-camera. Instead of a trigger it had a cable release and we set about making our first epic. We built a makeshift rostrum camera made from a wooden frame with a plywood base, drilled a hole in the wooden crossbar and attached the camera with a tripod screw. My first film was of four cut-out paper squares and a man painted onto a sheet of paper a frame at a time.

We sent off the film and waited. After what seemed like an eternity (it was fourteen days) the little 8 mm film canister arrived its paper yellow jacket. We nervously loaded it into the viewer that we had bought from the old local record shop. We switched on the little lamp and began to turn the film. There it was, basic, yes, but nothing up to that point in my life had given me such encouragement as to what was possible. Other than the odd hand in shot where Dad or I hadn't been fast enough to get out of the way, the film was perfect. The squares danced around and the little painted man arrived on the screen in his little painted house. I thought that we had made magic that only we knew how to do. None of my friends had much of an interest at this point, and Dad and I had made our first animated film. Many more experiments followed in quick succession. A jointed wooden mannequin from the local art store made all sorts of things possible. Soon we had him in all situations: being tied up with string that had come alive, trying to escape the hand of God as it reached down to grab him, pens and pencils would come alive and chase him around the room; anything went. It was guerrilla film-making at its best! All of this experimenting led to me being able to make a short animation for my GCSE exam. The film was much more ambitious than anything I had made before and was based (rather topically) on the subject of global warming.

Through the years my career has gone in the direction of CGI rather than stop motion, but I still have fond memories of making those first films. It was a brilliant time, without deadline or pressure; animation for the fun of it, and it started me on a journey that would become a hobby, a passion and a career.

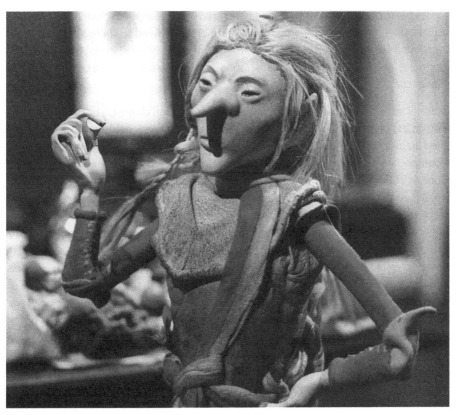

Cosgrove Hall's enigmatic *The Pied Piper of Hamelin*, 1980.

School

Conforming, sport, tradition, marching and more conforming were the norm at school, with the emphasis on learning facts rather than understanding or questioning. This might have blighted me for good, as my eventual university essays were little more than observations and lists rather than any original thinking. That only seeped through later. The arts at school were certainly plentiful, though at the time they seemed more worthy than dynamic. Shakespeare lost his dirty jokes; Chaucer never farted; D.H. Lawrence never ate figs, and the boys played girls on stage. I was way too petulent to appreciate just how much music and drama was being offered, or that my love affair with the arts was starting. My art master, Mike, encouraged me to find my own voice. For that much thanks this was more fulfilling than learning to shoot people, a skill I hope not to need. Another master held morally suspect but hugely enjoyable late-night candlelit 'coffee' evenings for a select few, with music beyond the ubiquitous *Planets* and *Four Seasons*. Names like Purcell, Rameau and Britten somewhat intoxicated me. He had books of provocative paintings, and poetry I almost understood. We retired furtively back to the dormitories, me high on newly discovered art, the others, well, high on other newly discovered pleasures. This was *Jean Brodie*, the *Dead Poets' Society* and *The History Boys* rolled into one, with maybe as much damage done. These sessions were about natural responses, intuitive passion and some inquisitiveness. Their illicitness causes a thirst that has yet to be sated. I don't think it ever will be, not while I excitedly fidget in my seat as the lights go down in a theatre or a cinema.

It surprises me that all animators don't necessarily have a passion for exploring anything new and artistic. I feel some guilt, embarrassment, rebellion and a need to apologise for artistic leanings. That's absurd. I risked unpopularity at school by receiving a house tie for directing a play (Ionesco's *The Bald Prima Donna*!) rather than getting one for scoring a century at cricket. That rather sums me up.

Film was not something to be studied. Only a trip to Aldeburgh cinema, a beautiful dilapidated building on the beach, to see *Cabaret*, came near to being educational, but a dazzling light switched on over me. The juxtaposition of the nightclub scenes and the real world, the choreography and violence mirroring each other made such sense. I responded to the music growing out of the story and situation, and to the idea that the artifice could say something more real than the real life. This confirmed thoughts raised by the *Lonely Goatherd* and Olivier's *Henry V. Cabaret* remains one of my favourite films. It is flawless and brilliantly structured, and its sleaziness was not unenjoyable. It whetted my directorial appetite, but animation was probably awoken by the music side of school, where the teacher endeavoured to make music interesting for the uninterested by the accompaniment of some rather basic illustrations on an overhead slide projector. *Peter and the Wolf* had obvious drawings, but with the *Firebird* we had little more than abstract splashes of colour, seemingly thrown across the paper, with real vibrancy. I wanted these colours to move to the music, and I still want to animate Stravinsky's *Firebird*. It's not the most powerful or dramatic of stories, but the music and emotion are breathtaking. When I heard the music it encapsulated everything I love about animation: a perfect, exotic marriage of music, movement and design, all used to illuminate an idea or story. This seemed a mighty interesting way to approach a story. This gloriously artificial combination excites me more than anything. Animation can do this extremely well, and it saddens me when animation goes through all the necessary effort and comes up with something literal and staid, and often frankly dull.

In thirty years there have only been a handful of days where I have not looked forward to animating and directing, even if the reality of the shoot sometimes disappoints in its potential. This potential is what keeps me excited, and the hope that I can contribute something to make a story or character more interesting. There have been days where I have been breathless with excitement about a scene. Creativity is a powerful drug.

When you animate is there a tactile pleasure, or even something more spiritual? Is some sort of life created through our performances – or is it just a job?

JD – Tactile pleasure, yes. Spiritual at times (but not often). Aware of creating life, yes. Creating characters and giving a performance, yes (some work has been perfunctory – such as spending a week animating butter pats doing an Indian dance around a tom-tom). I suppose my initial 'need' was to tell a story and give a performance.

TB – Human beings enjoy touching, so it's natural that stop motion animators would enjoy touching a tangible object such as a puppet, particularly breathing life into it. If not spiritual, then it is definitely something quite emotional. When I connect to the character, and crawl inside its head, becoming the character, then the performance will germinate. The creation of a successful performance is pure magic, regardless of whether done on stage, scene or film.

KD – Pure pleasure, but it's hard to not rush it to see what it is. I think as an actor. I like to act it out beforehand.

RC – I'm aware I'm an animator manipulating a model. At the same time, I am the model. Because the model can't move on its own, I rely on the real me to move the little me, so I can act. Other times, I'm outside it, moving the puppet through its paces so it does what I want it to do. My goal was to give the characters believability even if they only 'lived' for thirty seconds. If you're not honestly trying to bring that character to life, you're cheating the audience and yourself. Animating has never been just a job; it's been my life. Even with 'small' or 'boring' jobs, I gave them my honest effort and tried to make them as well as I could. If you do anything less, you're probably not an animator, just a talented set of hands.

DC – It's mainly a job, lighten up! I like the feeling of creating life though. If you make something move nicely enough people suddenly start to care about it. You can make people cry by showing them how a normally inanimate object supposedly feels.

AW – I feel animation is a tactile and spiritual experience. Mostly I feel like an actor. I never stop observing movement and breaking it down into 24ths of a second. I do it all the time. It's normal to me. Watching something come into being is a beautiful process – like making something on a lathe. I'm addicted to animation. I need it like a drug.

SB – I'm mostly trying to give a performance, although this can sometimes be difficult in preschool series work as some scenes can be dull, with a lot of talk and no particular emotion to latch on to. On those days it's just a job.

RH – When I am animating with puppets I feel like an actor, engaging myself within the individual characters' thoughts and motivations. I feel a deep sensation, getting into the characters' minds and bodies. I'm most happy animating when it's flowing well, and when the animation is working that I don't need to check it. We're fulfilling the need of the illusion of life – we're making characters breathe and live. They become believable.

JC – Mostly I love animating. It feels like a creative process, when I can put part of myself into what I do. I like the idea that I'm a 'shy actor', the puppets attempt what I cannot in public. I put life, character, humour into these beautiful puppets and the results entertain at some level. Though it's a wonderful job, it's more than a job. In general, most animators will go that extra distance to finish a project, even coming in, unpaid, to reshoot something they're not happy with.

FL – Tactile pleasure is one of the main reasons for doing stop motion to me. The feeling of creating life that wasn't there before should be another one …. It's a kind of magic to see your frames playing back, and that supposedly dead thing starting to move, breathe, live …. When you animate in stop motion you're not animating the representation of something or someone, you're actually bringing life to that thing. The puppet itself is the character, so you are giving life to the thing itself, and not to what it means.

Attempts at acting

It is my major regret that I am and have always been a terrible performer. I can't act, I can't sing, I can't do accents, I can't dance, and have a resonant voice with little range. Not ideal for a would-be thespian! I have relied on a certain presence rather than any skill. I started early, being the Raven (people as animals again) in our Nativity play. I was grumpy as my sister Amanda played the Dove and got a second entrance, while I sulked backstage, tempted to rewrite the scriptures. An unmusical *Babe in the Wood* in the village panto followed (my darling, supportive Ma probably overestimated my talents; still, I was a cute Babe). A succession of bad performances such as a Gossip in Britten's *Noye's Fludde*, bits in *Yeomen of the Guard* and *She Stoops to Conquer* should have put me off, but I felt comfortable in a theatrical environment, where costume, lighting, movement and all that seemed so important. This was never about being the centre of attention (something that I hate unless hiding behind a professional façade); it was about telling stories by being someone else. Studying drama at university, where a talent for acting failed to emerge magically, a stinker of a review for a play I was in and the humiliating experience of saying 'pardon' to a prompt conspired to make me have other thoughts.

Three reasons why I became an animator.

How frustrating, then, to understand the whole business of performing, and to love the craft with a consuming, almost obsessive passion. Although I never grasped the complexities of iambic pentameters, I loved unlocking the puzzles of Shakespeare's language and relished his themed palette of words for certain situations. Being a man of a thousand voices and all of them the same, I envied others as they controlled their diaphragms and fretted about thirds and semitones.

Although I strutted around a rehearsal room in expensive leotards, a certain chunkiness of thigh and lack of rhythm cut short any thoughts of being a dancer, but I wanted to know about dance and how the body could be used to tell stories. That was it, telling stories. How others told stories with the elements of music, voice, movement and design kept me hooked at university. I confess to finding most theory hard, emotionless, and removed from actual experience and practice. The reality of the business is very different. I work through instinct, research and, hopefully, acute observation. Anything I did live lacked precision and control, which could be my strengths with animation. It's ironic that I crave the adrenaline and unpredictability of a live performance, but animation gives you the chance to think and control every detail of your performance. If there was something half way, that would be perfect.

Nor was I good at critique. I wasn't eloquent enough to describe Goethe's romantic symbolism. Even my final thesis about 'Gilbert and Sullivan in performance today' was no more than an attack on amateur societies producing pale carbon-copies of dry D'Oyly Carte performance. I didn't have anything new or profound to say, but I began to realise that what little I might have could be said in an interesting way, from a different perspective, and that's been my mantra since. Stop motion gives me licence for this. I've never followed a crowd and have always thought for myself, maybe even being deliberately contrary.

I left university not equipped to be an actor, but with a rampant passion for all things performance based. Work as an assistant stage manager fed some of this hunger. I liked the camaraderie and, surprisingly, the routine built around the nightly show. Usually responsible for the props, I would get fussy, making sure each prop said something about the scene or the character. I'm still indulging this fussiness in stop motion. Being onstage in tiny parts I studied the more seasoned actors, envious their ease of performances. I watched particularly to see whether the eyes betrayed any lack of focus. This need to be part of a performance wouldn't go away, and with my first wage in the theatre I brought a camera capable of single frames. I wasn't sure where this was going, but I warmed to the idea of tricks. After the performance I would play with this camera, not aware of its potential, or of the significance of living in Chorlton cum Hardy, a suburb of Manchester, where Cosgrove Hall is still based, and that they were filming *Chorlton and the Wheelies*.

What sort of training, experience and advice helped get you started? Do you subscribe to any theories of animation, or do you animate by instinct?

JD – I animate with a combination of instinct and analysis. Art Clokey, although I annoyed him with my desire for technical improvement, was generous in giving me training in the principles of kinetic staging and editing (his personal passion).

TB – My wonderful parents, Portia and Jack Brierton, were my first major source of encouragement. Though I was doing something quite different to your average teen (sports and girl-chasing), they were intrigued I was doing something that I loved. I'm forever grateful for their love and encouragement and will never forget it. Ray Harryhausen sent me a nice letter when I was sixteen, and I still have it framed and on my living room wall. Naturally, that letter has been inspirational. I took many art and music classes, believing music and animation are blood brothers, because they share many things, such as phrasing, timing, pause, drama, rhythm, progression, and so on.

I'm a professional musician and composer and think in terms of rhythm when I animate. The principles of animation (key pose, overlapping action, in-betweens, ease-in and -out, etc.) are important, but I'm so used to them that I tend be intuitive. Most important is performance, and not losing sight of what the character is doing, and staying in character through the shot.

KD – My first film was *Beneath* for Onedotzero. Johnny Hardstaff, our mentor, scared me, pushing and pushing my thinking process. My dad got me my first single-frame camera, so crucial to getting a good result. My mom's (and my family's) encouragement. Ernie Farino became a good friend, giving me valuable insights on armatures and other things. Bob Arkwright gave me hands-on instruction in the mystery of tapping holes; Jim Danforth was helpful (and inspirational) in his friendship, comments, hints, and sharing some photos of his own marvellous armatures and sculptures; and Ray Harryhausen, whose work was the first inspiration, has been generous in his friendship and answering many not so easy questions.

DC – Practice The more you do the better you get ... hopefully. Watch and analyse!! Working at Elm Road Studios in Bristol gave me brilliant hands-on learning experience. College is academic and theoretical and I wasn't lucky with inspirational tutors.

AW – I've had no formal training. At the beginning I watched the other animators at Semafor. We had *The Illusion of Life* by Frank Thomas and Ollie Johnston at the studio. It was helpful to learn rules such as squash and stretch. But mainly I discovered everything by myself.

SB – I read your rules religiously, Barry! I animate by instinct, but I've learnt to prepare beforehand – checking puppets will reach what they're meant to, etc.

RH – Most of my training was at the brilliant BA (Hons) Film & Animation Course, at The Arts Institute at Bournemouth. Peter Parr, the animation option leader, gave me so much advice and guidance. He praised and criticised when necessary. I learned the basics of animation, and gained experience in directing. I animate a lot by instinct – sometimes it feels so natural.

JC – I completed a three-year honour's degree in Media Production (Animation), but felt I'd learned little that would actually get me a job. Once working I found my skills improved quickly. My first boss, Taffy Davies, taught me about the process of animating all day, every day. After an interview for MOMI animator in residence in the early 90s Barry Purves took the time to speak to me and, though I was unsuccessful with my application, encouraged me to keep in touch – we were both based in the north west. This contact helped inspire me to keep trying. I worked for several years freelance animating and made two self-funded shorts. Eventually I did a three-month training course at Cosgrove Hall Films, taught by Barry, which was a wonderful 'retraining' opportunity. It was great to go right back to basics and we were encouraged to study theatre, dance, film and real life to draw inspiration. The course was just three students, and set in a working studio. We were immersed in the studio environment and encouraged to work to a professional standard and speed from day one. At the end of the training we all secured contracts.

I've received additional training in CG courtesy of Aardman Animations, Skillset and South West Screen, that offered an opportunity to transfer model animation skills to CGI. A small contribution towards loss of earnings was invaluable to a jobbing animator, making the retraining more affordable. Once we got to grips with Maya the hardest thing was sitting down all day. I've spent a good portion of the last fifteen years standing. I enjoyed working on computers, liking that I could go back and alter timings or poses easily – the downside being that shots never felt finished. It was a new way of working, creating key frames then going back and filling in the action between. In model animation we plan a shot, knowing roughly the action we want and the timings, but ultimately we work in a forward-moving sequence.

DS – Pete and I had been to Ivor Wood, mostly for a chat and to talk about equipment and models. Our early feedback came from the *Vision On* team, especially Clive Doig, Patrick Dowling and later Chris Pilkington. The phrase 'I'm not sure this sequence quite works' stills rings in my head and we would then discuss why and what was needed to make it work. Very often this was before we shot stuff and sometimes afterwards. Working on a show that was going on air put a rocket up your backside to make sure the short pieces did 'work' and also stood up in the context of other work on the show. Pete had a natural talent for animation based on a keen eye for figurative drawing and observation.

Heading to Chorlton

I met Chorlton, with typical bad timing, on a train leaving Manchester, heading to Pitlochry for a long summer season at the theatre there. Reading an article in the *TV Times* as Manchester faded away, about Mark Hall, Brian Cosgrove and a group of unusually skilled artists setting up an animation studio (with both 2D and 3D under one roof) in Chorlton cum Hardy, animation suddenly seemed something that might satisfy my needs for performing. I'd had not an hour's training, but watching Chorlton rushing around those great sets, I thought, with great arrogance, that I could contribute something to that.

The movement of Chorlton was lively, if gloriously haphazard, but that was the joy of the series. I wanted to be involved, but I was heading to Scotland. Even with the routine of long days at the theatre, I managed some animation. I had my super 8 mm camera that had only been used for some strange homage to Georges Méliès. While experimenting with some clumsy stop motion using a shop-bought poseable *Pink Panther*, I wrote to Mark Hall asking about *Chorlton and the Wheelies*. Mark remembers being taken aback by the letter. You'll have caught some of my verbosity here and this letter to Mark was more an enthusiastic epistle running to several pages, proclaiming what I could bring to the company! Ouch! In one of those life-changing coincidences, Mark happened to be watching salmon in Pitlochry a couple of weeks later. In between performances of Ayckbourn's *Relatively Speaking*, a gorgeous production of *Cyrano de Bergerac* (where my obsession with imbuing objects with meaning allowed me to drop falling leaves, poignantly landing on Roxanne's tapestry on given lines) and an awful play about Bonnie Prince Charlie, I animated relentlessly. I started a pattern of doing more work after my usual work, much to the amusement and considerable interest of the cast and crew. After each performance, we would change the set ready for the show, so I would wander home way after midnight, enveloped in the thick mist, heavy with fumes from the Famous Grouse distillery. After half a mile I was quite literally drunk, and probably all my animation was performed in a rather alcoholic haze …. I'm probably not alone there.

I churned out idea after idea and eventually launched into the *Twelve Days of Christmas*. A ridiculously ambitious project, but I can see why I was attracted to it. I've always looked behind iconic pieces, wondering at their meaning and subtext. Something about the escalating structure of this song appealed. How were all the bizarre activities and characters connected? I was going to use way too many complicated cut-outs, and adding up how many I might need the total was 364,

one day short of a year. Since these are gifts given by 'my true love' I made a leap, worthy of *The Da Vinci Code*, imagining each gift as a quality needed to help the lady in question make it through the next year. The single missing gift would be her lover himself. It all fell conveniently into place, and with no grounding at all.

How were your first attempts at making a film?

JD – My first animation test, aged twelve, was a cowboy shooting a rattlesnake, using puppets made from coloured chenille-covered bendable pipe cleaners. I also filmed a Winnie-the-Pooh marionette scene using an old teddy bear, and my brother as Christopher Robin.

TB – I wanted to be like Ray Harryhausen and would come up with feature movie ideas, drawing key highlights of the film story. Being a teenager, I couldn't afford to make a feature film, so many of the drawings, sketches and creature ideas found themselves in shorter film experiments that my friend Kent and I did.

RC – The majority of us didn't want to be 'like' Ray … we wanted to 'be' Ray Harryhausen. Realising that the job's taken, we started to learn how to do it ourselves, designing characters, and fitting them into a story.

DC – I tried to pretend my toys came to life!

AW – I didn't know much about films before I started animating.

SB – I wanted to make sci-fi films, I tried to write a Battlestar Galactica script and got nowhere. Animation came later.

TD – Aged twelve I wanted to animate Richard Adams' *Watership Down*, to make the characters inside my imagination come alive in some way. My first serious attempt at a flip book was a hopping rabbit. I'd no idea how to proceed, and never finished it, but in trying to envision and figure it out, I found using many different parts of my brain together at the same time was satisfying for me.

RH – I imagined characters and storylines with my toys and wanted to make films with the family camcorder. I built Lego sets and made my own stories with the characters and acted them out. I had my own glove-puppet show, and once entertained lots of younger children at a birthday party.

JC – I never considered being a film-maker. I was always a storyteller though. I would write my own stories (influenced by books I was reading). One series was based on Lego figures we had. I'd write adventures heavily laced with descriptions of the surrounding, clothes and feasts. All the characters had the names of my extended family. Even my guinea pigs featured. I used the stories to mock my brothers. These were adventures with happy endings. For each story I'd draw a series of numbered pictures that the listener was supposed to look at when I read out aloud.

FL – No, I didn't make films as a kid. I'm thinking now that it is needed some technology, that I didn't have access to it. I did draw a lot.

DS – I was interested in process as much as anything, so as a youngster the idea of making a film interested me from a 'how is it done' perspective. At heart I'm a technician and only later did the idea of telling stories using the medium became the key factor. Aged about thirteen, I made a little model set-up with a Bendy Toy Gonk character on a crude desert island and wanted to film it. My father asked 'what's the plot?' and I found myself a bit flummoxed as I hadn't actually worked out the story other than there was gonk on a desert island!

I was enormously inventive and overcomplicated with these cut-outs, even planning camera moves and shimmering reflections for the swans: one scene featured 122 moving parts. These cut-outs were detailed, but drawing has never been my strength. Surprisingly, I'd not planned any music, nor had I timed the film or even storyboarded it. With all the information stored in my head. I sweated away, loving the process of touching everything. The camera was placed on a tripod above a rather large breadboard, and things were manipulated underneath. When the rushes arrived (what a misnomer: it took about two weeks to see the rushes) I was pleasantly surprised with the movement and the timing. Working in the theatre, timing cues to the rise of an audience's laugh or the beat in an actor's line gave me a good sense of rhythm and how long to hold something, but working in animation with everything so deconstructed, it's easy to get the timing wrong. It takes quite a skill, peculiar to animators, to time a laugh that may take a day to shoot but in effect runs for a few seconds. One frame too many can mistime a gag.

On the Eleventh Day of Christmas I met Mark Hall in Pitlochry and since the film was almost an audition, after our meeting I didn't exactly lose interest in the film, but I had made a point and

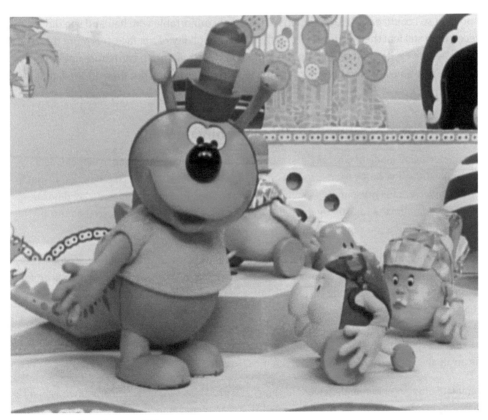

The gorgeous Chorlton and Zoomer.

the film never reached its spectacular conclusion. My true love never got her last gifts … but she didn't do badly. Nor did I. I'll admit to cheating a bit, as while it was easy to see how laying eggs, gold rings and turtle doves might be useful, I never worked out a significance for a partridge in a pear tree. Perhaps it was the gift of appreciating the absurd. Perhaps she would become an animator.

Mark invited me back down to Chorlton cum Hardy, and eventually to Chorlton himself. I had bluffed my way into a job through enthusiasm, albeit a certain informed enthusiasm. It was some time before I owned up to never having worked with a puppet (there, I talk about working *with* a puppet, as if it's a two-way collaboration. It is). It was a year before I started at Cosgrove Hall, as I was touring with the musical *The Boyfriend*. The actors were thrilled for me, even if they didn't understand what it entailed. I'm not sure I did either. I was so excited, but was I actually starting a new career? I had flirted with the idea of rescue from the theatre, but had I actually wanted to be saved? Animation seemed glamorous and better paid, but was this what I wanted? I was flattered by Mark Hall's interest, but I had pushed to do something exciting, and then felt nervously out of my depth. The thought that I might get to act, albeit through puppets, was exhilarating. I believed I could do this, and walking into Cosgrove Hall I realised it was the right decision. Here was a company, producing both 2D and 3D animation, actively encouraging young talent, and there was a feeling of shared discovery, led by Mark and Brian's great warmth and support. A lot of talent has been nurtured by this prestigious company and I've been lucky and pleased to be part of its family for three decades.

My first test was with a puppet called *Grandma Bricks*. She was a decent size, with a relatively short skirt so I could easily reach her legs. She had uncomfortable wire hair and she didn't fall to pieces. I can still feel the texture of her clothes and the solidity of her face, but more than that I remember the excitement of holding the puppet and discovering the armature under her soft latex. The first time I moved her joints, they stayed in the position I put them in. Well, that was it.

So how were your first puppets and did they animate well?

JD – My early 'puppets' were made of clay. My first 'serious' wire and rubber animation puppet was a squid made for an absurdly ambitious 8 mm production of *20,000 Leagues Under the Sea*. Before the squid, my friends and I completed a twenty-minute film entitled *Snag of Time*, in which animated clay dinosaurs appeared with live-action humans (mostly by intercutting). The big challenge was to keep them from distorting beyond all recognition during the scene.

TB – Most of the puppets that I did were experiments in foam built up over a wire armature, using straight latex rubber, which is too stiff for normal puppet work. I made a strange creature with a scorpion tail, bat wings, and a big Cyclops eye at the end of the tail, and two legs like the hind legs of a dog or horse, which I animated in front of a live-action image of my cousin flying about via an aerial brace, who shadowboxed as if the creature was in front of him. The image I projected onto a semi-clear piece of matte paper with a Super 8 projector. It was limiting, but the experience of combining live-action with animation was invaluable, because I learned about what NOT to do.

DC – I didn't animate anything I made; they were for playing with. The first character I animated was a Fisher Price director chap from a TV studio set. He was like a Star Wars figure in shirt and tie and was unanimatable with far too few joints.

SB – I made a couple of Plasticine models but they had no armature and got squashed.

TD – I was about seven when I made the first sculpture that was meant to be poseable. It was a Plasticine horse with yarn hair. I played with dolls by moving them through actions, animating them without a camera, seeing the process unfold and planting the visual/sensate elements of the process in

my little brain. Why I did this, why it was so important, and why it was so satisfying is a mystery to me. It seemed the most natural thing in the world to do. I could keep myself quietly occupied for hours. It never occurred to me to film the horse. I don't think I had seen much stop motion animation beyond the Gumby shows. I don't think I'd have understood then how it was done or how to proceed anyway. What was important to me then was the actual act of moving something physically and seeing the motion flow in my head.

RH – I made a puppet for an A-level project which unfortunately never got animated. Before that I attempted to make my own 'Toad' out of Plasticine – but, not surprisingly, it didn't live up to the original.

JC – I didn't make puppets as a child. I did play with Plasticine but never kept any of the models I made and didn't try to manipulate them.

DS – The idea of making a complex animatable puppet didn't occur until late, almost not until we were fully setting up. We knew of metal armatures and all that and latex but it seemed overly complex. We hit on the Plasticine idea which seemed to suit. We did make more complex models of St Peter and Erasmus for a short sequence in one of my father's theological documentaries but they didn't have complex skeletons inside them. It's odd having this interest in process and yet not getting around to the fabrication of a model even though we had a garage full of drills, vices, saws, etc.

Grandma Bricks was a two-minute soap opera in Thames TV's *Rainbow*. The set was one long street, along with a few interiors, peopled by various characters, including a black character, which must have been bold for 1978. My first shot saw Grandma Bricks walking the length of the street accompanied by her spirited dog, Fuzzby. The puppet of Fuzzby was easy as his front legs were a solid block, as were his back legs, with string-like fur covering everything. He was nicely balanced, so a walk for him was a question of finding an open-and-shut rhythm, and even with such little experience, I managed to get some character into Fuzzby and the timing seemed fine. To have launched into a four-legged character at that stage would have been hard. I still find four legs complicated. Grandma Bricks herself had large awkward feet with a metal loop, rather than the now-preferred flat plates. This didn't allow the under-set magnets to get a decent grip, and she wobbled a lot. She was always carrying stuff, which gets in the way of holding a puppet, but at least I didn't worry about the swinging arms. On my first day I walked this puppet down the street as best as I could, trying not to show my inexperience with everyone watching. There was neither video assist nor time for any exercises or tests.

When you started animating did you do any basic exercises, or did you plunge straight in with something probably way too ambitious? How were the first results – go on, please be honest?

JD – I didn't have the patience to do exercises – just plunged in and did what was necessary. But I made a lot of 'tests'. These were usually one-scene experiments with some idea that intrigued me.

TB – I plunged into it, although I did think about what I wanted the character to do. I dressed a GI Joe doll to resemble a desert sheikh, holding two swords, standing inside a tent. He lifted his head and began to dance with the swords. That animation turned out to be some of the smoothest stop motion I've done, probably because I poured a lot of TLC into it, taking my time, and thinking about the movements. I did this around when *The Golden Voyage of Sinbad* came out, so I assume that the sheikh was inspired from Ray's Kali sequence.

KD – Nope, went straight in for the Oscar nomination. I made a film about a dog who tried to commit suicide from being bored. It was a great little film, shot in twos, but I was proud of it. I nearly went for the person who deleted it. Plonker!

RC – I plunged in. I did little scenes first, to learn what I could do. I filmed in my basement. The old lights only had a four-hour life so my mom would yell down every hour and I'd open the lens a half-stop. I knew nothing about practical things, such as a simple lamp extension cord not being able to handle a set of four lights and my little rear projector. I blew all the fuses one night. God was watching over me that night. It was exciting to see the footage get better over time.

DC – I set my figure the task of building a telephone in three different architectural styles. The phone was my scale so the architect must have been from a different and tiny world. I plunged straight in with only the knowledge that 'you move it a little bit then take a frame!' and discovered all the limitations of my puppet, my set, my super eight camera, using daylight, etc. The finished piece was a mad three-minute dash in various daylight phases. He moved like the old black-and-white films, but you could tell what was happening and everyone was impressed by the magic I'd created. My toy had come to life and built a sort of telephone thing!

AW – After watching other animators I took an old Semafor puppet and I made a one-minute thirty-second shot. The director said (in Polish) 'Oh bugger, you're quite good' and accepted me onto his team.

SB – I tried to make a film with Phil Gray. It was frustrating. It didn't go well.

KP – My first animation on film was a 16 mm film-making exercise at university in 1995. I directed a film called *Visit to the Art Museum*, which was live-action with cut-out sequences of paintings coming to life, influenced by Terry Gilliam's *Monty Python* animation. I had a natural sense of timing from the get-go, but all the animation was a bit overexposed. My first clay animation was just simple tabletop clay snakes interacting to form letters for a title sequence. I was much more pleased with the results and was inspired to keep going with it.

TD – I plunged straight in, working intuitively, drawing on my early years of posing clay. It was a rather crude clay dragon waking up and eating a ball that rolls into frame. It turned out all right. I got enough positive satisfaction from the results to have another go. It's important to have positive experiences in the beginning. That keeps it fun, which sharpens focus and encourages taking on further challenge and complexity. I'd overloaded myself in the early stages of other creative endeavours before trying animation, and had a string of half-finished projects trailing behind me, which bothered me. I may have instinctively not wished to add another undone effort to that string. I was carrying a heavy course load at the time which sort of saved me from myself. I didn't allow myself to get overly embroiled in detail, which I probably would've done if I felt I'd more time.

RH – My first proper animation was on my foundation course, which was a drawn piece of someone painting a wall. It was actually pleasing. Studying the basic exercises followed this.

JC – At college. I tried to animate oil paints on glass unsuccessfully. The first problem being I was not good with oils, add to that my ambitious idea to trace the journey of a goldfish, flushed down the toilet, through the sewers and finally into the ocean. I attempted a drawn animation based on the painting *The Raft of the Medusa*. It involved one of the occupants sucking up the others like spaghetti. This too was a disappointment. Both projects were too ambitious for my level of skill.

FL – I'm actually in the starting now. But yes, I am doing all the basic exercises: walk exercises, weight, and ease-in–ease-out, etcetera. I'm trying to learn animation principles before making a full film. I've started many things in life thinking that I should make a masterpiece without even knowing the basic things. I've learnt it doesn't work that way. So I'm sure that I'm learning to learn.

DS – Pete was the main animator and I don't think we ever did things like walk cycles before we started. We didn't have any formal training and apart from reading a few books which were rather technical, there was nothing which said we should start doing five-finger exercises before we played Beethoven, so to speak.

We had to wait several days for the rushes. On seeing them, the timing was fine, but I had done something stupid, and had kept doing it. There was Grandma happily putting her toes down first, giving her an odd walk indeed. I took myself away into a corner and felt how I walked, feeling exactly what the feet are doing and why they are doing it. A hugely important lesson to learn at the beginning: in a casual walk, the heel always goes down first. Of course there are comedy moments and tip-toeing that need the toes to come down first, but it does look odd otherwise. I have never been one for looking in a mirror or videoing myself, preferring to act it internally, literally feeling the weight and positioning of the limbs. But I had animated a puppet, almost got away with it, and it was a glorious experience. I had given some semblance of life to a character, and she was acting. I was on a high, and the world, for me at least, changed.

What did it feel like when you first moved a puppet? Did the rushes elate you or disappoint you?

JD – Since my early puppets were so crude, there wasn't much elation during the animation process. When I saw the film and the darn things moved, then I was elated!

TB – My first stop motion was animating a Johnny West horse, which had a moveable neck. I shot on a sunny summer day on my parent's front porch. I was fifteen. The horse's head could move up and down and from side to side. I didn't have a projector, so I ran over to my aunt's house and together we saw my first animation. All I can say is that when the horse moved, I felt elated and simply overwhelmed with pleasure. An emotional orgasm, if you will. It thrilled my aunt and me, and I watched it about nine or ten times. I didn't think about the performance, because I was thinking more about the technique of moving single frame, though my first camera didn't have a single frame release, so I'd click the trigger and hope that I'd get only one frame, but sometimes I'd get three or four frames. Later, when more comfortable

with technique and a single-frame movie camera, I began to think about performance. Two years of drama in high school helped me a bit in preparing my animation. I studied acting and performed in musical theatre in college.

KD – I was beside myself with excitement. I love the studio set-up, the lights, the camera, the sets and the puppets. The puppet survived the film but not for much longer afterwards. It was shocking when I looked back. I wanted to animate like the greats, and was cheesed off that I couldn't. I found it difficult to remain patient and calm.

RC – The first real puppets I ever animated were very well made by Ernie Farino (a respected Emmy-winning special effects supervisor). They were armatured and cast foam rubber. I was able to get refined motion from them. I had worked out almost all of my timings ahead of the shoot, mainly because it was to a song. If I wanted the sweep of the arm to be one-and-a-half seconds, I knew I had to break that motion/distance into thirty-six individual movements (at twenty-four frames/second), allowing for any ease-in and ease-out. It worked well.

DC – It showed me how difficult it is to re-create realistic movement with a tiny plastic man. I enjoyed building up the action and trying to get to where I wanted with no experience or animation training. I liked the challenge and my little friend is still with me agreeing that everything since him has been better.

AW – Other animators told me to work on twos but I shot on ones. I almost died from the stress beforehand. I was shaking. Afterwards everyone came to see it. I don't remember how it felt during the animation. My brain switched off. The rest of the world and time disappeared. Afterwards everyone said 'Welcome to the team. Now go and buy some vodka'.

SB – I first properly moved a puppet at college. I didn't plan it properly (again) and it came out rushed and nothing like what was in my head. Only one bit worked – the puppet (a bogey man made entirely out of pipe cleaners) fell over and his hat came off, he picked it up and put it back on his head. Surprisingly that simple gesture gave him more life and character than anything else in the film

RH – I first moved a puppet before my degree, and was generally quite disappointed with the results. When I started animating at Cosgrove Hall after my degree, I felt much more comfortable with stop motion, and found a connection with the puppets that I hadn't felt before.

TA – My first stop motion was a tense experience. I felt nervous, like I was guessing, plus my handmade character could snap at any point! Each move of the puppet was small back then as I was afraid of moving it too much and ruining everything. Thus my animation looked tense and stilted. It wasn't fun to watch or to do! I was too scared of making mistakes to try anything bold. Liberation came in the form of trying bigger movements and learning at certain points I could take the puppet right off set midshot. I kicked the camera tripod and 'adapted' that into my first animated camera move! I felt free to play and, hey, animating became fun!

JC – When I got to animate a puppet I was surprised at how hard it was to control the movement. It was all jerky and much too fast. I was disappointed with the end result but also excited by the possibilities.

DS – It was magical to get the rushes back and see everything moving. Seeing the little models move about and come to life was great inspiration to do more.

Through the sheer joy of being able to move things did you at first overdo the animation? Have you learnt to be more disciplined?

JD – I'm more disciplined now, but I never had much of a tendency to overdo the animation.

DC – Well yes of course.

AW – Yes definitely, everything moved too much. I try to make gestures read more now, yes.

JC – When I first started animating I was exhilarated and disappointed by what I produced. My first attempts were jerky and much too fast. There was no sense of timing or balance. I was disappointed and felt that I could produce much better. In the interim years I've learnt to control the puppet and more importantly, myself. Often the pauses and held poses are more important than the movement. As Barry says, 'give the audience time to read a pose'. I now produce good work but it rarely lives up to my imagined end result – a common feeling among animators. We are always striving to improve and reach perfection.

Early days with Chorlton in Chorlton.

Chorlton and the Wheelies

Having proved some ability, I moved to working on *Chorlton and the Wheelies*. Mark Hall remembers the birth of this landmark series: 'One morning Brian Cosgrove announced "I've had this weird dream. There were these heads on wheels spinning round and round, on a plate, in space!"'

The energy buzz you get when such an idea hits the fan is intoxicating. We were on a high with this one and within a few days and nights *Chorlton and the Wheelies* emerged. Wheelie World would be ruled over by a misery-spreading witch named Fenella who saw no good and it would be saved by a happiness-spreading dragon called Chorlton who saw no bad. Classic good versus evil stuff.

We invented characters that allowed us to experiment with mixed methods of 3D animation that reflected the surrealism of their world. Heads on wheels was a good start. Other characters like the Toadies, toadstools, only had eyes to animate. Spikies were cocktail sticks stuck into central core balls, sprayed green and rolled around looking like some sinister military tumbleweed. Riley was Fenella's one-eyed telescope looking down from Spout Hall on Wheelie World, reporting back everything he sees to Her Miseryship. Only the pages animated on Fenella's spellbook. Broomsticks were confined to the brush cupboard, as her mode of transport was to pop up and down in a series of differing scale 3D cut-outs, pop pop popping all over Wheelie World. Simple but funny. She, like Chorlton, was able to be animated in the conventional way because of full armature. Both of them had easily replaceable faces held in place by small magnets.

The barminess of this wonderful, surreal show, entertaining to all ages, was the result of an exciting meeting of visual and writing talents. Both fed off each other. No better illustration of this was the arrival in Wheelie World of Pablo Petito – champion ballroom – Latin American – dancing duck. Daft, as writer Brian Trueman would say. Gloriously daft. Some dream.

Seeing some hugely satisfying results with Chorlton, and being surrounded by such an innovative team, all the elements finally started to fall into place, and a lifelong, if slightly peculiar, relationship started, not just with puppets and performing them, but with a whole breed of gloriously colourful, friendly, committed, passionate, unique and fantastically eccentric people called animators. I love them, and often they are more interesting than their creations … but that's another book.

Another way in – Andrew James Chapman, animator at Cosgrove Hall

I started as an illustrator creating my own characters, copying and refining work from a young age. I was always sculpting with Plasticine and drawing or bringing them to life. I'd been interested in 2D but never imagined I could do something in 3D, bringing an actual physical object to life and give it a personality of its own! My influences from an early age were mainly 2D cartoons such as *Dangermouse*, *Count Duckula*, *Transformers*, *Popeye*, and all the Warner Bros and Disney characters. But my first stop motion series I saw was *Morph* … wow! I was overwhelmed and gobsmacked by the magic it possessed. I thought it was real. Plasticine actually coming to life. I wanted much much more. The way it was able to change shape and move around like that was breathtaking, magic. This inspired me to reach new heights. Aged seven I knew I wanted to be an animator and started to watch as many stop motion programmes as I could. Even in my teens I was unable to have a go at stop motion as I had no contact with computers or camcorders … money was tight.

Thirty years of Cosgrove Hall (© Cosgrove Hall Films Ltd, 2007).

My first real go was at nineteen at university, with Plasticine under an old line tester. It was like a drug. Once I started to move the object and bring it to life, it was an immediate adrenaline rush, the best feeling ever, immediate results, incredible and addictive. I couldn't stop, didn't want to stop, that was it for me. I had found my perfect path in life. All I had to do was to see if I had the skill and ability to carry it all through. I knew which company I wanted to work for (Cosgrove Hall). I just had to persuade them. I graduated with an award for the best stop motion short film and after that made my way to Chorlton to pursue my next step up the ladder to become the Nick Park of Cosgrove Hall.

Enthusiasm like that cannot be bought.

PROCESS

The storyboard sheet reads:

BARRY J. C. PURVES
ANIMATION DIRECTOR
061 928 8955

PRODUCTION	DIRECTOR	PRODUCTION COMPANY	DATE FILMED	RUSHES VIEWED	SHEET NO
NEXT	BARRY P.	THE AARDS.			2

SHOT NO: 2 LENGTH: 4" 1/2

ACTION

DESCRIPTION/DIALOGUE: SHAKESPEARE FINISHES LOWERING HIS HAND. THE CAMERA IS BEHIND HIM, AND WE SEE IN TO THE AUDITORIUM. WE CAN JUST SEE ST. PETER. A FIGURE HALF LIT IN THE GLOOM. SHAKESPEARE IS WALKING DOWN TO THE AUDITORIUM.

EDITING NOTES, OPTICALS ETC.
FOOT STEPS

CAMERA MOVES
TRACKING SHOT

COSTUME SET PROPS AND LIGHTING REQUIREMENTS
PRACTICAL DESK LAMP PAPERBACKS (HALO + WINGS NOT SEEN)
CLIPBOARD AND PENCILS THE STAGE FOOTLIGHTS - PRACTICAL
POLYSTYRENE CUPS CIGARETTES SMALL GOLD HANDBELL
FAST FOOD CONTAINERS

Merely corroborative detail, intended to give artistic verisimilitude to an otherwise bald and unconvincing narrative.

W.S. Gilbert, The Mikado

Ideas and Storytelling

Montage of Next storyboard images.

Starting somewhere

Where to start with a film? Perhaps 'what's the point?' is a good question, followed by 'can this film be made with actors?' Others are 'do I care enough to spend a year with these characters?', 'do I know enough about it all?', 'have I got the energy and focus to go through with all this?', 'this may be my one chance with this theme, is it right?' and 'have I thought it all through?' Much soul searching happens before anything moves; well, it should. Then there are the technical questions about how long will the film be, what sort of scale, what sort of puppets, what about the budget, what about the technique, what sort of style, who is it for, and many similar questions. No animation can be done without such preparation. The main thought has to be the story or the perspective. I have been guilty of having great visuals in my head, but then have struggled to find a reason for them. Others have fallen in love with an innovative technique, but have not had the story to support it. Others start with a puppet then try to find a story for it. Puppets may not be the most appropriate way to go at all, and I have given up on good ideas before now, because another technique might validate the subject better. But 'puppets' is a vague word, probably defined as something loosely figurative that is used to express character and emotion; something that is given life and controlled by another, perhaps; something eighty feet high operated by dozens of technicians, or pieces of felt on a finger.

Often a piece of music starts an idea going, or a book, or an overheard conversation or a painting, but the desire to tell a story, or at least to communicate something, does need to kickstart a film. All animators can be indulgent, cursed and excited by so many ideas. It's structuring them, focusing them and making them mean something that's often the hard but essential part. Shortcuts are invariably disastrous. This is not a job to be approached half-heartedly.

How did you approach your first film? Did you find it hard to focus all the ideas? Was it somewhat indulgent?

JD – My first films I made were live action, 'winged' without a script. More ambitions live-action/effects productions were done with two chums. Carl was a would-be writer, so he wrote the prose and dialogue based on our discussions. Didn't experience the 'took longer than expected' problem on those films, but sure encountered it as my expectations and skills increased.

TB – My first script, in high school, was about the life of Jesus in thirty minutes! Well, what can I say? It was ambitious, with many puppets, sets, lots of dialogue, and music inspired by Fauré's *Requiem*, for key sequences, such as the resurrection of Lazarus, as well as the crucifixion, the resurrection and the ascension.

KD – I was so excited about storyboarding. I still have those early boards! Making the set and the armature, it was amazing. I was hooked.

RC. It was mostly tests …. I hadn't learned to machine armatures yet, so I was limited. Yes, I was always ready to move on. Even today, I want the next challenge.

SB – We had no story. We started animating Plasticine people in a band. We soon got bored and the characters fell apart. We then pushed yoghurt pots around. It was hard to focus on what we were trying

to achieve. The yoghurt pots would have been good if we'd made them dance or something. They just went back and forth instead.

TD – My first film was with another student who wasn't an animator but a photographer. Hence the decision to use stop motion. We looked at what was available or ready made, i.e. school equipment and facilities, and jointed dolls, toys and household interiors. We built a story around our constraints. We were pretty focused and direct about the whole process. We ended up having to shoot the whole thing twice as we shot on 16 mm with no means to 'see' what we were doing. We knew enough to stay out of the film frame while shooting, but we neglected our shadows, which were prominent throughout. A valuable lesson. My shadow hasn't been seen since! Another lesson is running out of film while shooting, and not knowing it.

RH – My first film was a combination of musical songs, woven into a kind of twenty-minute story. The script actually evolved out of the songs, but the songs were the key. The cartoon character tried to live as a human, but failed in the outside world. He'd return to the drawing board for helpful advice. In the end he gave up and remained a cartoon character, in his own medium, where he belonged. I was pleased to come up with the perfect title – *Back to the Drawing Board*!

JC – My first projects (mostly unfinished) were based around memory and memories. I was interested in the memories and feeling evoked by all the senses. I wanted to explore this and also combine animation with my interest in photography. I'd experiment with using a 35 mm stills camera, manipulating and animating the prints produced. I found most early projects would start with one idea that evolved into something quite different, usually better. I'd spend a lot of time working and reworking storyboards. In the early stages I'd talk to my contemporaries but often found they would try to take the idea off in a different direction, their direction.

DS – Our first film (which was cut-outs and chalk drawings) was pretty formless. From then on we had a theme to work for the *Vision On* work. This was helpful in focusing our ideas and I would recommend to anyone starting out as it avoids the 'what shall I make a film about' syndrome. Although we did short pieces with a variety of characters (abstracts, burglars, lumpies and little figures) they all derived from having a theme to work to. Morph of course came out of this and that's when we got into writing stuff properly in terms of storytelling. We had also by that time worked on the early *Animated Conversations*, where again the raw material of the soundtrack provides a great jumping-off point for ideas and approach.

I have never had a problem coming up with ideas, and never had any creative block. It's the outlet that's the tricky one, so I am surprised that one of the most frequent questions is 'where do you get your ideas from?' Sometimes, the trick is to block out the new ideas bursting forth before the current ones are sorted out. It can be hard having an imagination where everything is possible. It's a cliché that the smallest newspaper article has some germ of a story. The

success of the story is how interesting is the telling, and whether there has been a development, a journey, a point or a perspective that can engage the audience. Even the smallest story can be interesting if told in an involving way, with enough conflict, progression and a fresh perspective. Practically any subject, any genre can become a story, but we have to decide whether our particular medium is appropriate for the telling. Being aware of what animation can do that live action cannot helps to focus the flood of ideas.

It's easy for stop motion, and animation in general, to make an audience laugh, but can stop motion work in others genres, such as tragedy or with profound subjects?

JD – Stop motion can do tragedy. If King Kong breaking the jaw of the T-rex can make my wife wince, all things are possible. Perhaps though, the reaction to tragedy would always be somewhat removed, like watching monkeys or dwarves doing Shakespeare – quaint. Music would play an important role.

Profound is another matter. I've no doubt that stop motion can be profound, in that it can put forward illuminating ideas.

TB – I don't think it's a question of 'can animation do tragedy?' It's more a question of 'Can I write a good story that is tragedy driven?' Any genre can be done in animation, provided that the audience is engaged by the story and characters, and isn't more than an hour or so. I'd like to see more tragedies and dramas, more adult-driven themes. At least in America, there are too many stories using animation that rely on the unlikely hero with the second banana comedy-relief sidekick. Enough! My current film project, *The Labyrinth*, is a tragedy. Parents won't take their five-year-old to see it, but I'll take my siblings to see it. Of course, none of them are five anymore.

KD – Yes, I cry at the end of *Screen Play*. I can't watch *Watership Down*, I've never seen *Bambi* … maybe I have issues with death??

RC – Any genre, just done well. Fantasy obviously allows animation to excel in certain ways. If the audience is caught up in the story, they'll experience the emotions if properly handled. Disney's Dumbo was just a set of drawings, yet you'd have to be a pretty cold bird not to feel his pain when his mom's dragged away from him and he's alone. Or when he visits her in 'jail'.

DC – I'd like to see animation tackle any theme it wants. Its not all cartoons and silliness! There are many emotional moments in animated films but it's still treated and thought of as a kid's medium or lacking in serious film weight.

AW – I've never seen such tragedy in stop motion. But it is possible.

SB – Animation probably does comedy and horror best. In the right hands it can cover all areas, as long as it doesn't get pretentious and overly arty.

KP – I've seen some stop motion short films that affected me emotionally, although few of them are mainstream. It's easy for stop motion to make people laugh, no question. Aardman has created some of the funniest short films and features that I know. What I haven't seen yet is a stop motion feature that can resonate with the same emotional impact as say, Disney's *Beauty and the Beast*. The emotions stirred up by the music and performances are brilliant and hard to top. *Nightmare before Christmas* comes closest to representing truly powerful characters which I've personally responded to emotionally. Ultimately what brings tears may vary from audience to audience, and it'll always be the story and empathy with the characters that does it regardless of the medium used. I'd love to see stop motion match the emotional wallop of *Snow White* and *Dumbo* or the horror of *Pinocchio*, and it's capable with the right story. For sheer tragedy in a stop motion performance, Kong is still king, particularly for the era the original film was made and its place in film history.

RH – Animation can do anything, but a lot is relied on – such as the quality of the animation, the storytelling, the camera angles, the quality of the puppets, the lighting, etc. Comedy usually seems to be the easiest genre to achieve, whereas tragedy can be somewhat more of a challenge.

JC – All genres should be seen in animation. It's a powerful medium and can as easily entertain shock or upset as any other form of film. A powerful and sensitive performance is what matters. It can evoke belly laughs or torrents of tears.

FL – Any genre you want. Tragedy, the best of all. Stop motion is the most theatrical way of animation, and of film-making. It is marked by the mask, and mask was indeed the beginning of everything.

DS – If animated films are regarded as simply another form of film-making there's no reason why they can't deal with deep emotional subjects. Culturally they've often been classified in the west as being mostly for kids, but why?

PRW/MG – Yes, animation can do tragedy – *Screen Play*, *Achilles* and *Suzie Templeton's Dog* are superb examples of this. *The Periwig Maker*, directed by Steffen and Annette Schaeffler, brought to life the plague year in London, capturing the atmosphere and horror of the event. Another stop motion favourite is *Aria* by Piotr Sapegin (based on *Madame Butterfly* and using the music). When the puppet Cho Cho San discovers the truth about Pinkerton she strips her kimono from her and then dismantles her armature – thus committing sapuko. Heart-rending stuff! For us this was one of the most moving moments in animation ever.

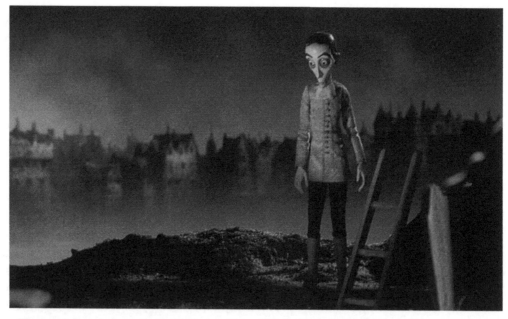

The moving and atmospheric *The Periwig Maker* (© Ideal Standard Films, Annette and Steffen Schaeffler).

With my imagination my own history is constantly being re-edited to make a better story; so much so that the more fanciful tales now seem to me to have happened. A vivid imagination can be confusing.

Developing ideas

I often do workshops about storytelling, with the emphasis on the freedom of imagination that animation allows; these sometimes involve throwing various ideas and images into a hat, and pulling out a random selection. We throw in a brief description of a character, then a location or context follows, and finally we throw in some sort of dilemma or weakness, or at least a complication. These are all standard elements for any story. The details on the bits of paper are hugely imaginative, and sometimes it is a tough task to pull out three bits of paper and link them all into a cohesive story with a point.

Occasionally, a story comes out that is just perfect for a short animated film, and one such was from a group of young animators in Portland. The first character we pulled out was a three-legged dog. He immediately seemed appealing because of his vulnerability and uniqueness. The location was a futuristic urban landscape, where all grass and trees and vegetation had been replaced by artificial equivalents and masses of concrete. It is a city run by robots. We didn't immediately think of an obvious story, as the robots seem to be the main and immediate image, but the dog as an outsider here was an interesting idea. The next piece of paper to be pulled out was the complication 'the character needs to go to the toilet immediately'. This caused many guffaws, but at once I started to link the three random images. Some story elements went off on embarrassing tangents, but there seemed to be something worthwhile here. The robots seemed to be a red herring initially, but I thought that robots don't need to go to the toilet and would not necessarily have considered the needs of others, let alone a little dog, and the idea of a three-legged dog seemed to make the idea of going to the loo even more of a drama. All the elements started to fall into place, making a story about a cold hostile environment, where robots had no need of natural things like trees, or of biological functions. This lone dog was some sort of survivor, and still with biological urges, and needed to go to the loo, but there was an interesting twist. Being male, he could only do so against a tree. The film could be developed into the quest for the perfect tree: I know my cat would have made all manner of informed and fussy decisions before he was content. The soil is either too wet or too exposed. The scope for gags about the unsuitaly of the right spot is endless, and add to this the ticking-clock element of how long his bladder will last, and there is the basis of a self-contained short film. The escalation of all the compounded frustrations, such as running gags about sights and sounds that make his toilet needs greater and more desperate, would need some pay-off, such as finding the perfect tree only to have it uprooted and the whole thing start again. Losers can never reach their quest, Tom will never get Jerry, nor will Coyote ever outsmart the Roadrunner. I should sit down and write the script for this dog and the perfect pee film. Even as I write my mind is stumbling over itself with a million gags and a million pay-offs for a story that seems to have gelled from three random ideas. And what's the story of the missing leg?

What strikes me as suitable for stop motion are the textures, with a suitably hairy and textured dog puppet contrasting with the smooth textures of the mechanised world. The lushness of a single green tree makes an interesting visual, and there is good scope for sound. Also, the movement of the dog, with his frustration and release, would be a gift for any animator. It would be a hard audience not to have empathy with this dog; a simple flaw makes him endearing. Underneath is a substantial theme of natural urges being unsquashable. All in all, this could be a pretty effective ten-minute film. All it needs now is a budget and a good title.

Tim Burton's *The Nightmare Before Christmas*, directed by Henry Selick (Kerry Drumm).

Emotions

The two scenes in animation history that have reduced most of us to tears both involve mothers: the death of Bambi's mother and Dumbo's mother locked in a cage for being mad, nestling Dumbo in her trunk. Producers know that the death of a mother is probably the most traumatic event in one's life, understandably, and the live-action film that most reduced me to tears was *Finding Neverland* with the slow fading of Kate Winslet. This and the death of Smike in any version of *Nicholas Nickleby* will see me in honest tears. I have cried in operas, ballets, plays and even with books, but only a few puppet films, such as *Kong* and *The Periwig Maker*, have truly moved me. Perhaps I am too close to the technique. I have felt other emotions. I remember the real dread at seeing *The Sandman*, but the sort of films that I connect with emotionally are not being made with puppets. Michael Dudok de Wit's two great short films, *Father and Daughter* and *The Monk and the Fish*, leave me dewy eyed, as much through the music and beauty of the artwork as through the story, and the end of Chris Wedge's computer graphics short film *Bunny* had me choking back something … but

no puppet films as such. I know we can do it, and I'm hoping it's not the all too solid nature of a puppet that prevents us being moved or shocked. *The Nightmare Before Christmas* and *The Corpse Bride* play with the conventions of horror, with darkly gruesome humour and exquisitely eccentric characters, but there are many more genres still to be tackled and other emotional buttons to be pressed. I hope that we can see the visceral and the downright tragic one day. Rumour has it they may be on the way.

A different perspective

I'm awake most nights with my head pounding with ideas for films, even though there is little chance of getting them made. Stories suggest themselves from a conversation at work, or something ironic in the paper, or someone's behaviour in a shop, or wondering what lay behind an expression I glimpsed. Could that expression be the start of a film, or is it the end of the film? A lot of animation is about finding a different perspective; for example, seeing complex human situations through the distancing of using animals or cars or ants, or by turning a given situation on its head, or by creating interesting dramatic conflicts by bringing unlikely worlds or themes together. Many films and plays depend on this change of perspective for characters to learn the truth about themselves. Shakespeare sends his characters into the woods (as does Sondheim) to see clearly, or he blinds them, or he makes them swap gender briefly; Ibsen sends them up mountains; others travel in twisters to seek fake wizards, some have to be visited by spirits from Christmas Past, some turn into swans, some lose their minds, some are exiled, some fall down rabbit holes, some see themselves from afar, some face big natural disasters, some have to lose everything they have, and some are told the truth by jesters. There are many narrative tricks to send a character on this journey to find them. With animation, this journey, this change of perspective is often the animation itself. Animation and puppets are good at showing us what we cannot see for ourselves. Truth is so often revealed through deception.

King Lear loses everything to see what he has (Richard Haynes).

The trick is shaping this change of perspective to make it interesting and exploiting the potential of what animation can bring to it. Of course, this is the real world and a film-maker has to take into account the reality of available resources; happily, I've found the tighter the budget, the more creative I become.

I love playing with structure and watching how it works in great pieces. Watching the dullest of films or plays is never a waste of time, as the mechanics of how things happen often gives me more pleasure. I marvel at how clever twists are introduced or how back-stories are revealed, or how a sentence is structured to give away so much information but still sound like natural dialogue. I'm not sure that my films are great examples of any classic ideas about structure, but they do flow and not a frame is wasted. I like to throw in unexpected narrative twists, but I am not consciously following any recognised formats or genre tricks.

Sondheim's musical *Sunday in the Park with George* imagines the painting of Seurat's, Sunday afternoon on the Isle of La Grande Jatte, giving every detail a new perspective (Saemi Takahashi).

My favourite structure is an obvious change of perspective to make the usual unusual, or the familiar look fresh. In J.B. Priestley's play *Time and the Conways*, he shows us a family innocently celebrating, with all their hopes and ambitions. Without warning the play jumps to after the war, to see how these ambitions have been crushed. Act three takes us back to where we were, and how hollow these celebrations seem, now we, the audience, know something the characters do not. The audience having secret knowledge is a prime device for tension. For twenty centuries audiences have screamed at Oedipus not to seduce Jocasta, alone knowing

that she is his mother. Another favourite structure is Sondheim's *Sunday in the Park with George*, where the audience watches the painting of Seurat's masterpiece, seeing every little detail echoing the artist's life. Every hitherto innocent detail is now teaming with imagined significance. In a daring moment, Sondheim twists the perspective and we see the artist's life from the character's perspective. In animation, the films of Paul Driessen often show the same event from different perspectives at the same time, and see their subsequent different meanings.

The most basic structure is to set up a situation of normality, then complicate it with change; perhaps the arrival of a stranger, a quest or a threat, then resolve it with some sort of confrontation, either real or internal, with a new order restored after what amounts to a journey of enlightenment. The three-act structure works even in short films, but what is more important than endless theory is to make the telling of the tale interesting, by drawing in an audience and teasing them into wanting to know more about the characters and their situation, being just that one step ahead of them, tantalising them but not confusing them, leading them one way then outwitting them, getting them to care. To keep them watching there is little point in giving things away from the beginning. I was disappointed that the recent remake of *The Wicker Man* chose to feature the wicker man itself on the posters. The butler might as well have done it, and told the audience as they came in. Information, both plot and visual, needs to be teased out and pieced together over the length of the film. In the popular stage and film versions of *The Phantom of the Opera* the big effect, the crashing chandelier, is given away in the first few minutes by seeing it rise into position. There is little surprise when it falls, although there is the rather clinical tension of waiting for it. I love structures where everything only falls into place in the last few frames, leaving you going back over the film, piecing it together in your head. I am bored, though, by films that put it all on a plate, usually linear films, with nothing left after the credits.

There are the classic themes on which all plots are supposedly based (with such stories as The Quest, The Journey, The Rise and sometimes Fall, the Battle against the Monster, A Second Chance, and Comedy and Tragedy, and all manner of variation) and following these guidelines leads to films that resonate, but I would encourage a bit of innovative lateral thinking. Animation of all art forms has licence to break rules and experiment. It can do anything, as there are no rules about making animated films, but the one thing it cannot do is be dull. Many an exciting film has been made of a dull book, thanks to an imaginative director and writer. True, many a dull film has been made out of an exciting book, thanks to an unimaginative director.

M.C. Escher and other artists

With his knack of challenging with a fresh perspective, it is not surprising that I love the etchings of Escher, and like many model makers and set designers I am fascinated by seeing these glorious optical illusions realised in three dimensions. That they cannot exist, except cheated to one specific viewpoint, adds to their appeal. Walking round such a model there would be significant gaps and unparallel parallel lines. It's his never-ending staircases in drawings such as *Relativity* (1953) that appeal to me and I will animate that illusion one day, but it would be a cheat. Stop motion is a cheat. It looks as if it could happen but it cannot. I push this element in all my films. *Next* looks as if it could happen on stage, but even with clever editing it could not. I like that delicious twilight area between total naturalism and complete abstraction.

The paintings of Magritte also interest me, and although perhaps they look a little obvious today (because there have been so many imitators who have taken his ideas even further), when first seen these paintings must have been astonishing. To juxtapose two different images, or reverse a perspective, is what animators do every day, and I am surprised that Magritte's influence on animation isn't greater. I wrote an animated feature film script with the bowler-hatted, apple-faced character from *The Great War* (1964) as a main protagonist, but was told that paintings were hardly a commercial subject. Shame. Magritte does turn everything upside down, with a great 'what if …?'

One of Escher's impossible architectures (Richard Haynes).

logic to the thinking behind the paintings. This 'what if …?' is so often the starting point of a good film, play or work of art. What if toys had their own private life away from humans, as in *Toy Story*? What if the characters in a painting had a life, as in Sondheim's *Sunday in the Park with George*? What if there were monsters lurking in the cupboards, as in *Monsters Inc.*? What if we saw *Hamlet* from the perspective of a couple of minor characters, as in *Rosencrantz and Guildenstern are Dead*? What if the Wicked Witch of the West hadn't always been wicked, as in *Wicked*? Asking this 'what if …?' about the most familiar day-to-day subject or cultural icon is to be part way towards a good story. For *Next*, the 'what if …?' was: what if instead of so many people doing Shakespearean auditions, it was Shakespeare himself who was auditioning? Juxtaposing ideas this way has great potential. Magritte asks what if the night sky was actually light and the ground dark, as in *The Empire of Lights* (1954); or the lightest of objects, a flying dove, was made of the heaviest, stone; what if a window blocked our view rather than making our view? I went to a fancy dress party as *The Great War*; among the vicars and tarts and nurses, I should have gone as a lead balloon. There's an oxymoron Magritte might have enjoyed. Actually, animation is a creative oxymoron, where things don't behave as we thought they might, or what we think is solid is soft, or what looks heavy is light, or what is inanimate is animated. I was interested to see that a production

of *Billy*, the musical of *Billy Liar*, had a Magritte-inspired poster, as shorthand for a skewed reality.

There is a subtle reference to Escher in the feature film of *The Wind in the Willows*. One shot has a rather clunky fish swimming underwater, while a leaf floats on the surface and a reflection shows the trees above. This consciously echoes Escher's *Three Worlds* (1955). My only Magritte moment, other than the script waiting to

A Magritte-inspired poster and animating Magritte for a commercial with Aardman.

be filmed and a stage set, was an animated snippet of his raining men (*Golconda*, 1953) in the Aardman *Manchester Evening News* commercial. I am glad that Magritte was chosen to represent art.

What sort of films do you like? Do they reflect the sort of animated films you try to work on? Would you actually watch animation for pleasure or, as most films are aimed at children, is it a guilty pleasure?

JD – A most interesting question. I don't much like watching long animated films any more (but did enjoy *The Corpse Bride*); perhaps that's because I know subconsciously that I won't get to do the films I wanted to. I almost never rewatch the Harryhausen films because the 'film-making' is so bad that they no longer entertain me. The black-and-white Harryhausen films are an exception for some reason, and I occasionally watch those – *The Beast from 20,000 Fathoms*, or particularly *It Came from Beneath the Sea* because I like the repartee between the three leads. Sometimes I watch a Trinka film, but not often.

TB – I enjoy character-driven films. I'd watch animation any time and day. Animated films that have strong stories speak to me. *The Iron Giant* is an animated film, but the story and relationship between the boy and the iron man is most touching, and succeeds on many levels. Its ending is what I enjoy most; self-sacrifice and loving selflessness, themes that I am attracted to the most.

KD – I enjoy Tim Burton's films; they take you somewhere, an imaginative world, somewhere with a slight edge to it.

RC – I enjoy all sorts of films; mystery, fantasy, adventure, drama and comedy. It just needs to be done well. From a Hopalong Cassidy western that's played 'straight' to a Marx Brothers' farce to something as classic as *Casablanca*. A well-written film has universal themes anyone can relate to, so they speak to adults as well. I can watch animation any time.

DC – No guilt, it's what I do. It's homework or research, but mostly it's my passion and interest. Animation when done well has a magic I enjoy. I like to still have questions after a film about how they got what they got.

SB – A good film is a good film whether or not it's animated or for kids or adults; people like Pixar and studio Ghibli have proved that.

RH – I'm a big fan of all genres of film, but musical and comedy are my particular favourites. When these two genres come together, like in *Mary Poppins* (which features animated sequences) there's a film I can relate to and enjoy. My love of music and humour shows in my animation, and my ideas. I feel guilty pleasures in watching all kinds of animation – it's an art form I get great enjoyment from watching, no matter what the subject matter.

JC – I love all sorts of films (although as a 'scaredy cat' am not so keen on horror films). I love silent comedy, old musicals, war films, romantic comedy, westerns, thrillers, arts cinema. I wouldn't limit myself to working only on selected projects. Diversity keeps you fresh and challenged. I'd say that if a project particularly interested me I'd pursue it harder.

FL – I feel sometimes like a kid and sometimes like an adult when I see animation films. And sometimes I feel both ways during the same film.

Narrative structure and artifice

Animation, unfettered by reality, has the liberty, more than most art forms, to play with structure. I have seen many films with brilliantly innovative structures, and then there have been those that lacked any structure whatsoever. I find linear films dull and a waste of animation's enormous potential. Likewise, at festivals I have watched films that have been an abstract succession of colours and shapes and movements, without an idea or concept. I feel stupid as I must be missing something. Perhaps that the images change is enough, and I know not everything needs a plot to work, but I do like to see some thought process, even if it's only a slow change of colour or a movement speeding up, or a progression of some sorts, or a reaction to some music. Things so stripped of shape and form I find hard to applaud.

I respond more to ideas that are played with, even if these are basic ideas, such as literally seeing how colours change next to each other. A film like Raimond Krumme's drawn film *Rope Dancers* appeals to me as it takes a simple idea of two sketchy men tied together by a red line. The film follows their attempt to escape each other, and in the process they play with every perspective possible on a flat piece of paper. The series of gags is given dynamics by an increasing desperation,

The zebra from David Bintley's ballet *Still Life at the Penguin Café* (Joe Clarke).

and wildness in the gags. At the same time the film plays with our perception of what we are looking at, while also making some comment about interdependence. This is true of the great Tom and Jerry films, the Road Runner series, and Bill Plympton's hysterical films. There is seldom a plot, but there is a relationship or a strong theme, and a series of linked and escalating gags that play on every combination of these themes. One of my favourite cultural pieces is David Bintley's heartbreaking ballet *Still Life at the Penguin Café*. In a café setting, various animals introduce themselves, dancing their character and predicament with pure elegance and wit. There is no narrative as such, but towards the end an accumulated theme and connection emerges that these animals might be endangered species pleading for a place on the ark. On this occasion all are saved, except for the great auk. This sounds as if there is a plot, but all this is satisfyingly oblique. A series of characters or gags linked by a common theme appears in so many animated films. *Next* is little more than that, but hopefully none the worse.

With my obsession about seeing the mechanics of storytelling, it's little wonder that my favourite films are about seeing the stories behind the stories. In them all is some façade, some iconic exterior, be it personal, theatrical, sexual or artistic, that has to be maintained, even if the interior is under stress and falling to pieces. The conflict and tension between this outer face and the inner face makes for good drama, where the two worlds reflect and illuminate each other. Films such as *The Dresser, The Red Shoes, Living in Oblivion, Noises Off, Truffaut's Day for Night, Theatre of Blood, Les Enfants du Paradis, Some Like it Hot, Girl with a Pearl Earring, Amadeus, The Boyfriend, Oh What a Lovely War, Cabaret* and *Dream Child* all have some outward show to preserve, while the inner show is something totally different. I love this tension and role-playing. In the Mousetrap scene in *Hamlet*, Shakespeare uses a short theatrical piece to bring all the unsaid accusations into the open; he shows the truth by showing it as artifice. The point of a piece being distanced can be, in effect, to bring it closer. All the trivia is cut away, and the essence of the situation is brutally revealed. That's what animators do so well. Since animation is such a painstaking process, we are hardly going to animate the unnecessary. Like caricaturists who capture a face in a few lines, animators can capture a mood, a movement or a character in a few economical frames.

This stripping back could be described as theatrical, although that seems to be a derogatory word, but it does describe how I work. I have developed a definitely simplistic style. This grew out of necessity on *Next*, but now I revel in it. When I have designed stage productions for my local Garrick Theatre I've tried to create a visually interesting and sometimes startling space where the actors are still the centre of attention. I have little patience for literal representations of spaces, feeling that both theatre and animation should celebrate the artifice of the medium. Neither art can ever be realistic, and it seems a futile exercise trying to be so. A more apt word is 'credible'. If the actors and puppets exist in a credible space, a space where their performance can work, then we will believe them. I'm sure that much of the appeal of stop motion is that we are aware that these characters are puppets, and there's a handmade element involved. The fact that we are taken in by them is all part of the satisfying complicity with the film-makers.

Shaping Ideas

Next

Next was the first film that I had written and directed, and after eleven years of animating and directing for others, I was exploding with too many ideas. It was a fantastic opportunity, thanks to Aardman Animations. I'm not sure where the idea of something Shakespearean came from, but it was probably just wanting to do something different and classical. Thankfully, it was both. I was in danger of cramming absolutely everything in, probably even the Elizabethan kitchen sink if Shakespeare had mentioned it.

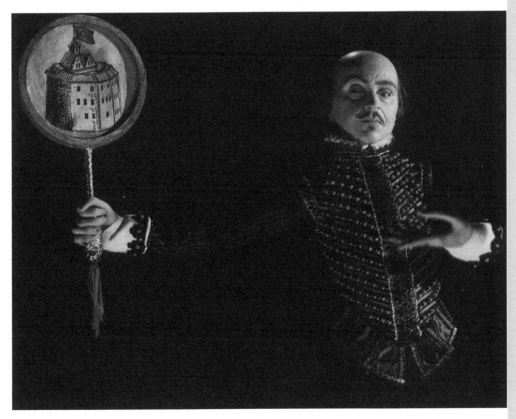

William Shakespeare from *Next.*

I had wanted a sizeable cast of characters, but the budget allowed for one decent puppet, and actually that made and focused the film. The Channel Four brief for the *Lip Synch* series was to play with language, and while the other films in the series, *Creature Comforts, Ident, War Story* and *Going Equipped*, all played with verbal language, I was tickled by the conceit of telling some Shakespeare stories without words, just using body language.

Auditions

Affording only one puppet reinforced an idea of having Shakespeare himself acting out the stories, and the idea of an audition developed. Auditions do not come more clichéd that those for Shakespeare pieces. Auditions have clearly scared me and scarred me, but they were all good background experience for *Next*. I once auditioned for Jack Point, my favourite of all the Gilbert and Sullivan characters. Great acting, I was told, but the singing, erm … next! Decades ago, I auditioned for *Let My People Come*, a limp sex musical cashing in on *Hair*. Being a student I thought working backstage might get me a theatre career. As I stood naively on the huge stage, they asked me to sing. I explained that I only wanted to work backstage. 'Sing!' the voice in the darkness bellowed again. A snippet from *Yeomen of the Guard* didn't get me the job (surprisingly), and they had clearly realised that there was no decent physique as compensation for the lack of a voice. Next! I didn't get a job backstage, but the thrill at standing on stage peering out over the footlights got filed away. You never know when you'll need this scrapbook. Shakespeare's actions in *Next* come from bitter experience.

Auditions are, as for most performers, part of an animator's life, but like everything animation based, they only amount to a few seconds, and for that reason, auditions can be tough. The purpose of showreels is to show that you are proficient and versatile, but auditions are geared towards being appropriate for a certain project. Usually it can take a considerable period to know a puppet, the recording technology, the studio etiquette, the story and so on, but when auditioning, the animator is often thrown in at the deep end and is judged on the few seconds produced. It is harsh, but even in those few seconds you can tell a lot about an animator. Auditions can reveal animators' strengths, whether they are comfortable with action, or character or humour. I will happily audition, but being asked recently to recommend any good animators rather bluntly put me in my place. I don't envy those who audition, but it is best to keep it clear, simple and controlled. Do not try to overreach yourself trying to show off. In a nutshell, let whatever you do read … this is my other mantra, I'm afraid. Like showreels, producers would rather see something simple done well and completed, rather than something complex done badly and unfinished.

Creative discipline

At one point in *Next*'s development, snippets of famous actors each saying a line of Shakespeare and cobbling that together into a typical speech seemed a good idea. Copyrights killed that.

Using local people for the same idea and 'inspiring' Shakespeare would have been in keeping with the rest of the *Lip Synch* series, but was too close to *Creature Comforts*. I even looked up the strolling players' cod Shakespeare speech in *Huckleberry Finn*, but not enough plays were quoted. I had wanted a lot of sets and mock Shakespearean backdrops, with homages to every production and actor I had seen and loved, but the budget forced me into a more disciplined creative direction. A tight budget does challenge me to be creative, so maybe a lavish budget would allow creative laziness.

With the one puppet I decided to go the whole way, and have Shakespeare perform the 'Complete Works' on an empty stage, a notion in keeping with Elizabethan theatre. Now that seemed to be an exciting challenge, to which I rose. A whole summer was spent reading the plays, finding common images and props that could be reused, making the film flow, while allowing for changes in pace and unpredictable dynamics. Nothing is deadlier than a film or a performance or a movement that happens at the same constant speed throughout.

With every frame counting, I made sure I segued from one play to another as smoothly as possible. I had drawn my favourite main images from a play, and images that Shakespeare could represent with different parts of his body. I laid these out, moving them around endlessly trying to find links, such as horses, crowns and murders. I tinkered with structuring the plays chronologically, but that wouldn't necessarily have flowed dramatically, and I needed to start small and end with a big finish. The final scenes of *Cymbeline* see a god arriving, dressed as a gold eagle amid thunder and lightning, allowing a memorable final image. (Incidentally, this scene contains a moment that could only have happened in stop motion. One of the wings got caught on the starburst, bending then springing back with a ping! I saw it happening and, rather than restart the thirty-second shot, I used it as a nice spontaneous moment.) So out went a chronological structure. I watched the film develop, moving away from my first intentions to somewhere shaped both by Shakespeare and by me. Scripts develop and evolve, and you have to let them. You aren't going to get the script right first time. Another fact is that once you have filmed something, only then do you begin to know what it was all about. Too late, of course, but it is always good to make a mental note to 'explore it more first!' Echoing the plots of many films, making a film (and writing a book) is a journey and your perspective on the subject is wildly different by the end. Let the script develop, but keep asking yourself whether this is *the* most interesting way to tell this story.

When making *Next*, MTV was in full swing with its quick-fire editing. This led me to want longer sustained shots, with Shakespeare himself controlling the rhythm of the film, and not the editing. I tried to run at least four or five plays together in one shot. I get a selfish rush from long shots, and hopefully the audience is aware of a different discipline from that of a short snappy shot, with greater fluidity; and you get to see the performance.

Hands and body language

Much of the inspiration for *Next* came from a stage piece by the great mime artist, Nola Rae. In an evening of Shakespeare-related pieces was *Handlet: Hamlet* told through her hands alone. A breathtakingly simple idea, executed with such imagination. Within the creative confines of a small Punch and Judy-type frame, Nola represented each of the characters with a different glove. Hamlet was a mean, tightly clenched black leather glove banging himself against the side of the frame; Gertrude was pink and fluffy; the players were as rainbow-coloured knitted gloves with bells; and so on. Just to confuse the issue, once you had accepted that Nola had only two hands, there would be three characters all apparently performing at the same time, although this was clever timing. The sublime moment was the gravedigger tossing spadefuls of earth into the audience while Laertes jumped into the grave and lifted up the wet, empty, white lace glove of Ophelia and wrung her dry. Drip, drip, drip. A hysterical gag, but a gag born out of the recognisable truth of the situation; saying something about the characters and playing on the convention of the gloves themselves. An absurd moment that was also embarrassingly touching.

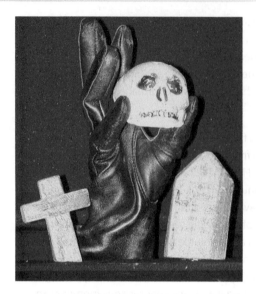

Nola Rae's brilliant *Handlet*, Hamlet told with gloves (courtesy of Nola Rae).

There is something very animatable about gloves, although maybe hands bringing hands to life is an odd idea I saw a beautiful film where a stop motion glove played the piano in an effort to bring a live-action couple together. So much expression can come from a glove; well, the hands. Most life forms seem to be constructed of a body with five limbs for locomotion (head, two arms/fins/wings and two legs, sometimes with a sixth, a tail, thrown in for good measure), of whatever degree and arrangement. A hand is merely a variation on this. Another film spoofs various film genres, from the western to the Hollywood musical, just using gloves.

Of many surreal moments in animation, one was watching *The Lion King* on Broadway, with Charles Addams' widow. We had been introduced by a film company wanting to take the *Addams Family* film franchise into a different direction after the death of Raul Julia. Animation was one possibility and I was asked to come up with any ideas. For me, the hand in the series was always one of the most interesting characters, as I loved the performance potential, with digital effects giving him a new mobility. Seeing the hand, I thought it would be quirky to base the film around its quest for the other hand. This quest could have easily led us through history with the ancestors of the Addams Family, giving an opportunity to reinvent great moments of history seen from the perspective of the hand. I managed to get the Addams Family in some strange places, but it culminated in a reworking of a Busby Berkeley routine performed just by hands and legs and other disconnected limbs. The twist was that the hand was only ever just one hand, with a moral about being content with what you are. He walked off into the sunset, hand in hand with another hand. I love animation – that you can write such sentences and they mean something. The film was never made, but it reinforced my belief that hands, along with eyes, are the most expressive of features, and in *Next* Shakespeare uses his hands constantly.

Entrances and exits

I had wanted Shakespeare to start the film by walking on, but that was too literal, apart from being time consuming, in both shooting time and too many seconds in an already short film. I love characters emerging into the light, much as lights go up on a screen, or a day begins. It's a good start, and a quick and dynamic way of

introducing the characters. Shakespeare, finding himself in the spotlight, is surprised. It could suggest that he has been summoned, perhaps against his will, immediately implying some pressure with this audition. Yes, it's theatrical, but it's economic, which is important when every frame counts. The first and last shots of films usually set the tone and stay in the mind. My films start not with credits but with some sort of significant revealing of the major character, usually through lighting. This confuses most projectionists, who tend to miss a few seconds, and every second counts. I am always keen to ease the audience into the film, much in the way that most experiences in the cinema or theatre begin with a moment of darkness. It's a way of crossing from the reality of sitting in the seat to the fake world on screen. That moment, usually a few seconds after 7.30, is the most exciting I know. It always has been. I get comfortable and challenge the piece to entertain me and let me in.

Against black, lights reveal Shakespeare in a frozen pose. Slowly he animates a bit at a time. In *Screen Play*, the Recitor is introduced onto an empty stage, coming to life off a screen. In *Rigoletto*, the Duke rises into an empty frame, wiping his mouth tellingly after another sordid encounter. In *Achilles*, the chorus emerges out of the darkness. In *Gilbert and Sullivan*, an illuminating moonbeam finds Carte asleep in bed, disturbing him. In *Hamilton Mattress*, the rising sun reveals the characters. In all the episodes of *Rupert Bear*, Rupert emerges out of a door.

A sunrise, always a strong beginning, from *Hamilton Mattress*.

Even books have a few pages of information in which to draw in the audience. An overture settles an audience into a musical evening, a convention telling the audience to come on the journey. In short animated films we don't have the luxury of long establishing shots, but we still need to orientate the audience as soon as possible. All major characters benefit from a build-up and a good introduction, an

entrance, however short. I don't always have substantial sets, so I tend to use light. As a character is revealed by the light, we're off.

The pacing of *Next* has enough pleasing highs and lows, while generally getting more frantic and inventive. Constructing the music with Stuart Gordon, the composer, we had set a mathematical beat. Each 'play' was worked out as a phase of 160 frames of eight counts, with the action held on the seventh, allowing a tableau. This could have led to a dull, constant rhythm but variations of musical colours and orchestrations surge towards the climax.

In my mind when writing *Next* was the Pressburger Powell classic, *A Matter of Life and Death*, where a character's life hangs in the balance while the jury makes the vital decision. The outsider judging and watching the main character is an unconscious theme in all my work. Maybe it's me seeking approval for my work being worth something. I wanted to give the film gravitas so that it wasn't just a series of gags, but this aspect was probably the weakest element. If I'd had the time, I would have developed this with other characters such as Leonardo and Mozart, waiting in the wings, ready to strut their stuff. This, though, would have meant an extra puppet. As it is, I rather shoehorned another element into an already crammed story, and the audiences don't need a throwaway twist at the end. It is clumsy, and I would love to reshoot the ending; I should have just left it as an audition. I needed a producer out in the auditorium providing necessary tension and the audience's perspective. The suggestion, though, of a long line of artists waiting to audition would have provided a satisfactory sting.

How was your first film? Did you structure it as you wanted or did you compromise? How was working in a team?

JD – Other than an ill-fated attempt to get funding for a puppet film of *The Firebird*, my first professional film attempts were in the live-action/animation genre. Although I got rave reviews for a feature screenplay I wrote and the budget that Karen and I put together (one completion-bonding company asked permission to use our budget as an example of how it should be done), the independent distributors were closing down faster than we could get submissions to them. The result is that the only dramatic live action of any length that I've directed is for a ten-minute 'trailer' for a proposed Sherlock Holmes adventure, *West of Kashmir*. Some of it actually came up to my expectations. What didn't was cut out – a luxury that one has when making a fictitious trailer.

I like some aspects of working with a team of people, but learned the hard way that my dream of making a film with friends was misguided, since they wanted more control and input than was possible on a film for which I was responsible to the backer, as well as to my own muse.

I find I have little patience with those who drain my energy by attempting to apply their attitudes to a project that is not of their devising. As an example, I told a production manager to 'please leave your attitude at home' when she challenged my attempt to include props she considered 'politically incorrect' (a bear rug, for example), which were entirely appropriate for our nineteenth century set.

TB – A friend of mine, Lance Soltys, is a cinematographer and shoots most of my projects. In '90, we conceived of a stop motion short called *No Exit?*, about a living skeleton's ill-fated attempt at escaping from a dungeon. We were both students (I a grad student in music and Lance an undergrad in cinema). We finished the film before we graduated college, but the animation was hurried, so it wasn't good. Right after college, around '92, we both moved to Chicago. That year I met and later married my late wife, Lily Klinger, and Lance and I resurrected *No Exit?* and made it again. It turned out rather well, and has screened at a number of film festivals in the US. The film was scripted and storyboarded rather extensively. I use storyboards as often as I can, in planning out the scenario visually. Lance and I work well together, bouncing ideas off each other, managing to do it in a way that neither ego is seriously bruised. One has to look at ideas objectively, which is difficult, especially if it's your own idea and you don't want to give it up, even if it isn't serving the best interest of the story.

RC – When I was hired at The Animators, I didn't have a lot to say about how things were done. What eighteen-year-old kid would? (Well, maybe Jim Danforth did.) After five years, I became a partner and also took over the animation for the studio. After fourteen years, I started my own studio in 1979. Finally I had the ability to control the decisions and have a major influence on the entire production. In my small studio, I generally do most, if not all of the animation, and often quite a bit of in-betweening. I did have staff or freelancers who also did in-betweening, inking and cel painting. For stop motion jobs, I machined the armatures, sculpted the puppets and animated them. I designed the effects work as well. For CG jobs, I again did all the animation myself, and did the modelling of the characters, with some help on props from assistants.

DC – Work experience – *Wallace and Gromit: A Close Shave*, 1995.

SB – My first film was meant to be forty-five seconds long. It was actually quite good to think of a simple idea that would tell a story in such a short space of time. I knew character would be important and that the end would probably be more important than the beginning or the middle (it had to lead to a punch line, not just fade out). I started by thinking of sketches or jokes, but they felt a bit empty. I felt it would have more impact if I had something to say, or was trying to explore an idea of some sort. I thought about how I was feeling and why I wanted to make a film. I remember I was feeling that working on series was like a factory line, all getting monotonous and that I wanted a film to reignite my passion for animation. That's how the film about two robot arms, bored with their job packing Christmas crackers, started.

JC – My first film was based on a true story I came across when researching a project on memories. One interviewee had met the Beatles on the set of *Help* and had dinner with them. She told me that she had changed her life because of something Barry Manilow had said in a concert. What initially seemed like an absurd story turned out to be an inspirational tale … far more interesting than my original idea.

DS – We've been lucky in that so much of our early professional work was headed by experienced producers who could give advice and make suggestions – *Conversation Pieces* with Colin Thomas and Bill Mather, for example, and even the early Channel 4 work had input from Paul Madden. And of course there were the early commercials (although they didn't arrive on the scene until we had done a few shorts for C4) where there was constant input from the agency creatives. We learnt a lot from those guys over the years.

Screen Play

The starting idea of *Screen Play*.

Visual storytelling

Screen Play was tricky to structure as it was, in effect, one long sustained shot, that once started could not be stopped. The rhythm and the dynamics had to be right first time, as they could not be helped by editing. Foolhardy, of course, but exciting. It seems that I was afraid to give any control to the editors, and maybe I was, but now I happily invite their essential collaboration. *Screen Play* was developed wanting to include all manner of different visual languages. As a child I adored transformation scenes in pantomimes and big musicals. They were more magical than anything I had seen on screen, as they were happening in front of me, contained in the box of the proscenium, and if *Screen Play* wasn't exactly about transformation scenes, it did need to flow from scene to scene without ever cutting, a constant thought in everything I do.

I wanted to treat the story as a memory piece but hadn't initially worked out how to separate the main character from his memories. A circle seemed appropriate, much as sumo wrestlers have a circle to contain their action, and also a reminder of the Willow Pattern plate. I gave myself the convention that anything outside the circle was a comment, and anything inside was happening in the reality, well memory, of the film. I cheated a bit, with the reality spilling out over the circle, but essentially it was a good convention, and helped to define the narrative. Whenever the narrator character crossed into the circle, he became a character, and didn't use the sign

language. This came from watching sign-language performers busily working at the side of the stage; observing but still performing. I find having dramatic conventions a good shorthand to help with clarity and storytelling.

Screen Play and its narrative defining circle.

As in *Next*, I didn't want to waste precious screen seconds by having the characters walk on and off the wide stage the whole time, so the moving screens allowed me to reveal a character instantly, wherever I wanted. As a painted screen slides by, the same character is revealed, as if stepping off a screen, a story coming to life, being animated. The whole film was about using many different means to tell a story, and as in *Next*, where I manipulated Shakespeare manipulating a puppet that in turn manipulated a puppet, here just as many levels are going on.

Working out the screens' movements took months of shifting bits of paper, coming up with surprising shapes and patterns, making the whole thing look as if it could happen on a stage, but then pushing it considerably further. There is a clear structure to the movement of the screens, starting with a simple slide across the stage and building to a complex use of the double revolve and all eight screens.

The layout of the revolving stage came after much fiddling about with simple cut-outs, and thanks to the mechanics of some propeller-makers, it was a superb piece of engineering, allowing me all manner of smooth transitions, hopefully echoing memories flowing from one to another. I love the way that the stage can do this so well, and how film uses camera moves to produce the same effect. The last section of *Screen Play* was an acknowledgement of a different way of telling stories, a much more cinematic way. In theatre, which has so many slightly different points

Montage of initial storyboards for *Screen Play.*

A detail of one of the scene-setting screens, illustrated by Barbara Biddulph.

of view, although all one basic wide shot, the director has to tell the audience where to look through composition, colour, design, music, performance, movement and stillness. On film, the camera can physically move from wide shot to close-up and is not contained by one general viewpoint. This leads to a totally different way of storytelling. My films lie somewhere in between.

Rigoletto

Musical storytelling

This piece follows the structure of the opera, with considerable liberties taken to allow for the half-hour length and a family-orientated television audience. Thankfully, no commercial breaks were required. Condensing the piece from over two hours to thirty minutes was not totally impossible. Much of the music went and the plot was simplified, but big chunks of the score had been written for the practicalities of performing in a theatre. We justified losing some of this music by telling the story filmically. There is music covering scene changes and intervals, music as entr'actes and music to give particular singers a break, which becomes redundant on film, let alone with puppets. Even so, I would have liked an hour to do the work justice. It's a complicated plot, and in condensing it I asked the audience to concentrate on every frame, as what I couldn't communicate in narrative, I tried to convey visually. Animation, particularly my animation, usually tries to tell complex stories that are probably too big for the time available, and that leads to some dense storytelling. There is a lot going on, which is both my films' strengths and their weaknesses.

Whereas Verdi had time to set up the debauched world and characters, I tried to show the hierarchy of the society instantly through the costumes, in particular the masks they wore. I tried to show literally who was above whom, by situating the whole film on a craggy mountain with the Duke lording it above everyone else and poor Rigoletto down in the depths. Colours and textures distinguished the two different worlds. The more that could be communicated visually the better, as editing Verdi is not as straightforward as saying 'I'll have two minutes of that,

A sheet from the music score and Rigoletto himself.

followed by thirty seconds of that'. Music, like good movement and gestures, depends on what precedes and follows, with the shape of the whole piece more important than individual notes. With *Rigoletto*, the music director and I broke the piece down into about twelve substantial, almost complete sections, but because the narrative had to race along, I couldn't allow a song that was traditionally a solo to be just about one character for three minutes. Other strands of the plot had to overlap. It's not hard to communicate several things at once in the same shot, as long as you tell the audience where to look. Adapting the music was a lengthy but hugely rewarding process. Well, it doesn't get better than Verdi. I'm ready to tackle a full-length opera now.

One reason for making this film was the chance to deal with some pretty heavy emotions, not usually associated with puppet animation. This meant focusing on the three main characters, giving them as much screen time as possible. Even so, I would have liked longer to explore their troubled stories.

Achilles

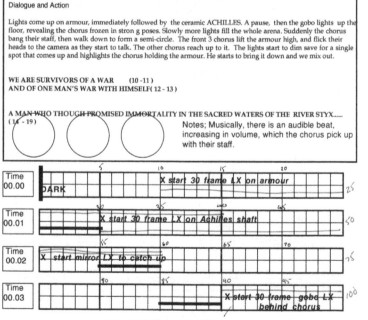

Scene; 1	Shot; 1	Length; 18" 15	Running total; 00.00 - 00.04	Page; 1

Dialogue and Action

Lights come up on armour, immediately followed by the ceramic ACHILLES. A pause, then the gobo lights up the floor, revealing the chorus frozen in strong poses. Slowly more lights fill the whole arena. Suddenly the chorus bang their staff, then walk down to form a semi-circle. The front 3 chorus lift the armour high, and flick their heads to the camera as they start to talk. The other chorus reach up to it. The lights start to dim save for a single spot that comes up and highlights the chorus holding the armour. He starts to bring it down and we mix out.

WE ARE SURVIVORS OF A WAR (10 -11)
AND OF ONE MAN'S WAR WITH HIMSELF(12 - 13)

A MAN WHO THOUGH PROMISED IMMORTALITY IN THE SACRED WATERS OF THE RIVER STYX......
(14 - 19)

Notes; Musically, there is an audible beat, increasing in volume, which the chorus pick up with their staff.

Time 00.00	DARK				X start 30 frame LX on armour				25
Time 00.01			X start 30 frame LX on Achilles shaft						50
Time 00.02	X start mirror LX to catch up								75
Time 00.03						X start 30 frame gobo LX behind chorus			100

ACHILLES

The first page of the *Achilles* storyboard and the same scene on film.

Stripping it back

The development of *Achilles* happened alongside the design; the two elements bounced off each other, hopefully provoking something interesting. As I usually do, I started with a visual image or a novel way to tell the story; in this case it was a Greek chorus telling a story. I then had to work out what to do with that image. I knew I wanted to do something with a large group of characters, and I had imagined all manner of wild and grand choreography and relentless energy, probably inspired by the Bolshoi Ballet's epic *Spartacus*.

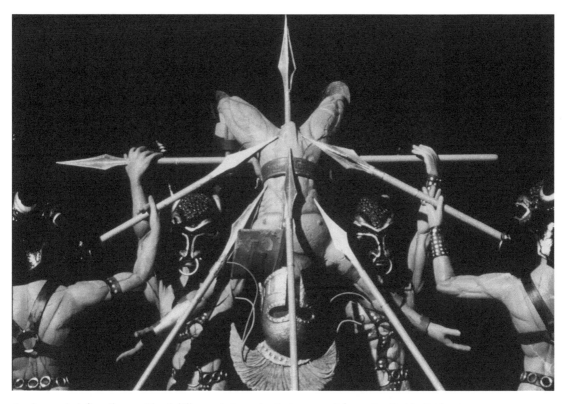

An image briefly glimpsed in *Achilles*, and shamelessly borrowed from the Bolshoi's *Spartacus*.

This may not be the best way to start, and I would probably encourage students to have something to say first, and then find an interesting way to say it. But I'm guilty of simply wanting to use a Greek chorus on a totally stripped back set. I had just finished filming *Rigoletto*, whose gorgeous and lavish sets and costumes got in the way of the animation. So with the next film, which turned out to be *Achilles*, I wanted to concentrate on the animation. A crumbling stone circle suspended in space seemed an appropriate image and fitted the Greek chorus idea perfectly. But what to do with the Greek chorus once I had got them onto this stone area?

Achilles, of all the films I have done, drifted off in all manner of unnecessary directions before finally coming into focus. My first idea was the story of Orpheus and Eurydice told with an interesting structure that allowed a lot of visual play-acting and the creation of different illusions. I wanted to tell Orpheus's story of rescuing Eurydice from Hades, but to stop as he starts to turn round to see

whether she has followed him, contrary to the condition of her survival. At that moment, the story would stop and out of the shadows arrived the chorus, who proceeded to act out six Greeks myths as cautionary tales, all involving characters looking where they should not have looked. Figures such as Acteon and Diana, Echo and Narcissus, Pandora, Priapus, Daphne and Apollo echoed the main plot, and would have been acted out around the frozen Orpheus, challenging him to make the right decision. As they fell back into the darkness, he would come alive again, only to make the wrong decision and lose Eurydice once more. This seemed an interesting structure, capturing the nature of a chorus, but a detailed treatment came in at about twenty-five minutes, and Channel 4 was giving me eleven.

The floor plan of the Greek theatre Epidaurus was the basis for the set of *Achilles*.

This caused a major and reluctant rethink, but I still wanted to play with a chorus, and was hesitant to move away from the other myths, some of which were excitingly visual and bizarre, and hadn't been done in animation before. The remit to produce something challenging, unique and thought provoking made the Orpheus story a bit too straight. I started to find something racier that could push a few animation boundaries. The confused sexuality of Achilles seemed perfect, but this was a complicated story, and one lacking any obvious animation opportunities. You can't mention Achilles and Patroclus without mentioning Paris, Helen, Hector, Agamemnon and other characters who offer parallels and historical background. To do this in eleven minutes seemed worrying. Before writing the script, I wondered how to focus on the relationship between Achilles and Patroclus without the others getting in the way. This intense physical relationship developed into the focus of the film, rather than any more Harryhausenesque aspects of the Greek myths. Intimacy had not really been treated seriously with puppets. Much as the stories of Paris and Helen are interesting, this film was not about them. Each film needs a personal perspective, and here the perspective is Achilles'.

 This is where the design solved a narrative problem and provided a pleasing visual. Other than the story of someone incapable of expressing love, and of someone who expressed too much, I wanted the film to use the conventions of Greek art and drama, much as I used certain Japanese conventions in *Screen Play*. Grateful of an excuse to research museums and books, it was obvious that the main representation of human figures was either beautiful pale statues or the glorious

black and terracotta vase paintings. These latter were more stylised than the majority of the cleanly elegant statues, which twisted and turned with so much sensual life that they were almost animated.

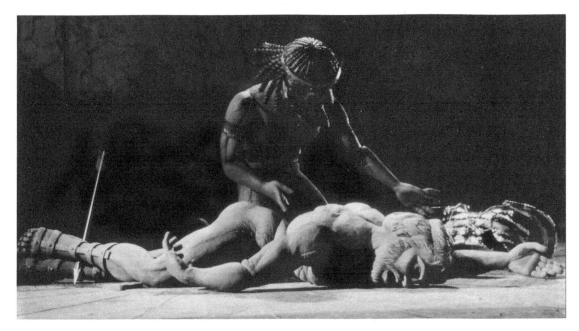

The dead Achilles and a chorus, showing the helpfully different colouring.

Here was how to separate Achilles and Patroclus from the rest of the characters, by contrasting them as more sculpturally realistic white statues against the darker and heavily theatrical terracotta coloured lovers, the Paris and Helen characters. True to Greek drama, there are usually only two characters on stage at a given moment, although often accompanied by the chorus. Suddenly, this was all falling into place. The story developed with the chorus playing the minor characters. Putting them in masks, again true to Greek drama, in effect, removed their eyes, and stopped the audience getting involved with these characters, thus throwing all the focus onto Achilles and Patroclus. A recent inventive production of *Twelfth Night* saw any characters that stepped off the acting area don a mask, allowing them to play instruments while watching the other actors. The mask distanced them from the action and also enabled them to position props without being 'seen' by the characters. An effective convention indeed.

The lack of colour made Achilles and Patroclus stand out from the crowd, and with their animatable eyes and mouths, we could suddenly see these characters thinking and could thus relate to them. I go on about the importance of eyes, and how just the smallest of movement can invest so much life, and here I was depending on that to carry the film.

Having found the visual idea of the film, I followed the structure of Greek drama, alternating scenes between the chorus and the main characters. As this was a piece about history, or rather myth, I was keen that the first image suggested this. Achilles' armour is a vital part of the myth, and became the first and last sight in the film. Initially, it seems to be about being a great soldier, but by the end of the film it is about armour protecting something far more vulnerable.

The *Achilles* puppets had cracks added into their skins and green weathering, reinforcing the idea that these are statues, not humans; although still people ask whether they are actors in make-up. One wide shot in particular, with Achilles on his back drinking, confuses people. I put this down not to great acting but to a credible pose. This film would have worked differently with actors, the nudity becoming an awkward distraction (nudity immediately separates the actor from the acting), but it might make an interesting dance piece – I wanted as much choreographed movement as possible.

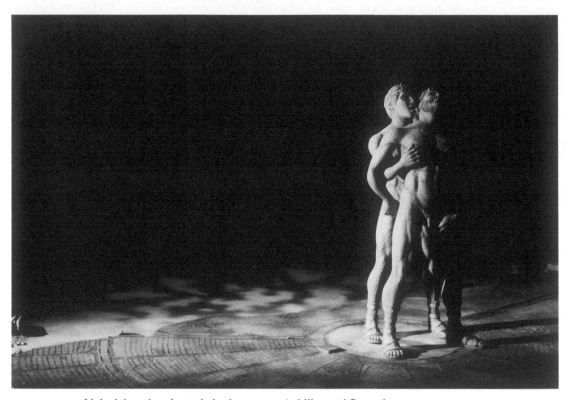

Naked, but they kept their shoes on – Achilles and Patroclus.

The sculpted sandals are there as a constant reminder, not only of the story's 'sword and sandal' nature, but also that a simple piece of clothing often has the effect of eroticising a naked body. We often found on *The Wind in the Willows* that the act of putting a scarf on a hedgehog suddenly made it undressed, especially next to the dressed main characters. A tricky area.

I had intended that every piece of clothing or prop would be an extension of the statue and would be painted and sculpted with just a hint of a colour long since worn away. Somewhere along the way I lost that, and the amazingly detailed clothes do not quite fit 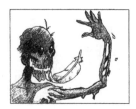 my original convention. Both Achilles and Patroclus' faces have a sculpted band around their heads. I had meant to brush this with gold, but in the whirl of preproduction I lost that detail as well.

The sculpting and texturing of the red figure vase painting characters manage to be both a three-dimensional figure and a reflection of their more graphic source.

Like the drawings on real vases, the muscles and details are drawn onto flat colour, but here we kept the drawn details and made the lines follow a deeply sculpted contour, rather than just being drawn. As they move, they catch the light and every subtle piece of sculpting is visible. The puppets for this film were finished in latex, for many reasons my preferred material. Model-makers prefer silicone for ease of maintenance and durability, but latex has a glorious and unexpected life, wrinkling and creasing as flesh does. When lit appropriately, this can be a great feature. Animators tend not to warm to the heavier silicone as nothing will stick to it, and it does have a memory, slowly creeping back a bit after a move but, as always, it is what is right for the project and budget. Silicon has a beautiful translucency that echoes real skin. When backlit, it has a gorgeous softness at the edges.

Gilbert and Sullivan

HERE'S A HOW - DE - DO!

A series of 5 x three minute animated films
written by Barry J C Purves
with Wyn Davies

- based on the works of Gilbert, Sullivan and D'Oyly Carte -

A BARE BOARDS FILM FOR CHANNEL FOUR

Concept drawings by Joe Holman, and an original title thought too obscure.

Words and music

There were many reasons for wanting to make this film, but to do something different with words and music was exciting. Since my university thesis on 'Gilbert and Sullivan in Performance', I have been campaigning for a rethink about these operas. It is ungrateful of me to criticise the D'Oyly Carte Company for continuing to preserve the original productions, as the operas may well not have survived

without such efforts, but right up until the 1980s there were some pretty stale productions. Amateur societies were even worse, doing copies of the Carte productions, which were already pale copies. The 1980s' English National Opera's legendary production of *Patience* had the glorious pairing of Derek Hammond Stroud and Sandra Dugdale as Bunthorne and Patience. This ignored any traditional stage directions and totally rethought it as a piece of living theatre. It was a dazzling production, lavish, fresh, hysterically funny and imaginatively staged, with music and words treated with real respect. Gilbert's words had resonances that had been lost through years of dusty touring productions. I can't believe that Gilbert, such a theatrical innovator in his time, would have been happy for his productions to stand still. I'm sure he would have whole-heartedly embraced new staging techniques and ideas (as long as they were his!). This lively production made me listen to the words afresh and marvel at just how sophisticated the lyrics are. There is no doubt that the words marry with the music so well, and naturally this collaboration has had a huge influence on music ever since. Rodgers and Hammerstein echoed the successful partnership, and George Stiles and Anthony Drewe look like carrying on that tradition, but other cases where the words have been so in tune with the music have often been penned by individuals, such as Cole Porter and Stephen Sondheim. This idea of a creative partnership led me to think about how Mr Gilbert and Mr Sullivan are believed to have been cold with each other: professional but cold. It struck me as an unlikely relationship, but I have been in similar professional relationships. Complicating matters with Gilbert and Sullivan was D'Oyly Carte keeping them together, somewhat against their will, but promising them success and wealth, and even building them a theatre for their operas.

A contemporary illustration of Gilbert and Sullivan.

How could they refuse that offer? So, begrudgingly, they kept churning out their comic masterpieces, and they are indeed masterpieces, especially *The Mikado*, whether you enjoy them or not. Both Gilbert and Sullivan continued to work separately, hoping to be remembered for their more artistic high-flown endeavours. Sadly, those works have faded, and the pair is remembered for their highly commercial pieces. Art versus commerce is one of the most common struggles for anyone in the arts today. I have faced that struggle and lost, but I've been pretty happy with the compromises most of the time. I was lucky to be spoilt in the 1990s by Channel 4 who, under the primary guidance of Paul Madden and Clare Kitson, were passionate about pushing the creative boundaries of animation. By the time I came to make *Gilbert and Sullivan* for them, things had changed drastically, and even a film about Gilbert and Sullivan, one of the most popular and visible icons of British culture, was seen as rather élitist, apparently even more so than Shakespeare.

Next had done well for me and had done something vaguely different. I was keen to make some sort of follow-up, and correct the faults I felt the Shakespeare film had. I was getting excited about the possibility of two puppets to work with, and the range of staging and acting potential that brought. My Shakespeare always looked rather lonely on stage, especially with a lifeless dummy for company (although, hang on, aren't they both technically lifeless?), and I wanted puppets to do some serious and intimate interacting with each other. I had envisaged a string of films looking behind various cultural icons. Gilbert and Sullivan seemed an obvious choice for a sequel, *Next Two* in fact. That seemed a totally appropriate pun of a title.

This was intended as a thirty-minute spectacular, with just the two of them, and structured after a typical opera, much in the way that Anna Russell (the singer behind the stunning vocal performance of the Witch in the 1950s' stop motion film *Hansel and Gretel*) sang her brilliant parody, *How to write your own Gilbert and Sullivan opera*. It was written as a lively and inventive piece, but I'm glad it didn't get made then, as the film was about the operas themselves rather than about the relationship between the two men, and their struggle with artistic compromise that the film eventually became. Cultural references in themselves are usually too self-indulgent, but when used to shed light or as a counterpoint to something else, they become much more dramatically interesting. Revisiting the idea nine years later, I was clearly having that artistic struggle myself, and had a much more experienced perspective about creativity and earning a living. I had also had more experience working brilliantly with people who perhaps I didn't necessarily socialise with, but with whom the working relationship was fantastic, and vice versa. This all boded well for a tuneful film about the frustration of working in the arts and relationships with other artists.

Channel 4 was quite keen on the idea, but rather than a big half-hour slot, they offered five three-minute slots on consecutive nights. I wasn't going to be precious about that, and snapped up the chance. Secretly, I worried about making what were in effect five separate short films, knowing that the audience may not see every film. This was going to have a huge impact on structure, but being rather obsessive about this I managed to turn it to my advantage. I like restrictions and I find they stimulate and inspire me.

I agreed to the series of short films, but asked that they could sometime show all five as one piece, talking myself into twice as many problems by trying to structure a series of three-minute films that were not only self-contained with their own theme, a suitable climax and a resolution, but could also play smoothly when

EPISODE ONE
- overtures -

D'Oyly Carte's sleep is disturbed by thoughts of his successful but troubled collaboration with Gilbert and Sullivan.

As Gilbert draws in his notebooks, Sullivan finds himself dressed as 'Little Buttercup'.

EPISODE TWO
- collaborations -

EPISODE THREE
- success -

EPISODE FOUR
- drama -

EPISODE FIVE
- finale -

Carte, Gilbert, and Sullivan dance a stately gavotte, wearing hats suggesting characters from the operas.

Carte, Gilbert, and Sullivan toast to their new wealth and glamourous lifestyles.

Carte, Gilbert, and Sullivan dance wildly, after the success of 'The Mikado'.

Carte, Gilbert, and Sullivan row furiously with each other about the merits of their work.

Gilbert writes a letter to Sullivan, acknowledging his respect for Sullivan and his work.

Carte, Gilbert, and Sullivan make an unlikely trio of little maids.

Carte, Gilbert, and Sullivan take a bow after another successful first night.

To Gilbert's great resentment, Sullivan is knighted by Queen Victoria.

Sullivan is furious to be playing yet another middle aged woman; this time the queen of the Fairies from Iolanthe.

Sullivan, dressed as Jack Point, suffers a heart attack.

As D'Oyly Carte finally wakes from his dream, he wonders whether his collaboration with Gilbert and Sullivan will be remembered.

Montage of the five episodes of *Gilbert and Sullivan*.

strung together. The five-act structure worked surprisingly well, and I started to think of five sections based on musical terms and themes: Overture (for introducing the characters to us and to each other), Harmony (where things were going well), Counterpoint (where differences of opinions were starting), Discord (where things started to fall to pieces spectacularly) and, finally, the Finale (where there was some sort of resolution and all the pieces tied together). All in all a pleasingly neat structure, which I might not have considered had I been allowed to do what I wanted. It is always good to be open to things developing; a painful process but usually productive. It is tough opening up to other people's opinions, especially when they aren't close to the project. You learn that although they have different ideas, the ideas are not necessarily for the worse – they are often better than yours!

Once I had found this structure, I knew the flavour and tone of each film. Wyn Davies, the musical director, and I made a decision, in keeping with the dreamlike quality I had imposed onto the film, that the songs should be sung by the voice Sullivan had written them for. Fifteen minutes of, otherwise, just male voices would not have been true to Gilbert and Sullivan. This led to Gilbert singing in soprano one moment, and when the song called for it, singing as a bass. This seemed perfectly reasonable and logical to me, although the film has been criticised for this. It gave us freedom to use a balance of songs, structured not just to reflect the scope of Gilbert and Sullivan, but also to help the drama.

No story of Gilbert and Sullivan can ignore the involvement of the more pragmatic D'Oyly Carte, who was responsible for bringing the two men together. Taking a cue from an opera, *Iolanthe*, I had Carte's sleep interrupted by his conscience. I used one of the moments in *Ruddigore*, where a character is visited by the ghosts of his ancestors, to have Carte visited by the shades of Gilbert and Sullivan (although Carte in reality did not outlive them both), giving him cause to reflect on the merits of his having brought the two men together and releasing those unstoppable tunes on the public. This easily enabled me to be free of any literal staging, and to have a different styling for Gilbert and Sullivan themselves, putting them apart from Carte. This freedom was a necessary justification for the surreal mayhem and cross-dressing role-playing that followed. Gilbert and Sullivan being dead throughout the film added certain poignancy, and echoed the ghosts giving Scrooge his new appreciation for life. Again, I'm grateful to Channel 4 for imposing this structure.

In this scheme of things, the characters having different voices fitted quite nicely. The cross-dressing is there, incidentally, not as a cheap laugh, but also as a visual suggestion of how low Sullivan thought he was sinking. He was far from happy when Gilbert had three male characters don female identities in *Princess Ida*. This he thought cheap and very beneath him.

The added pressure of working on three-minute chunks was that the music and words were even more difficult to edit. A fifteen-minute piece would have allowed for some considerable chunks of music, and let me cram in many different examples of songs but three minutes is tight and precise.

Wyn was familiar not just with Gilbert and Sullivan, but with music editing. We had worked together previously to edit Verdi's epic *Rigoletto* into a thirty-minute piece, and strove to ensure that we were true to the spirit of the Gilbert and Sullivan operas. Probably one of the happiest periods in my career was sitting next to Wyn at the piano, trying to segue one piece of music smoothly into the next,

while juggling keys and rhymes. Music cannot just be edited into random, tiny pieces fitting a neat three-minute structure, as this could produce unfinished rhymes and unbalanced use of the voices. Our primary edit of the music score came in at something like twenty-five minutes instead of fifteen, and somewhere there is a tape of Wyn and me singing our way through it. I am a man of a thousand notes, all of them the same. Shame, as I love singing so much. Still, I learnt a lot in these sessions.

Steven Pimlott, me and Wyn Davies at a screening of *Gilbert and Sullivan*.

We made a demo tape, with five singers and a piano, making sure that there was a clear narrative and that every note had some contribution. Channel 4 seemed happy with it, only asking for a couple of cuts and changes, and one personal request for a much-loved piece. The score was orchestrated for sixteen players, which is smaller than Sullivan would have liked, but more than he gets on some small-scale professional productions these days. We didn't want to jazz up Sullivan's music, but we made sure that there was enough colour and rhythm to help the animation. Nor did we want to sound like an impoverished orchestra, so a banjo and a glass xylophone crept into the orchestrations, giving the pieces a fresh but joyously quirky feel. We had assembled a wonderful cast, and working with such performers is why I love this job. We had Sandra Dugdale, the legendary and influential 'Patience'. Christopher Gillet sings with many opera companies, and Roland Wood and Anna Burford were fresh from the Royal Northern College of Music. Our final singer was the theatre, musicals and opera director Steven Pimlott, who happens to be a great comic performer. Sadly, he died in 2007, but I'm pleased I had the chance to work with him. When I phoned him to invite him on board he was out at the theatre: not one of the great opera houses he worked at; rather, he was playing in the orchestra of an amateur production of *The Pirates of Penzance*. Here's a man who loved his Gilbert and Sullivan, and I was thrilled and very flattered to have had him on board. This animation lark has brought me into contact with some hugely exciting people.

The look of Gilbert and Sullivan

This film is the first where I've pushed the physical shapes and all important silhouettes of the different characters. I liked the absurdity of Gilbert being

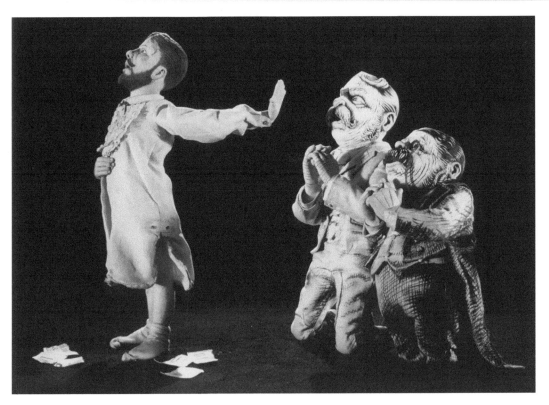

Messrs Gilbert, Carte and Sullivan from *Gilbert and Sullivan — The Very Models.*

immensely tall, and imperiously looking down on the immensely short Sullivan, with Carte stuck in the middle. It was a cheap visual trick to highlight their obvious differences, as well as acknowledging something of how they were in real life. We did a lot of research looking at contemporary illustrations, especially the engravings. With these figures in Carte's imagination, the black-and-white engravings seemed the right way to go. Finding the equivalent of this graphic nature in a texture in the sculpting was challenging for the puppet-makers, but the puppets are some of the most beautiful I have worked with. Because of the pronounced scale differences Gilbert ended up at about fifteen inches, which is taller than normal and meant chunkier joints, but he was a joy to work with. The costumes also had to have a graphic illustrative feel to them and we tried to give them a dark side and a light side, hoping that this would ultimately correspond with the subsequent practical lighting. It didn't, but we tried. Having the main costumes and characters as black and white meant that we had to be careful with the lighting so that they did not burn out. The other big problem with monochrome costumes and skin was keeping them clean, as we only had one set of puppets and costumes, and there was seldom a shot that they were not in. They got dirtier as the film progressed. I'm not comfortable with wearing gloves; not many animators are. I need to connect physically with the puppet, which sounds horribly pretentious, but true. The heights and proportions of the puppet naturally suggested various gags. It is enormously satisfying when design and storytelling become one.

In the end, I was enormously pleased with the structure of the film, although inevitably, the more you become familiar with a subject, the more you discover. After filming, I came across an account of their first meeting, where Mr Gilbert showed his indifference to music and musicians by saying something along the lines of 'I know of but two pieces of music, Mr Sullivan. One is "God Save the Queen", and the other is not'. It is a suitably pithy, beautifully structured comment, and I wished I had been able to use it at the beginning of my film, as it would have set up the discord in the relationship from the start. As it stands, Gilbert just seems tetchy. Oh, the joy of hindsight.

Different Techniques

Brian Cosgrove's drawing celebrating diversity.

It's a given that I prefer to work with puppets, and I structure the film around their strengths and abilities, but puppets are not the only way to go with stop motion. Most of us enjoy stop motion because we like touching something, but there are many different techniques, each one affecting the narrative and how you film.

Replacement puppets

Mostly my films have been about beautifully articulated puppets, and I'm not sure the films would have worked in another technique. I have never warmed to replacing rigid puppets with puppets

in a new position, or even just replacing a head with a differently sculpted shape. Although the results can be staggering, there isn't much fun in the actual animation process. This is purely selfish as the audience doesn't need to know about technique. In general, the fun and decisions are to be had in the preproduction stage by the director, designer and the model-makers, when the various replacements are sculpted. This leaves rather little spontaneity in the actual shooting. The performance has, for the most part, already been created by the time the animator arrives, but it's impressive to see, for example, faces and limbs repeatedly stretching and distorting in ways that no armatures could allow. Replacements permit easy repetition of mechanical movements, or choreography of massed ranks of puppets all perfectly synchronised. Cycles are perfect for replacement animation. You could even mix replacements of a cycle of a horse trotting, but with a fully armatured puppet riding it. The substituting of one previously sculpted puppet for one in a different position is probably quite tedious and labour intensive, but then we should remember that this is for the audience, not for us, and it's the end results that matter. George Pal and his great Puppetoons use this technique in many films to great effect. He made dozens of commercials with hundreds of soldiers, machine parts or less figurative characters marching about in unison; you can understand how the process of animation is speeded up by replacing a pair of legs sculpted in the extreme pose with a pair of legs in the closed position, or just replacing the whole figure with a slightly different one. Some of the facial expressions he managed with his characters are amazingly fluid and full of character, but I would have felt cheated as an animator, as there wouldn't have been much I could have brought to the performance. You're rather stuck with what has been sculpted, and to some extent the animator's skill is excluded and reduced to something mechanical. Also, there is not the one single puppet, and the relationship between puppet and puppeteer is diluted. Replacements do not allow for those telling spontaneous movements, or for that ever so subtle easing in and out of a movement that only a human hand can do. George Pal didn't just limit himself to the replacement technique, and it's definitely worth looking at the sequences he directed in *The Wonderful World of the Brothers Grimm*. There's a sustained stop motion dragon sequence, involving a live actor, with some impressive animation, mixed with some full-scale model work. An equally long sequence with some rather hyper elves cobbling real shoes has the elves as leathery as the shoes they are fixing. Both sequences are hampered by some annoyingly inappropriate 'cartoon' sound effects. But do find the lovely throwaway shot when Russ Tamblyn discards some drugged wine into a plant pot. The plant, beautifully animated by Jim Danforth, has a wonderfully melodramatic swoon worthy of any diva.

Was your first film meticulously planned, and were you already impatient for your second film? Did you base the film on something else or was it entirely original? Did any of your favourite themes start to appear?

JD – *Venture into Space* was an all-miniature film, probably an outgrowth of the various George Pal films, like *Destination Moon*. *Snag of Time* was meant to be taken seriously. It derived from the dinosaur genre, with a sequence in which a fellow gets gored by a triceratops, as in *Lost Continent*. I became aware of that similarity only recently when writing about it for my memoir. We shot part of the film in the Los Angeles county arboretum – the same location used for many Tarzan films. I was a 'promoter' even in those days and talked the administrators into letting us film there at no cost. The film existed until just a few years ago, but I've been unable to find it. I've one or two stills. The film was somewhat inventive in that it involved time travel, which I don't believe had been done filmically at that time (1956). I probably got that idea from Dr Wunmug's time machine in the *Alley Oop* comic strip. I used the same basic idea,

particularly the race to the pick-up point, in my *Timegate* feature project, which got financed and partially filmed in 1977. No, I wasn't ready to move into another film before finishing *Snag of Time*. Slightly later I started work on the *20,000 Leagues* project.

TB – I got as far as a few key drawings and a thirty-minute script, until I realised that thirty minutes wasn't going to be enough. I finished a wire-armatured Jesus puppet as well, but didn't shoot anything. As I realised how much I had bitten off, I got discouraged and disbanded the idea, moving on to more manageable ideas. I have no stills from my work in high school. I never thought of archiving at the time, though I remember my mother telling me I should. How right she was. I'm still attracted to the idea of selfless, sacrificial love (such as the story of Calvary), and like using those themes in my work today. When I realised I wasn't going to be able to complete an overambitious project, I simply moved on. I always stayed busy writing stories and making puppets, and of course animating.

KD – I planned a lot; the film was based on my neighbour's dog called 'Crackers' and he was hilarious, but he was bored senseless being in the house all day. I remembered I wanted silence in the house, just the dog. My tutor, Joe King, said 'it's more silent to have a quiet ticking clock than just silence'. I've always remembered that! Yes, other themes reoccur which revolve somehow around death!

DC – I shot three minutes of super eight to use up the film. Not much planning, but it still exists and the stills were of better exposure and focus than the movie.

SB – The first film was a disaster, but it got us interested and wanting to learn more. I got to meet Mark Baker who kindly lent me a copy of his *The Hill Farm* and he photocopied Bob Godfrey's *Do it Yourself Animation Book*. I now had a guide of how to do animation (even if it was 2D), but I didn't have my own camera.

TD – We planned it all; it was entirely our idea. We shot it all in our dorm studio. Living there made shooting our first film possible. Among other facilities, our dorm had a common room that had been converted into a shooting studio, which we used. If we were doing something other than that, if we were trying to explore meaningful themes I don't think we would have finished. There just wasn't time for that kind of love and reflection. I was happy doing the physical process of animation, which was (and is) still strangely numinous for me.

RH – *Back to the Drawing Board* took a song from three musical films, with scripted scenes tying them together. Although the songs were restaged, the whole film was entirely my own idea. For its opening titles I used music by Leroy Anderson, whose music I later used in my first animated film, *The Typewriter*.

JC – I'm not sure my early work was ever a spoof or homage. I was influenced by the humour of Paul Dreissen. A later work, *Gary Glitter Changed my Life*, did have a stylistic homage to *Paddington*. I used 2D cut-out crowds in a concert scene, keeping the main character 3D. I wanted to produce films that were funny, intelligent and accessible to people – not too 'arty farty'. There are themes reoccurring in my work, for example the look or style. Though mainly derived from the need to keep things simple and cheap to construct it is also a look I like – a theatrical set on a plain background.

DS – The two first films were *Godzilla* and *Trash* (or is it the other way around?) Both used cut-outs and chalk and yes the first inspired us to do the other, equally formless!

It's interesting to see the photos of Pal at work, with his immaculately dressed animators wearing laboratory coats, significantly looking more like technicians than animators. I can't begin to think of the coordination and planning such shoots must have taken, but for the animators it can't have been much fun. Although they were still touching the puppets, they weren't getting that all-important and satisfactory tactile pleasure of feeling the puppets actually move. I'm all in favour of good armatures that allow the animator to choose a size of movement that feels right at that instant. Whenever I've worked with replacements, there never seems to be the shape or position that I want. Again, for me, it's all about trying to keep a feeling of spontaneity, but then, for some of the massed ranks of Pal's characters the very important effect was the lack of this spontaneity. With a producer's hat briefly (a hat that doesn't fit me), it would terrify me to have to build a replacement puppet, however simple, and only use it for a few frames.

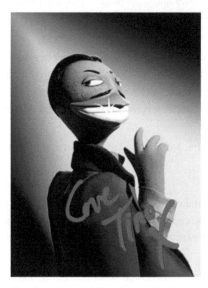

The lugubrious Tino from *Hamilton Mattress*, whose mouth was a series of replacements.

The more satisfying use of replacements is when they are just an element of the puppet, such as in *Creature Comforts, The Nightmare Before Christmas, James and the Giant Peach*, Tino in *Hamilton Mattress* and many other films. There's usually a fully articulated main puppet which allows the necessary range of performance, but with a mouth, or even a whole face that is replaceable by other pieces, giving extreme shapes that an internal armature might not manage. This all depends on the director and how much emphasis he wants to put on the mouth and facial performance. The areas next to the sets are littered with well-labelled boxes of replacement mouth shapes or eyebrows. Making replacements tests the skills of the puppet makers, as the joins have to be carefully hidden or disguised as part of the design. They must fit perfectly as otherwise there will be unpleasant twitching. For the animator the actual replacing of the bits can be fiddly. The replacements are usually held in position by a combination of rods and magnets, but sometimes, in the middle of a shot, the puppet may be in such a position in the set that there is little room to pull off the face. A lot of planning has to go into working with replacements, which is why I like fully armatured puppets. I would prefer to do the storytelling with the body rather than the face.

Armatured puppets suit the style of animation and the detailed performance I try to achieve. It may not be realistic, but it allows me to be elegant, detailed, complex, florid and subtle.

The characters from Henry Selick's *James and the Giant Peach*, many of which featured replaceable elements in their faces (Saemi Takahashi).

Do you aim to produce lifelike and realistic animation, or do you like to push it stylistically while still remaining credible?

JD – That depends on the genre. I tried to make my creatures lifelike, avoiding the hyperdramatic approach of Ray Harryhausen. Not that Ray's approach wasn't gloriously powerful, but he'd already gone down that road.

TB – It depends on the story. For my recent project, *The Labyrinth*, I'm going with realistic puppets and lifelike animation, because I perceive the story as a tragedy. If I were animating a cartoony-type film that's being shot on twos, then naturally, the approach would be different. Style is important to me, but the style is generally dictated by the story. Would a *Chicken Run* story work for a stop motion version of *Othello*? Probably not, but it might be interesting to make a *Chicken Run* version of *Othello*. Who knows? Imagine a chicken version of Desdemona being killed by a rooster Othello. The mind boggles.

RC – I haven't had broad stuff that would allow me to do something more exaggerated and be appropriate.

DC – I like to push my acting and to tackle new challenges, but I generally work on projects that have an existing style and I have to adhere to that for continuity reasons.

SB – I don't think it has to be lifelike, just full of life. A lot of it is down to timing.

RH – I never see the point of making things too lifelike. Animation is a medium of its own, needing good reasons for not producing it in live action. I aim to achieve a balance between soft, natural movements and quirky, snappy poses that read.

JC – It's never been my aim to produce the most realistic animation possible. If that's your goal then live action filming will do it better. I've wanted to produce characters that are alive but that have their own sense of reality and timing … to create strange and new people and places.

Replacements can give the energy of a drawn film with exaggerated squash and stretch, but usually there are signs that give away substitutions and replacements. I watched an episode of *Chorlton and the Wheelies* recently that I had worked on, where Chorlton the dragon lost his spots and they migrated to the other characters. That's easy to write in the script but as these other characters had faces that were removed and replaced by a different expression, this meant trying to match up the exact placing of the stick-on spots. That they didn't match gave more random movement in the face than necessary.

The charming and mischievous *Pingu* is for the most part animated with replacements, and the on-screen effect looks pretty spontaneous, but I can't imagine it being much fun to animate. The performance element is rather limited to the choice of which beak to put on. For all that though, the results are charming.

Pixilation

Here's a fascinating technique, saving the building of puppets and miniature sets, which can be done with the most limited of resources. Often, as in the films of Norman Maclaren, human actors are animated frame by frame in real sets or locations, doing impossible things such as sliding around the floor without walking, then disappearing through walls, or changing costume instantly. Buster Keaton and Georges Méliès flirted with this technique. It was really a special effect using an animation technique, but more recently there have been astonishing uses of pixilation with films like *The Secret Adventures of Tom Thumb*, where human actors have been animated interacting intimately with animated puppets, in this instance a miniature clay figure. The results are gloriously disturbing, but a lot depends on the skill of the human performers to sustain their physically draining poses. With the Aardman series *Angry Kid*, various techniques all came together for something unique. Real actors were used wearing masks that were changed for different expressions or lip-sync. This determined that the actors would be pixilated with the masks changed every few frames. This calls for a lot of planning, especially with the masks, but the effect is pretty extraordinary.

I was involved with the groundbreaking *Manchester Evening News* commercial for Aardman, where the uniquely talented Nick Upton sat in a chair while his environment was pixilated behind him. The shoot took over three weeks and saw him being dunked in a swimming pool, placed in a football ground and sat under Jodrell Bank telescope dish, while it was animated behind him: surely the largest thing ever to be animated. This remarkable commercial would probably be done with computers today and would definitely lose some of its charm.

Eadweard Muybridge

I was asked to reconstruct a Muybridge sequence of a naked man running. The original Muybridge used a series of several dozen cameras parallel to the action, all triggered step by step by a tripwire or other means as the athlete ran by. For this shoot, we had just

one camera, locked in a fixed viewpoint. As the athlete ran across the studio, the parallax changed as he progressed through the shot, first favouring his front then his rear. The producers were hoping, as many animation students have done, to put this into a loop, but the changing perspective made nonsense of that. This surprised the producers, so I suggested physically animating the man standing on the spot, giving the impression that he was moving, which would have at least

Muybridge figure running (Steve Boot).

echoed Muybridge's set-up and kept the perspective constant. I knew my walk cycles well enough and the man seemed contented to be physically manhandled. I kept talking about the strong key poses in a walk cycle, asking him to emphasise the storytelling moment of a walk when the front leg is stretched with the weight on the heel, and the back leg is starting to peel off. This honed athlete was a hurdler, used to doing everything at great speed, and the idea of working out what his body was doing at a given split moment quite alien to him. He was not able to coordinate himself under these conditions. I'm the opposite these days. I'm so conscious of what shapes my body should be making to express a movement that I don't think I can do anything spontaneously. As a live performer I have lost all the coordination that I can do so well as an animator.

The punchline with the naked athlete was that animating him just didn't work, so we tried filming both at high speed and at slow speed, but the rushes showed both a slow walk with an inappropriately mobile set of genitals and then the opposite. It was an important lesson in getting the balance between the effort of an action and the effect; that, or don't attempt to animate naked bodies. Photographic reproductions of Muybridge won out in the end. Having extra cameras would have worked, or at least a camera that tracked precisely with the figure, as would have animating with a puppet. Once again it's about choosing the right technique for the subject. Muybridge, in so many ways, knew what he was talking about, and his photos of figures and animals in action are still a fascinating, invaluable and essential part of any animator's background. Like many great icons, his images have been overused these days, and probably lost their innovative freshness, but do try to look at them with open eyes. They are quite startling.

Cross-over techniques

Plenty of areas of animation cannot be defined as pure model animation, but combine the textural pleasures of puppet work with the painterly and drawn feel of traditional two-dimensional animation. The American artist Joan Gratz works with clay to combine her passions of painting and animation. Her animated clay paintings, in such films as the Academy Award-winning *Mona Lisa Descending a Staircase*, 1992, have the beauty and subtlety of paintings, but their added texture, shadow and movement give them an extraordinary life and we see the images with new eyes. It is this texture that draws so many of us to dimensional animation. There may not be such an infinite range of colours, or maybe there is, but you don't have to worry about the paint drying or splashing, and the physical act of pushing the clay around and blending must be hugely satisfying. The great sadness about such a work as *Mona Lisa Descending a Staircase* is while every frame is a glorious work of art, the technique demands that each image is altered or destroyed before the next frame. This is like moving a puppet forward to the next frame. There is no way to go back, and the work is about getting the image onto film. Once captured, the real craft is discarded. With drawn animation, the drawings exist long after the film is completed. With Joan Gratz's films all that is left is some jumbled-up clay and some guide images. With puppet films, all that is left is some decaying puppets. Maybe part of the appeal is about a single, never to be repeated moment being captured on film.

Joan Gratz and some of the images for her clay-painted film *Mona Lisa Descending a Staircase* (and an award that nearly was …).

The puppets used in my films are rotting in the *National Museum of Film, Photography and Television*. Their skin's drying out, becoming crunchy and showing the mechanics underneath. Around their feet gathers a small amount of dust that was once flesh. Their glass eyes still sparkle undimmed, but the rest is fading away. At some expense, a new skin could be cast and repainted, but that would be

cheating. Although a puppet can be reskinned during a shoot, reskinning a puppet outside the film is different. It's not the same puppet that had life breathed into it and was captured on film.

Cut-outs

Another technique that marries various forms of animation but still revels in the tactility of dimension is cut-out animation. When I joined Cosgrove Hall I did a lot of cut-out work for Thames TV's *Rainbow* that featured animating paper cut-outs. This was basic, but getting expression out of simple lines and shapes was tremendous experience and a great exercise. Finding it fiddly, I have huge respect for such artists as Lotte Reiniger and Michel Ocelot, whose films have used paper cut-outs in different ways. Reiniger used delicate jointed cut-outs silhouetted against a bright background, often using different levels at the same time, creating enormous depth. Michel Ocelot's early films used equally delicate white paper cut-outs lit from the front against darker or coloured backgrounds. Both artists' work is incredibly beautiful, and like working with puppets, they exist in a dimensional space, but once the frame is taken, that moment is gone. Working with hands, or with tweezers, the process has to be incredibly precise. I found it hard to isolate a movement without accidentally moving the whole character. I'm not sure I had the right thickness of card, as the characters were usually curling up under the lights, giving distorted shapes and unnecessary shadows. I didn't master an effective jointing system. As with puppets, there is the dilemma of needing the characters to move smoothly and freely, but also having them stay rock solid when you are moving other parts. Yuri Norstein has taken these skills to sublime levels. It is hard when watching such films as the poignant and evocative *Tale of Tales* and *Hedgehog in the Fog* to work out exactly what techniques are going on. There are cut-outs involved on many different levels, giving some lovely soft-focus effects, and there are many layers of mist and fog, giving a lyrical softness. The animation is exquisite and delicate, and the film full of surprising textures.

Such techniques give a film a unique quality. There is depth to them, but the fact that the puppets can usually only move from side to side (running a character to camera would be tricky, but not impossible) provides a graphic feel as well. One of the joys of tabletop puppets is their ability to move in space so freely.

My favourite scene – Anthony Farquhar Smith

I attended a presentation by the Russian animator Yuri Norstein. I was new to his work and was treated to several exclusive extracts from the film he was working on at the time.

Norstein's world is one of ephemeral beauty. It is an intricate, multilayered tactile world. When you look at it you feel you can reach into the screen and touch the roughness of its inhabitants. If the scene were sunlit you would feel the warmth of its rays, or if it were windy then you would experience the breeze.

Two sequences I remember vividly. In the first a leathery old man, bundled up against the weather, traverses the snowy streets of an anonymous town. In the second the same man sits at a candlelit table in a cold room and sets about composing a letter. Even out of context from the rest of the film I felt drawn into these short scenes by the realism of their rendering. The half-light glow of the snowy street, the old man's movements impeded by the cold and the depth of the scene from the falling snow to the fronting

of the buildings to the half-glimpsed alleys between them. At the table the stark, flickery warmth of the candle contrasted strongly with the old man's shaky movements as he prepared a quill and drew a blanket around his shoulders.

Part of the magic of these scenes lay in not quite being able to figure out how they were achieved. With a conventional cartoon you know it comes primarily from drawings, with stop motion from the manipulation of puppets. But with Norstein there is a quality that is intangible, a combination of several intricate methods that unite in an extraordinarily lifelike way.

We were lucky enough to be given a practical demonstration through the use of an overhead projector. Norstein laid textured shapes of paper down, an abstract collage of unconnected pieces. He pushed them around until suddenly, almost miraculously, the head and shoulders of the old man appeared. We were shown a photograph of his studio where every surface was covered with these tiny elements, thousands of them. By meticulous lighting and camera work these fragments become characters, buildings, firelight and the weather. One of the last questions from the audience was whether he had a system to categorise them, by writing reference numbers on their backs or something similar. He replied, a little indignantly, 'No, of course I don't. Do you think I am mad?'

My favourite scene – Jessica Koppe

I love Lotte Reiniger's *The Adventures of Prince Achmed*, the first animated feature film from 1926. It's a silhouette film without sound effects or dialogue. The music was played by an orchestra originally. The music gives the rhythm to the storyline and the action takes a subordinate role to the rhythm. It doesn't need perfect, fluid movement, but it always needs rhythm. Animation is always some kind of dancing.

And these scissor-cut puppets dance! They move in a totally theatrical way, every gesture is clear and leaves no space for speculation. Props and backgrounds fit perfectly to the puppets and the *Tales of Arabian Nights*.

The most impressive scenes are when Achmed comes to the country of Wak Wak, the demon's land. There he meets their queen Pari Banu at the Magic Lake and falls in love with her. The reflections on the water surface are completely made of animated black cardboard because Reiniger's team had less special effects.

In animation everything is possible. I could tell every story I want to. There is only one requirement to be fulfilled: the viewer has to believe that my story could be real. And that's why it needs a good animator who has to become the characters he's animating.

In my opinion, telling stories is one of our most important cultural skills. People have always told stories and they always will. I can tell a story with words, with pictures, with music or any kind of art. But the sum of all I'll find in animation films, it is tradition and innovation at the same time.

Lotte Reiniger's *The Adventures of Prince Achmed* (Jessica Koppe).

Tadanari Okamoto's *The Magic Fox* uses figures of painted papier mâché.

Sand

Working with sand or salt needs the same painstaking precision and the same loss of the actual artwork, but the results are beautiful. I'm not sure whether animators actually touch the material as fingers are too clumsy and clunky, which must slightly take away from the pleasure of feeling the material. Pushing sand and salt around with brushes may not be the same. Every time I see an exquisite sand animated film I can't help fearing what a disaster a sneeze might be. I like the way that sand can be placed on translucent screens and lit from underneath, making a silhouetted texture. The effect can be reversed so the sand is pale against a dark background. Often sand has been featured to great effect (especially in the two great films, Co Hoederman's *Sandcastle* and Tyron Montgomery and Thomas Stellmach's *Quest*) alongside articulated puppets that look as though they've been formed from sand.

Tyron Montgomery and Thomas Stellmach's *Quest,* whose sole character, although armatured, resembles sand (Aaron Wood).

Claymation

I'm in awe of animators who work with clay and Plasticine, as apart from needing the skill of animating, they have the extra skill of sculpting. My skill in sculpting is pretty non-existent, and I was deterred at school after managing to sculpt two pretty impressive pieces. One was a dinosaur, which looking back is rather odd for me. I worked for days on the texture with the end of a biro pen, getting every little scale and wart. I can't deny there was some satisfaction from such painstaking

detail, and the act of smoothing it out with water was pleasantly tactile. It was a triceratops and I had found a suitably lively pose suggestive of a beast in motion. Being about ten inches in length, it was perfect for animation. The other piece was a larger than life size human hand, again caught in some action. Years later when I saw Trnka's masterpiece *The Hand* (which mixed an exquisite puppet with a large clay and sometimes real hand) I had a sense of déjà vu, as I had unknowingly built a similar story around this hand. Like the triceratops, there was a week's work put into the texture, suggesting veins and fingernails, and trying to find the right pose. The night they both went into the kiln together, I could hardly sleep, desperate to see the hours of work come to fruition. Come to dust actually: as the exploded pieces lay ruined so did any thoughts of ever working with clay again. I gave up frighteningly easily.

It's a shame, as I enjoy the transformations possible with claymation, and the rawness of it, but in this instance I would lack the patience for the sculpting. In the lengthy period of resculpting and smoothing out I would probably lose my sense of movement and performance, so it amazes to see so much performance out of Wallace and Gromit, and in such lively films as Will Vinton's tour de force *The Great Cognito*, in which a single head and shoulders transforms into many of the major figures from World War II. In many respects I like shooting ten or more seconds a day as I can tangibly experience the performance. I'm not sure I could at one or two seconds a day. How claymation animators ever time a gag over such an extended period is beyond me.

Apart from the labour-intensive work involved, I would miss the texture of rich and lavish costumes and wrinkles in the skin, although looking at Wallace and Gromit this never seems to be a problem, as the sets are so lavishly textured and tactile. The contradiction between all the steel and rivets and bricks of West Wallaby Street and the smoothness of Gromit's skin and Wallace's chunky pullovers just shouldn't work, seeming to belong in different films, but it does. Maybe it's this contrast that gives them their charm. The other thing I would miss through working with clay is a certain elegance of the sculpting and the movement, but then again Wallace and Gromit are hardly static. I respond to the finesse and delicacy that finely engineered puppets give, especially in long legs and arms and fine fingers. Claymation is particularly good for overemphasising the facial expressions and squashing and stretching, and I'm not sure that's how I think as an animator. I'm probably far tighter and controlled, which is not always a good thing. I don't always try for realistic movement, and love a florid performance, but I'm uncomfortable with stretch and squash in a physical puppet as I feel it destroys the credibility I've tried to set up. I would rather suggest the weight and inertia through the performance than through distorting a puppet.

Most claymation, probably owing to the sheer time constraints and labour, is shot in double frames, which works for most people, but personally, I love single frame, and would be happier shooting fifty frames for a second. That would give me the detail and complexity of movement I would like to achieve, but it would be pretty impossible to shoot the required amount each day. I find that when I'm totally absorbed in a shot, I get into a quick routine of move–check–click–move–check–click. There are some actions where fifty frames a second would be a waste of effort, but then there are many movements, like Ratty playing the piano in *The Wind in the Willows*, that would benefit from this number of frames. As it was, there were just not enough frames available to reproduce the exact movement, but then the suggested movement

I found was better. I have a feeling that if a lot of claymation were shot in single frames, the boil on the surface, which is a considerable part of the charm, might be too manic. The feeling is that doubles work for some situations, and singles for others. Much of it is due to budgets. I would, though, encourage colleges to teach singles as the norm, showing the subtlety and richness that is possible before making the personal decision to work in doubles.

Do you prefer shooting in singles or doubles? Is this a personal artistic choice or due to budgets and schedules?

JD – For *Dave and Goliath* we shot on 'twos'. Otherwise I never shoot on twos unless the move inaccuracies exceed the desired increment.

TB – I prefer singles. I think it looks nicer and is easier on the eye. Doubles works well for cartoony-type animation, but if I want to shoot realistic animation, then ones is the way to go.

KD – University it was always on doubles. I would love a go at singles!

RC – Singles for stop motion. Doubles for traditional, except for fast motion, which needs the additional information for the brain … and also during panning shots. There is a place for doubles in stop motion but depends on whether the style, as well as the size of the puppets permits it or warrants it. For especially slow movements, sometimes you can't put in any more increments because of the size of the model, so you have no choice but to resort to twos. If it's married to live action, it needs to be on ones.

DC – I have mainly worked at Aardman where the style is doubles, but we use singles if the character is moving fast or the camera is moving. Sometimes we move the camera or the puppet while the camera takes a frame to produce a blurred effect giving a more realistic (motion blur) result. The new popular digital equipment has yet to cope with this magic filmic quality. (Although post-effects can produce a fake version that often suffices?) There is definitely a place for doubles and it wins Oscars!! ✕4!!!

AW – I prefer ones. But for slow movements, twos.

SB – There's room for both.

KP – Depends what I'm animating. Doubles makes it easier and faster, and sometimes it looks better, but eye movements always look better on singles. I've always preferred shooting on singles because I've grown so accustomed to it. A lot of high-quality animation is shot on doubles, and some (like Tom and Jerry) are shot on a mixture of the two. There is always a place for doubles, providing it's the right circumstances and the right show for it. The eye seems to be able to adjust to both mixed in 2D animation, but only one or the other in stop motion. This is something to do with the realism of stop motion, and that the eye 'wishes' for things to run smoothly.

JC – I've only recently started shooting on twos, on projects like *Koala Brothers*, *Creature Comforts USA* and *Shaun the Sheep*. I prefer twos. You can be more subtle and they allow you the time to get the performance right. There are times when shooting on singles is essential – to stop strobing for example.

FL – with my brief experience, I can't tell what I 'prefer'; but I do everything in ones. I enjoy animating and want to learn to do it well, so I don't see any reason yet for me wanting to shoot in twos. Just to do it faster? I want to make it for a long time!

With what little actual animation I've done with clay, there is no denying the pleasure of getting one's hands dirty. It doesn't get much more tactile than this and the response of the puppet moving is immediate. I think that the relationship between the puppet and the puppeteer is even more confusing here as the creations are so transitory and almost all of them will be thrown away. With my way too emotional attachments to the puppets, I would find this difficult. Either that or I would be totally emotionally detached from the puppet as I would be hard pressed to shake off the knowledge that this puppet is just one of many variations. There just is no original, or is everyone original? As Mr Gilbert would say, 'When everyone is somebodee, then no one's anybody!'

Adam Elliot

In contrast to the sophistication, detail and lavish production values of the Aardman claymation films is Adam Elliot, who uses clay in a different but equally brilliant way. In anyone else's hands, his three short films, *Uncle* (1996), *Cousin* (1998) and *Brother* (1999), and his epic, Academy Award-winning *Harvie Krumpet* (2003), would look so basic and economical that one would be hard pushed to call them animated films. But with Adam behind the film, he manages to turn a single blink of his usually damaged characters into a complex expression, and perhaps *Harvie* is the nearest to tragedy I have seen with stop motion. Ignoring most animators' urge to move everything in every frame, Adam's characters stand and stare, a lot, while fate deals some rough cards. Whether this lack of motion started out as a deliberate choice or whether it evolved from limited resources I don't know, but this utter economy is a brilliant trademark. Every little gesture is timed to perfection. I love the way that the clay puppets are deliberately rough, with Adam finding creative ways to avoid walking a puppet. These characters exist in simple cardboard sets with no pretension to realism. These production values are accessible to most animators, but what sets Adam's characters apart is their dignity and innocence, even as they suffer. Most of his characters have been tragically scarred or brushed aside, and are usually unaware of their lot. With brilliantly droll narration and an emphasis on understatement these characters convey genuine emotion. It's a testament to dazzling film-making, and a good lesson, that less is very much more. The ideas and the characters are strong and the animation conveys no more than it needs to, which is a lot. Catch *Harvie Krumpet* to see how to time a shot and develop a story. Not a single frame is wasted or indulgent. Oh, if only I could manage that skill! The simplicity of the technique perfectly complements the charm of the characters.

A masterly touch in *Harvie Krumpet* is the use of music. After all Harvie has suffered, some explosively joyous Respighi over the credits releases both Harvie and the audience, celebrating the power of a good story told with real warmth and imagination. I eagerly await his forthcoming feature film.

Adam seems to have a lot of acting in his early background, and that stop motion wasn't his first intention, but came about when other things didn't happen. I'm envious that Australia has embraced and nurtured Adam's talent, and acknowledged this quirky thing called animation as something to be enormously proud of, not something to be embarrassed or faintly irritated by. That films so obviously devoid of talking animals and product placement, and about much darker, difficult subjects can be made is definite cause for hope.

Harvie Krumpet, Adam Elliot's heartbreaking film, with Harvie made out of clay (Saemi Takahashi).

Adam Elliot

I have to admit, I've never been a big fan of animation. *My God*, you're all shrieking! *Blasphemy*! How can an Oscar (TM) winner for animation dare say such a thing? Well I could lie and say how Sjankmayer, Harryhausen and Park have truly inspired and rocked my world since I was a foetus. I confess; they have not. I admire, respect and acknowledge all of their wonderful films and will always speak highly of their work, but for me, becoming an animator was never a dream and quite truly an accident. I'd always been creative; drawing since birth and making deformed objects from egg cartons and pipe cleaners. But though the big strange adults around me marvelled at my artistic flair, it was just a pastime and an excuse not to play football or any other kind of dull and enforced exercise.

I dreamt of becoming a vet and gathered around me as many sick and sorry animals as I could capture. I'd administer my own medicine and invented treatments, and regrettably did more harm than good. I poured seed down a maimed sparrow's throat hoping to nourish and feed its twisted wing back to health. Sadly, my premature mind had no idea that the seeds needed to be husked first and the poor bewildered creature choked to death. I've always felt guilty about the many defenceless animals I put to death precipitately, and as some sort of homage and recompense, have honoured them in all my films.

To help fund my way to university, I was also a keen entrepreneur, devising many unique but flawed ways to make money. Aged six, I jumped on the 'pet rock' bandwagon and made a tray of my own mutant pebble friends with stick on eyes that resembled people from the dark end of a mental asylum. While other kids sat out the front of their homes spruiking lukewarm, unwashed, hand-squeezed lemonade, I set up shop on the curb with a card table and sign; 'Adam's Pet Roks – 25 sents eech'. By lunchtime I should've sold out and been on my way to fame fortune and the owner of the biggest veterinary clinic Australia had ever seen. Disappointingly, I only sold one pet rock, to my next-door neighbour, Mr Stewart, who was dying of emphysema and felt more sorry for me than I did for him. He pointed out that we lived in a court and that foot traffic would always be slow and perhaps I should go and play on the freeway where there were more customers. Anyway, I digress. My burning desire to be a vet did not waiver even into my adolescence. What did waiver, however, was my skill at maths and science; key subjects needed to study medicine. Sadly, the left side of my brain, according to the latest pop psychology books, was 'defunct' and not firing on all cylinders, while the right side and 'creative' part of my head was bursting with fecund activity. I was doomed to become an artist and unsurprisingly in my final year of high school, didn't receive the grades to get me to college. I stumbled into the real world with no idea how I would survive; all I could do was draw. I remembered my days as a pet rock entrepreneur and wondered if I should set up shop again. Perhaps I could sell something more appealing this time. It was then I started down a career path revolving around tee-shirts. I set up a stall at the famous outdoor St Kilda Esplanade Craft Market where for the next five years I sold over five-thousand shirts, all individually hand painted with little strange cartoons. My most popular design was 'Murray the Tap Dancing Dim Sim' (a type of Asian dumpling). It was a great lifestyle; I only had to work a few days a week and the money was abundant! However, after five years and thousands of Murrays, I got bored. Was this it? Was this my life? Was this as good as it was ever going to get? I looked at the man next to me, Neville, who sold handmade coffee tables. Nev had been down at the market for 25 years and looked windburnt, downtrodden and bored to the point of suicide. It was then and there I decided to leave. Where would I go, what would I do? I had no idea. At that stage all my friends were graduating from university. I felt left behind and 'stupid'. I was twenty-five and had zero qualifications.

I decided it was time to study again, so I visited all the universities in Melbourne. The choices offered were soon narrowed down and the only courses I'd a remote chance of getting into were in the fine arts. I thought I might become a purist and devote my life to portrait painting, marble sculpture or abstract Japanese printmaking. I visited the Victorian College of the Arts Film School and stumbled across their animation department and realised here was a course especially designed for me. My pet rock making skills and Murray tee-shirts must surely impress the entrance assessors; how hard could it be? I enthusiastically applied and patiently sat by the phone for weeks waiting to receive my acceptance call. Sadly, my naivety was strong and I was totally ignorant of the fact that the VCA film school was one of the most competitive and prestigious schools in the country. They only accepted eight students a year and I sadly was not one of them. I looked for another course and discovered a picture frame-making class at the council for adult education. This was a much easier course to get into! You just paid $150 and for two nights a week over two months learnt how to frame your own pictures. I'm a keen amateur photographer and thought I would buy a little picture frame-making shop! They accepted me eagerly and the evening I got ready to head off to my first class, the phone rang. It was the film school administrator telling me it was my lucky day and that one of the eight successful students had decided to drop out of the course. They had a waiting list and even though I didn't have the required skills, they thought I had *potential*! Did I still want to become an animator, she asked? I was gobsmacked and shaking. I told her I was excited but was not sure I would get my $50 deposit back from the picture frame-making course. She persuaded me and the rest is history.

I look back concurring how a pivotal moment can change a person's life. What if I had have done the picture frame course? What if that anonymous person did not drop out of the top eight? What if I'd stayed down the market selling Murrays? I know for one thing; I would not have an Academy Award sitting on my shelf. I am happy and content nowadays as an animator and have thoroughly enjoyed the thousands of hours I've been locked in my studio moving blobs of Plasticine in almost microscopic increments. I've been lucky that all my films have been warmly received and cared for. They are my children and I'm always humbled at how much the public enjoys and embraces them. I hope to make many more claymated films, but if there comes a time when they no longer work and audiences shun them and my career as an animator is over, I can always think about becoming a vet again. Either that or go back to selling mutant pet rocks.

Personal approaches

The Brothers Quay

No technique is written as a hard and fast rule, and animators such as the Brothers Quay manage to bridge a huge variety of techniques, often combining rough puppets with organic and found materials. I'm in awe of these brothers, Timothy and Stephen, and especially of their

career. They have managed to escape being pigeonholed as merely animators, bringing their unique sensibilities to operas, film, ballets and the theatre. I applaud the producers that have the vision to see that the brothers' skill can be applied to any medium. Their work is highly visual, and every frame resonates with echoes and allusions to all manner of less mainstream cultural sources. I admire their utter bravery in going against what is seen as commercial and traditional, and they have pushed what is capable with stop motion. More often than not, narrative plays

only a small part in the films, where the key elements are atmosphere, lighting, music, texture and design. Their work bears great similarities to dance, where ideas are explored and juggled with. I get the impression their work grows as they develop it, and should they find something like a beautifully textured antique watch, it might be incorporated immediately into their current project. You look at some of the objects in their films and wonder how they thought to put them together, but don't they work well? There is a feeling of spontaneity, yet carefully thought through randomness in their films, and a disconcerting atmosphere in everything they do. Shadows play an important part, and touch on fears that we never quite know what lurks in the dark when our back is turned. The films are shot making great use of focus, picking out the texture in a pile of dust and making it look beautiful and significant, or the focus being sharp on a screw twisting up out of a floorboard, giving an inanimate object such presence, even a character. Their films celebrate all that is great about stop motion, and it is hard to think that the brothers could be satisfied in working in any other form of animation. I'm not sure a computer would let them revel in such a variety of textures and light and shade. The puppets that wander disorientated through their amazing environments seem to be cobbled together from found objects, often bringing with them echoes of previous lives. Disfigured dolls and real puppets figure largely, as if discarded patients from some terrible experiments. Look at the beautiful, but disturbing *Street of Crocodiles* (1986), to see the epitome of what makes the Brothers Quay so disconcerting and haunting. It seems that the making and shooting of the film is an experience in itself, an exciting event where possibly the film leads them as much as they lead the film. I doubt that they think of what they do as a job.

Apart from the dazzling artistic merits of their work, one of the main achievements of the Quays, in stop motion terms, has been in getting emotion and expression out of the most abstract and unnaturalistic of objects. Evoking a reaction from the audience with a discarded object scuttling across the floor is a testament to what animation can do best and shows that we don't always need realistic and identifiable replicas of humans or animals to have interesting characters.

It is probably futile to try to find answers in their films, and this appeals to me. Not everything is explained, and the viewer's imagination is made to confront the breathtaking visuals. The films, like the museums and cabinets of curiosities that influence a lot of the work, are full of suggestions of disturbed childhoods, savage politics, skewed perspectives, repression and torture, and crammed with literary, artistic and musical references to mainly European figures, such as the painter Arcimboldo, the anatomist Honore, the writer Franz Kafka, and the writer and artist Bruno Schulz. I admire their ability to namecheck and develop work around these artists, especially when told that my film about Gilbert and Sullivan was too esoteric. I have wondered about this, and perhaps the fact that my puppets were quite literal, and that there was a conventional narrative going on, made the film look as if it was commercial, bringing with it commercial expectations that perhaps Gilbert and Sullivan could not sustain. Maybe Gilbert and Sullivan are just not interesting enough.

Linking Gilbert and Sullivan to Timothy and Stephen Quay is an important element of a third party. In Gilbert and Sullivan's case this was Richard D'Oyly Carte, and with the Quays it is the producer Keith Griffiths. This seems to have been an enormously successful collaboration and a staggeringly prolific one, and highlights the importance for all creative people to have a solid producer; I have not sustained such a relationship, and I appear to have drifted and lost my

way. Nor have I secured an agent or a management company. Agents make life easier, and are the first to hear of any new films being planned. There were times years ago when I got caught up with several commercials at once, each changing dates on a daily basis, and all getting grumpy when I had to turn someone down. That's when an agent would have been great. They're also better at opening doors to interested parties who might otherwise shut the door to a giddy director clutching his latest project.

I owe the Brothers Quay a huge debt, as their film *Leon Janacek – Intimate Excursions* introduced me to the music of the Czech composer Janacek. I have explored and loved the music as a result, and it has become an ambition to film his opera *The Cunning Little Vixen* using puppets. It has been animated as a cartoon, but the slight drawings and basic animation couldn't manage to complement the richness and energy of the score. The story is complex and full of sexual imagery, violence and rebirth, and to reduce it to a tale of cute singing animals is to reduce it too much.

Outside animation and film, the Quays have given me some great nights at the theatre, their designs for Opera North's *Love of Three Oranges* being a particular favourite.

Jan Svankmajer

In the same breath as the Brothers Quay one has to talk about the prolific Jan Svankmajer, although he needs a whole book to himself. Like the Quays, Svankmajer has been challenging the conventions of stop motion for decades. He has a background in theatre, and this shows in his use of music and masks, and a real joy in theatrical presentation. He revels in getting an interior life out of objects and materials, ranging from real organs such as liver, to food and clay, often mixing live-action actors with animation. If it can move, Svankmajer will move it. His work contains bleak messages and strong political ideas, and a lot of scenes with animating offal are uncomfortable to watch, but I sit through every film, astonished at the imagination and the output, and how the most ordinary object can be used to express something. Stop motion is the perfect medium here, as its inherent roughness gives the appropriate edge to the work. The films are so much about textures and contrasting textures, and the sheer physicality of putting a cow's tongue in a small theatrical set, that I can't imagine these strong images working in any other medium. The audience knows that is a real tongue animating, and the feeling of revulsion wouldn't work if it was a computer-generated tongue, however well animated it was.

My favourite Svankmajer film, and the most succinct and tightly structured, is *Dark, Light, Dark*, in which various clay organs and limbs gather themselves into a small room, bare except for a suspended lightbulb. As other limbs join, they try to assemble themselves, going through some frightening and hysterical combinations. Among the clay, a real tongue joins. I can only imagine the discomfort of animating such an object under hot sweaty lights, but that's why

we do it. If we didn't want to enjoy the direct, tactile process, we would use other methods. Slowly, all the limbs find their right positions, and a huge naked figure sits contorted and cramped into a tiny space, like a fully grown foetus, waiting for whatever happens next. A stunning film, with all manner of messages to be read into it, not least ideas about the creation of life and animation itself. When I last spent time with Jan, he was on a quest round Buenos Aires for an armadillo shell. Animators!

Images from Svankmajer's films
(Paul Flannery).

Christine Edzard/Sands Films

In the 1980s the wonderful designer Christine Edzard made a few films that contained elements of stop frame. What was refreshing about these films was not so much the rather rudimentary animation, but the sheer beauty of the design. What a film for Channel 4 based on the *Emperor's Nightingale* lacked in narrative finesse and animation, it made up for in breathtaking sets and costumes. At the centre of this film is a finely detailed pagoda, and puppets and costumes that look as if they were made out of lead. Even more beautiful was *Tales from a Flying Trunk*, loosely based on several Hans Andersen stories. One featured animated kitchen utensils, but the climax featured the vegetables of Covent Garden staging a ballet to prevent the Opera House from closing … ah, the gloriously strange world of animation. There were numerous scenes of real vegetables doing ballet classes and rehearsals, but you could see the vegetables visibly wilting between frames. This was amusingly effective as three long sticks of celery wilted while doing exercises at the barre, but for the most part the wilting was, not unsurprisingly, uncontrolled and juddery. Come the day of the performance, and as the vegetables leapt on stage, they were replaced by Royal Ballet dancers in some of the most sumptuous, ravishing and witty costumes I have ever seen. The dancers, in their vegetable costumes, caught the essence of cauliflowers, peas and tomatoes far more than the real, clumsy vegetables. Three willowy dancers with beautifully dyed floaty fabric and leafy hats perfectly captured the tallness and uprightness of the celery sticks, and moved in a way that real celery couldn't, but suggested a way that celery might move if it could. Against the elegant movement of the Royal Ballet dancers, the animation looked considerably ropey.

New combinations and techniques are being developed for puppets each day, so it's essential that you work out what is the most appropriate technique, for the film and for the budget. Don't assume that the only way to tell a story is with hugely

complicated armatured puppets. Conversely, if you are looking for subtlety and richness, you're unlikely to find that with basic puppets, but watch Jason Wishnow's remarkably lavish and surprising effective version of the *Oedipus* myth, told entirely with vegetables. This is not the first film to work with vegetables (Svankmajer's films often reference Arcimboldo's vegetable portraits), but it's testament that if you are good enough you can get a complex emotional performance out of anything, even potatoes.

Two characters from Jason Wishnow's epic *Oedipus*.

Jason Wishnow

Once in a while, immediately following a screening of *Oedipus*, someone from the audience will ask, 'Was that all computer animation?' So I explain: No, if you set out to make *Oedipus* with vegetables, you need to use farm fresh produce, and stop motion is the only way to go. Not that I've anything against CG, we used it for a few scene enhancements, but we set out to capture as much of the story in-camera as possible. There's a uniquely handmade texture that only comes from building Ancient Thebes from the ground up. The rough edges are integral to its charm.

I didn't come from a traditional animation background. Every new project I take on tends to be dramatically different than what came before, in both style and content. For the uninitiated, like me, stop motion was a process shrouded in mystery. When I began production, I had never heard of armatures,

dope sheets, or the difference between shooting on ones or twos. I thought the entire process would take two months, not two years, and never would have believed it would require one-hundred pairs of hands. Fortunately, the crew was divided between seasoned visual effects veterans, and … the rest of us. This isn't meant to suggest that we came at it as a bunch of blind amateurs, everyone involved was wildly overqualified in their respective fields, but we certainly were dilettantes reinventing the concept of playing with our food. And we all learned from each other.

Film-making is always about happy accidents. In retrospect, the laborious trial and error we applied to the early stages of production directly led to creating some of our more unique and meaningful results. I've never been a fan of using technology for technology's sake, but I do like making complicated processes seem transparent, and part of that fun is finding the perfect tools to tell any given story or scene. We probably were the first stop motion production to shoot entirely with digital still cameras and output to 35 mm Cinemascope. At that time, 2002–2004, everyone experimenting with digital stills seemed to fall into each other's company, so I met some incredible people whose work I had admired since childhood.

I rejected conventions that might have made our process easier or faster; for example, I insisted that the characters wear clothes … made of cloth woven fine enough that the fabric wouldn't look like a rattan chair on the big screen (a pet peeve of mine). So we dressed our vegetables in silk, which looks beautiful but flutters to the touch and requires the most delicate hand to animate. We lost so many shots at first because the potato's robes kept wiggling out of control.

I foolishly assumed that characters with vegetables for heads would be easier to animate, especially without eyes or lips to tweak from frame to frame. What I found out, however, was that we had to devote a lot more attention to the nuances of any given gesture. I knew I was on the right track when I brought my parents a few shots from the fight scene. One of the greatest compliments I received on the film came from my father, that night, when he said, 'You can really see what the broccoli is thinking'. It's out of character for him to comment on subtleties like that.

The end result was always meant to feel as grand and cinematic as possible, complete with all the clichés of the genre, and I think we achieved that. For everyone involved, it never once felt like we were simply making a cartoon, rather, we were producing a legitimate Hollywood epic, only on a tiny scale … with cauliflower.

Preparation

The teams behind *Rigoletto* (Manchester, 1993) and *Hamilton Mattress* (Bristol, 2001).

Storyboards, animatics, previz

These are probably the most essential tool in the whole process of stop-frame animation. The temptation for many artists, and especially students, is to make a work of art, running riot with fancy, accompanied by beautifully shaded drawings, extreme camera angles and actions that are totally unpractical, but look amazing. They're probably more useful as concept drawings, giving a director a flavour of the scene. Storyboards need to be more grounded.

In reality and practice a storyboard is where the film is made and directed, with any problems being anticipated in advance. Nowadays, dependent on budget, the storyboard can develop into animatics and previz, essentially animated storyboards. Animatics usually consist of still drawings cut to appropriate lengths, or at least they may contain some basic moving imagery. Previz, done on a computer, are more a tool to show the director what is possible in terms of angles and staging a sequence. The artist provides a general staging of a scene with simplistic characters being blocked through a simulation of the scene with roughly corresponding geography. A director can move the virtual camera around, looking for interesting angles, making decisions about close-up and wide shots.

The film I have eventually made has matched the original storyboard nearly 100% … OK, 90%. Budgets and schedules, and not having the luxury of reshoots meant that essentially the film was directed on paper. The board contained all necessary information about props, camera angles, costumes, action, and so on, and I have stuck to that. After the film was shot it was assembled pretty much as the storyboard, as there was little alternative footage. Shooting on digital now gives the option, at the press of a button, to instantly flip a shot, crop it more tightly, extend a shot or condense it. We can run back a part of the frame while the other part runs forward. We can transfer characters from one scene to another. The whole process of editing has been transformed from the laborious, although rather evocative, process of literally cutting, splicing and juggling thousands of strips of film. Rearranging a sequence was pretty complicated, and inevitably it meant resynching the dialogue. If it didn't work, it was as laborious a process to change it back. Today we have the luxury of being able to tinker with and manipulate a sequence easily, going back to the original instantly. There's so much more creativity in the editing, as there is more choice. It's the part of the process that I used to hate, as the mistakes were there and could not be changed. I now love the postproduction process; the mistakes are still there but they can be corrected, and the good parts fine-tuned.

Knowing that there is this safety net might allow us to be a bit more relaxed or careless with the storyboard, and in the shooting, assuming there is a magic button in the edit suite called 'fix it in post'. There isn't. A detailed, comprehensive storyboard is still the backbone to the whole production. Editing gives the production its creative polish and finesse.

Storyboards should be drawn taking into consideration all the geography of the sets, the proportions of the puppets, any particular quirks of the director and the lenses that are available. The director has done a camera script in advance, breaking down the approved script into close-ups and long shots, making detailed notes about the staging, choreography and character motivations, suggesting camera moves and effects. The voice recording may happen after the boarding, and an actor might have delivered a scene more quickly than anticipated, making the six drawings/shots allocated to that scene look now too fussy. The board needs to

be adjusted, and if the plotted action flowed and everything fitted like a jigsaw, you'll have to make substantial changes as the jigsaw pieces will no longer fit.

Ideally, it's good to have the artist around for the whole boarding process, so that frames can be redrawn. This is seldom economic or practical, so I prefer to have my boards drawn with one page representing just one shot. It is essential that a board can be flexible. A drawing showing the start of the shot and, if there's been significant movement, one at the end helps. One page a shot speeds up deforestation (and takes up a lot of wall space), but hopefully it saves resources elsewhere, and electronic boards make life easier. I'm fussy about which shots go next to each other and for weeks I play with the sequence of shots, taking drawings out or moving them around, until I'm satisfied that the whole piece flows. Editing should be practically invisible, with shots following each other naturally and unnoticed, and this only comes from much work on the storyboard. With multiple panels I find it hard to rearrange things, and this leads to crossing out and confusion, with shots ending up numbered 120 B, part 2 (there is no 119!). The artist has to be especially careful with stop motion, where the puppets do not necessarily have the squash and stretch of his drawings. Too often clients or producers see a particularly lively board with a character at full stretch and are disappointed when the puppet doesn't replicate that pose. Likewise, a board is just one drawing for several seconds of film, and it takes some imagination from the same clients to translate drawings into moving puppets.

I try for the ideal timing, sometimes hoping for long, sustained shots, but the practical process of shooting stop motion can conspire against this. The sheer mechanics needed to keep animators constantly shooting means that sometimes an hour left of studio time does not allow for a lengthy shot, so a short shot has to be found, even if it means dividing an originally longer shot. Likewise, a long shot that was shooting all day and which now looks unlikely to be finished has to have a small close-up inserted to cover any potential light change. It's inadvisable to leave stop-frame shots overnight, as so much can go wrong. The sheer heat and cooling down of the lights makes sets expand and contract, however well they're made. Puppets can also move around owing to temperature changes or from being left in awkward positions with the skin under tension. Often, the animator is in a different frame of mind in the morning from the previous evening, and it's surprising how this can affect the animation. Like the animator himself, morning animation can be lively, unhurried and detailed. After a hot, sweaty, smelly day animation is invariably rushed. I look at my own animation and know when a shot was filmed. Shots evolve for numerous reasons, and this has all manner of repercussions with the board, so storyboards need to be versatile …

The development from storyboards to animatics and now animated previz allows the director to move the camera around a virtual set, looking for the right angle, before committing to expensive studio time. This throws up a million options, sometimes too many. Having done previz for other directors I found it hard to keep the staging to a general world view, as I'm itching to tell the story using precise set-ups. I'm used to tight schedules making me try to be focused and get things right first time. I tend to stage specifically for a given camera position rather than let the camera sit there recording. Similarly, with computer graphics (CG) animation you can move the camera round an animating character to see it moving from any angle, and probably discover interesting angles and shapes. This has so many advantages, especially in terms of possibly using a shot again, but I'm probably still stuck trying to compose the body for a particular perspective and camera angle that lets the gesture read for the best.

The larger a production the more valuable are accurate storyboards, as the crew will have become fragmented. It is impossible for everyone to know exactly what the others are doing, and the storyboard becomes the bible.

"Alleyway"
Set Design by Matt Sanders
for Hamilton Mattress film

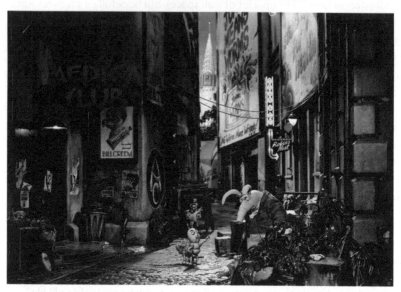

Details and finished set from *Hamilton Mattress* by Matt Sanders.

Sets and design

The important thing about designing sets is not what they look like to the passer-by in the studio, but what they look like through the lens, and whether they complement or distract from the characters. The set builders have an obvious, rightful pride in making good sets, and it is hard to resist the temptation to make them like beautiful dolls' houses, looking fantastic as a whole piece, probably with detail that the camera is unlikely to see. The designer has to know exactly what sort

of lenses, framing and compositions the director is likely to want, and exactly what the characters will be doing. There's no point in building a glorious set if it doesn't work for a particular camera lens or aspect ratio. Not only is animator access a bane to the designer, but cameras have to get in and the sets need to be lit. Access is obviously essential, not just on the sets but below, as the animators need to reach underneath for whatever securing device they are using. Usually an animator will be holding the leg of a puppet with one hand while trying to reach underneath with the other. This means that a set must be constructed around the length of an animator's arm. For larger sets, various trapdoors or swinging walls need to be built. On the sets, particularly the interior sets, for *The Wind in the Willows* and *Hamilton Mattress*, we tried to shoot completely round the rooms. Some of the sets where small, such as the bar in *Hamilton Mattress*, but every wall was removable. This takes some ingenuity, as sets can sag when various walls are taken away. In general, a wall is removed for the whole shot, but walls in shot can be taken away every frame to allow the animator access. This only works if the walls are precisely replaced, otherwise there will be all manner of juddering. Magnets can be used to secure the walls, or they can swing out or lift out, and then be secured by something reliable such as gravity or clips.

I have tried to be clever with removable walls that cannot be detected, and in one scene in *Hamilton Mattress* the bulky 35 mm camera travels from an outside alleyway down a corridor and into a ballroom seamlessly. In one of those cheap tricks I love so much, the corridor was dismantled section by section as the camera moved, the joins of the sections confused by various design elements. This is complex to plan and shoot, not least for the lighting guys who hope that the lighting does not change as a section is removed. Considerably smaller digital cameras now let the camera into difficult places, allowing more design freedom.

Antonio's *The Passenger* has a simply remarkable final shot where the camera starts tight on a character in bed, withdraws through a barred window, then wanders round the piazza outside, before finding the room once more, all in one take. This involved cleverly removing and replacing parts of the wall as the camera passed. Hitchcock, too, was adept at deconstructing sets to let his enormous cameras pass. Another shot, from *The Wizard of Oz*, probably one of the most significant shots in film history, is still impressive in its deceptive simplicity. This is the transition from monochrome to colour as Dorothy steps into Oz. I recall a film professor waffling on about the use of a clever matte sequence, but it seems no more than sleight of hand. A body double for Judy Garland, with her back to us, and wearing a monochrome costume and wig, approaches a real monochrome door. As she opens the door, revealing the colour of Oz, she steps back out of shot. The camera eases forward, losing the sepia set. Almost instantly, Judy Garland, in full colour costume, steps in front of the camera and into Oz. The camera follows in a sustained tracking shot, revealing the entire Munchkin town. It is clearly shot in one take, moving from the sepia close midshot of the door to the wide shot of the colourful town, but then a close midshot of Dorothy's reaction as she steps out is inserted. It is a beautifully acted shot with Judy Garland looking awestruck, but the continuity is all over the place and the flow of that amazing shot is interrupted. Maybe Dorothy's reaction needed to be seen sooner, or the close-up covers a technical hitch, preventing a costly reshoot. I admire the audacity of doing such a complex, important shot, showing the transition between the real and fantasy, all in one fluid take and with no effects at all, just simple lateral thinking. Quite breathtaking.

Screen Play had a shot linking the two different of worlds of animation and live action. In the final sequence the camera pulls back to show the discarded

puppets and props standing on the table, and keeps pulling back to see this image as part of a storyboard. My live hand shuts the storyboard, and the film ends with the film itself running through the gate. Various showy elements made it a tricky one-take shot. Computers would make the shot easy to do now, but would have lost the showmanship.

The tricky final shot of *Screen Play*.

Another favourite transition is in Terry Gilliam's *Baron Munchausen*, where an audience in a bombed-out theatre watches a florid production of Munchausen's adventures. As the actor emotes the camera moves onto the stage and gently glides into the real world of his tales. There's no cut, but the effect is subtle and thrills me. A similar moment is in *Poltergeist*, where the camera follows an actress away from an empty table and as she walks back all the chairs have been stacked on to the table. This is a big jump for the audience, and would not have worked with a cut or a CG effect. The awareness of real time and of 'before your very eyes' makes the shot work. Long takes remove the safety net, and knowing there's no cheating, any effects work better. Some scenes just have to be told in a continuous shot. Imagine if Fred Astaire's famous sequence of dancing over all the walls and ceiling had been done with cuts. There would have been no magic or thrill. With this in mind I try to do long takes in stop motion as the challenge produces adrenaline, for me, and maybe for the audience. I'd rather the puppet's performance created the energy than rely on quick cuts.

Today, CG trickery, blue screens, digital cameras no bigger than a few inches and second passes have made things simpler but possibly not as fun. I love working out all the trickery. With stop

motion you have the luxury of time in between the camera exposures to play with all manner of effects. The concept behind the sets in my film *Screen Play* was to look as though this could happen on stage, but then to take it further. We were building, painting and destroying the sets frame by frame as the film progressed. As screens slid across, I popped down props or characters behind them that were subsequently revealed. On stage, such characters could rise up through traps as the screen slid by, as with many stage illusions (detailed beautifully in *The Prestige*),

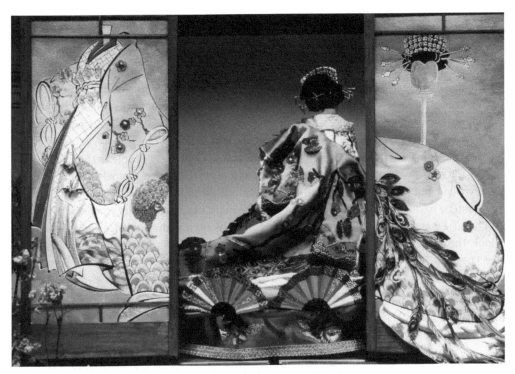

The *Screen Play* wedding screens part to reveal the wedding itself.

but my tricks were with the screens themselves. This took some planning, and I'm particularly satisfied with the scene in the dead garden where the Recitor reminds the girl she is to marry the Samurai. The open stage is full of dead flowers but no screens. I needed the reminder of the Samurai to be instant. A screen sliding on would kill the impact, and it couldn't just appear. I drew a thin vertical black line on the back wall, for just one frame. On the second, it was a piece of black tape hanging in the space where the screen was due to appear. Then a thicker piece, and finally the screen itself edge on, its thickness only just wider than the black line. The next frame had the real screen revolving towards the camera, until it was face-on, showing the Samurai. As the screen came edge-on again, a second screen was hidden behind it, and as it continued a double screen was revealed, now with the wedding dress spread over the two panels. After a beat the two screens slid apart, revealing a blue sky being painted frame by frame over the old yellow one. I couldn't stand by watching paint dry, and there are a few flickers as the colours dry or I altered the shape I was trying to anticipate. Also revealed behind was the girl now wearing the wedding dress; we had seen her running across the stage just one frame before, with a bit of costume trailing for a few frames as she is seen behind the screens. Modern techniques would make this easy to stage, but the effect of the scene flowing smoothly from the Recitor reminding the girl of her marriage by seeing the Samurai on the screen, to the illustration of the dress, and then the girl in the dress itself at the wedding, works because of its real physicality. This is highly indulgent, but great fun to conceive.

This could have been done with cuts, but it wouldn't have had the lyricism, in the way that music often segues from one theme to another. Transformation scenes on stage always impress me, not just because of their technical trickery but because of how they move the action along, telescoping it, making visual links between the overlapping images.

My first theatre job was in the stage crew on the big 1976 stage musical of *Hans Andersen*, which contained a sequence that I never tired of watching. Alone on an empty stage, Hans sat on his trunk, ready to leave his cosy hometown for Copenhagen. He looked like a little boy lost. A piece of set emerged out of the darkness suggestive of a carriage. The trunk was tossed up and the rocking movement, caused by yours truly, gave a convincing impression of a horse and carriage. Without losing sight of Hans this carriage unfolded to become the rails of a ship. Billowing silks suggested sails and the wild sea. As these were whisked away, the lights of wonderful, wonderful Copenhagen were seen glinting in the distance, before all the lights came up and there was Copenhagen bustling away with forty people. In the middle was Hans still with his trunk. He had not moved, but all around had. It was shameless theatrical storytelling, but with the lighting and choreography it swept the audience along on a complete arc, and by having Hans hardly moving among the midst of all this activity you never lost sight of him. He was still the focus. A lesson learnt about making sure the audience knows where to look. The real lesson is to always collaborate with the set designers, telling them how the sets will be used. Too often, beautiful puppets disappear in front of similarly coloured or fussy sets.

Achilles, an easy set to work on, and an image most indicative of my work.

I'm not always happy working with literal sets, preferring to play with illusion. A favourite shot in *Hamilton Mattress* is Hamilton and Feldwick walking happily in front of a blue sky, which turns out to be a gigantic poster for the ubiquitous mattress. In the nightclub, the murals of the baddie, Balustrade, picture him as a game hunter. Set into this are numerous hidden doors. The murals make a colourful comment on the characters' perceptions. Likewise, Rigoletto is often shadowed by an enormous rock carving of the Duke. The Duke's palace has a painting of

a gloriously idyllic pastoral scene; a façade that hides the terrors inside. Floating newspaper headlines say much about Gilbert and Sullivan while other action is going on. Using such visual devices, it is easy to convey information about the characters or plot when time is short. All the plays I have designed give the actors a colourful, almost graphic space to play in, bursting in and out of invisible doors. An architecturally solid set, with no stylistic tweaking, on stage or in animation makes my heart sink, as the enormous potential is not realised. In all I do, I make sure every colour, every prop, every item of set has a reason to be there or makes a comment. If that reason is that it's just pretty, that's not enough. It has to add to the story or atmosphere or go.

Confessions of a set designer – Matt Sanders

I was lucky have quite an auspicious baptism with animation, building sets for Wallace and Gromit's third film, *A Close Shave*. MDF and plaster were transformed into streets of houses, shops and warehouses, whilst I spent the hot summer of '95 outside, sculpting enormous polystyrene cliff-faces for the climactic chase scene (and getting a great tan in the process!). I produced most of the country lanes (dry-stone walls et al.) for that chase scene – only to see it all whiz past the camera at fifty miles per hour. Many model-makers will tell you this is a recurring theme of their career – weeks of hard work amounts to mere seconds on screen – but when the resulting film is as good as that one we're simply proud to have been involved.

This was one of my first opportunities to design elements for animation, including some of the shops, and the clock tower that Gromit cleans, helped by Wallace with the Sud-U-Like gun. This scene must have been memorable, because Aardman licensed a company to produce plastic alarm clocks based on my clock tower – though sadly, my royalty cheque is still lost in the post …

Later came *Stage-Fright*, an animated short set in a Victorian music hall – we built an impressive miniature auditorium and stage. This was a great project, and the best part was that in some scenes it was seen years later in a dilapidated state, so I had the unusual honour of vandalising the set, smashing the walls, and strewing dust and cobwebs.

I was a team leader on construction for Wallace and Gromit's feature film *Curse of the Were-Rabbit*, where everything was done on a much grander scale. Indeed, because there were so many animators, we needed duplicate copies of many sets – so you wouldn't build one Ferris wheel, but three of them. We built the church to the same scale as the puppets, plus a smaller copy to appear in the background of other scenes set in nearby gardens. Often, the streets themselves were made by moulding and casting complete houses – but sadly there were no short-cuts when it came to painting all those bricks.

I produced many of the more unusual set items, for instance an 'aluminium' greenhouse, made of silicone rubber with a wire armature cast in, so that it could crush and bend when a car drove into it. And Lady Tottington's Victorian rooftop conservatory, for which the 'cast iron' frames were actually cast in carbon fibre. Again three or four copies were needed, interiors and exteriors, plus a miniature version for long-shots of the house, and breakable sections for a scene in which the were-rabbit attacked – we like a challenge!

One of the first animated commercials I designed, for Direct Line, called for their red telephone-car to drive around six miniature street scenes – terraced houses, semis, tenements and docklands flats, etc. – perhaps forty buildings in all. We had three weeks to design and build all this, so I put on my Rumplestiltskin hat and churned out drawings in the evenings, whilst a team of ten model-makers built the sets during the day. We were so busy building houses, we didn't have time to make model trees for the gardens, so we bought some miniature conifers and assorted plants from a garden centre. They

looked great in the studio, but of course during the animation these live plants grew slightly, and when the rushes came back it looked like they were auditioning for the title sequence of *Tales of the Unexpected*. One thing you do in this industry is learn from your mistakes.

Another set by Matt Sanders for *Hamilton Mattress*, using the Pepper's ghost principle.

When I was asked to design sets for a revival of *Pingu* the penguin, I was faced with the unenviable task of watching all 104 previous episodes, in order to match the continuity of style. And I discovered that Pingu's igloo had changed shape about four times, his front door was sometimes white, sometimes blue, sometimes yellow – indeed sometimes different colours in the same episode – so much for continuity!

Perhaps the longest single design project I worked on was *Hamilton Mattress*, which featured many interesting locations, from a desert and forest, to a glitzy city and its seedy underbelly. Some of these sets were large, but of course there's only a limited amount of space in the studio, so the forest for instance was kept to quite a small size, by placing the trees close together, so you couldn't see far between them. But then a shot called for Feldwick (a caterpillar) to climb up a tree-trunk, and the camera to follow and look up into the canopy. Obviously we couldn't fit full-height trees into the studio, but nor could the shot be done as a miniature, since the puppet was in the frame, so instead about forty trees were built in forced perspective with exaggerated taper, and then (the difficult bit!) they were held at different angles to cheat the perspective, so the camera could shoot horizontally whilst appearing to look upwards. In order to hold all these trees in place at the correct angles, a large conical plywood tunnel was constructed, ten feet in diameter – the studio crew subsequently christened it the Stargate!

"Forest"
Set Design by Matt Sanders
for Hamilton Mattress film

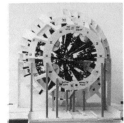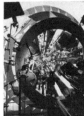

"Star-Gate" false-perspective set,
cardboard mock-up, and full-size set

Matt Sanders' set design for the forest in *Hamilton Mattress*.

A seedy alleyway was also built in false perspective, to make the most of the available studio space, whilst the bustling city centre was represented by just four or five shops, which were re-dressed and rearranged to appear different in other shots. Since the city was populated by birds (and called Beak City) the architecture reflected the bird theme, with beaks, claws and feathers influencing the styling of buildings, and indeed vehicles. A scene at a rubbish dump featured cranes with beak-shaped arms, and lifting claws like birds' feet. Personally, one of my favourite challenges is to take a real item or established design, and subtly pull it in other directions to produce something familiar but strangely different, so this was an ideal project for me.

The world of the set designers and model-makers is a world in miniature but never small.

Access to sets

Rigoletto featured a completely circular small room, with every surface lined with mirrors, a perfect expression of the Duke's monstrous vanity. Showing as many reflections of the Duke as possible while hiding the camera would seem impossible, but each mirror could slide upwards, and the lens could be gently positioned in the subsequent gap. There were convenient cushions and bits of furniture to hide the reflections on the opposite wall. The set, probably four feet in diameter and three feet tall, was an animator's nightmare, but I had only myself to blame. The Duke lay back on a low bed, indecently enjoying the myriad of reflections. The only way I could reach him was by sliding a mirror up each frame and reaching in. The mirrors were constructed so that you barely noticed any movement in them as they were replaced. Some audiences still wonder how the character was animated. Being able to insert walls and other pieces of the set as digital plates these days does make things both so much easier and more

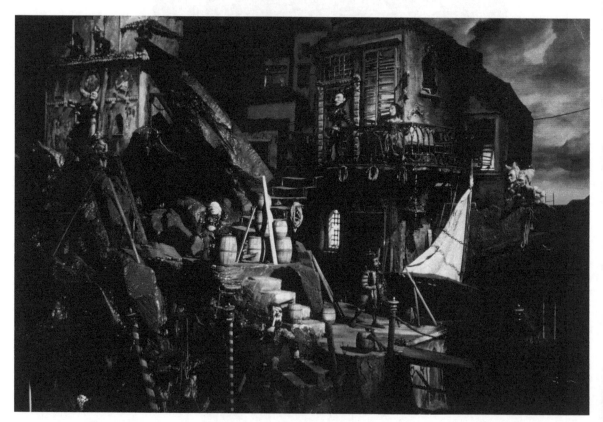

The enormous set for *Rigoletto.*

complex to work out, but I miss the tricks. Spending weeks shooting against blue screen is a disheartening experience for any animator, but ultimately a creative one for the director. An animator has to work even harder in these blue vacuums and it's hard not to lose track of eye lines and a sense of the geography.

In theory an audience shouldn't question the logistics of putting a camera anywhere. Hitchcock apparently did not want any music in his film of *Lifeboat*, as he worried that some of the less savvy members of the audience might wonder how

The Africa Club from *Hamilton Mattress* being built and animator Will Hodge at work in it.

an orchestra was in the ocean, although might that same audience not wonder how a film crew got there? The sets of *The Wind in the Willows* were so designed to be flexible enough that we were able to place a bulky camera absolutely anywhere, but there are some places that a camera just cannot, even in the illogical world of animation, logically go. Ratty's house had a noticeable desk against a wall that had sea charts and the like behind. Shooting reverse angles over the desk showing the top surface was fine, and seems perfectly logical, but sometimes the camera accidentally catches the back of this desk, and the logic totally falls to pieces. It implies that the camera has squeezed itself between the desk and the wall, or the wall was removed or the desk moved forward away from the wall. Basically, the audience become aware of the camera and that the set has changed. It always annoys me in live action to see characters running down a

corridor towards the camera and then having to sidestep at the last moment, making me think 'what a silly place to put a camera!'

Getting animators in and out of large sets is always a problem, but disguising their access can be something of an art: an invisible art. Jane Austen talked about the country houses in her novels having ha-has in their landscaping, a ha-ha being an invisible ditch hidden by the contours

Fighting for access on *Next*, and another ha-ha, with animator Steve Boot on the set of *Gilbert and Sullivan*.

of the garden. It is too deep and wide for the sheep to cross and does away with fencing, allowing for huge sweeping gardens. We have similar invisible troughs built into the set to allow the animators to move about. This means that the action has to be planned accordingly.

Space and scale

Being about puppets existing in real physical environments, space is very important to stop motion, and we try to make films that contain both intimate close-ups and huge, epic, wide shots. A film full of close-ups hardly realises the potential of animation: we want to give our characters somewhere to move around in, and not just be about talking heads. Inevitably most studios are tight for floor space and these wide open spaces have to be suggested through other means. Drawn films and CG can do this easily, and thankfully blue screens and digital imagery make this relatively easy for us today, as all manner of sets and landscapes can be put in at the postproduction stage, without eating into expensive studio space. Before this luxury, animators came up with all manner of creatively inventive ways to suggest sets and landscapes disappearing off into the distance.

One of the main problems is to give an impression of scale, not just imagining the puppets to be bigger than they are, but also giving the illusion that the sets go on for miles. Focus is the real problem here, as even softly painted hills a few feet away from the main set look like, well, what they are. Trying to get a sense of distance is very important for a credible illusion. At Cosgrove Hall, the first time we tried this was on *Pied Piper*, using a large seamless gauze between a midground piece of landscape and a background hill. Suddenly, with its density diminished, the hill looked a long way back in the distance. It's an old, cheap and simple trick, but it works every time. Gauze is also useful for flying cut-out birds, as I tend to in every film, and for shining shafts of sunlight or moonlight. Clouds can be easily attached.

At the beginning of *Hamilton Mattress* is an epic wide shot of the savannah, backed by a huge gauze on a metal frame. I wanted the effect of the sun rising and burning away the clouds to a clear sky, as the day became hotter. Today we might have done it in CG and achieved even more scale, but even then there is no button marked 'easy shrinking clouds'. So our animators gamely moved this epic gauze a millimetre each frame, snipping away at the cottonwool clouds until the clouds, in effect, evaporated. Complicating this was a huge heavy sun rising slowly, and several characters moving across the set in the midground. If that wasn't enough, we wanted a lake shimmering in the distance. A simple piece of mirror foil was effective, but the lake itself looked dead, so we put a Perspex rod covered with silver thread along its horizon line, as well as several threads across the lake itself, and when these were twanged each frame, the lake looked as though it was glistening in the morning sun. The set was probably twenty-five feet across and about fifteen feet deep. To help the scale even more we made several anthills of different proportions, with tiny ones placed at the back of the set. This all looked pretty magnificent, but was time consuming and a hard, hot set to shoot on. The sheer scale of it meant that to allow access for the animators, channels had to be constructed in the set, that were either invisible to the camera or disguised as canyons. It's an odd experience to see this epic set, and then watch as an animator pops up, totally ruining the illusion of scale. I enjoy simple physical effects on set, and the lake here worked amazing well.

What would have helped with the epic opening shot of *Hamilton Mattress* even more would have been to build small-scale versions of the puppets themselves, but that would have been expensive. Probably today we might have animated the characters on a blue screen, enabling us to control their size more. We used, almost successfully, various scaled puppets on *The Wind in the Willows*, but it becomes complicated, with the need for small-scale duplicate props and so on.

A legendary production for Opera North of Prokofiev's *Love of Three Oranges*, designed by the Brothers Quay, was one of animators' first forays into stage design, and they threw every trick in the book into it, coming up with some startling and hysterical illusions. One involved two characters stuck in a desert. They decide to run off for help and race into the wings. A spilt second later, smaller versions of themselves are seen running across the background. Then two small children raced back across far upstage, giving the stage a huge perspective. It was a great moment, bringing together tricks from all media, and done with a large knowing wink at the audience.

I love working with false-perspective sets, but usually these sequences have to be planned meticulously, so that the illusion works. Another set in *Hamilton Mattress* had towering buildings on either side of a narrow back alley. It looked deep, and thanks to clever set dressing and hidden doorways, the animators were able to reach almost down the whole length of the set. Feldwick, the caterpillar, was required at one point to scuttle off down this alleyway, but we had to be careful that he didn't appear to grow as he receded. We couldn't shrink the puppet, so just before the puppet appeared to grow in relation to his surroundings he subtly disappeared into the shadows, and with the help of fading footsteps you appear to see him walking off into the distance. To help set the mood of an emotionally downbeat scene, with the characters at their lowest, rain was pouring out of drainpipes and newspapers were flying about, all trying to make things look cold, windy and wet. As these newspapers disappeared down the alleyway, they could have given away the perspective, so we contrived to cut them smaller and smaller in each frame the further they went down the alleyway. Likewise, we had prominent dustbins made, getting progressively smaller and forcing the audience to see the depth.

Making the most of the physicality and depths of these sets depends on how they are shot and lit. Whereas 50 mm lenses will squash and flatten the image, a 24 mm lens will begin to make the same image look panoramic. Not every stop motion shoot has the luxury of camera moves, being time-consuming and cumbersome to set up, but simple movements can give huge depth owing to shifting parallaxes. Zoom lenses tend to be counterproductive as the parallax doesn't change and emphasises the flatness, whereas a camera actually moving through a set shows off the spatiality. As soon as a camera moves, though, it is expected to move the whole time. It would be odd just to have one or two moving shots.

Likewise with lighting, the depths of sets are shown off by the characters moving in and out of dapple. All movement is better when it's seen moving against something. With flat, shadowless lighting movement can struggle to be seen as little seems to have changed from frame to frame. It also helps to make full use of depth in the staging of a scene. It is easy for characters to end up in a straight line, but that hardly makes use of the spatial advantage unique to stop motion.

Using the camera

Camera moves

When it comes to camera moves stop motion drew the short straw. CG animation produces amazing, dazzling camerawork taking the viewer anywhere at the press of a button. With planning, so can drawn animation, but with puppets, it's not easy. The physicality that is such a joy in stop motion has the drawback of the camera being in the way. In live action, the camera takes its motivation to move from the actors; with stop motion, in effect, the animator takes his motivation from the camera. Once a move is planned, as it must be, the animator has to move at a certain speed, reaching a mark at a particular frame. If a camera move were to adjust to

every change in speed of the animation it wouldn't flow. This is hard and restrictive. We have strobing to contend with, something less of a problem with live action and CG, where the blurring of the image is a helpful part of the process. Depending on the budget, we can blur the image in postproduction or move the camera during the exposure of the frame, but still the animator has to follow the camera.

This is unnatural. Like good editing, which is usually invisible, camerawork wants to be inconspicuous. The worst moves direct the eye, anticipating something or giving something unnecessary import. Relating a moving camera to the eye, the eye is watching something in front of it, and then gets distracted by something to one side. The first response is to move the eyes, only moving the head when necessary for a better view. The body follows. Likewise, once the eyes have focused on the object they stop, and the head and body eventually catch up before coming to a halt. It doesn't happen all at the same time.

When a puppet starts moving, it is a mistake for the camera to move on the same frame. Like anything in animation, nothing starts at full speed, so the first frames of a camera move must be small fairings, building up to the accepted speed. If the camera delays for too long or takes too many frames to get up to speed the puppet can move out of shot, unbalancing the framing. Slowing down the puppet while the camera catches up or suddenly speeding up results in an awkward move. In general, once a camera is plotted and on its way, there's no stopping it. Shakespeare was prone to jumps in *Next*, with the camera following him. These jumps had to be carefully plotted and anticipated in the bar sheets. The heavily structured music score helped. I plotted the camera move to accommodate the jump on a certain beat, and trusted that I could animate the puppet into the right place at the right time, coordinating with the camera. This takes a lot of planning and even more instinct.

A camera move, like the animation itself, wants to flow, but, like the animation, this is not a matter of mathematics and equal division. The animator needs to work precisely with the cameraman, plotting the camera moves, rehearsing them, making marks, giving the impression the camera is following the animation.

Rigoletto was shot in a suitably Gothic railway arch in with trains regularly going overhead causing vibrations in the studio. We anticipated these by pausing, but we had not anticipated the electrical and magnetic surges that played havoc with our carefully planned camera moves. The camera wandered off in totally the wrong direction. (As did the radio-controlled animals in the stage musical of *Doctor Dolittle*, set off into uncontrollable spasms by passing taxis and the overhead planes coming into land.)

Rigoletto needed as much camera movement as possible to illuminate the music. Because the schedule was tough, walking the puppets everywhere on a huge set was impossible. They couldn't be static with that lively music, so the moving camera helped to suggest that it was finding the characters on the run, giving the illusion of more movement than there was. Some scenes were passive, but a slowly creeping camera stopped the scene becoming stage bound, in the worst sense. Our particular camera was limited to two axis, but we were inventive enough to push its limited movements. Moving the puppets to the camera with this music became like dancing with a partner.

These puppets were particularly impressive, able to take close-ups of their amazingly articulate mouths. To have shot this film with too many close-ups would have worked against freeing an opera from the stage. I wanted a dimension that

could not be done on stage, and set the whole action vertically, on a tall mountain. It worked as a visual metaphor for the film's hierarchy, and allowed some impressive visuals of characters dwarfed by this mountain, echoing the story. Too much spectacle would have separated the audience from the characters' emotions, so there had to be a balance.

It is important to know what camera moves and lenses are available when writing and planning a film. *Rupert Bear* did not have moving cameras as such, pushing me into finding a more energetic way of telling the stories. I had characters running in and out of shot, popping up behind things or racing about on skateboards. If a camera cannot provide movement and energy, then make sure that the staging does. Shooting with wide-angled lenses will emphasise any movement more than the limiting close-up lenses.

Strobing

Strobing can happen easily when, even though the puppet appears to be moving in the same direction as the camera, its relative position within the frame changes slightly, appearing to move backwards. This gives an unpleasant judder. This is unavoidable if the camera is moved in singles and the puppet in doubles, making the puppet shift around in the frame, fighting the move. A good reason not to shoot in doubles.

The easiest way to avoid strobing is, assuming the luxury of a monitor, to mark a constant point on the character on the screen for each frame, making sure that each new move progresses with roughly the appropriate increments. If it slips back or has a lesser increment then it will strobe. If there is no monitor, then a pointer attached to the camera can be lined up with the puppet in each frame. It's not enough to think of the puppet moving around spatially on set, you have to think about it moving around the actual framing, and the more a puppet relates to its subsequent position, the easier the animation will read as clean and smooth.

Getting hooked – Dave Sproxton, producer

My interest in models and film started as a child. We're all fascinated by miniature things, tiny detail and creating worlds – despite everything model railways are as popular as ever. A seminal moment for me occurred visiting London's Science Museum when I was six or seven, a regular occurrence at half-term. I can still remember the hall full of model steam engines in glass cases and the entrance mocked up as a coal mine. What engaged me was a small model display depicting the forum scene from Shakespeare's *Julius Caesar*. Its model was four feet long and two feet wide with small figures standing on steps. It had a simple plain background. What interested me was the small lighting console by which both colour and intensity were controlled. With a few deft moves the whole atmosphere could be changed from bright day to sombre night or even a vivid red. By today's standards the display was primitive (being six individual circuits and one master dimmer), but the impact was huge. Pushing a few knobs could dramatically change the emotional response to the scene purely by light. Nothing changed in the model, no sound effects, no words were spoken, just the lighting. With another push of a button the scene was washed by white light and looked boring. The model was crude under these lighting conditions but came to life as you moved sliders and dimmers. I became hooked with the impact of lighting on a scene and at home made simple, crude lights changing colours by sticking coloured cellophane over the fronts. I

was fascinated by the illusion of having a set and influencing the audience's emotional response to it. I lit stage shows whilst doing my degree, seeing a set of bland objects on a theatre set come to life with lighting. Linked to an interest in photography (my father being a keen amateur photographer) I found myself becoming a miniature lighting cameraman.

There is still something fascinating and absorbing about being given a model set, something on which static puppets will be brought to life, and being asked to give it atmosphere and vitality through lighting. It's a precise business compared to live action lighting because you're often after the same effects, separation, delineation, etc., but the physical space is so much smaller so different techniques apply. The animator and the camera are likely to be close to the set and the lighting must work around them and still do its job. From the start I thought that we should light our sets with the same approach to the drama as a live-action film. There's always been a tendency to have flat, overall lighting, for ease of shooting and speedy set-ups, but perhaps nobody considered the potential. My theatre experience showed me techniques which could be precise using profile lanterns, which weren't generally used by the film industry at the time. Whenever possible I give our miniature sets some atmosphere and life in exactly the same way as lighting cameraman would do on a drama. I'm pleased this is something which distinguishes the Aardman output, particular the feature films. They look like full-blown films and you are drawn into the film rather more than you might be. It's all film-making, we just do it on a smaller scale and take a lot longer. The animators appreciate the effort put into the lighting as it gives their work more punch and drama, making the whole thing more believable for the audience, if you can call something like chickens trying to build an ornithopter a believable activity!

Water

Water is another special effect that never used to work in the old movies. You just cannot create the illusion of huge waves by filming a model boat at high speed in a tank and thrashing about in the water. It comes back to texture, and how things behave. Blown-up water tends to look like syrup, and the motion of the boat being tossed about has little resemblance to a huge vessel. This is one area where CG has made things so much better. The first CG water was pretty awful but now it is utterly convincing.

On *The Wind in the Willows*, animating water and animating on water was a daily problem. Our huge tanks were barely more than eight inches deep, and being so shallow there was little density in the water's appearance. The beautiful fishtank pebbles on the bottom were too visible, whereas in a real river you can scarcely see the bottom, no matter how clean the water is. I remember pouring milk into the tanks to cloud them, but that smelt too awful. Eventually we found a chemical that gave the water a viscosity and a fantastic feeling of depth. Plunging one's hand into this thickened liquid was most unpleasant, but that viscosity allowed a certain amount of surface animation. You could place a leaf on the surface and it wouldn't float away. Even Ratty's boat sat there comfortably. The drawback was that while it looked to have depth it was terribly lifeless, with no movement. Reeds and things could be animated, but the water was dead. The solution was the trusty gobo, an old theatre trick. Light shone through an animated revolving disc gave the water movement it didn't have.

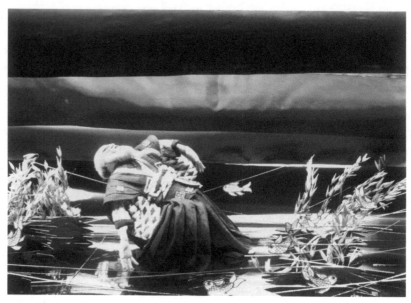

A very different approach to water in *Screen Play.*

As and When Men – Rick Kent with Jeff Spain and Richard Sykes, set and prop builders

8.30 am Monday morning, too early, the phone rings. 'Hello, have you got an ovarian cyst?' 'Look I'm a bloke; I've not even got ovaries. Who is this please?' An explanation follows from a designer. A period medical drama needs a prop cyst. Have we got one? How much will it cost and when can they have it (yesterday would be nice)? I don't know the answers and will have to look them up in my *Boy's Bumper Book of Model Making and Pricing Guide*. I'll get back to him when I've found the right page. Back to the day job.

Our bread-and-butter work is making the sets for small woodland creatures or talking machines or unbearably cheerful tradesmen to inhabit. It must be interesting work, I hear you say. Well the first fifteen years are, ho-ho.

The As and When Men in one form or another have been making sets and props for over twenty years and actually it is quite interesting. Some shows are more rewarding than others, but all have challenges. Some are beautifully designed, some have challenging building problems and some help to pay the rent, say no more.

Why does nearly every show have a forest in it? Trees and by extension forests, forests are a real sod. Trees, we've made literally hundreds of them. Easy, you say. OK, try making one then. I want a show set in a desert ... but with buildings in it, lots of buildings ... well I've got to do some work to earn a living.

A whisper goes round that a new show is in the offing; we ignore it – this happens all the time. When it becomes more than a whisper we prick up our ears and believe we might stay in business. This year at least we might have Christmas with dinner and presents for the little children.

Then it comes. A production meeting. We see the designs and meet the designer producer and director, we know them all, we've known them all for years and this makes life easier. As usual 'can they have prices ASAP', even though everything will change before we start the build. We scratch our heads and pore over the designs; how do you price up a forest, how big is it, how many trees make a forest? It could be any size and please why can't they cut it please?

Work starts and for a while all is well; this is the best bit (apart from getting the cheque at the end). A day later it turns into a nightmare, deadlines creep closer, freelancers are unavailable, the sets have unaccountably got bigger since the quote and it'll never get done on time. I don't actually know why I worry. It always gets done on time.

Each set is finished, approved, changed, approved again and goes out. Now the magic happens as it goes through several transformations. It looks great when it leaves us, then it's propped and dressed and looks even better. The lighting cameraman waves his magic wand and it starts to come alive. Puppets next and then the real heroes, the dollywagglers, complete the transformation from wood and canvas (actually MDF, glass fibre and artex) to a living, breathing world.

Surely it must give you great pleasure and pride to see your work on TV. No. It goes out at some unearthly hour for the kiddies, while we're at work; and if we have no work we're too busy worrying about the lack of work to watch TV.

For the ovarian cysts, we cut the fingertips from latex gloves filled them with KY Jelly, tied a knot in the end, painted them with liquid latex coloured blood red, left them to dry a bit, then rolled them about a bit to mess up the latex so it looked like fleshy tissue, and popped them in the post.

Props

Since most animation films feature less than human characters existing in some sort of recognisable variation of a human context there's always bound to be interesting conflict when a character has to act in a human way. In *The Wind in the Willows*, Ratty played a seemingly endless ditty on the piano, called 'We'll go boating'. When faced with such things I jump in and take this as an excuse to learn the piece precisely – can there be such a thing as method animation? The beautifully made piano had proportions more suitable to a realistic human, not an Edwardian rat! If it had been, it might easily have lost its essential piano quality. Come the weeks of filming, I had to adapt the playing, as not only did Ratty not have enough fingers to play the notes exactly, but his girth meant that he had to sit close to reach the keyboard with his short arms … so short that his belly got in the way of playing some of the notes. Add to this the fact that his snout was so large that unless he turned or raised his head, he would have pressed up against the music sheets. It is a great challenge to make this work. If I couldn't play the exact notes, I could be overemphatic with the rhythm, which is the storytelling part of playing a piano. Ratty had lovely supple wrists, fingers and thumbs, so I was able to make some rather delicate and precise wrist actions that gave the impression of playing the piano exactly. Hopefully the audience were watching the rhythm more than watching the notes the fingers were playing. The bar sheet looked a totally incomprehensible series of swoops and curves, but it

worked. It always pays to ask of any movement: exactly what is the essence of that movement? The answer is often neither the most obvious nor the most realistic. What part of the action do we recognise as making that action what it is?

This piano problem might have been made easier through constant discussion with the designer or art director, relaxing the reality of the piano. I do get, er, ratty, when design work is confused with reproduction of historical artefacts, with no adaptation for the characters or the styling. The adaptation of reality is a beauty of animation. In this case it might have been more practical to have designed a mini grand piano, not an upright, so that Ratty's nose could have projected over the keyboard. The keys could have been gently lengthened or Ratty could have had a pair of longer stunt arms for the close-ups. Working with all members of the team is essential. All prop designers must know what is expected of the props, and which characters are going to be using them. Production meetings can save a lot of hassle. Often on a production meeting it is difficult to get all the members of the crew together at once, but such meetings are absolutely invaluable.

Invariably, animated characters have unusual hands, traditionally missing a fourth finger, and a thumb that can't exert the necessary pressure to grasp things. Great thought has to go into how a character can hold a prop. It helps if the props are light, as a puppet's arm will droop if a prop is too heavy. Again, it's all about talking to the designers and being flexible with the design.

Day in the life of an art director – Barbara Biddulph

Any number of job descriptions fits the role of art director/designer. Each industry, company or project will have its own expectations of the role.

I work within a large animation studio in Manchester. Originally there were approximately twenty people employed to create the stop-frame children's programmes. I joined as an illustrator to complement other skills within the team. As the team was relatively small we were expected to cover tasks that we weren't necessarily trained or had experience in. I found myself working more and more on the sets, using my illustration techniques on 3D constructions. These tasks were quickly followed by designing sets, overseeing their making, and dressing the sets to camera in the studios.

We now have several art directors in the company; each one comes from a different background. These include theatre, model-making and set-making. All have some sort of art education, but none specifically in art direction.

If you're not a team player you won't find this job easy as it's all about working alongside others and communicating. This includes accepting that you won't always be right, being able to listen to other ideas, discussing the pros and cons of all the suggestions on the table and following through the decisions made.

You have to work with speed and accuracy, use a huge variety of materials, communicate with lots of different people and come in on budget and schedule.

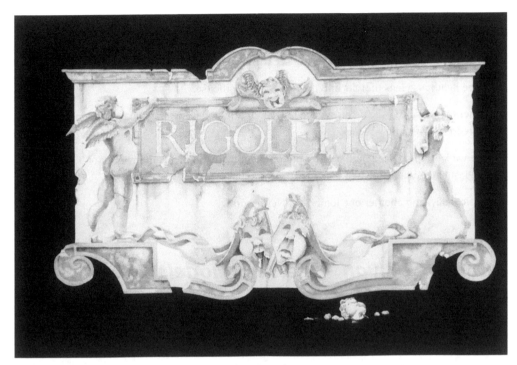

Barbara Biddulph's atmospheric artwork for the title card for the pilot of *Rigoletto.*

A typical day commences at 9.30 am.

Call on the walkie-talkie. 'Mud' is needed on the set. We use Plasticine to create this. It must be warmed (in the microwave if necessary), applied to the set in sheets and smoothed with lighter fuel. Also need to move a couple of shrubs to hide a gap on the set.

Remove a lighthouse lens from a set. It has been 'broken' in the story. So I've cut it into pieces on the band saw. Then 'rust up' the metalwork around it, using sawdust and PVA, with paint to finish.

Discuss the design of a proposed set with the animation director, as to how we can exaggerate scale by using different shooting techniques. Will use this information to design and build a maquette of the set before it goes to the set-makers. The maquette can be seen by the camera/lighting department too, if there are any queries about access, etc.

Present a finished logo design that will be painted onto the lighthouse and costume. This is the final of several ideas that I have gone through.

Have a break. Catch up with my e-mails.

Print off the first treatment of a future extended episode. This is a mini version of a storyline; I'll read it and give any thoughts to the scriptwriters. This can cover building techniques, sequence of building, information on materials and tools that may be used or bits of information the characters can say to enhance the story.

Reorganise a schedule to give us more time to make trees for a set, which is a bit thin at the moment.

Call on the walkie-talkie. Need to dress in some more 'construction' on a projection screen for an outdoor cinema that Bob is building.

Another call to extend a set as the camera can see the edge of the set.

Work on the lighthouse lens that fits into the top of the lighthouse.

Cleared a set that has been shot. This will be reused for another scene. It could be used many times, each time redressed as a new scenario.

Call on the walkie-talkie. Need mud splatter put onto a toy dragon that is in the back of a trailer on the set. More Plasticine. Will be dressed ready for the morning.

A fairly typical day, and another one tomorrow. Never boring.

Gilbert and Sullivan – The Very Models

A patriotic image from *Gilbert and Sullivan* with Carte's bed at the heart of everything.

This film's set needed to segue smoothly from D'Oyly Carte in bed to scenes from the operas. I had intended to design a solid bedroom for Carte, but the budget made me more daring and imaginative, forcing me to focus the attention on the bed in which Carte is 'lying awake with a dismal headache, and repose is tabooed

by anxiety'. So just a bed it was, and all the action happened around it. Some reviews suggested that the bed, where so many relationships are made and unmade, seemed an appropriate visual metaphor for this particularly stormy marriage. Well, maybe, but the bed helped to suggest that the action was happening in Carte's sleepy mind. The bed was the stage on which this surreal drama was acted out. With the art director I took this image further by having the bedspread ruched and decorated with gold tassels, much like theatre curtains. Being deprived of a set, we found the richest crimson fabric to make the bedspread an unmistakable focus. The As and When Men, a props company in Manchester, made the bed, complete with the initials G&S incorporated into the metalwork. This wasn't just a reminder of the story, it suggested that D'Oyly Carte's lifestyle owed much to those two men. Gilbert and Sullivan literally funded the extravagant bed.

The beautiful detailing of Carte's bed from *Gilbert and Sullivan*.

Happy with the bed as a central image, it was relatively easy to plot the film around it. Once again, I find limitations liberating, and thought of a million ways to use the bed to say something about the relationship. I had wanted the bed to be surrounded by small gaslamps, like the footlight shells in *Next*, but I couldn't find any and even in the oddness of having a bed in black space footlights might have made things too peculiar. We tried candlelit softness in the lighting and shot the first week without the benefit of rehearsals. I was disappointed with the grubby and dark rushes. No-one's fault other than tight schedules. I couldn't have the whole film looking gloomy so, thinking quickly (another reason why stop motion is exciting), I found a reason to incorporate a change of lighting into the action immediately. D'Oyly Carte snaps

his fingers and suddenly the light is much brighter and more comprehensive. I justified this by Carte wanting to see his midnight visitors more clearly, and by acknowledging that Carte was the first to install electric light into a public building, as he did for the premiere of *Patience*. In a subsequent premiere, the chorus girls were dressed with tiny lights in their headdresses. These operas and their staging were not dry and dusty at the time, so it saddens me that they have that reputation.

Colour

Colour is an element that the artificiality of stop motion lets us exploit. As invariably our films are shorter than we would like, colour coding characters or having obvious palettes for certain scenes and situations can certainly help the narrative. Animation is not about real life, but a shorthand to things we recognise or find credible, however fantastic. I have always been thorough about plotting the use of colour, and I find it tricky nowadays that my most comfortable colour, blue, has to be limited through so much blue-screen work. Blue can make life harder in the postproduction.

As I give myself a discipline in storytelling and sets, I seldom use a specific colour because I happen to like it. An obvious example would be to dress *Romeo and Juliet* with the Capulets in yellows and the Montagues in blue, and only mixing their colours as the families are united in their grief. A recent production of *King Lear* saw the opening burst forth in a riot of golds and dazzling rich colours, all flattering the eye as the court flatters the king, but as Lear lost his reason the colours faded away to almost monochrome. In animation, where everything is accentuated, we can have fun with using colour tricks like this. Rather obviously, the costume for Rigoletto was of two colours, split down the middle, immediately expressing the two sides of his nature. I deliberately plot the colours to say something about the characters, the narrative, the emotions, the mood and the geography. In both *Achilles* and *Screen Play*, red is only seen with the death of a major character. Water features heavily in both films as a theme, and these scenes are saturated with blue, a colour I find calming and comforting.

Costume

Having been commissioned to make *Next*, my first consideration, knowing how long these things take, was to start thinking about Shakespeare himself. All the portraits were painted after his death, usually as him in mature years, but there is a perceived image of him that would have been perverse to ignore. I worked with sculptors and puppet-makers who would later develop into Mackinnon Saunders. We gathered much Shakespearean imagery, mainly the Flowers portrait, but the sculptor also thought to put an element of me in it. Even before this, essentially my first film, I had a reputation for being somewhat theatrical, and it seemed

appropriate to blend some of my features into those of Shakespeare. This was one of the most elegant and sophisticated puppets the Mackinnon Saunders guys had made so far.

There was little point in designing complicated mouth mechanics, as Shakespeare did not speak, but I wanted a hint of smile, and achieved this through a tiny paddle under the skin. This was smooth and subtle, and although he only smiles obviously

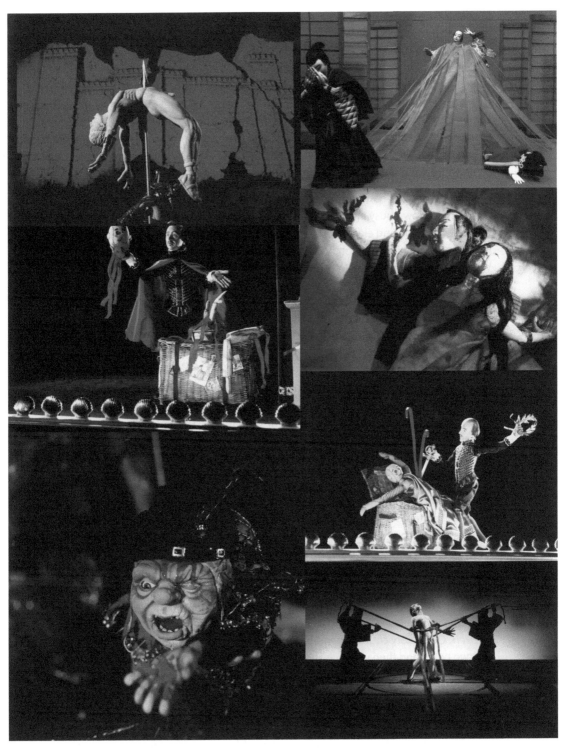

I clearly have problems with red: recurring images of blood from *Achilles*, *Screen Play*, *Next* and *Rigoletto*.

in one shot he does have a constant appealing smirk. His eyes, too, give him life. I'm usually frustrated by puppets that have painted eyes, as this limits the acting considerably, and the majority of any communication and character comes out of the eyes. I don't know whether Shakespeare's eyes were pale blue, but they give the puppet an instant life. He doesn't blink throughout the film (blinking would have meant extra costly mechanics) and I wasn't going to put any Plasticine blinks on such a beautifully sculpted puppet. Blinking would have added something to the performance, but I was still happy with his expressive eyes. A tiny pinhole in the pupils enabled me to move them a millimetre each frame and get some great nuances out of the character, although sticking a pin into his eyes was most uncomfortable. I felt that somewhere a human might be screaming in pain or going blind.

Along with the eyes, hands are hugely expressive, at least in my style of acting. My own hands flap with their own busy incomprehensible language, but I can control a puppet's hands with precise expression and elegance. The puppet, on display at the National Museum of Film, Photography and Television in Bradford, gets people asking why his hands are so big. When they move they don't look out of proportion, although they are bigger than natural proportions. I wanted to feature these hands. Throughout *Richard III*, the title character is likened to numerous crawling insects, and I thought it would be an interesting conceit to interpret that play with just his hands being beetle-like. To help these hands stand out clearly, we made the costume black. My immediate instinct was to have the most elaborate costume, showing off my love of things Elizabethan, but common sense made me think about a neutral rehearsal outfit. I was keen to see his beautifully lithe physique, but also be true to the Elizabethan peasecod silhouette. This curved shape gave him a great dignified bearing. I was pleased we resisted the idea of giving him slightly comical doublet and hose, and instead going for pantaloons that emphasised his great long legs. The vertical lines inherent in the fabric give him a refined upright bearing. I was keen to give him a ballet turnout, and his legs were sculpted with very shapely calves. This is the most beautiful of puppets, and he naturally dictated his poses. He simply had to stand up tall and poised.

The design of the puppet and the design of the costume all work together as a complete whole. I liked this black rehearsal idea but I knew that the backgrounds, necessary for the tricks that made the space so fluid, would also be black. Anticipating how this film might be lit, Nigel Cornford, the great costume-maker, found particular black silks and other fabrics that caught the light as the puppet moved, highlighting his shape and letting him stand out against the darkness. The dozens of tiny beads not only pick out his torso, but the V-shape of their pattern highlights a satisfying triangular feel to his jacket, giving him elegant proportions. I knew that Shakespeare would work with his mirrored reflection to suggest the twins from *The Comedy of Errors*. CG trickery could generate a second image, but I wanted to see Shakespeare become the two twins, and then watch as the puppet became one again in one take. The inevitable edge of the mirror was clearly visible, but vertical seams in the costume, and his symmetrical pose, confuse the moment when the mirror is removed. Smoke and mirrors, quite literally, are

often the most effective way to approach such problems. Another point of the tiny beads in the doublet was to disguise the tiny black fishing hooks needed to take the fine fishing line that would support the puppet as he jumped. They are still there, making me sympathetic towards fish. Not being a fisherman, I had no idea what line to use. The best had the name of 'Shakespeare'. Most puppets today can have a rig inserted, to help the puppet jump or support it when the toe joints cannot help. This rigging point needs to be thought about in advance and

Thanks to Nigel Cornford's costume, Shakespeare could not fail to look elegant.

incorporated into the costume. Don't believe the director who says that the back of the puppet will never be seen. It will. It is best to disguise the rigging points through some design feature, or accept the fact that the inevitable hole left by the rig will be painted out in postproduction. The holes for Allen keys, necessary for turning head mechanics, can be more easily disguised as they are much smaller, but rigs can be quite substantial. I don't like rigs, as I try to keep a shot as pure as possible, minimising the postproduction. I'm much happier suspending puppets on practically invisible fishing line. Film, and good lighting, is helpful here, but I fear the that new high-definition formats will make that harder for us.

In keeping with the period costume, we gave Shakespeare small white cuffs and a white ruff to ensure that his head and hands stood out clearly from the background. A larger ruff seemed too indulgent. Subtle but rich backlighting also gave his black costume a discreet halo, easily separating him from the black behind.

I have done a reasonable amount of Renaissance and Elizabethan dance, often dancing in costume. I thought this to be an agreeable affectation, but feeling what restrictions the costumes imposed suggested how the dance might have been performed. A heavy ruff effectively limits some head movement, so any glancing and flirting has to be done by turning the whole body … what a magnificent statement to the assembly this becomes. I tried to incorporate elements of this into Shakespeare's performance, as well as recognised etiquette and the received knowledge of how Shakespeare's plays were performed.

I get sidetracked and excited with all this research, and I love it, as it helps to feel how the character might behave, stand or move. This probably sounds like

method animation, but it's not about reproducing real life. It's more about giving the character a comprehensive and disciplined physical lexicon. The Elizabethan fashions emphasised the male legs, which must have played a significant part in their body language. In this tiny film, I exploited every part of Shakespeare's body to tell the story.

Costume designs for a Shakespeare play were required by my school art exam, and here I started playing with the idea, hugely exciting to me but hardly a radical thought, that costumes could be an extension of the character. I chose *The Taming of the Shrew*, and I had only seen the Zefferelli film, which clearly had a seemingly endless budget. Reading the play it seemed that Katherine, fiery Kate, was constantly moving, usually hurling things at Petruchio or chasing suitors away. With not the greatest of subtlety I gave Kate a flame-coloured dress, while her sister Bianca was less colourful. Yes, all rather obvious, but I wanted to emphasise the movement, and designed a variety of layers, folds, trailing sleeves and ribbons that were easily agitated. I was pleased with that, although today I would be more subtle with red. In my work it is never a friendly colour. I would probably now give Kate an outwardly sober dress which, when provoked, would reveal shocking slashes of unexpected scarlet. This would be a nightmare with stop motion, as anything to do with dresses spells trouble. For every frame the dress itself needs to be lifted up, to get to the feet, and then lowered. This is alright if the dress and the character are moving, as whatever jitter there is can be absorbed into the movement. A more drastic way is not to bother with legs at all, but have a more solid padded dress, with some sort of mechanics that simulates a walk with a rise and fall. Clothes cut so tight so as not to allow any movement do not appeal, but they are an answer. This would limit your movement, and probably mean another version should the puppet sit down. I would rather battle with an awkward but flowing dress than one with no movement, making the character look like a toilet-roll cover and sliding round as on ice. A wired hem, small magnets in the hem or lining the fabric with thin foil are probably the best ways to animate a dress.

Making costumes say something about the characters may not be realistic, but it conveys character traits quickly when we have so little time. I have always enjoyed stories of how costumes have been used in the theatre: in *Phantom of the Opera*, the sleeves of the phantom's jackets are traditionally made shorter to emphasise the hands, which are such an important part of his performance, especially with a mask hiding much of his face. As Evita dances with Che, denying her illness, the costume she wears is an uneasy combination of black and dark green, saying more about her than she would admit. In productions of *Candide*, the old woman deprived of one buttock usually has a large, lopsided, hooped skirt along with a lopsided wig. In drawn films, costumes are usually disappointingly simple, uncluttered, lacking any interesting use of texture or colour, owing to the sheer amount of work involved in animating anything complicated. The artists use the outlines and costume silhouettes to make their statements. A silhouette is much easier to keep consistent than complex patterns on a dress and is perhaps more instantly identifiable. With stop motion, we have the luxury of infinite textures and colours, although we have problems making small fabric not look like heavy

hessian when blown up on the big screen. Most fabrics have to be printed to the right scale, as bought patterns betray their size. As with most things in animation, an element of illusion is necessary, and with costumes, it is giving the illusion that this piece of lightweight fabric is actually much larger and heavier. Small costumes do not hang in the way that they would on a full-scale performer, so any help in the cutting or with weights goes a long way towards preventing them sticking out unnaturally.

A detail of the delicate costume from Trnka's *A Midsummer Night's Dream* (Saemi Takahashi).

A piece of fabric fresh from the shop looks just like that, sitting awkwardly on the puppet, not looking like a piece of clothing the character has selected. It usually helps to weather or break down the costume. A slight darkening under the arms, in the folds or round the hem always helps. It's good to scrunch the fabric, or drag it round the car park or wash it several times before making a costume, just so the fabric has a history. It's a shame to make these beautiful costumes then go and dirty them down, but they'll look so much more convincing. They will get dirty during the filming, with sweaty hands mauling them all day. Gloves help, but animators are seldom comfortable wearing gloves. Provision has to be made for duplicate costumes or for time to wash and maintain them.

Visual concepts

The finale from concept artwork by Colin Batty for *Noye's Fludde*.

Few things give me more pleasure than what would be my desert-island luxury, a toy theatre. I enjoy looking at the set models from the great designers, but I have never had the chance to collaborate closely with such designers. I got close when a film of Benjamin Britten's *Noye's Fludde* hovered briefly into view. A big-name choreographer was briefed, but even then the designer was a little confused as how this would work, as I clearly have such strong visual ideas, which are so inseparable from the direction. This can be a problem, as I find it easy to come up with striking visuals and conventions and concepts, but I don't necessarily have the technical expertise to execute them. All my set models are pretty basic in construction, but are quite eye catching. I would be more than happy to work with a designer who could take my conventions and concepts even further, and finesse them more than I am able to. The ideas are the easy bit; it's the practical realisation, the measurements that I struggle with.

Stop motion animators, and animators in general, are spoilt in that having made our own short films, we're likely to have written, designed, even done the music, animated and directed, and as such the vision has an integrity and cohesion. Film and series do not always work that way. I don't understand how a director can be presented with a design for a set or film by the art director or designer, and then be expected to get on and direct it. Design, to me, is such an integral part of the storytelling that I cannot separate it, or all the other elements, from the direction.

This is not about ego but about having a unity. An intimate collaboration could achieve this. It amuses me to see the films from the 1930s credit 'Décor by … ', as if the design was no more than decoration. Often in those films it was just background, but not always. This seems to undervalue the contribution of the design.

I admire the many great long-standing director/designer partnerships that exist in film and theatre, where they have a symbiotic understanding of each other's craft. The perfect partnership must be that the direction inspires the design, and the designs inspire the direction, a two-way open collaboration. I have only designed one show, the musical *Jekyll and Hyde*, for another director, and as it happened, it was a huge success, with the design became instrumental and complementing how the show was staged. The director had asked for lots of levels, but I gave him a huge drum that revolved from inside to outside, from black to white, from chaos to order, from wide opens spaces to dark claustrophobia. The director came up with ideas that I had not thought of, but I did want to get in there and push the potential of the set and the conventions and colours I had set up. It is hard not to be a director the whole time, but this was a good collaboration. I would not enjoy, either in theatre or in animation, working with a design that was predetermined as that would so dictate how the direction and the storytelling was to happen, allowing no room for evolving.

This probably makes me sound awkward to work with, and maybe I am, but it's about making sure that every element fits into a larger scheme and it all ties together, all working to tell the same story. Making sure that all the elements have resonances for the whole production takes no extra effort. That is the role of the director. He has to pull all these different elements together to give life and meaning to the film, and in small-scale animation it is too easy to be all things. Perhaps that's what gives stop motion one of its unique qualities. When a film works, such as *The Sandman*, all the elements complement each other, through having such a small unit where the personal vision can still be maintained. It must be hard on huge productions not to have the vision distilled through sheer numbers. It is essential to communicate and share ideas.

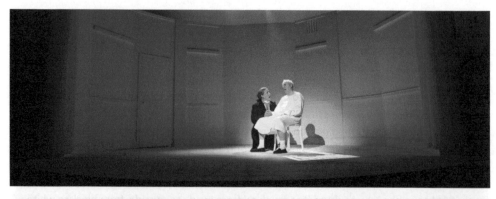

Several sides to Jekyll and Hyde: set design for Altrincham Garrick, 2006.

Upcoming production of The Importance of being Earnest, 2008.

PERFORMANCE 3

Punch and Judy, early puppets for many of us (Richard Haynes).

If you think we are worked by strings
Like a Japanese marionette
You don't understand these things

W.S. Gilbert, The Mikado

PERFORMANCE

3

Getting Moving

Being an animator

Throughout history, as soon as a skill or technology developed enabling some sort of image to be drawn or captured, people at once wanted to give it life. The buffalo cave drawings, once their artists seemed satisfied with the representation, were given multiple limbs to suggest movement. Giotto managed to suggest movement by depicting the main character in various stages of the story: an early storyboard. Once photography had developed, it wasn't long before the images started to move. As soon as computer imagery appeared, it started to move. Creating life in whatever form seems an unavoidable instinct.

Ethan Marak, animator

As I work I think about what goes on between the frames. One of the big differences between stop motion and computer animation has to do with the process with which the movement is created. I have worked in both forms, and have spent long hours pushing both pixels and puppets. While both techniques are capable of producing beautiful animation, there is something unique to the stop motion process that I crave when working at a computer. I miss the energy of human interaction with the physical world. I feel that all stop motion animation is infused with this energy; even a beginner's jittery first attempts at stop motion are more interesting than much of the silky-smooth CGI out there. The stop motion animator is having physical interaction with the puppet in every frame. Time folds and condenses an hour of work into a second or two of finished animation. Between frames, the animator is forcing their will on the inanimate, coaxing it to life. Focusing thoughts into tangible, real stuff. With any creative act, the mental state fluctuates throughout the process. All sorts of thoughts and feelings bounce around as I am animating. Frame 10, feeling good, focused. Frame 30, should I take a break? Frame 76, did I turn the stove off? Frame 125, almost done! Is it possible that these moments are not completely separate from the animation, and that the energy exchange between the animator and the puppet is somehow reflected in the final product?

I'm not sure that I would call it a soul as such, but when we are animating we give our puppets something that perhaps other techniques cannot. Through all that touching, the sheer physicality and the painstaking labour, something does cross into the puppet through a kind of osmosis. Animators do bond with their puppets, although that's not a given. There have been

puppets I have not warmed to, and this resulted in only a decent mechanical performance. With others, there's a two-way emotional and physical connection, with the puppet defying its base materials. Those moments when a puppet lives are what we're after.

I'm often asked what qualities an animator needs, well, that's a big question. If you're bored easily this is most definitely not the profession for you. The process is usually compared to an elephant being in labour for many, many months and then finally giving birth to an ant. Now an ant is a glorious, complex creation, but it is still tiny. Unless you find said ant beautiful, look elsewhere. If you have no imagination, look elsewhere. If you cannot tell stories, definitely look elsewhere.

The essential quality to have is not so much that of a performer, as I know many animators who would curl up and die if a spotlight was turned on them, but it's having a performer's sensibilities. It's knowing how to use all the resources of animation (movement, rhythm, timing, gesture, design, music, etc.) to tell a story directly to the audience. We have to be multiskilled: we have to be a choreographer, an expert in body language, we have to be musical, we have to be a director, an editor, we need an artist's eye for composition and a sculptor's eye for a strong storytelling pose, we need stamina, we have to be a juggler keeping many different balls in the air at the same time; the list goes on, but above all we have to be interesting storytellers, and for every story told there has to be an audience. I have seen animators not immediately concerned about the audience, even our audience of the camera. Much as we may like to make films for ourselves, there's little point in making them without an audience to see them. Likewise, there's little point in doing exquisite animation if little is communicated. Sound and fury signifying nothing. If our reason to make films is purely indulgent catharsis, we might as well sit with a therapist. We need the desire to tell a story, to communicate, and to make it as interesting and as clear as possible. A lot of my own work is full of references, oblique puns and conventions, but I try to question whether that is being obscure and pretentious, or whether it does actually provide an extra facet to the story. There is a distinct difference between being a mysterious, teasing storyteller and being downright obscure. With the imaginative freedom that stop motion allows, I'm sure we have all been guilty of the latter.

Film grammar

Being an animator is not just about being able to move things to tell a story. The animator has to have an awareness of the much bigger picture, of the design, the pacing, the style, and so on. The animator has to be a film-maker, with a thorough understanding of film grammar and composition. While busy animating away on a certain shot, you have to be aware of how this shot will fit into the next shot, and how the composition flows. I would love every college to drum into the students on the first day (after having shown them the 1933 *King Kong*, of

course) just exactly how some shots work next to each other and some do not, and why. Cutting from a wide shot to a close-up is a very unnatural experience, and it has to be made easy for the eye. It's not helpful if the character in the wide shot is standing on the right of frame looking to the left, and then when the camera cuts to the close-up, the continuous action has the same character on the left of frame looking to the right. This will jar enormously and utterly disorientate the viewer. This may be obvious, but it's an easy mistake to make.

Probably every close-up of a puppet is filmed with nothing to react to, although it always helps to have a prop, if not an actual puppet, standing in a position to suggest the eyeline of another character. It's easy to get the eyeline wrong when you are shooting a series of close-ups from the same angle, and as soon as that happens the whole geography of the scene collapses. Establishing the geography in a scene is utterly important, and it surprises me that in even the biggest budget movies, film grammar gets sloppy and immediately disorientates the viewer. In the fragmentary nature of shooting stop motion, when some consecutive shots are filmed months apart, it is easy to lose sight of film grammar. Every director prattles on about 'crossing the line', and a detailed description of its mechanics can often totally confuse people, but the best way to remember about this is to ensure that a character is looking in the same direction from shot to shot (if in real space that's what they are doing).

The smoothest cut is if, in the new shot, the character occupies much the same portion of the frame and is at least looking the same way. Like most things in animation, the more one shot relates to the other the more fluid the cut. It is essential to use a strong movement to smooth through a cut, at the same speed. It is tempting, and I'm guilty of this, to treat a shot as a complete story, and resolve the action in the shot, even if the next shot is sequential. It's best to start the next action in the previous shot, giving a reason to cut to a different angle. I ask animators to start the action of the next shot and sometimes have been given just one frame or two of the next action. This is not substantial enough. Something needs to happen to draw the eye's attention. A move in one or two frames is just a twitch, but a five-frame move reads.

Every time a shot is cut, there is a momentary jar which sets up a beat, and a series of very quick shots will give a rapid beat and you end up with a rhythm like a Rossini overture. Long, sustained shots suggest a Mahler adagio, so where you cut a shot is hugely important to the pacing of a film, and animators who extend shots or cut them short need to be aware of the musicality and rhythm the director or editor has plotted. The enforced discipline of animating to music makes me much more focused and creative.

The animator has to have the skills not only of a choreographer, but also of all the dancers. The animator must be able to move characters around in space, hopefully keeping them all visible if that's required, or staging it so that the important characters read. Invariably in most scenes, there is a dominant character that the director needs the audience to focus on. Other characters busy doing their own thing are distracting. Making a character stand out is not just a matter of sticking him in the front of the shot. Grouping the other characters in a certain way can make even a character at the back be important. Colour and lighting can pick out characters. Telling the viewer where and when to look is the job of the director and the purpose of an editor, and with close-ups, different angles and camera moves, there's a whole range of tricks. On stage these tricks are very different, thanks to the sheer joy of the artificiality of the medium. On film it is rare to see lighting change obviously during a shot. Usually the lighting is set, and dimming one area and highlighting another in the middle of a naturalistic scene might destroy the scene's credibility. On stage, lighting is a prime means of storytelling, and it is very acceptable for a character to be standing alone in a spotlight. This is the equivalent of a film close-up. Lighting has a million ways to manipulate the audience. Just watch the end of a big joyous musical number on stage, and see how the lights brighten, urging the audience to burst into applause.

How are you with film grammar, or do you just like to concentrate on the shot you are doing? Do you read the whole script?

JD – Read the script? Depends on the project. Sometimes I have been involved in making significant changes to the script, as with *Caveman*, where I added a sequence in which a giant lizard attempts to eat Ringo Starr, just as Ringo is attempting to eat a small lizard.

Film grammar is my specialty. Again in *Caveman*, I had to flop some of the storyboards to maintain filmic continuity. In other cases I had Randy Cook white out and redraw portions of the boards in order to make them filmable. For *When Dines Rule*, I did most of the storyboards, and therefore had much control of the filmic 'grammar', but even so, there were times when the director decided to make a change from my boards, always with unfortunate consequences.

TB – I have always been fascinated by film theory and grammar, and I teach it at the college level. I teach film fundamentals in all of my animation classes, because most students don't know the first thing about film theory and how to put shots together. All they know is what they've garnered in video fighting games, which is hardly film or storytelling; although for the past few years, many games are beginning to offer attract modes that are cinematic in quality. However, students, have not studied how shots are put together, and they don't know the first thing about editing and composition (montage and mise-en-scène), so I'll show them examples from not only animation films, but live-action films as well.

RC – Well, I would say I would want to read as much of the script as would be necessary to do my job well. If there are relevant sections, then yes, absolutely.

DC – I like to know what's going on and why and would like to direct something sometime somewhere somehow (I've only directed two episodes of *Morph* so far), so I feel my attention to film grammar is improving with my inquisitive interest

AW – I always try to see the big picture. The story, and the shots before and after are very important to me, and I do read the script.

SB – I look at the whole script so that I understand how everything relates and how the scene fits in.

RH – If there is time I try to read the whole script, particularly concentrating on my scene. It's always important to consider the whole shape of things in the story, and not just the shot itself.

JC – It can be helpful if you have a sense of film grammar, you can pick up on things that are not right before they get to the edit room. It's essential to have a good knowledge of the whole script. It's important to know where a scene lies within the story and where the shot lies within that scene. I feel continuity is as much my responsibility as the director's.

Acting

An animator is often compared to an actor, but actors have the luxury of several weeks to rehearse a play, playing with the character, the movement, letting things develop and grow. We have to be pitch perfect on the first take, as that's all we get. To some extent we cannot grow, as the more recent rushes would sit

uncomfortably with the early shots. We just have to be ready and right on the first shot. In a way this is like being a stand-up comedian, except slower. This is a tough way to work as you can't help but discover things as you progress, little ways of holding the character's head, or a flutter with the hand that you wish you had thought of earlier. You have to do extensive homework and find this lexicon of movement for the character and stick with it.

Two beautifully performed puppets from Kawamoto's *Dojoji Temple* (Saemi Takahashi).

What is it about stop motion that we love? Is it the technique itself, or the strange movement, or the design?

JD – Usually I was involved in animating creatures that didn't exist and wouldn't have looked too good as costumed actors or mechanical creations. The Pillsbury dough boy portrayed by an actor in a costume ... I don't think so. Both the strange movement and the design make us love stop motion.

TB – For me, there is a sheer magical quality of shooting actual three-dimensional objects and manipulating them in space with our hands, heart and eyes. It's tactile and fun. I have taught both stop motion animation and computer animation classes at the college level, and one thing that seems to be fairly constant is in the area of emotional attitude. In my stop motion classes, students are always laughing, giggling, moving their bodies as they act through the movement, and generally having a heck

of a good time making their puppets and sets. Conversely, in my CG classes, students remain at their monitor, stare at the screen, don't talk or act out the movements with their bodies, and don't talk to anyone unless they're interrupted. Why is this? It's because human beings enjoy touching and being touched. We have a puppet that we created, that we can touch and manipulate through space. We've given birth to this creature, and now we are giving it life. How can that not be fun? For the CG animator, how can staring at a flickering monitor, with the only emotional link being a mouse, be considered emotionally fun? Perhaps some people find it so and that's fine, but in my experience, many CG students don't seem to be connecting emotionally, or at least express it externally.

KD – For me, it's about bringing something to life, creating 3D 'real worlds' in which fairytales, nightmares, love, humour all take place, a step further than the illustration, painting or photograph. Once it's in the blood ... that's it, you're hooked!

RC – The first thing I love about stop motion is that there is something unreal being brought to life. Ray Harryhausen says, 'It has a dream-like quality'. The fact that we are not machines allows the artist and his imperfection to make the technique what it is ... a near, but not totally, perfect performance that appears to be something beyond reality.

DC – A unique Wallace and Gromitty charm? The strange magic of watching something live and breathe. When all the elements work together and you stop thinking about why it works, then it's magic. The design or movement or music or story on their own are not enough, they all have to work together in harmony ... like us!

AW – I love the process of making.

SB – I like the fact that it's physically there.

KP – Basically people just love watching real objects move on screen. It has something to do with unconscious memories we all have from playing with clay and toys as children. Seeing obviously real materials move with a life of their own, and in the back of your head knowing that human hands touch them between frames, is a strange kind of Jungian wish fulfilment. There's something very primal and spiritual about watching stop motion. Computer models look pretty and can be very expressive, but there's a distance there that's created without the sense of touch implied. It's a different kind of visceral experience.

I've taught students from all over how to animate in stop motion, and I've found that many students I've had from Mexico have a particular interest and passion for stop motion that is different from anyplace else. I found this same quality when I visited Mexico City and spoke to students there. My theories are that the Mexican culture still has a long tradition of pride in making things with their hands. It's evident in their artwork, history and lifestyle, and they have traditions such as the Day of the Dead which are such a part of their culture, that when they see a stop motion film it resonates differently for them.

RH – I always loved the look of stop motion, and I later found that I loved the technique itself. Animating from start to finish is an art form in itself, and the fact that you can't create your key frames before your in-betweens is an exciting challenge. Sometimes other mediums can be easier and less rewarding for this reason.

JC – I love that animation has its own reality. I love that we can create lifelike movements or push the timings. We can animate a dancing Aardvark, a talking pig or a crying lady. We can capture reality or push it to the edge. Though the technique is laborious sometimes, even tedious, its very nature means you

have time to think through what you are doing, adding those extra touches that make it magical. Whatever our physical ability we can become graceful dancers or tough fighters or Andy Pandy or Shaun the Sheep.

DS – We've found that its sense of tangibility gives it a different emotional response to either 2D or CGI. Seeing the craftsmanship on the screen, in the form of paint strokes or fingerprints, does subconsciously remind the audience that this is hand made and that adds something. When it's working well there is something in stop frame that resonates with people that doesn't with other forms. Having said that, the film must be engaging in the first place.

PRW/MG – Stop motion can give a feeling of being more real, more three-dimensional, even if the characters do not look particularly real – for example in Paul Berry's *Sandman*, which was very frightening. In some cases stop motion can be more real than drawn animation, but not always. Stop motion is more real than CGI, much of which has no soul. Most CGI characters are visually grotesque with a kind of 'grotesqueness' that is ugly and bland (lifeless) rather than character driven.

Scale

Ray Harryhausen's Cyclops from *The Seventh Voyage of Sinbad*: a small puppet looking huge (Saemi Takahashi).

Among the many things we ask of an audience is to accept that a small, twelve-inch-high model is not only living, but is meant to be many feet high, sometimes several dozen feet high, as with King Kong. To create this all-important illusion is not just a matter of blowing up the image to the appropriate size. It is an

unavoidable fact that a creature just a few inches tall will behave and move very differently from a thirty-foot-high beast; this is a surprise to most beginners. First, you need to look at your puppet and ask yourself just how tall it is meant to be in the imagined world. For all its sublime and spirited animation, the original King Kong does sometimes betray its eighteen-inch height. Giving the sense of scale and weight can be helped enormously by the camera work: if a character is perceived to be unnaturally tall next to the 'normal' protagonists, as in the case of a rampaging dinosaur, the camera is usually looking up at it for most of the time, from our characters' point of view. Conversely, a camera usually looks down on characters regarded as small. Even so, the camera work alone is not likely to help create the illusion of mass and weight in a huge creature. This has to come from the animation and acting. If you look at some of the shots of Kong swiping at passers-by, some of the gestures take perhaps a mere half a dozen frames to move from his chest to a more outstretched gesture. With a puppet just eighteen inches high, moving an arm through the real six-inch spatial radius of its arm in six frames seems entirely credible. But transpose that to the twenty-five or thirty feet that Kong was meant to be, and the same gesture has an arm supposedly travelling through a space of perhaps twelve to fifteen feet in six frames. By any physiological standards it would be pretty impossible for muscles and a skeleton to work like that. The bigger a character it is, not only do their limbs have further to travel, but also they are going to be heavier, with a bulkier skeleton needed to support that. This is another mistake often made about scale, that an unnaturally large-scaled character is just a matter of blowing up the proportions. Most characters we animate need to obey some laws of physics and anatomy, and generally the bigger something is the more mass it is going to need to support it. This not only leads to necessary design decisions, but also decisions about how such a character will move. A huge, thirty-foot character might lose some credibility if it were to skip about like a two-foot-high newborn lamb. You need to find a movement that suggests its bulk and weight, and this usually necessitates moving a character far more slowly.

In the early days of special effects, when real lizards and komodo dragons were used to suggest dinosaurs, they were filmed from a very low angle with a distorting lens, and always a high speed, so when the film was run normally the dragon appeared to be moving so much more slowly. I don't think I was ever convinced by these special effects, as there was always some quality to the movement (as there was always some movement in rotoscoping that betrays its origins) that gave away just how big or small these animals were in real life. Probably something about the way the skin wobbled, or the way the tongue darted, or maybe just how anatomically unconvincing the texture of the skin looked when blown up to such proportions. I was always thinking there should be more scales on a creature that size. The inevitable stuck-on fins or stegosaurus plates totally gave the game away. But it was definitely the movement that I saw through, especially when two lizards were fighting. Their reactions were just too speedy and they lifted off the ground for too long and too easily. There is no getting away from the fact that a bigger creature will be built differently and move differently from a small creature, whatever the environment.

Talos

Harryhausen's animation of Talos in *Jason and the Argonauts* is a great example of mass. Looking about sixty feet high, Talos is moved slowly, with movements that do not stop in a couple of frames, but have a long, slow follow-through, suggesting an enormous inertia. There are no quick movements as they would destroy the

An excuse to see Talos again (Richard Haynes).

illusion of scale. Even if the character did a quick movement, at that scale it still has a lot of imagined space to travel through. The editing does not race along, giving us only snapshots. More often than not Talos is there in all his full-scale glory.

I would suggest one reason for this sequence being a favourite scene for so many (me especially) is that unlike the majority of characters in these films which are 'alive' in the context of the film, Talos is actually brought to life, echoing the whole process of animation itself. Harryhausen gives the character a deliberately awkward gait, as if this was a creature that had never walked before. Talos does not spring into action, but slowly shifts his weight from foot to foot, eyeing up the situation. He walks with a speed appropriate to his huge scale. You never doubt for one second the sheer scale and heaviness of Talos. Harryhausen even puts in little jerks suggesting the rusty mechanics of this heavy statue. Like Kong and the T-rex standing facing each other for moments of stillness, he is thinking. The performance has many beautiful details, such as the swapping of his sword from one hand to another … little details that bring it to life. The late Paul Berry and I used to watch this scene and act out the swapping of the sword. Like Kong snapping the T-rex's jaw, this is an iconic moment, a real celebration of the joys of stop motion. Here is a fantastic character brought to credible life by an animator, and glorifying in the medium. Talos is hardly a realistic character, but we believe in this creation. Sound plays a huge part in giving him life. The metal strains as he moves, with an echo that suggests its hollowness. Harryhausen's sculpting perfectly captures the essence of Greek statues, rejoicing in the male physique, while the texturing of the surface suggests years of standing

in the open air, weathering slowly. Just by looking at a still of this creation, we know his history and his purpose. The camera work, mainly from a low angle, helps to give the statue scale. It is an amazing scene, by any standards, and defines what stop motion is about.

Likewise, such big bulky characters are probably going to have a low centre of gravity and be unable to lift legs up to great height – imagine the muscles needed to do that – so you should structure walks around this heaviness. Of course there will be fantasy creatures that disobey any rules and will work for that reason, but when you approach a new character for the first time, always have an image in your head of just how big it is in the world of the film, and how far the few inches it travels on the set transpose to the imagined world. I'm not an animator who finds stopwatches terribly useful, but try to imagine the time of movement in the film world. I despair when animation books state that a walk cycle is twelve frames, for example. A walk cycle depends on so many factors, of scale, of geography, of mood, of environment, of emotion, and so on. A beetle might do a walk cycle in considerably less than twelve frames as its feet don't cover much ground, but a huge dinosaur would take considerably longer to move his feet through a cycle; at least that is the effect you want to convey by the difference in speeds.

Walking

In a real-life walk, we may not notice the toes peeling off as the back foot comes up, or the toes flapping down on the front foot, but that moment is the storytelling moment in a walk. Every gesture and movement has such a moment when the shape defines what is happening. The eye, when seeing this for real, can read these key poses very easily, but animation has to stress these moments. With a walk it is the inverted V-shape that is so strong, and I would give this position more frames than seems necessary, while not exactly holding it. Let the viewer see the moment when the back foot cannot stay on the floor any longer as the hips are going forward. Show the heel being peeled off, while the toes stay on the floor, giving that last moment of leverage and push. As soon as the foot is free, the leg flicks it through quickly in just a few frames, to avoid being unbalanced. The heel is slapped on the ground as soon as possible to take the weight, and the toes trail behind, and then flap onto the ground, spreading the weight and balance. Each foot peels away and then slaps down in every cycle. Puppets without a toe joint will lose something in making this read.

How far the feet are apart in a walk cycle depends on so many factors, from the speed and energy of the walk to the size of the feet themselves. Many animators give their characters joyously slapstick-sized feet, hoping this will help to support the characters without the usual pins or magnets or tie-downs, but large feet cause many problems. To move a body forward, the equivalent of caterpillar tracks or wheels would be ideal, but we have equal length legs. With both feet flat on the ground, balanced, it's pretty hard to move forward. Ideally, and this could lead to very interesting anatomy, we would have to shrink a leg like a telescope, and then

flick it forward before extending it again so that we could move forward onto it. The development of knees and hips has done much the same thing. To unbalance ourselves we shift sideways. This frees the other foot and with the knee bending we can flick it through, with the foot trailing underneath, just skimming the floor. This, in effect, makes the forward-moving leg smaller. The knee straightens again, ready for the leg to take the weight of the body that has been thrust forward with leverage from the other leg. The bigger the character's feet, the more the legs have

to shrink to be able to flick the foot through. If it is necessary for a character to have a large foot for comedy reasons or whatever, you'll find that the feet will need to swing at right angles to the leg to get them through. The alternative is to raise the knee ridiculously high.

Again, many animators are indoctrinated into thinking that a walk cycle is exactly twelve frames or whatever, and set about dividing a step into twelve equal movements. Well, it doesn't work like that at all, and that would give such a dull boring walk with no energy, no character or life.

Unless there is a deliberate reason to do otherwise, once the character has started walking, the torso will travel forward in each frame. If torso has moved back and then forward again, there'll be a horrible jerk. This constant movement in the required direction has to come naturally, and has to be felt through the hands as well as through the eyes. Find a mark on the torso and plot its movement forward each frame. If a character is on a horse, trotting or cantering, then the torso might move back and forth, but over a series of frames. Tracing a movement in a canter would reveal a series of elliptical arcs.

Paul Berry's animation for *The Sandman* contains beautifully clear rhythms in the walking (Saemi Takahashi).

A lot of drawn animation books stress the importance of rise and fall in a step, as well as a sideways swagger from hip to hip. It would take a pretty sophisticated puppet and a generous schedule to be able to put such detail into a puppet. Swaggers and bounces only register if they are part of a succession of repeated actions. One hip bump to the left in a walk doesn't make much sense without seeing it several times, and because of the spontaneous nature of stop motion this repeated movement is very hard to replicate each time. This is why I tend to avoid walk cycles as such, and try to encourage the puppet to be actively doing something as it is walking.

Body language

I wonder whether always having had pets around has helped me anthropomorphise characters. My last three cats, the glorious Inigo, Scrumpy and Benjamin, have all been highly involved with my life and we seem to have been able to communicate and respond to each other in pretty complex ways. Now the accuracy of the emotions I have read into their body language may have been fanciful, but it has been an excuse to watch Inigo when he came bounding up to me as I arrived home and to see what is it about his body and movement that is expressing such an obvious joyful emotion. I liked watching him to see whether his stretching out of a paw is actually a prehensile movement or just an instinctive one. I was surprised once that when I was laid low by a bug, Inigo seemed clearly distressed by all the coughing and spluttering and just came and laid a single paw on my cheek. I never tire of watching animals move, especially all their different rhythms when using four legs. Animating four legs on a puppet is always a logistical nightmare, and never something that comes easily.

I always enjoy being up close with animals and responding to them. At a festival in Singapore I went to the zoo, where the animals seemed very well looked after. A large ape was being upstaged elsewhere, and threw some fruit at me and started gesticulating. He clearly wanted it thrown back, and we began a game of mirrored actions. It was an extraordinary moment to see this animal making very precise articulated gestures, and mimicking me, and for a moment it felt as though I was manipulating a puppet, or being manipulated. Studying any sort of body language can only help us as animators, but I'm still surprised as how expressive animals can be, especially vocally. Inigo had a vocabulary of several dozen 'words', each accompanied by a particular body language, and I knew exactly what he meant by every one of them. Since most stop motion films, well most animated films, inevitably, involve animals, we cannot study them too often. There's something very direct and honest about an animal's movements. Sure, they can trick and outwit, and be cunning, but I'm not sure an animal is capable of deliberately lying or deceiving or hiding what it feels. It's pretty easy to look at a cat's body language to tell whether it is contented or frightened, but there are many subtleties involved. There are so many clues, and it is these that animators need to be able to read clearly and use in their characters. Inigo was a rescue cat, and a pretty damaged untrusting one, who couldn't even play, but I won his trust by some rather over-obvious body language. Lying on my back next to him, exposing my stomach with my limbs in the air clearly struck some sort of chord and he would follow suit. I have yet to use that exact

Clearly not a timid animal.

gesture in a film, but it's not hard to understand the emotional difference between arms folded protectively over the stomach and arms flung wide open, exposing the vulnerable areas. Every time I look at an animal, I am mentally storing its movements in my head.

These are quite natural gestures, and can be explained psychologically: you are not likely to expose your vulnerable areas to someone you don't trust. Such gestures

are easy to read in any culture as they are common sense, but most countries have developed gestures totally incomprehensible to others. These develop much like dialects and as a result of specific cultural references and backgrounds. An outsider would be hard pushed to make sense of Japanese Kabuki theatre, where every movement has a meaning specific to that art form. The audience has learnt exactly what a flick of the head means, or understands the colour coding of a piece of fabric, but these clues are not connected to the same logic that makes hands fluttering over a heart easy to understand. When dealing with any body language you have to think whether it is a learned gesture, a natural gesture or a cultural gesture. When I learnt British Sign Language for *Screen Play*, I was surprised that this was not a universal language and that some signs had clearly different meanings elsewhere. A two-fingered salute can have far too many meanings. For stop motion, it's all about finding the appropriate, truthful and honest vocabulary.

Whenever you have a scene with several characters, or even just two, you need to ask yourself just who is the focus. Which character is the active one; who is looking at who; or rather, who should the audience be looking at. There are so many ways to focus attention on the main character, which is probably just another way of saying 'make sure the story comes across clearly'. You do not want the audience to be distracted by unnecessary stuff going on in the background. During a scene the power and focus will probably shift back and forth between characters, and the relationship will change. There are plenty of body language tricks to show who is in control. Try and study how characters echo each other, or move in synchrony, or assume opposite poses, or slouch or stand tall, or turn away or invade the other's body space. There are plenty of great books about body language, but you do need to be familiar with how characters respond to each other. Again, watch animals together, as they seem unable to hide their reactions to each other as we can. The bodies communicate more clearly. It is unlikely that two characters will just stand still in each other's presence without giving something away, unless that stillness is part of some larger expression. It's not just unlikely, it's also very uninteresting, and that is one thing we just cannot afford to be. For every scene with characters communicating, just ask yourself how you can use the physicality to make the scene more interesting

Finding the body language

Before even thinking about filming you need to think how the characters are going to move. One of the first commercials I animated and directed was a campaign to introduce a soft chewy cereal bar alongside a crunchier chunky bar. The ad showed two humanesque figures made out of the respective cereals, beautifully sculpted in amazing detail. It was inevitable that the female character would be the soft one, and the male the crunchy one. The curves on the female were emphasised and the male figure actually had sharp edges, giving him a feeling of being a slab of oats. These two figures undressed sexily from their wrappers, then performed a very athletic ballet. They got a bit carried away, then realised they had an audience, and slunk back into their wrappers. An original idea was for the male to get a bit too intimate with the female, and she was to knee him gently in the groin, at which point two 'nuts' would have fallen off. For some reason this never made it into the final shoot, but the male's punishment for getting too frisky was to get himself caught as he pulled his wrapper up round him, as if catching himself in his fly. Gloriously bizarre. The challenge for me was to show the difference in the bars by the way they moved, and we managed. The agency producer and I danced around a vacant office trying

to find interesting moves and shapes that expressed this difference. We took Polaroid shots of every step and every strong pose. I was reluctant to take video, as it would have given the client an inaccurate impression. With animating the puppets I would be able to keep the beat, but to do a video, I couldn't have done the jumps or probably kept to the timings. Unusually, the music was recorded after the filming. This is definitely not the way to work, but we managed to find a strong beat and rhythm for the choreography. We gave the female very fluid moves that flowed into each other, but allowing the soft shapes and silhouette to register. I gave her a lot of follow-through and soft fairings out at the poses. I made the male very angular, strong and abrupt. He came into his poses with no fairings, and had very strong open poses which he held for a few frames. I managed to do quite a bit of jumping with these figures, using good old fishing line again, and they are still just visible now. Today it would have been easy to remove the wires digitally. Animating two such very different characters in the same frame is always a challenge, as it's all too easy for your animation to find a common middle ground of style, and the two characters end up moving like each other. It happens all the time, but fortunately here the choreography was all planned and was extremely specific.

After the shoot it was felt that one of the pack shots, containing the female, didn't have enough screen time, which is a fair enough comment, so one shot had each frame printed twice, doubling the length. The pack was on longer, but it made a nonsense of the animation. The soft chewy figure became a jerky figure. Today it would have been very easy to have fixed that without touching the animation. This is when digital comes into its own.

The commercial was an interesting challenge, and a pleasure to work solely on body language, with no dialogue. The puppets had two seeds for eyes and a shape for a mouth that opened. There were even eyebrows that helped to register the male's pain as he caught himself in his wrapper. A very simple set of hessian artfully draped and beautifully lit. Nice and simple, with the focus purely on the movement of the animation, and eating dozens of crunchy and chewy bars during the shoot is always a bonus. Sometimes there is so much product around, and everyone tucks in on the first day of the shoot, only to go off it rapidly.

Federico Landen, Argentina: animation enthusiast

Well, that's what I am, a simple fan of stop motion, with the dream to become an animator.

What attracts me? The movement. Not just the movement of the puppets, but mostly my own movement.

I'd done some film studies some years ago, and decided that I wanted to be an animator. CG was the obvious route to take (yes, it was obvious, but I don't know why it was so, anyway. Sometimes I ask myself the right question after searching for its answer for a long time ...). Took a course for about a year, and every day I felt more far away from animation. I missed the movement.

Working with computers all the time is getting the memory out from our bodies. Every day a new part of human knowledge reduces its practice to just typing and clicking. You may be a doctor, lawyer, designer, accountant or an animator, everything is done through a keyboard and a mouse.

Soon everyone will move just in the same way, no matter what he or she does. I am not against the computer itself, and I don't want to sound like 'The end of the world is nigh' or anything. I just want to

say they I like the differences. Different things made in different ways, that is a great thing to me; and I won't let my body (me) forget all the beautiful things that it (I) can do. We can't forget movement. We won't be able to deal with time and space if we do that, so we won't be able to animate or to live.

Discovering stop motion a few months ago was like breathing again. It allows me to use my fingers, hands, arms, legs, eyes, head, nose, in different ways in each different step: making an armature, building a set, mounting a camera and, of course, animating. For the puppet to begin to move, my whole body must be moved, and I love that.

So that's what attracts me about stop motion animation.

Pushing the puppet's laws

In another commercial a lump of square cheese had to look sexy as it strutted down a catwalk in front of rather too excitable cheese crackers. How sexy is a cube wrapped in foil? Not very, I fear. As I walked it with a certain cocky rhythm I had to twist its shoulders, but it was one of those moments that when you push a physical object out of its ordinary shape, it stops being credible. Fine, if this was a drawn lump of cheese or a CG cheese, but somehow physical objects have an unwritten law about how far you can push, squash and stretch them. Cartoons thrive on this elasticity, but puppets do not. Even though they may be the most fantastical creations, they do need to obey some rules and logic of physics and anatomy. Wallace and Gromit are stretched to a certain degree, and that is definitely part of their appeal, but you couldn't stretch them in the way that Tom and Jerry were stretched like a twanging rubber band. My sexy cheese might have been that sexier if it had stayed a rigid cube and I had relied totally on subtle changes of rhythm; as it was, the cheese suddenly looked rather elastic and very unappealing.

The physicality that one gives to a puppet can be both a handicap and a release. In my film *Next*, it seemed totally in the context of the piece that Shakespeare might pull his own head off and use that as Yorick's skull, as he was already doing some pretty bizarre acrobatics. I had made my Shakespeare puppet so credible (some people today still do a double take – oh yes, I have had letters addressed to the actor who played Shakespeare …!) that I could push his physicality only so far. When the time came to stage the Hamlet scene, I couldn't do it. I had given that puppet a life and shown him obeying gravity, albeit a rather fluid gravity, and other natural laws. All of a sudden the gag seemed totally out of place in the film and, being honest, I'm not sure I would have liked to have seen that puppet without his head. By that stage of the filming, Shakespeare was more to me than a puppet. This pushing of the credibility of a puppet is an odd thing. We strive to make inanimate things do things that seem possible, while live actors and circus performers often strive to do the impossible. In *Aurelia's Oratorio*, Chaplin's great-granddaughter delighted in extraordinary illusions just feet away from me. One of these involved apparently separating her head from her body and letting the head float up attached to a string as if it were a balloon. It was a staggering illusion as she could have hardly done that for real. The audience knows the physical limitations of the performer, and yet here she was apparently crossing those limitations. If I had done the same illusion with my Shakespeare puppet, no-one would have blinked an eye. Animation is the reverse. The audience know

the physical limitations of a puppet, but here we are, apparently crossing these particular limitations. That's when magic, illusions, animation, trickery, etc., work best; when you show how the trick is done by showing the apparent limits, or at least fool the audience into thinking they know how it is done, and then outwitting them.

The removal of Shakespeare's head might have worked if I had shown it to be a trick performed by the puppet. One of the greatest and most effective 'beheadings' I have seen was in the Royal Exchange's *Cymbeline*, where the actor was lying on a pale-coloured bed, and as the sword was lowered, a black cloth was placed quite deliberately across his head, covering it all. The effect was hardly realistic, but it took my breath away. Once again this glorious use of black to suggest something is not there. I could have used a similar idea in *Next*, and I'm sure it was a convention used in Elizabethan theatre. Another production of *Titus Andronicus* saw Lavinia wearing black gloves to suggest her amputation, and as she opened her mouth, a flood of bright red ribbons cascaded out, and hung there for the rest of the scenes. In a way, this was far more shocking than any splatter movie, because the imagination is involved. Knowing it is fake makes the illusion all the more breathtaking. We like to be fooled.

But I could not bring myself to pull off Shakespeare's head. This was not only an artistic thing concerning the style of the film; it was a personal thing, as it would have felt like mutilating something that was very much alive. It pleased me to see the animators in *The Nightmare Before Christmas* boldly remove Jack Skellington's head with a flourish, but he is a skeleton and he can survive in the same way that Sally can sew limbs back on when they have been tugged off. If Jack and Sally had expressed pain, or had started to bleed, that would have been a totally different matter. But I do think it vitally important to set up the physical rules straight away in a film, about what the role of the puppet is and how it fits into its world, and just how far it can push the laws of physics and nature.

What are you thinking when you hold a puppet? Do you feel what it feels or experience some of the situation? Is it a sensual experience?

JD – When it's a puppet designed by someone else, I'm less empathetic than if it's a puppet I designed. Usually, for a 'creature' film, my primary interest is in the story, editing and staging of the scenes. For a puppet scene or sequence, my interest tends to be in the characterisation and stylisation. I often feel the mood of the characters. Sometimes, for a creature film, I'm able to get into the character, but not as often as for a puppet film.

TB – I first think about who the character is. A monster? Well, what kind of monster? Iago was a monster, but he was also human. So he was a different kind of monster. Was King Kong a monster, or a tragic figure? What if the character you're animating is a ballerina who has just learned that her father has died, just as she is about to perform the death scene from *Swan Lake*? How much will she feel the death of the character when she gets to that point? Probably quite a bit. We all bring many, many experiences to the table as performers, and animators are no different. Being moved when I saw the scene of the baboon from *Sinbad and the Eye of the Tiger*. He sees his reflection and realises that he is no longer a prince, but a baboon, and begins to weep. Once the actor has latched onto the mind of the character and becomes the character, the audience will almost believe it. It's all about illusion, about being someone else for a

brief moment, and sustaining that illusion through the scene and story. I probably find more emotional connection and satisfaction if I am animating and working on a film that I have written and designed. I do speak to them and make sure they are wrapped correctly and repaired when they need it. I'm very protective over them!

RC – There is a sensual satisfaction, in the meaning of sensory as opposed to sensual in a sexual meaning, from actually manoeuvring the puppet so it can act. It's the whole 'bringing it to life' experience.

DC – I worked mainly with the Vicar in *Curse of the Were-Rabbit* and got quite emotionally involved. I knew him and why he was doing what he did and I had to understand how he felt so I could portray that in his/my acting. The better the puppet the more emotional it can be and consequently the more emotionally you get involved. I knew all the people in the church by name and knew how they would behave in different circumstances. One shot had fifty-four characters in it and I knew what everyone was doing and why. Some puppets were limited background characters and so their emotional involvement in the scene was similarly limited!! Some fell apart but somehow I didn't!

AW – In *Peter and the Wolf* I animated the shot where the wolf eats the duck. I felt horrible. I felt stupid because it's just animation, but I was affected by it. I felt like I had murdered my own friend.

SB – Because I hold a puppet just about everyday what I'm feeling varies. Sometimes I feel like I'm just going through the motions and sometimes I get absorbed by what I'm doing.

RH – I can almost always recognise my own animation, and sometimes I get a pleasant surprise when I see my own work. Sometimes, it looks better than I had remembered it. On the day you are so wrapped up in what you are doing that you become too critical and too much of a perfectionist. This is true of my case, but it forces you to do your best, and so therefore your work turns out better than you anticipated when you view it away from the atmosphere of the studio.

JC – Puppets are a little like people, some you warm to, others you don't. If a puppet is well made, allowing good movement and control, you would like it. It's more important for the puppet to have an interesting character, good or evil, funny or sad, something to get your teeth into. Good lines always help. On any show different animators will have different favourites. Sometimes you have puppets that you just don't get on with. I do prefer characters I have created. Then I know exactly where they are coming from and how they would react.

TA – If a shot was of particular pleasure or pain to do, I seem to keep an emotional memory of how I felt doing it. If I watch such shots as part of a finished film, those distance feelings do resurface slightly. This can actually get in the way of simply enjoying the film! On *Peter and the Wolf*, I did a piece where Peter opens the trailer door to release the wolf back into the wild. It's an important shot where they stare into each other's eyes and we see the unspoken bond between them. However, I get memories stirred of being so tense whilst animating it. Both puppets had lots of hair or baggy clothing and I had to be so careful where I touched them. It took four days! It's an unpleasant memory.

On *Fireman Sam* a squirrel had to animate fairly realistically. Squirrels move so fast I could move it from one pose to another in just two or three movements. You could take it off set for repairs midshot because the moves were so big. I had such fun playing with squirrel actions with no fear of limitations. It freed my work up and I have happy feelings watching those shots these days.

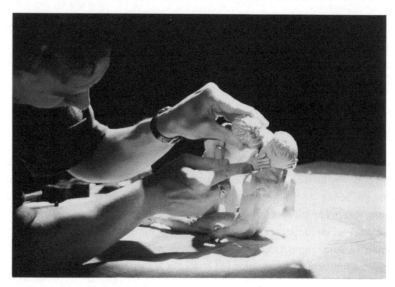

Animating doesn't get more intimate than this.

The same moment in the film *Achilles*.

Hands-on

I'm naively too much of a purist when it comes to the animation itself. The pleasure of stop

motion is the real hands-on approach, the direct intimate relationship between the animator and the puppet and the level of performance that this enables. CG animation by its very nature requires several people to create the performance, which is both a huge strength and, in the wrong hands, a weakness. With puppets, and the right direction and communication, the finished performance can be created right in front of the camera. This excites me, and I like the thrill and having to get it right first time, but perhaps I am blind to the huge potential that digital

postproduction can bring these days. So much can be shot against a green screen and the characters' actions moved around the frame, or looped or flipped. This is an absolute godsend in series production and for fine-tuning and correcting inevitable flaws, or duplicating shots, saving precious shooting time. It's a way of shooting I'm getting used to and embracing, but aesthetically I still adore the bare-boards approach of a space, a puppet and a camera. I like the puppet being able to respond to the lighting or to other characters around, or unexpected events as I'm animating. I'm a bit wary of creating a performance in editing, as I just see every action as being specific to a given situation. Of course, this is living in cloud cuckoo land as reuse is an essential part of any production. Maybe I fear the improvements done in post production as the necessary result of my bad animation, or maybe I am just too much of a purist, or maybe it might be about losing control of one's work. It takes some of the fun out of animation, but that is a totally selfish thing as the viewers should not be interested in the personal satisfaction of the animator. It is what is up on screen that counts.

My limited experience with CG animation has been mixed. I love the way that the machine can take a lot of the actual physical labour and grind away, and that you can have the luxury of preparation and rehearsal, and that you can redo moves, and that you can stretch and shrink the timing, but I was frustrated with never being able to feel the character move as a whole. The emphasis is on moving over the whole shot and not just the individual complete frame. It's just another way of thinking, and its benefits are clear to be seen, and I know if I had more experience I would find great satisfaction in being able to get those subtle shifts of weight CG can do so well, or in being able to go back and insert a gesture I had only thought of as I had been animating.

For the same reason, when I teach I am wary of too much emphasis on walk cycles, although they are brilliant for working out the mechanics of motion. I would rather get the animator to question why a character is walking, and what needs to be expressed: the performance. Cycles are good for things such as non-anthropomorphised animals where a repeated action is what defines that animal, but for a character, they walk somewhere for a reason, and they respond to their settings, and they are feeling something, and they change their movement as they get nearer their objective. These are the things I consider important. What is motivating this movement? Unless there is a good answer, I'm not sure I would move it.

What is the best piece of animation you have done … and the worst? And what is the most absurd thing you have animated?

JD – The first shot of the *Here's Lucy* title may be my best shot (three takes required) or possibly the shot in which the flower falls asleep in *Brothers Grimm*. The worst is two shots in *Jack the Giant Killer* – one with the two-headed giant walking along the beach, the other the one-headed giant stepping over a wall (later double-framed optically, which only made it worse).

TB – I was very happy with a shot from *No Exit?*, in which the skeleton pulls off his leg. It turned out very well. I've done a lot of bad animation, but one thing I wish I could have had the time to change but didn't was a shot in *No Exit?* in which the skeleton walks up a staircase. It's too long and ponderous, and jerky. It drives me nuts. Animating a Jim Carrey puppet kicking the crap out of a Bruce Willis puppet was the most absurd thing I ever did.

KD – I did a film where my character was walking in the wind and it was amazing … then the computer crashed and lost the lot. We were all just standing there shocked that it was gone – someone piped up that it was some of the best he had seen. My worst was when I was trying to have my character leap out of a box and float. It was so ambitious but I just didn't have the tools to do it and it was so frustrating as I knew what I wanted to do but it just wouldn't happen!

RC – Haven't done my best piece yet … hopefully I'm still improving my art. Worst piece would probably be the first character commercial I did. It wasn't that it was terrible or anything; I just had a lot to learn. Some of what I didn't like was the staging, which was out of my hands at that early point in my career. There were shots that had emotional connections that needed to be made in short close-ups and medium shots that were boarded as long shots. Most absurd? Well a frog holding up a pizza would be in there, as would kids being devoured by giant Venus flytrap plants (cel animation for *Creepshow 2*), as would a crawling severed hand (*Evil Dead 2*). Absurd in the overall sense, but perfectly normal in their given venues.

DC – My best work has been with Rev. Clement Hedges on *Were-Rabbit*. He was so tense and emotional and made you feel what he was feeling! My worst work is when I'm tired and unimaginative and the puppet won't help you or is being downright unhelpful! Then I get lazy and just want to get the shot done with no frills so I can go home. I did a shot where nobody moved apart from the Vicar, saying 'Beware, the moon!' There were about ten of them and they didn't even blink, because I was so tired. The director, Steve Box, was very unimpressed but there was no time to redo it. I've recently animated slugs floating on a cocktail umbrella blowing a raspberry in *Flushed Away*! It's a funny life but it's all I know. I animated a five-foot globe populated entirely with Tefal frying pans full of food dancing and chatting for an advert that no one remembers.

AW – My best animation is the wolf coming down the cliff in *Peter and the Wolf*. I've made thousands of bad shots but I couldn't reshoot them because of schedule and budget pressure. Nothing is absurd to animate.

SB – I've yet to do my best, the worst I have too many to choose from.

RH – The best I have done has been a scene on *Rupert*, where I animated a whole group of characters clearing up a mess in the woods. The worst was my first shot of Tiny in *Little Robots*, the first series I worked on. It was so slow and shaky, with no strong poses – I wish it didn't exist today! This is a testament to my progress since then. The most absurd character I ever animated was Aunt Tulip in *Fifi and the Flowertots*. She was a lovely looking puppet, but extremely difficult to animate well!

TA – The shot that I'm proudest of has to be my wedding table scene from *Corpse Bride*. This is the scene where the camera slowly tracks across the long dinner table while bad guy Barkis delivers his self-indulgent speech to eleven half-asleep guests. Now this is not the best animation I've ever done, nor is any one bit of it particularly challenging or satisfying. It was damn boring to do! It was about taking a challenge and rising to the occasion. Scheduled to take me four weeks, two seconds a day, with repetitive subtle movement throughout, this was like running some animation marathon! There wasn't an option to reshoot if the worst happened and the DOP jokingly dared me, 'if I didn't make a single mistake he'd take me out to dinner!'

Fuelled at the notion of a free McDonalds, I set about clambering around the large set on work that was genuinely intricate (i.e. knock the puppet by mistake and you've ruined everything!) and my biggest

A tender moment between aardvark and caterpillar in *Hamilton Mattress*.

challenge was to make it work despite the ongoing monotony and sheer tiredness. Being too delirious to construct a sentence to the Director and hearing the walkie-talkie 'Cancel Tim's takeaway, I'm sending him home', I completed my animation marathon, on time and 'in the can'. It was more a turning point that if I can do this, no shot can intimidate me. Plus we cancelled my Big Mac and I was treated to a very expensive sushi restaurant!

JC – I still think my best shot is from *Hamilton Mattress*. There is a moment when Hamilton is sitting on the floor a little dazed and a feather gently drops on his nose. As he studies it Feldwick rushes about him, tying a rope around his middle. Hamilton's movements are quite subtle, his body reacts to Feldwick's pulling and prodding while he seems totally focused on the feather he is holding.

The worst shot … there have been so many. Probably on *Corpse Bride* – Victoria has escaped from her room by climbing down a quilt, the second half of the scene is a bit dodgy, but the worst is the last shot of the scene, where she runs away from camera. It just looks silly.

The most absurd thing I've animated … a scrabble board, drumming aardvark, limpets circus, zombies, too many to mention. I have had an 'absurd situation'. I made a film called *Gary Glitter Changed My Life*, the story of a woman whose life changes because of something Gary Glitter says at a concert. It is gently inspirational tale and has little to do with Gary Glitter himself. (In fact the original star was Barry Manilow, but I was unable to legally use his name.) The film was shown at a lot of festivals but was suddenly dropped after the paedophile scandal. I was left with a self-funded film I could never show.

I would think it a mistake to let a character portray its main characteristics in every action. Lady Macbeth must have moments when she is not scheming dark deeds. That was the danger with Toad … he could have always been manic, but the quiet reflective moments are just as telling. If you played a character with the same tone the whole time, the audience would soon become very numb to him. The best balance is to find variations within a set of character-defining parameters. This may sound obvious, but you would be surprised at how much one-dimensional acting I have seen from animators.

My favourite cross-dressing amphibian, Mr Toad, as a washerwoman.

Stop motion is unique in that a puppet is generally manipulated by just one animator at a time. For better or for worse, this must surely focus, personalise and concentrate a performance where multiple people involved might dilute.

What sort of emotions do you enjoy animating most? Do you like broad slapstick or subtle emotions? Do you get any excitement from animation or is it just a chore?

JD – I enjoy animating comedy. Sometimes animating is a chore, but it is often very exciting, particularly when I get an 'on-camera' inspiration.

TB – I seem to be at home with drama and intense emotion, such as confrontations. But I also like comedy a great deal. I enjoy acting out subtle actions, and I feel more at home with those. I don't find animation a chore at all, unless it's working on something that I don't find particularly challenging emotionally. I found being on a week-long test shoot of *Celebrity Deathmatch* just plain stupid. I was completely bored by it.

RC – I tend to like broad motions, as well as powerful emotions. Delicate is nice, and there's a place for that, but I enjoy making an emotional statement within the physical action the best. My strengths are applying principles, and being cognisant of playing to the viewer, and relationships in the scene, and clear staging, as well as timing relationships so motions and statements are clearly defined

DC – Variety is the spice of life. It can be very exciting but also very dull because it takes so long. When a shot is interesting for whatever reason, difficult emotional content, new character, complicated action, etc., it is much easier and rewarding to work so long and hard. At the end of the day/week you want something to be proud of.

SB – Anything with a strong emotionally resonance is good to animate; you get a lot of flat talking shots in series work. You can't beat a bit of slapstick.

RH – I'm nearly always excited by animating, and like animating the subtle ones' emotions. I like a good mix of these with broad, bigger movements, especially in the same shot. I know that using rigs can push a character's movements, but I'm not a big fan because they need fiddling with – and sometimes the puppet needs to be taken off the set to attach it. Then, you lose the sensation you've been feeling all along, and you're back to square one. The results are usually satisfying though.

JC – We all have days when animating is a chore but over the last fifteen years those days have been few and far between. Most studios are great places to be. Outside of the pressure of deadlines you spend you day with creative talented people from many fields: costume; puppet-makers; set-builders; prop-makers; camera crew and directors. I like animating the 'up close and personal' stuff. Anything I can get my teeth into …. I secretly wish I got more bad guys to animate. There was a show at Cosgrove Hall called *Rotten Ralph*. The puppets were tricky, lots of fabric and fur, but they had such great characters. When a new script came in the crew would be excited to read it (a rarity on children's series).

On the Set

On set of the winter sports episode of *The Wind in the Willows*.

Securing a puppet

Before beginning to think of performing a puppet you have to make sure you have control of it. When new animators come to hold a puppet for the first time it often comes as a surprise that the puppets have to be secured to a floor of the set. I'm not sure whether they had assumed it was like drawings or CG where those lucky guys have managed to cheat gravity. In spite of all our tricks, we still need to balance a puppet when a character is walking or running. Gravity is very much part of our work. In a run a puppet is off the ground for part of the cycle, and even in walking the character is unbalanced as it moves forward. Its forward momentum stops it from falling over in real life. Walking is basically unbalancing forwards, but throwing a foot forward to catch yourself, then unbalancing again. Apart from securing a foot while the other foot is moved through a walk position, it's always good to secure the puppet tightly to a set so you have the right leverage to move the rest of the body. As you are manipulating the torso and arms, the last thing you need is for the lower body to be sliding around.

How you secure the puppet to the set is usually dependent on what the set is made of. I have worked on a very soft fibrous wood, and hated every frame of it. The only way the puppets could be secured to this was by nailing or pinning them on every step. The particular puppets had a small bar running down the length of the foot, which could only be accessed by peeling back the material of the shoe, then rather clumsily banging a small nail through a hole and into the set. It didn't offer much secure contact, and to remove it, you had to peel back the shoe again and then lever out the nail with a pair of pliers, usually knocking the puppet with the force required. Just getting to the foot was time-consuming and way too fiddly.

A more productive way is with tie-downs. This takes a good deal more planning, as you need to plot the path of the character through the frame, before you start the shot. Ideally, you would drill holes in the set, and then plug them with Plasticine. The set could be thin wood, perforated steel or any suitably thin but strong material. These tie-downs consist of a long thread and a tightening wing nut. You place the preferably flat foot over an appropriately predrilled hole, then screw the thread through the hole and into a corresponding hole in the foot. Once you have a good contact, you lock it into place tightly with the wing nut. This is a strong method of securing puppets and you can hold the body tightly and bring it forward a few millimetres, forcing the heel to peel naturally off the floor and into the next position. If the joints are strong enough, the puppet can balance in even the most precarious of poses. One disadvantage is that you leave holes in the set, but these can be refilled, and you need to be pretty specific in working out in advance where the puppet is going. You usually need an assistant to do the screwing of the thread while you hold the puppet on the set above, unless you are lucky enough to be able to reach both the screw and the puppet at the same time. You cannot let a foot land then decide to drill a hole. This entails sticking to your plans. Very small tie-downs can allow the puppet security on the tiniest of surfaces such as a step or a branch, and are especially good for small, delicate feet. The Cosgrove Hall series *Brambley Hedge* needed the mice to be on tiptoe and not on the full flat foot, and this method was perfect. Fiddly but perfect. You could even put a hole for a tie-down in the toe of a character should they want to be *en pointe*. Tie-downs are also particularly good for shoes with high heels. This method allows for animating on some pretty uneven surfaces. I find it a bit time consuming and tricksy, and much prefer working with magnets.

Magnets are such a boon to an animator. Time and time again they offer a strong bond while being totally removable. Securing a foot to a set with a magnet depends on having a rather flat surface, and like tie-downs, the set must allow access to both the magnet under the set and the puppet above the set at the same time. I have a long and happy history of working with perforated steel sets: the perforations are brilliant as they seem to localise the magnetic field, and when you are looking from underneath the set, you can generally see the position of the foot under which you are trying to place the magnet. I have worked with inexperienced model-makers who had heard about this idea of magnets, and thinking to make things easy,

put the magnets in the foot itself. This is pretty disastrous since it makes it pretty impossible to place the puppet's foot just millimetres above the surface, as the magnet will drag it down straight away. By having the magnet under the set, with a metal surface, you can remove or place the magnet in position only when you need it. If you need to lift the foot off the floor, just take the magnet away. Again, I have worked with green set-builders who did not understand the magnets and made some rather gorgeous sets with unmagnetic surfaces; the magnets would only

stay in position once the foot was on the set. Any slight separation of the foot from the surface and the magnet went crashing to the floor, smashing into a dozen expensive pieces. There is no doubt that magnets are a great device, but they are expensive, and can catch your fingers if two get too close to each other. Many an animator is seen with blisters from jumping magnets. If you look at an animator's hands you can probably tell whether they use magnets or tie-downs: blisters from being trapped by magnets and painful pricked skin from the tie-downs.

Magnets have the advantage of not marking the surface of a set, although an animator's trick is to stick a pin through the surface and use this as a guide for locating the magnets. The damage by these pins is negligible. Magnets are brilliant for using with props, especially props that need to move during the shot, but you don't want them to move too easily by themselves. Magnets seem to me to be a much more sophisticated approach, and cause the least interruption to the performance.

Other than rare-earth magnets, tie-downs and pins, another method of securing a puppet to the set was tried on the film *Hansel and Gretel* in the 1950s. This involved magnets again, but these were numerous large electromagnets under the set. I assume that they were quite localised. An apocryphal story has a technician leaving at night and turning off all the electricity, followed by the sound every animator dreads so much: that of numerous puppets falling over with a series of dull thuds, undoing the whole day's work.

I was involved in a commercial for a house-cleaning product, with the idea of having a toy boat, representing a young child, racing round the house at great speed. Now, having a toy tug imbued with the actions of a child was one thing, but animating this boat was another. The director wanted authentic shiny surfaces everywhere, and as is the way of these things, tiles had been imported from Italy and covered the whole of what was in effect the ground floor of a house. We had designed the boat with little legs and a good chunky boot at the end. I wanted a very quick up-and-down motion in the legs, as if this child was excitable and impatient. But how on earth could I make this boat, probably sixteen inches in length, able to stand on one leg while standing on the most slippery of shiny tiles? I cannot claim to have come up with the answer … the ingenious guys at Asylum Models take that credit. The solution was clever but time consuming. Each leg had several replacements. One was tucked up under the keel of the boat, another was half way down and the last was flat on the floor. The foot that rested on the floor last was filled with as much mercury as it could take to give it weight, while the raised foot replacement was hollow. This more or less balanced the boat, but to give it extra balance, inside was a heavy weight that could slide from one side to another, acting as a counter-balance. It was a kerfuffle to do each frame, but I'm happy to say that I managed to get a lot of expression out of this boat. It had a replacement smile and rocking mechanics inside so that it could tilt as it went round corners. I also borrowed a few tricks from Tom and Jerry and other classic cartoons, which I was a little nervous about with such a flesh-and-blood toy. In one shot it fell over the edge of some stairs, but its little funnel 'hat' stayed in the air for a good dozen frames before catching up. A 2D gag like that almost breaks the physical rules and logic and credibility we strive to set up with puppets, but it seemed to work here, probably because of the colourful design of the toy. I also had it skidding round corners with its rear end going wide. It echoed those scenes where Tom chases Jerry round a corner but his back legs carry on going in the original direction in a circular blur. The skidding, with the legs working madly away but not actually covering the ground in a corresponding way, was effective in showing how shiny

the surface was. An agreeable commercial to work on, but after I'd crawled my way into the huge set wearing tile-protecting rubber kneepads, some technician had to follow me polishing the floor again. CG would do it so much more easily today, but we wouldn't have had such fun, and would the boat have had the same physicality? CG might have saved my knees, though.

Another challenging commercial saw me having to balance a toy elephant on a huge ball and appear to walk the ball up a large slope. Balls of any kind are notoriously hard to control, as they roll about. Having an elephant balanced on top seemed a recipe for disaster. I decided I wanted to have the elephant secured on the top of the ball by one foot and then fake some leg movements that would give the impression of it turning the ball as it walked up the slope. By securing the elephant, this meant that the ball itself could not revolve, so we shaved a tiny slither off the base, and inserted a good strong magnet in its base. The slope was metal, so this ball was quite happily located, but I still needed to give the impression of it spinning. So we came up with a pattern of circles lined up with the direction of travel, so you wouldn't notice whether they were spinning or not, but then we made a big star shape that sat over the shape of the ball which I animated frame by frame as it 'rolled' up the slope. The illusion was perfect, and the ball totally controllable. It's probably having to think totally outside the box when faced with things like this that make animation so exciting. Just a trivial problem, but great fun to solve. Since then I always shave a bit off the bottom of wheels, or balls, so that they rest flat and do not roll away when I'm animating, and if some motion effect is necessary I just move a hub. Simple and effective.

Is working with puppets a two-way relationship?

JD – Well, I once swore at a puppet when the tie-down broke and the puppet fell off the animation table, but I usually don't talk to them. Since I am the 'actor', the puppets sometimes mirror my poses if they are humanoid. It is not unusual for a puppet to suggest other poses and lead the animation in a new direction.

TB – There is room for improvisation. Beginning a scene, I stay until it is finished. If I can't, I'll take copious notes of what was happening (I can also see the playback the next day), so I can continue with the performance the next day.

RC – As far as the character guiding, I'd say that is in the prep, and knowing your character; after that, it's being true to it. I never felt I was animating a part of the performance that wasn't true, and the character was letting me know. We often tend to animate certain things the way we would do them, but perhaps with a bit more flourish (if appropriate), as long as it's right for the character.

DC – Yes! Sometimes it's hard to suddenly talk to real people. 'A cup of tea! Do I want a what? Where did you come from? ... When!'

AW – I always feel like the character is guiding me. I always stay in the scene at night.

SB – I animate pretty loosely so there are times when the puppet is guiding me. This doesn't always work out for the best, but I find if I have too much of a rigid plan it'll start to go wrong as the puppet will bend or move in a way I hadn't predicted.

RH – I do usually feel a strong relationship with my puppets, although I do mentally leave them at work when I finish at night. And I do sometimes talk to the puppets as though they are real, living creatures – but only under my breath!

TA – When I animate, the instinct kicks in and I simply do what I feel is 'right'. It becomes unconscious and I find it very hard to cut corners (we've got deadlines to meet!) and not adjust my puppet if I feel it's in the 'wrong' place. Thinking about the decisions I make every frame and trying to explain the thought process help me understand the skills that I take for granted, making me a better tutor and animator.

JC – The puppets can suggest things to you. An armature can lend itself to a certain walk, though the puppet's perceived character is the strongest guide. I constantly mirror the action of my puppets. It's the best way to think about how they would move, to work out balance and timing. On occasion it is useful to get someone else to act out tricky moves, and then you can not just feel what your body is doing within a movement but see it too. It's hard to switch off at the end of the day. I find I work through movements in my head, often acting them out in the shower the next morning.

Letting a gesture read

Like moves in a dance or words in a sentence, a gesture must be given time and space to read, otherwise itwillendupasabitofamessmergingintothenextone. This is essential … gestures often do not make sense until you have gone past them and had time to absorb the pose or the rhythm. A rhythm isn't a rhythm until a pattern has been formed. Think of gestures as punctuation in a scene, and many are a 'full-stop' type. Let it register before you are ready for the next one. If lots of gestures run into each other at the same speed they become totally meaningless as you do not have time to separate them. The eye needs a few frames to think about something before it is ready for the next image. Try to avoid any significant gestures in the last couple of frames in a shot, as their shape will be lost in the cut; likewise, don't do anything important on the first frames of a shot. Let the eye adjust to what it's seeing, and let the movement guide the eye to what is important. While filming *Hamilton Mattress* I drove everyone mad with 'don't forget, five frames and a blink!', but it is good advice. If a character was to shout defiantly 'go away!' that is quite a dramatic moment, and you would not cut one frame after the last sound. You want to see the character clearly in that dramatic moment, and then relax out of it for a few frames. The relaxing is just as an important part of the pose as is the storytelling part.

A bad pose with messy lines and shapes and no weight or movement. It doesn't read as anything.

Elegance was once described as the maximum of expression with the minimum of movement. That's another way of saying that it pays to be economical. I drum it into students that an audience would rather see one beautifully thought-out and paced movement than five clumsy, awkward ones that do not have time to read.

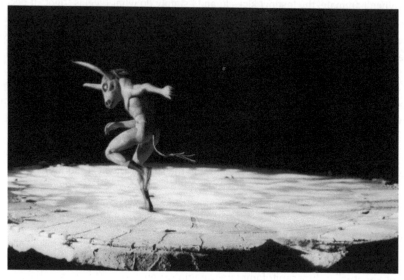

A clearer shape with an implied sense of movement and weight.

Shape of movements

A tip for any move is to imagine a marker at the end of the limb. Over the series of frames trace that line through space. If it is a jagged line which stutters then you can guarantee it's going to be a jerky and ugly move. This may be intended, but if you're after a clean, readable move, the line traced should be a clear contour. This is about relating a move to the previous and incoming frame: that is the most basic fact about animation, that consecutive frames must relate to each other, otherwise the eye cannot make sense of it. You cannot just think of the frame you are working on. It is just one of a sequence. By looking at each frame you should be able to work out which way a limb is travelling. If you can, draw on the monitor itself, plotting a neat line, to help you become aware of the shapes you are making. This can help to gauge the rhythm of a move. The worst move is one that is mathematically divided into even parts. The best is one that starts with small increments then builds before coming to a halt with small increments. If you mark each frame you will be able to transform a few dots spaced apart into some concept of speed, much as a musician can feel the pace of a musical score by the closeness or gaps between the printed notes.

In any action, like a walk, there are going to be dozens of different bits moving at the same time, and you need to make sure that each of these has its own shape and pattern. If you trace

these movements, you will get some surprising and beautiful patterns. Norman Maclaren did something like this in his experimental films, especially in *Pas de Deux*, which illustrates very succinctly the shapes made by a body moving through space.

When turning a head you can mark out the move by drawing a line through the eyes on each frame. You're unlikely to want the head to be dipping or tilting

up during a turn, and if the eyes follow a clean line, the turn will be easy to read. The eyes in particular will want to follow neat clean lines; if a puppet wobbles its head about too much, it is clearly not focusing on anything. If a head wants to focus on something, it will find the most direct route there, without bobbing about. It is particularly useful to plot the movement of the eyes in a walk, as we usually focus on something, either a set distance in front of us or the pavement, or on the door we're going through. I would draw a very gently undulating, almost straight line through the eyes, and have them follow along this path as the character walks. This is not real life, but it will give a controlled shape to the movement of the head which, left to its own devices, can be thrown all over the place. As the dancer finds a spot to lock onto when she is spinning, you could make an X on the screen, the focus of the character's walk. Walk the puppet, making adjustments to keep the puppet focused on that spot. It will make things very clear.

Think of a swan with a beautiful long curving neck. As it bobs about, much of the rise and fall is absorbed by the curvature of the neck, keeping the head on a level plane the whole time, and the head focused.

In your exhilaration at things moving was your early work overanimated?

JD – I am more disciplined now.

DC – Well yes, of course.

AW – Yes, definitely, everything moved too much. I try to make gestures read more now, yes.

JC – When I first started animating I was both exhilarated and disappointed by what I produced. My first attempts to create movement were jerky and much too fast. There was no sense of timing or balance. I was disappointed and felt that I could produce much better. I've learnt to control the puppet and myself. Often the pauses and held poses are more important than the movement. As Barry says, 'give the audience time to read a pose'. I now produce good work but it rarely lives up to my imagined end result – a common feeling among animators. We're always striving to improve and reach perfection.

Physical quirks

Working in stop motion is a surprisingly physical job and with it comes problems, although I'm sure that sitting at a keyboard for the same period every day or bent over a lightbox brings its equal share of physical problems.

Stop motion animators are usually on their feet for at least nine hours a day, working in hot, bright, necessarily airless conditions; concentration often gets in the way of noticing this too much, but you will see animators standing on a carpet square. Most studios, to stop any external vibrations, have an unremitting concrete floor, so anything that can ease the standing has to help, whether it is carpet, slippers or bare feet. Nearly thirty years of animating seems to have given me calves that a carthorse would be proud of.

There is no way getting round the bending, stretching and twisting. Fewer films shot on 35 mm cameras has made things a little easier for animators. These cameras were huge but fantastic monsters. Put one of these near a set for a close-up and there is little room for an animator. With the dexterity of Houdini that animator has to manipulate himself carefully at very odd angles, being careful not to knock the camera, and twisting to avoid large sheets of poly board and carefully positioned hot lamps (many animators carry scars from intimate contact with these lamps). Once into the set, the animator plays with the puppet, feeling every muscle in his lower back grinding away from such an unnatural position, before sliding out of the set backwards. Doing this some 250 times a day inevitably causes back problems. Many studios hire a masseur or a chiropractor, or make sporting activities easily available. One studio had the genius idea of having the camera mounted on a motion-control rig out of consideration for the animator. After an exposed frame the camera tracked back, courtesy of a computer, out of the way, letting the animator do his stuff in comfort. Once done, the camera resumed its position. It made life easy for the animator, but it needed an extra person and slowed the process down, and I'm not sure that I trusted the camera to find its exact mark in each frame.

Proximity to hot lights does little for the skin or hair, and the close-up work of manipulating eyelashes on a small puppet does strain the eyes. Animators drink a lot of water as by the end of a day the studio can be relentlessly hot. Fans can be secreted on the set, but there's the fear that they will move something. There's no way round the heat and all the bending, but it is worth considering the physical side of animation before jumping in. Good set designers and lighting cameramen will make the set as accessible as possible, but inevitably there's a lot of climbing, kneeling, hunching, squashing and stretching. At the end of a day's shooting, with the intense concentration and the physical side of things, you feel every frame.

I have found being able to type useful (I learnt to type to music, which still makes me speed up or slow down depending on the music I'm listening to) and numerous attempts at playing the piano have given me, if not quite the dexterous and versatile hands of a marionettist, hands with a ten-note finger stretch. This is advantageous when working with puppets, as often you are called upon to clutch a puppet with the thumb and next two fingers of one hand, while trying to manipulate its limb with your outstretched little finger. If there was a word for digital (as in fingers) gymnastics, then it is definitely to be encouraged; presdigitation is a good word, and it relates to the magician's art of working with the fingers. Simple piano scales are effective in loosening the fingers. Having short, fat dumpy fingers is not going to make animating easy as you need to get your fingers into extraordinary positions, and be able to poke and lever small things. Having decent fingernails helps with the fiddly side of easing out eyes or replacement pieces, although the disadvantage of nails is that they can tear the skin of a puppet too easily. Playing the piano or working on a keyboard also develops a precise mental muscle memory in the fingers. I never look at the keyboard any more when I'm typing, and am very aware of where my fingers are spatially, always a good skill when handling a puppet. Strange, the things we need to think about.

I fear that hours spent in bright lights peering at something inches from our faces doesn't do the eyes much good, especially with the constant moving from the bright light to the darker off-set areas. Still, I'm lucky enough to have only started wearing glasses a couple of years ago, but it did get to the point where I simply could not focus on the puppet's face.

Hard things to animate

Probably one of the hardest things to animate in stop motion is a snake. To progress a snake forward you cannot just move it a fraction; every element of the whole body has to be radically rearranged, as each bit of the snake finds itself on a different part of a curve in every frame. I've often pondered how to animate a snake. I thought of having a featureless skin and a long body made up of identical replacements, with just the head and tail being different. Each frame you could take the head off and take a piece from the end and put it behind the head. That way it would have progressed a bit without having disturbed the whole body, but that would only work with identical replacements, and you would be stuck with a certain speed and no taper to the body. In fact, that's a pretty useless method unless highly stylised. Perhaps if you slackened all the joints of an armatured puppet, it could be manipulated easily along a preplotted clear path, and you might not notice too much twitching as you reshaped it for each frame. Alternatively, you could rethink the whole movement, basing it on one of those side-winding snakes that get themselves into a certain condensed shape and then spring themselves forward. Different snakes move in different ways, and it is a hard movement to replicate, although probably the rhythm is the storytelling factor here. In an advert for Aardman and Ariston I did venture to animate a snake, although this was highly stylised as it was a tie and was vertical like a cobra. As the front section locked off, the back was brought up tight and then the front was levered forward. Then all this was repeated. It was a good effect, but hardly true to snakes. The realistic way is not always the best way to animate.

Touching

A rare tender moment in *Rigoletto.*

Achilles and Patroclus together.

I'm always encouraging animators to get their puppets touching. There is definitely a frisson when a puppet responds to another. Sometimes I have taken this quite far in my films, with various sexual scenes, but even with the mere holding of hands, something extra comes across. These lifeless bits of wood, brass and silicone suddenly connect with each other; not only have we appeared to give them life, but they are responding to each other. However, such intimacy is often quite hard to animate. Holding hands, for example, can present problems peculiar to stop frame; well, that's not quite true. Most animators have problems locking two objects together and moving them forward, but for puppets this can be particularly difficult. Imagine two separate puppets, one pulling the other forward, with their hands folded round each other. If you move the leading puppet, ideally you need to move the puppet behind at the same time, but as the animator only has two hands, this becomes a tricky task. It's not just a question of moving the first puppet and hoping the second will follow. Practically, you need to untangle the hands, move the first one forward into an appropriate position, then move the second one to catch up. It's repositioning the hands in the same grip that is difficult. The angle of the arms will have changed in relation to each other, and having taken the hands apart and put them together it is unlikely that you will get them in exactly the same position, and they will twitch,

making it look as though the characters have a very shaky and loose grip with each other. One way to get round this is to give the arms a very definite movement of their own, such as a swinging movement, so that any twitching about in the hands is disguised in a larger progressive movement. Very often it pays to distract the eye away from a necessarily insecure movement with a much larger controlled, clear and confident movement. You won't notice anything weak going on elsewhere if there is something good to hold the attention.

Takako and Naoki's brief moment together in *Screen Play*.

Circles

Another difficult situation to animate is characters or objects in a circle. Imagine a group of a dozen characters dancing in a ring, or even twelve coins in a circle, and they need to move to the left. Number 1 needs to move first, but it can't as number 12 is in its way, so practically you'd need to remove a puppet each frame to allow the progression forward of all the others, and then carefully replace it. This is tricky, as it is nearly impossible to remove a puppet and then try to get its feet back in the same position, but there are moments when we have to take a puppet out of the set to be able to animate it. Imagine the difficulty of animating twelve characters in a circle all holding hands. An answer to this would be either to change the choreography, or to use some very creative camera angles, where there are some master shots, where we see everything, but then in subsequent shots just give the impression of dancing. I did a commercial shoot involving an animated face made up of hundreds of peas and grains of rice, very much like an Arcimboldo painting. Not only did I not have the time to animate each grain into a new position, but the face would have twitched hideously, looking as though its face was crawling. A lot of movement was required out of the face, and thankfully there was a plain background: so plain that you couldn't tell it that actually moved on a turntable each frame, giving the impression of the face moving. I moved certain elements of the face at the same time to confuse the issue. Happily it worked well, otherwise I might still have been counting those grains of rice today.

A similar cheat was with the many rats in *The Pied Piper of Hamelin* for Cosgrove Hall. There were just not enough hours in the day to animate each of those rats. Admittedly, there wasn't much to animate on them, as they were two inches of solid flocked rubber with an animatable tail. We were relying on sheer force of numbers rather than beautiful animation. We started to animate them individually, but tore our hair out very quickly, especially when there were a few we had forgotten. The solution to moving them all was to stick groups of them on some fine netting and drag the netting along for each frame. Cheap, and in the context it worked adequately. So that it didn't look too mechanical and uniform, we animated a few separate rats darting in and out of the main crowd. *The Pied Piper* is a story that has always been with me, particular

because of the mysterious outsider and the nasty twist in the story. I would definitely like to return to it one day. Our film just about stands up today, but it was quite remarkable at the time, considering what else was on television. A few years later, Jiri Barta's extraordinary, dark and vicious animated wood-carving version came along and became perhaps the definitive version of the story. It featured amazing chunky puppets carved out of wood as if they had stepped off some wooden panelling. Our version was clearly intended for families, but Barta's provided the imagination and truly unsettling nature that perhaps ours did not quite have.

There are other circumstances where you have to work hard, animating for very little obvious result: a character leaning forward against a wall, for example. It looks so simple on film, and the easiest way would be to lean the character in, while holding his hands flat against the wall with your fingers. As you push the character forward you keep his hands in place, by keeping them located, which is much harder than it seems. Animation looks pretty clumsy when the point of contact, like shoes on the floor, or hands against the wall, is slipping all over the place. It instantly ruins any illusion of contact and weight. The most practical way to do this scene would be to draw the exact position of the hands on the monitor, or make some subtle visual mark on the set itself. For each frame that the character is moving forward, it is likely that you will need to pull him back a bit, then readjust his arms by pulling them back, allowing some space for the body to move forward. You will then need to reposition them precisely again, adjusting the angle of the wrists for maximum contact. Any form of contact is hugely fiddly to get right, but the results will look easy and natural.

On the studio floor

The studio set-up is highly dependent on budgets and schedules, but it is unlikely that one animator is going to film every shot, whatever the size of production. Usually several shoots are filming at once, needing duplicate puppets, duplicate props and often duplicate sets. The recognised way of working is to allocate one animator to each camera set-up, but I have worked in many set-ups. On some of the early shoots there was a team of animators, each with specific characters that were yours alone. This successfully gives a consistency of performance throughout the film, but it is less successful around the camera itself. With a team of two or three, it can mean a lot of downtime for those animators whose characters are not involved in the shot, and there is nothing worse than a restless animator. Even worse was having one animator animating the shot, while the other sat down and clicked the button and operated whatever technology was necessary. This led to awkward body language and uncomfortable situations involving hierarchy. The animator at the set cannot help feeling slightly superior to the one with the menial task of pressing the button, or feeling a little embarrassed about continually asking the other to press the button, or keeping them waiting, and having to say 'thank you'. You feel that chat is required, or feel rude for asking for silence while you concentrate. Just having a presence there the whole time adds unnecessary tension.

Animators may be performers, but they do not like audiences. It is a minefield of etiquette and invasion of personal space. It requires animators to communicate like dancers. If you don't talk and work out exactly what happens on the set, you will end up with characters happily doing their own thing in their own space in a dead shot. Under these circumstances I can tell which puppets were mine, and there is an invisible line drawn down the shot, dividing the puppets of the two animators. Achieving any spontaneity and reaction among the puppets

is downright impossible, as is timing a gesture, when you are not certain what the other puppet is doing. One can happily animate a puppet to the other, only to find that the other has casually wandered off, leaving you looking awkward, in the middle of an empty gesture. Even if animators do get on, communicating almost telepathically, it still takes a lot of valuable studio time to work out who is doing what, who does it first, and where, and it is simply more sensible for one animator to do the whole shot. This can mean one animator unfairly having a dozen characters running about madly, while another has one puppet in a simple close-up. The subsequent difference in the secondage shot that day is hard to explain to the accountants. Usually, things balance themselves out, but there is a great joy, for me at least, in working alone on a set. The director has explained everything, and you are left to concentrate, knowing exactly what is happening. Two puppets shaking hands can be timed with a precision impossible with another animator. Timing reactions between puppets is disorientating when a moment on film in a split second takes a good half hour to film, and having a second animator will only confuse things even more.

Puppets pick up on nuances from other puppets when you work by yourself. You can adjust the whole composition of a shot if it goes astray. Trying all the various permutations, there are many advantages to working alone, especially if you are able to do the whole sequence. Inconsistencies in performance are less noticeable outside complete sequences. If different animators do consecutive shots, the different animation styles and rhythms are very obvious. It is extraordinary how differently a gesture can be interpreted and timed from one animator to another, and it takes a good animation director to set a rigid lexicon of physical behaviour and body language at the beginning of a show, pulling all these differences together into some consistency. This is no different from dancers and actors, who all have their own way of moving or speaking, even with set choreography.

Animators working alone are cut off from the other sets by heavy black curtains, which have the practical value of preventing any light spillage, but also help the animator to focus on his own space, often oblivious to the outside world. With personal music players, animators can cut themselves off even more. Outsiders may find it odd to hear so much music being played in a working studio. It depends on the music and how intrusive it is, but far from being annoying, it helps to block out other distractions. Personally, when working I prefer light classical music playing, invariably ballet or even opera. Clear words, especially the radio, distract me as I want to listen, but gentle music is a real aid to concentration and a gauge of progression. I cannot walk away in the middle of a shot and take a telephone call, preferring to film in a complete chunk of time. Walking away feels odd, and feels a little rude to the puppet as well … very bizarre. This is all about me seeing animation as a performance, and a performance that already has too many interruptions. Some of my better animation has been of a move–click–move–click–move procedure. Having done the preparation, I just want to get on with it, ignoring the doubts that playback can suggest. Other animators, however, can happily take a break and carry on a good while later, and you cannot see the join.

What is in your toolkit next to your workstation?

Answers included:

Surface gauges and tacky wax, plus a few sculpting tools and clay (for blinks, etc.); a ruler or tape measure for plotting camera moves; some clay for refilling drilled out tie-down holes; a hand drill for tie-downs; lots of water; a bathroom comes in pretty handy; everything but the kitchen sink; all sorts, glue, tape, tools, nylon string, light meter, stopwatch; white editing gloves to keep the puppet clean; an exacto knife; paint for touch-ups; replaceable mouth or head sets, X sheets; extra tie-downs; tools like a dentist's kit, some from pottery and sculpture, some actually from dentistry; babywipes to keep my hands clean; previous bits of favourite Plasticine mouth shapes and eyelids; tweezers, Allen keys, wooden paddles, pens, pins, wedges; cocktail sticks (which have multiple purposes); Vaseline (useful lubricant for eye pupils); cotton buds; lighter fuel/water to keep puppet clean; pencils; chinagraphs (useful to mark on monitor); highlighter pen (useful for dope sheet notation); Perspex blocks (helpful to discreetly steady a puppet mid-walk); scalpel and blades, fishing line; safety cows (small foam cows placed on the end of Climpex rods or other sharp objects around the set); A 'Mid Shot' sign; talcum powder (to remove the shine from latex puppets and as a barrier between Plasticine heads and mouths, easier to remove and replace); lighter fuel as a 'de-bonder' for some glue; KY Jelly (useful lubricant for tears), glycerine (makes great raindrops or tears); chocolate.

Drawing away at a lightbox or hunched over a keyboard may bring its own physical problems, but not usually the heat of a stop motion studio. In a big set-up, there are usually half a dozen or so animators enclosed in small areas by heavy drapes, with dozens of hot lights inches from them. It's a killer but is part of the job. It makes for sweaty working conditions, but the heat also causes problems for the puppets. It can disastrously tighten or loosen joints (both human and puppet!), and the sweaty animators' hands ultimately make the puppets dirty and tacky. A quick brush of talcum powder can help, but can dull the colour. The heat causes problems for the sets, expanding and shrinking them in the cold overnight. This makes the floors buckle, with cracks appearing. This is mostly fine, but if you have a lengthy shot that has to be left overnight, be prepared for some movement of the set. A director can anticipate this in the staging by allowing for the insertion of a suitable close-up if necessary. The trick is to make something interesting happen in the close-up. Directors cannot structure a film around shots that can be completed in a day, otherwise the pacing of a film would be frantic, but they do need to be aware of the physical problems of shooting … and there are many. I love the challenge of a long shot, not just sustaining it in technical terms, but also sustaining the interest in the puppet. The nine-and-a-half minute shot in *Screen Play* was done without moving the camera, but we did unload the super 16 mm rolls every week. The film was

structured so that any changes in colour temperature or slight camera knocks would be absorbed by visual distractions. I needed to choreograph the action so that the Recitor could come off the set, to be straightened out and cleaned. After particularly long complex scenes shrinks as his joints fold in on themselves or become twisted. His white mask got grubby in the process, so with a valid excuse to disappear behind a screen, he was taken off set for maintenance and emerged a few frames later as good as new, ready for a new scene.

Using the Body

Silent comedy and mime

Any animator can learn from the silent comedians. It's these great physical performers with whom I have most empathy, through their use of body language and mime and the all too real tricks and stunts. My personal favourite is Buster Keaton. With his lack of expression, the totally flexible body and the pushing of his physicality, it is easy to see parallels with what we do with puppets. A favourite sequence is in *The Playhouse*, where he plays all members of the orchestra, the people in the boxes, and then a complete minstrel show, all beautifully in sync with each other, with no suggestion of any joins in the screens. A duet he dances with himself is so precise that it's hard to believe he had to stop the camera and start dancing again on a

Buster Keaton and that falling house: *Steamboat Bill Jnr* (Richard Haynes).

different part of the stage, and without any reference other than feeling the part. Later in the same film he surprisingly uses a bit of pixilation for a chorus of tumblers. In another film, he has some cast members come in with various limbs and assemble them, only for the character to walk off very much alive, all without an obvious cut; a trick that Georges Méliès would have loved, and probably did many times, and a trick not dissimilar to any of ours.

I get the impression from biographies that Keaton was far happier with gags that relied purely on his incredible physical dexterity and versatility, than on mechanical effects, and I feel much the same about the stop motion I have been involved with. I would be very happy with a simple wide shot showing a full-length puppet with a space for him to move around. I would like the tricks to come from what I could do with the puppet rather than any special effects. I am very much the purist. Give me a few props and I'm sure I can get a good story going: bare boards and a passion. I would love to build a series around a central persona, for a series of comedy-led films that did not rely on words, but told their stories totally through pantomime and body language as Keaton does. This mime is not the mime that involves the shorthand of pointing at wedding rings and fluttering hands over the heart, but much more about communicating emotion through a walk, a ripple through the body, a pause or a well-timed prat-fall out of a window. Much as I adore ballet, and I do, my heart sinks when various 'mothers' start pointing at their fingers then at various princes. It seems to be cheating, as they are capable of saying so much through their bodies and dance, and this literal spelling out seems to be a bit of a failing. I know that it's a convention going back several centuries, but it's all a bit obvious and stops the flow. There must be choreographic ways to convey the same thoughts.

There have only been a few occasions where I have had to resort to wedding-ring acting, and one was in *Achilles*. This was fortunately in the play scene, so the scene was quite stylised, and a lot of information had to be conveyed very quickly. Achilles and Patroclus act out the story of the other lovers. Patroclus, acting as 'Paris', flutters his hands over his heart at seeing 'Helen'. Achilles as 'Helen' taps her wedding-ring finger and removes a non-existent ring. I doubt the Greeks wore wedding rings as such, but it did convey very quickly that Helen was going to run away with Paris. I'm reluctant to use this sort of acting, but here it worked as it was removed from the main convention of the film. I similarly dislike pointing fingers to the mouth for when a character is thinking, and reprimanded an animator who did just that on *Hamilton Mattress* for acting as in a bad children's television series. There are far more interesting ways of conveying things, and I find these visual shortcuts lazy, unimaginative and dull.

It amazes me how silent comedians were able to time a gag on film and make such finely tuned films without being able to see any playback, but most of these performers come from the theatre, where gags and storytelling have to be told without the safety net of retakes and editing. It becomes totally instinctive. Many of Keaton's gags have some mechanical or set element that could only be done once, and that sort of pressure must keep you on your toes. The preparation must have been extraordinary, especially for films such as *The General* or *Steamboat Bill Jnr*. There are several sequences where you can see Keaton having to think quickly, still in character of course, as something has gone slightly wrong, such as in the scene where he is washed down some dangerous rapids and even though his safety wire snaps, he still keeps in character. In many respects that is how stop motion animators work. We do the planning, but generally only get one chance at a shot, thinking quickly if things go wrong. This can be exciting and terrifying. Sometimes you scream, wishing you could press a button and rewind

the shot, but again this is the beauty and the very nature of stop motion. It is unpredictable, and that is what gives it an edge over other animation.

Humour

I find timing gags very hard, especially gags that need setting up with a subsequent pay-off. Most of the humour in my films is contained within a single shot, or comes out of a bit of character business or a visual pun. Plotting gags throughout a film does not come easily to me, and to some extent it is a mathematical process. A gag falls flat if it is mistimed by even one frame, and working in such scrupulous detail, it is easy to lose sight of the gag itself. A favourite gag is in Nick Park's *A Grand Day Out*. Wallace and Gromit are on the moon and they kick a ball, with the gag being that after an exquisitely timed pause and a suitably nonplussed expression from Wallace, the ball doesn't float back down. It's funny for numerous reasons, but especially for the absurdity of while they spectacularly ignore the laws of science, the ball unexpectedly obeys them. This is a nod towards the ridiculousness of it all. The introduction of a beautifully textured cooker on skis turns up the absurdity, but the real laugh comes much later when we have forgotten all about the ball, and the adventure over. Suddenly the ball reappears. In a script of mine, I have a similar gag which works on the page, but who can tell whether I would have Nick's perfect timing. A group of Venetian tourists, who just happen to have bird heads, is attacked by birds. This is very much an Agatha Christie/Hitchcock film, and the victim is a small child holding a red balloon. Avoiding seeing his gruesome demise, we would see a flurry of wings and the red balloon, miraculously unscathed, rise slowly out of the mêlée, with a small hand still attached, and very little else. A gruesomely black gag, perhaps, but an effective way of showing the death. Again, the film carries on, and all the plots are resolved. As the credit roll, there's a hiss and the balloon, hand and all, falls with a squish. Cue blackout. I want to make this film, pushing animation into a very dark-humoured area. One day.

Another favourite gag is from Bill Plympton's film *Sex and Death*. A man late for work rushes off, forgetting his car keys. He rigs a noose up over a ceiling light and proceeds to hang himself. The laugh is the man's unexpectedly extreme reaction. There are more laughs as the man's life flashes before him, full of beautiful sight gags. Bill rightly saves the biggest gag for the last image; in his flashbacks he suddenly sees where he left his keys. He untangles himself and is off, confounding the audience's expectations several times. The secret is probably to lead an audience in one direction, and just when they know what to expect, the director outwits them. Is comedy as simple as that, I wonder? Is it about the unexpected? But that's another book.

My all-time favourite gag is from Keaton, and Buster must have liked it too, as he used it in another film. Why not? Rossini recycled his best tunes. In *One Week*, Keaton and his bride are transporting an eccentric mobile home. The house balanced perilously on lopsided wheels is funny enough, especially as, true to Keaton's persona, buying a new house might make them more socially acceptable (this hubris is a common theme for comedy). They build the house from a kit, but thanks to the meddling of a spurned lover, the house is a distinctly odd shape. They have survived all manner of chaos and storms only to find the house is literally the wrong side of the tracks. So they tow it behind a car. And sure enough, they cross the track, the car breaks down, and a train whistle blows. In a succession of great slapstick moments Buster tries everything to move the house off the tracks. The approaching train builds the tension (a ticking clock and a sense of imminent danger are essential to most gags) and just when it looks like being

too late, the train passes behind on a different track. Keaton and his girl stand back, breathing a huge sigh of relief with the audience, only for a beautifully timed second train to thunder in from the left, destroying the house. This is the last straw, and Keaton puts a 'For Sale' sign on the pile of rubble, and walks happily off into the sunset with his girl, thumbing his nose at the idea of having to climb social ladders.

Keaton liked to let the audience think they had outguessed him, only for him to double-cross them with an unexpected twist. This gag is funny for many reasons; funny because of all the effort, funny because we just did not expect the second train, and funny because Keaton brought the disaster on himself; the loser is never allowed to succeed.

The silent age was a gloriously inventive period, and the lack of sound, and especially dialogue, meant that body language was paramount. Keaton earned his nicknames of 'stoneface' and 'frozen face' (in France he was often called Frigo, after a make of refrigerator), with an immobile face but wonderfully expressive eyes, like many of the puppets I have worked with. Everything was done with a hunch of his shoulders, or a brilliantly timed double take, or a daringly executed prat-fall. His characters were funnier the more serious they became. If I could style my animation and storytelling on anyone it would probably be Keaton. His physicality is astonishing, but there are also just as important moments of absolute stillness. The gags were for real and never constructed in editing. Can you imagine how cheated the audience would have felt if the shot had cut half way through the legendary falling house sequence in *Steamboat Bill Jnr*? We would have suspected that some cheat had happened, rendering the stunt impotent. It has been copied many times, and sadly there is usually computer trickery involved, and it's just not impressive. Like the train gag, Keaton used this falling house in another movie, and it worked both times. It's a beautiful shot, made more so for Keaton's total calm in the midst of the storm. In the bottom screen left window, there seems to be a technician running away, presumably making the decision to let the huge house fall.

I also admire Keaton for always finding a solid reason for a gag. If a gag defied science and nature, he would find a pretext for that. Many of the gags in *Sherlock Jnr* are impossible sight gags, but then they happen in his dream as a projectionist. Not all comedians have this integrity, and I have to find logic to a gag even within the upturned logic of animation. I cannot do a gag just because it is funny. It has to grow out of the character or the situation. I like Keaton's melancholy, for which his face is perfect. Rejection is a common theme in his films, but he seldom plays purely for sympathy. Rejection is expressed as something physical, as many of the films includes scenes where he is thrown out of buildings, off trains, off the stage, thrown out of a society he had aspirations to join. But there are few things funnier than a well-timed prat-fall, and Keaton did these by the dozen. In reality there was a great sadness to him, with failed marriages and a loss of control of his work, through studios telling him how to perform. I am thrilled that his work has been rediscovered and seen as the brilliant pieces they are. Most particularly, I was thrilled to meet his widow in 1995 and express my admiration.

Every animator can learn from his work. He moves with such clarity and elegance, and every thought process is clear from his body. If I could only animate with half that expression! He is the nearest thing to a living animated character, and the link with animation is not far fetched at all. Like all the silent comedians he was experimenting with every technique and inventing new ones if necessary. One film has Keaton as a stop motion caveman, perched on the neck of a stop motion dinosaur. I hope he animated that himself.

Chaplin

Keaton using his body against the wind in *Steamboat Bill Jnr* is one of the most basic animation exercises in action. His tumbles are as good as physical comedy gets. I warm to his melancholy, which is generally free of Chaplin's sentimentality. I used to think Chaplin was all facial ticks, splayed feet and overemphatic saunter, but a recent screening of *The Gold Rush* changed my opinion. What soured me against Chaplin are the millions of Chaplin impersonators who, like Chinese whispers, have built and built on the original until there is only the most tenuous link to Chaplin's performance. The mistake impersonators make is to play every character trait all at the same time, and relating that to stop frame is useful. A character seldom displays everything in his make-up at once. If you animate like that, there is no light or shade, and the character ends up as pantomime of the worst sort. I walked in to *The Gold Rush* dreading a barrage of twirling canes, twitching moustaches and constant hiking up of his baggy trousers. Chaplin's performance was more subtle, and the whole film full of great humour and warmth, with brilliant gags that make me want to revisit other films.

In contrast to Chaplin's dishevelled persona and Keaton's more presentable image was the Frenchman Max Linder. Altogether more sophisticated and dapper, with a very refined physicality, although I have only managed to see a few of the existing films, I remember some startling surreal moments in his comedy. Sadly, for all his high wit, Linder had a truly tragic life.

Personally, and I apologise for this, I never enjoyed Laurel and Hardy, mainly because their personae were so irritating. To me they lack the emotional centre that Keaton had. Keaton had an emotionally motivated way of moving, stopping and falling over that communicates so much as well as being funny. I'm sad that we will never see those comedians as they were. Their trademark movement owes much to hand-cranked technology as well as to their brilliant performances. I wonder, if they had been filmed with today's cameras, whether the loss of the erratic movement would have changed anything. Probably, quirky movement defines silent comedy as it does stop motion.

Falls

What is so inherently funny about a fall that it is such a staple element? Is it because the character seems to be cheating gravity, physics and anatomy? Would it be funny if a prat-fall was accompanied by sick crunching sounds and blood? Possibly not. To be funny the character must survive, even if we see them wearing comedy plaster and bandages. My favourite falls is Ethel Merman's at the end of *It's a Mad Mad Mad Mad World*, when this gorgon of indestructibly strides into a ward full of the injured cast. She does a fall that lifts her up before spectacularly crashing horizontally to the floor. A great piece of physical comedy made better by the comeuppance and public humiliation the cast and the audience have been waiting for.

Applying the same fall in the same situation in a stop motion film would, I fear, not be as funny. We know these characters are puppets that cheat physics without getting hurt (although the character gets hurt), and for the gag to work it has to be about the comedy of the movement. We cannot copy a live-action fall. We need to emphasise the choreographic elements that will make us laugh; the flailing of the limbs, the attempts to stay upright, the suspension before the heavy landing.

Like many, Keaton had a vaudeville background, and could make his body communicate to the back of the stalls, both with huge physical stunts and with more subtle gestures. Any form of acting training is a bonus to animators, and it surprises me that so many do not see this as an essential part of any training. Of course, there are many animators who come from an acting or movement background.

Later than Keaton was Jacques Tati in France, a silent comedian existing obstinately in the brightly coloured full-sound era, and again sharing many principles with animation. Some of his films were shot silently, relying on hysterical but subtle artificial sound effects added afterwards, as we do in animation. The housewife in *Mon Oncle* is defined by the extraordinary click-clack she makes as she totters around her immaculate house. Her latest gadgets are made funny by the unexpected sounds they make. They are not the obvious effects from a cartoon, but finely crafted sounds. Many of Tati's characters are cartoon characters living in a real world, their shapes and movements subtly distorted. Tati's *Monsieur Hulot* has an unreal walk full of faltering steps and large strides, but how beautiful it is. Animators strive to find comedy walks like that, but to give a puppet such a walk it would have to be so defined so as not to look like lazy animation. Again, humans try to be unrealistic and animators try to be, well not realistic, but recognisable. I would encourage animators to watch Tati's gentle physical buffoonery and slapstick. His gags work more through repetition, building to lyrical chaos. Tati's pacing is slower than the silents, which often had to cram everything into two reels, but this is their charm. Tati's films always integrate a jaunty, oh so French music score. These films are an acquired taste, but I adore them, especially *Playtime*, an epic about a very mechanical ordered society, with a restaurant scene that is a masterclass of structured chaos.

If there's a modern-day descendant it would be Rowan Atkinson's Mr Bean character, and how ironic that the character is kept alive now in an animated series. The year 2007 even saw the release of *Mr Bean's Holiday*, surely a direct homage to the *Monsieur Hulot's Holiday* by Jacques Tati. I don't warm to his constant gurning as much as I do to his rubber limbs.

I prefer to use the whole body in animation rather than relying on facial gurning. Whenever I have acted my face seems to be doing too much, led by a pair of eyebrows giving their own independent performances. Maybe because I feel have a face for radio and a voice for mime, I feel uncomfortable depending on the voice and face for performance. With actors on stage unable to rely on close-ups for their expressions, and using their bodies more, perhaps that is why I enjoy theatre. It's probably because I appreciate movement more than anything. I'm more responsive to the films of Fred Astaire and Gene Kelly than to most modern film musicals, where much of the movement is created in editing. Admittedly blown away by the sheer bravado of *Moulin Rouge* and *Chicago*, the fast paced editing annoyed me, as I felt cheated of seeing the dancers using their bodies to sustain long takes, which is much of the appeal of dancing. Astaire and Kelly often shot their numbers in long fluid takes, with the whole of their bodies completely visible. They both enjoyed camera tricks and probably would have jumped at the chance to utilise any computer trickery today, but I have a feeling they would still have been filming themselves full length.

Jerky movements

Not all movement is perfect for stop motion. As I write, dozens of birds are sitting on a tree outside, their heads twitching back and forth in startling jerky and sharp

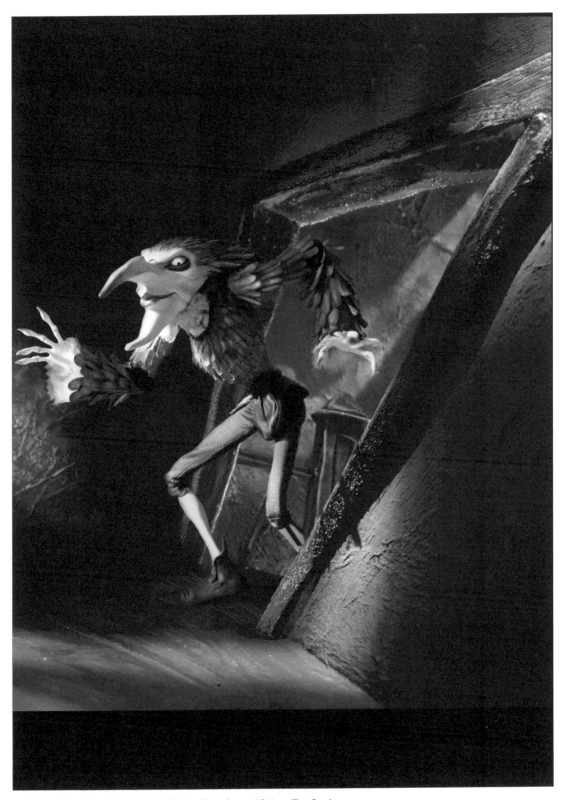

Paul Berry, Ian Mackinnon and Colin Batty's terrifying *The Sandman*.

moves that appear to have no fairing in or out. To animate literally like this would suggest very bad animation as it goes against the smoothness we try to imply. One way to animate such birds would be to be selective in the jerkiness, still doing large moves, but softening them slightly at the ends, giving the impressive that the large move was deliberate. In Paul Berry's brilliant *The Sandman*, the main character contorts his arms to become wings, flapping them violently, although there's still a softening at the ends. If the arms had just battered back and forth, the effect would have been less successful. It's about giving the illusion of movement, not the replication of real movement.

For a commercial I had to copy Michael Jackson's *Thriller*, with some shop mannequins coming to life after hours. The producers were keen for me to replicate the movements exactly. Reluctantly, I did and the animation looks very ropy. Michael Jackson seemingly defies the laws of anatomy through jerky precise sharp moves, but when translated to animation, these moves look like rough animation. This was an interesting shoot, as we were combining full-scale mannequins with not very identical puppets, shooting on a set built in a room in an old castle outside Barcelona. This was long before computer effects and the director wanted to film in smoky conditions, much like *Thriller*. Smoke and animation do not mix that well, and with every window and door taped up to stop draughts, only the essential crew was allowed on set. I still had to move to animate the puppets and this caused the smoke to swirl around, so I was encouraged to move in slow motion. The smoke was oil based, and I wore no more than trunks and a mask as it was so hot and unpleasant. After a shot, the doors were unsealed, and we were released into a magnificent garden with a full spread of amazing food laid out. One of those experiences that don't quite make sense. The final commercial was disappointing as it just had not been possible to replicate *Thriller*, with its sharp movements and all of its smoke effects. An interpretation of the movement would have worked better. The smoke in the animation sections twitches madly, compared with the slowly drifting smoke in the live-action sections. A second pass would have been more practical, but the moving puppets would not have generated their own shadows. In the end, it was the experience of working in a castle in Spain that was more satisfying.

The illusion of movement

Stop motion is about trying to suggest the illusion of movement, and while it is obvious to concentrate on the main characters themselves, it's always useful to suggest this movement with secondary animation. It's an effective trick to have something blown about in the wake of a character. Having things disrupted in an imaginary slipstream makes it look as though the character is actually moving through physical space and is affecting its surroundings. It's not, but the more we can suggest this, the better. If a vehicle races through shot, try to litter the set with leaves or newspapers that can flutter and float about. Those 1970s' detective series knew how to spice up what probably weren't very dangerous stunts by perpetually driving cars into

cardboard boxes or fruit stalls or through puddles. This suggests great speed or cause and effect. A fast car is exciting, but you only get a sense of the speed and the danger by seeing an effect of this speed. Seeing a car splashing through a puddle is a real visualisation of the speed. A car going down a straight dry road with no grass to be ruffled, no newspapers to fly up, no puddles to splash, and no means to gauge its speed, is less than dynamic. Whenever Toad drove his vehicles, there were lots of leaves covering the road that fluttered as he went by. We gave

Toad an animatable scarf whenever he was in a vehicle, not just as a nod to his fashion sense, but because a scarf flapping behind him does so much to suggest an illusion of movement. Likewise, hair and clothes flowing behind help the illusion. To see a character running at full pelt with a long coat hanging motionless around its legs totally defeats what we are trying to do. It's more effective to see the coat billowing out behind. When designing a character, always think of what clothing can be added to suggest this movement.

Likewise, a shot travelling with a plane flying against a clear blue sky will look very static as there is nothing to show it is moving. Moving shadows across it from unseen clouds suddenly suggest that it's moving.

All this is about giving the illusion that the character is securely located and existing in its own physical world, not necessarily a real world, but a very credible world, and one that has its own laws and logic. The more ways the puppet can interact with its world, the better. Often CG characters that have been composited into drawn or model or even CG worlds do not match the lighting, or worse, the very solid character has no shadow falling on the ground. Suddenly credibility is gone, and even the youngest viewer feels that something is not quite right. If the puppet is not connected to its world, then neither is the audience.

Falling leaves as a dramatic element are ripe for a full thesis, but apart from suggesting movement, they usually come with an emotional connotation, much in the way that falling snow is shorthand for evoking certain feelings. Invariably, falling leaves contrive to suggest an ending, usually where melancholy is appropriate. Leaves fall in *Screen Play* to suggest loss. If Toad were to drive into a thick tree trunk, as he invariably did, leaves fluttering down would show a more credible expression of impact than a cartoon wobble of the tree itself. All the time we are trying to find ways to suggest a movement, an energy and an inertia that just isn't there. It's about finding what the truthful storytelling moment of a scene is. What exactly is the gesture or movement that tells us what we need to know? What tells us that something is going fast? For example, how do we know if it is windy in a scene, when we can't see the wind? A sound effect can be used, or a character can tell us, both of which make for rather lazy film-making. More effective is to contrive to put things in the scene that can be affected by the wind. Leaves, newspapers, flapping flags, doors banging away. There's a whole repertoire of tricks available. Again, it would be hard to suggest a windy day in a wide-open barren concrete landscape. In that instance one would have to resort to sound, or maybe the luxury of having moving shadows on the floor, but a strongly discernible movement is much more visually satisfying and evocative.

In an episode of *Rupert Bear* that I directed, half the cast of characters were invisible for much of the show. This added a surreal quality to the story, but also it was an economical way of shooting; well, sort of economical, as again it's all about suggesting what's not there. Shots without a character in were very dull, but shots with the invisible characters giving signs of their presence were more interesting. We create movement by stopping things, so we create invisibility by showing things, a nice irony. If a character were invisible he wouldn't bump against everything, just as those police cars wouldn't hit every cardboard box, but doing so places the characters in the world. Animation is about not the real but the suggestion.

An element of stop motion is the equivalent of watching a dancer perform those thirty-two fouettés in *Swan Lake*. You are watching the beautiful lines and the

synchrony with the music, but you are also watching someone overcome physical constraints such as gravity, anatomy and exhaustion, all while making it look effortless. To animate a ballerina in drawn animation or in CG, you immediately take away the physicality. It becomes merely a series of elegant shapes and movements. There isn't the excitement of 'will they get through it?' Stop motion still has the physical side to overcome, as well as a sort of live performance to it. Usually a stop-frame animator will endeavour to complete a shot in spite of technology, blowing lamps, schedules, fatigue, heat, sagging puppets, etc. Starting a stop-frame shot is unique in animation. It does have spontaneity, an improvisational quality that is both scary and exciting. This element is the adrenaline rush.

Suspended animation

In the wacky world of animation, characters are forever jumping or running, or bounding with leaps and exaggerated walks that happen to leave the ground for a few frames. An early jump I did was in the *Pied Piper of Hamelin*, where some thin brass rods, carefully angled to be as invisible as possible, assisted the Piper to look like he was jumping, although he was merely climbing and balancing on these supports. A very cheap trick but it worked. Even cheaper was a young child skipping around, framed so as only to see her torso and legs, her head supported out of shot.

A tricky shot of Toad balancing on a bicycle saw him hanging from an anglepoise lamp with fishing line and sticky tape. Imaginative, if not very technical or precise! During *The Wind in the Willows* we became familiar with Climpex, a godsend to animators. It's a range of easily movable and tightened rods and joints. A goalpost frame can be constructed just outside the shot to suspend the character. This was all very basic and time consuming, but shooting on film is very kind to puppets hanging by fishing line, making it almost invisible. This depended on the lighting and the background, but it was easy to hide the line with a marker pen or an antiflare spray. A cheaper trick was to knock the hanging puppet gently an instant before the frame was taken, thus blurring the line into insignificance.

Thin tungsten line is often used to suspend characters. It is so thin as to be practically invisible, and often animators appear to be struggling with nothing in their hands. The drawback of tungsten is that it snaps with the slightest jerk, and gets itself into very tight knots. In some older films you can still see the wires suspending characters or props. Pal's decision to deprive his Martians of tripods in his *War of the Worlds* feature must have led to some angst on the set. In spite of all the lighting effects you can still see the many wires too clearly. Shooting on digital now cruelly exposes such methods. Animators now often suspend characters on blue rods and rigs, filmed against blue screen. These will be later matted out.

Most puppets now are designed with one, or even two rigging points somewhere on their body. Invariably, this point will be in the wrong place for some shots, but immensely useful in others. A metal rod, preferably square to prevent any slipping, is inserted into a predetermined

tight-fitting hole on the puppet. This rod is attached to a series of short manoeuvrable joints, which in turn are attached to a flat base that can be attached firmly to the set. The joints are sufficiently tight to support the puppet off the ground for when jumping. This is fine and helps the animators to produce some lively animation, but in postproduction there is no button marked 'rig removal', however much blue paint is valiantly applied to the rigs. The poor technician whose painstaking job is rig removal has definitely drawn the short straw.

I have tried to use rigs as little as possible, and have managed to cheat a lot by clever editing or supporting the character out of shot, or equally dubious methods. This is me still trying to have the shots as pure as possible in front of the camera, which is a somewhat outmoded approach when digital technology can help so much.

Jumping, like all actions such as running and walking, take a lot of practice to get right. Expressing the choreography is one thing, but getting the right balance between the effort and the length and elevation of the jump is much harder. This is an essential point: do the effort and energy match the effect? When I started, they did not. My first jumps had characters rising to a great height with the smallest of preparation, or showing a huge amount of effort, but jumping only a fraction of space. This may be what's required, but you still need to learn how to time and express a jump before you can deliberately get it wrong, and this applies to most things.

A dancer in full flight with clear shapes (Petros Papadopoulos).

Like a dancer, animators need to think ahead with a jump. A dancer knows how many steps the run-up will be and more or less where they will land, and how long it will take. Inexperienced animators can misjudge the space needed for a jump, resulting in cropped figures or ugly compositions; there's not much point in going to all this trouble and then not seeing the animation, as the character has moved out of shot. Much of animation is about anticipating the frames ahead, not just anticipating the use of space but also anticipating the choreography. Is the character on the appropriate foot and how many steps will it take? A movement is not just that

moment, but is part of a bigger sequence, and when animating that sequence can take all day or longer it is hard to feel the structure of the movement. I am often nervous when producers or clients watch me in action, as often a gesture or movement only works when you have gone past it and put it into context.

More importantly, what is the motivation of the jump, and what story or emotion is the character expressing? There has to be a reason for a jump, and this should be clear from the head. The head can tell us whether we are running from something, or heading somewhere with a purpose. No move starts with the whole body. A move has to begin somewhere and then activate the rest of the body, or let the rest of the body catch up. The character needs to show that it's thinking about doing something, and display some preparation. If a character jumps with no preparation this will result in boring and lifeless animation. Preparation could be a backward step or a crouch, or something smaller, but it needs some moment of preparation and anticipation, and this should read with just enough frames to see the clean lines of the limbs telling the story.

What is your actual animation process? Do you need a video assist or other technical aids?

JD – I've never used video assist, except once when the moves were so small that I used a separate telephoto lens, to see an enlarged image (I put markers to gauge the incremental moves at a larger-than-life size). Due to video 'drift' this didn't work very well. I've never used frame grabbers, because the technology didn't exist. I prefer to finish a shot in one 'sitting' rather than letting it go over several days.

TB – I read the script and, with the help of the director, find the character. That's the most important thing to me I use video assist for difficult movements such as walk or run cycles. For subtle performance animation, I rarely use video assist, though that might freak the director out. I use surface gauges quite a bit, but I'm from the old school. Some of my best animation was done intuitively, by just getting into the rhythm of the shot and going with the flow. If I stop to check the video, then I tend to lose track of the moment, of the performance, and then I'm in trouble.

RC – Many have animated perfectly fine without the technology we now have.

DC – I find the monitor important for framing and camera angle, but the video quality isn't good so you have to 'know' the shot. Shooting on digital makes it much easier to see what's going on and to fix mistakes. (Apparently, of course I wouldn't know!) I flick between the current and last frame but I try not get too glued to the monitor. You lose your flow. It takes me a moment to get back into a scene after a break. If I've just completed a long shot I can't immediately start talking to real humans!

AW – I look at and feel the puppet, not the monitor. All my life I've animated with just a camera. *Peter and the Wolf* was the first animation I've done with software. I can walk away from a shot for a long time and then return, remembering every single frame.

SB – I'm a product of the digital era, I couldn't do without technology. I like to see each frame as part of a sequence and how each shot fits into the scene.

RH – I look and feel the puppet, but I see the monitor as an essential tool – because I'm used to working in this way. I always flick between the last and current frame. This just works because I know how far the

movement should be, and I can see whether I'm right or wrong. I occasionally view the shot so far. If I'm pleased I am lifted. If I'm not, I usually have to push myself more to make the shot work.

JC – We rely on technology too much. It has raised the quality but it has made us slaves to machines. When I first started on a show called *Rocky and the Dodos* we had monitors and a 'digi' box allowing you to see your last and current frame but no more. We shot faster because we couldn't replay the shot and working quickly would keep the feeling for the movements in your head. I find the monitor a useful tool but try not to let it slow me down. In CGI two monitors are essential as there are so many screens and graphs.

FL – I've incorporated the frame grabber into my process and I've found it useful. I don't want to stay away from the puppet and be too near the monitor, so I go from one to the other. I would love to try animate just with a camera again.

Touching a puppet

Something odd happens when touching a puppet, especially one designed ergonomically for you. 'Achilles' fitted my hands perfectly. Since he was free of clothes or hair I could grip his chest firmly while moving all his other limbs with the fingers of the same hand. It's important to get the size of a puppet right. Too big and it becomes heavy, causing problems securing it to the set. The joints have to become unnecessarily chunky and rigs are needed. I'm very much a purist and like my hands to be directly controlling the puppet. If the puppet is too big, then the sets by proportion get too big, and this has a huge knock-on effect with space, and lighting.

You give yourself just as many problems if the puppet is too small. Sometimes fingers are too fat to manipulate tiny joints and tweezers are used. I resist anything that doesn't involve my hands; I feel a lack of control. The puppet-makers encourage us to wear surgical gloves, but we might as well wear boxing gloves. I can't feel the puppet responding, and that's what it's about. I have developed an acute muscle memory where I can feel the spatiality of a move, and how it compares to a previous move. Working with students, I encourage them to manipulate coins into a straight line or various shapes, but with their eyes shut. A muscle memory may be redundant with technology for showing the last frame, but it is hugely useful to be able to feel a puppet moving in a defined spatial area. Whether I have a photographic memory or not I don't know, but if a puppet falls over, I can exactly reposition it. Rather bizarrely, like an actor who has been playing Hamlet for six months can suddenly forget those lines after the last performance, I can retain a huge amount of visual information, until I have seen the shot complete, and then that information is redundant. Shooting without video, I would replay every frame in my head, fretting about minute details, for days before the rushes came, with every frame crystal clear. As soon as the rushes were approved, it would all go, no longer needed, although it is probably still rattling in there somewhere.

Flow

Watching an amateur production of *A Chorus Line* typified exactly what inexperienced animators get wrong. Cassie was going through *The Music and the Mirror*, strutting through her carefully rehearsed climatic routine, looking splendid (if a little too fleshly), and it was simply ghastly. She seemed to be striking the

Dancers are always aware of the shape they make for the audience (Susan Guy).

right poses, but something was wrong. It just didn't flow into one complete dance. You could see her counting four kicks there, two kicks there, step turn, but there was no feeling that these steps were linked to the previous ones, adding up to a whole. She was ticking off each pose and shape, but it was not dancing. It was moving from pose to pose. This bit was slow, this bit quick, rather than growing and evolving from a slow section to a quick one organically. Stop motion can be much the same, where we put so much effort into concentrating on a particular frame that we can overlook the previous and incoming frames, not looking at the bigger picture. I try to have something like a heart line in my head, seeing not only the troughs and peaks but where they come in the whole phrase of the movement. We cannot hope that a series of individual frames placed together will produce a beautiful movement. There has to be a shape and structure. A musical tune is not about the individual notes, but the placing of notes next to each other and how they flow from one to another. It's the same for words in a sentence. It is important to see animation as a phrase, not just individual letters or frames. Stop motion is half way between dance, which makes obvious statements about its artificial movement by drawing attention to repeated patterns and shapes, and live action, which is full of quirky, unpredictable clutter. Stop frame must have the clarity of dance but the spontaneity of live action.

Rhythm

This is a much overlooked aspect of movement, as more technically minded animators can find it hard to move away from dividing a move into exact calibrations. Such precision produces dead animation and does not help the illusion of anything having life or energy.

A great example of rhythm is in Suzie Templeton's *Dog*. The young boy is brushing his hair, and although the prop comb may not physically go through his hair, Suzie has the boy do several repeated strokes of the comb. As he pulls the comb the moves are slow and small, with a few sudden quick moves at the end as the comb leaves the hair and starts again. She also moves the boy's head as if it is being pulled along by the comb getting stuck in the hair. This is pure mime, but the difference of pacing and repeats capture the essence of brushing hair. A bad version of the same scene would have been to have had equally paced strokes back and forth, with no movement in the head. There wouldn't have been any suggested contact or effort.

Small moves

Small moves are enormously satisfying if done well. Again in *Dog*, Suzie Templeton manages to make the most subtle of movements. This all depends on the schedule and the sophistication of the puppet. There is a danger in small moves that the natural memory in silicone, for example, will not help. You are pretty lucky to have a puppet that will precisely stay where you put it first time. Gravity, tensioning

and the puppet's materials can move a limb back a fraction after it has been repositioned, and in small moves this can result in a judder. You take a risk in a lengthy sequence of small moves that the slightest inconsistency becomes very obvious. It takes absolute control. Glitches show up all too easily, whereas in big moves, you can get away with a certain roughness; but there's something very beautiful about a long, slow move.

One of the most subtle performances must be Phil Dale's animation of *The Periwig Maker*. For most of the film, the puppet stands and stares, either looking out of a window or writing a diary. There is little that could be described as action, but the puppet is so alive. He has a static face yet his pupils move across his large eyes with so much expression, and his gestures are timed so that the pauses speak volumes. I'm sure that Phil, like most of us, animated his puppets is a whirl of action when he started. It takes much more discipline and control to move puppets slowly and to include lengthy pauses. The puppet doesn't necessarily stop performing just because it has stopped.

My favourite scene: *The Periwig Maker* – Charlie Hopkins, animator

This is one of the best animated shorts ever made. It's a film that is beautiful throughout. The settings, costume, puppets, animation and story are wonderful, if a little dark. A modest tale of a periwig maker during the plague in the seventeenth century, that's slow burning. Kenneth Branagh narrates, reading actual diaries of the time, over the subtle performances of the puppets.

The periwig maker is the observer of the terrible times, and is as much a victim of the plague as those around him … he is also a victim of guilt. He witnesses the death of a little girl that he could not help out of sheer caution or cowardice.

The little girl's family has died, and she is left alone boxed up in her plague-infested home, guarded by a brute of a man waiting for her to die. The girl is lonely, and seeks company and comfort from the wig maker, but sadly he cannot let her in, afraid that he too might get infected.

My favourite scene from this film is the way the guilt of the man is acted out; through subtle movements … he believes the little girl is in his home, though it's actually his imagination and guilt. Sometimes the best animation has few or no movements to it at all, and this is evident in this scene, and is all the more powerful for it. The wig maker's eyes move slowly around the room, his head slightly twitching as the little girl explains her predicament …. It is cold, scary and moving.

It is a truly wonderful and remarkable film, with a very sombre and sober twist.

I worked on a series at Cosgrove Hall called *Rotten Ralph*, whose style was all about slapstick, involving very frantic movements. This was practically a three-dimensional cartoon, about energy, big moves and extreme reactions. I found this enormously hard, as I wanted to put lots of detail into the movement. I couldn't move a puppet across a room in three frames. I wanted to spell out the mechanics of the walk or the gesture, but that wasn't what was required. A move can be so large that it's in danger of not relating to the previous frame, losing all meaning. The trick is to make the huge moves, but to feather the move out with a few small increments at the end, to suggest where the move has come from.

The lip-sync on the cat and the human characters were extreme shapes with no in-betweens or neutrals. It was all either or nothing. It was liberating but not something I felt comfortable with, and admired the animators who almost literally threw the puppets around the set. I wanted to work out every cause and effect of each move, letting the action start somewhere, seeing it travel, letting it read, and then letting it finish. All that was required was fast action. To animate like that you still need to learn to animate all the mechanical detail first before throwing it away. Like anything, you have to learn something properly before you can be seen to get it deliberately wrong.

My boldest move was as Achilles crouched over the body of Hector. The mythical arrow was fired into his heel, and to express the pain I'd got him in the hunched position so he could fling himself backwards in literally a couple of frames. They were huge frames and filming them I worried that I had pushed the moves too far, but by adding a couple of tiny moves that brought him to a strong, clear pose, the big moves made sense, and the whole action expressed a suitable pained jerk and a relaxation to it.

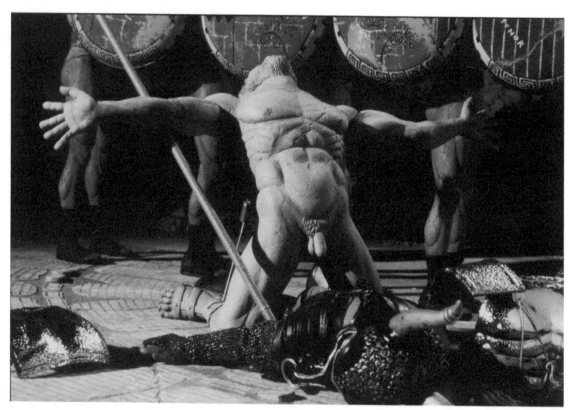

Achilles at the end of a huge move.

Similarly, if a character is required to be pretty manic with arms flailing about, the moves can look random and disconnected. The trick here is to have one part of the character totally controlled and moving at a slower pace, or even totally planted in a specific spot. This makes the wildness look deliberate, and it gives the character moves of different speeds, much as *Pachelbel's Canon*, in which one melody trundles on while others weave in and out ever more furiously. The worst animation has everything moving at the same speed with no sign of inertia or

rhythm, which is easily done if the animator is not yet seeing movement as a performance. All movement needs to build and slow, but if this is done clumsily the puppets look as though they are animating in syrup, with nothing clear or defined, constantly moving without much effect. The best animation has dynamics and clarity, with every shape clean and readable, and animated to the camera, making the best of its shapes, with every acceleration and slowing down absolutely clean.

Dance

I'm forever trying to get animators to experience dance in all forms. There does seem a resistance, as there seems a general resistance to most things live or cultural. I'm not sure why this is, but dancers are doing exactly what we are doing: telling stories, and expressing ideas and emotions through the movement of their bodies. Any understanding of dance can only help an animator. Of all forms of dance, I would recommend tango and ballet.

The dramatic body language of tango (Susan Guy).

Ballet flows like no other dance, and you will seldom see more grace or cleaner lines, but tango is the most exhilarating, sensual and dramatic of dance. Every limb tells a drama, with movements from sharp, angular shapes, through the softly sensual, to the amazingly extended openness of the body. In every step there is a strong through line between the dancers, making uncluttered, easily readable shapes. Through the fantastic compositions and rhythm, you know what the dancers are feeling. They connect with each other, and respond to each other.

Animators can learn from this ebb and flow, and there is seldom a move that isn't motivated by some sort of story or relationship. The dance is also about communicating to the audience, not just for the benefit of the couple. The shapes are clearly structured so an audience can see the strong limb extensions. At other angles, the impact of the dance would be lost.

It's not a bland, dull dance. Some aspects of tango would be impossible to animate, just because of the sheer speed, but you will see the dancers letting the strong pose read for just long enough. I would kill to work on something that could exploit these strong shapes, the dangerous energy and the exhilaration of such movement. I have danced tango, both in the UK and in Buenos Aires, where I took the excuse of three visits to sneak in some classes. While the apparent spontaneity of it terrifies me (the man is improvising from variations, communicating this to his partner through his hold), as I cannot think that quickly, I respond to the drama and the storytelling.

Sport is another invaluable activity to study. When working the sportsmen may not be conscious of the shapes they are making, as dancers are, except for gymnasts and the like, but they will push their bodies into extraordinary extensions and contortions. The act of kicking a ball needs all manner of coordination in the body and fine balance, and it's good to see the lines, especially the diagonal lines made by the body. Gymnasts and divers are just a step removed from dancers, depending on precision control of their bodies. To see how a body works and balances, you can't go wrong in freeze-framing a gymnast. This is a perfect way to study movement. Dancers are great for the shapes and rhythms, but they do try to disguise any signs of effort, making it look easy, whereas sportsmen are all too happy to show that effort.

In animation, I have always tried to have absolute clarity in a pose, whether it's a strong extension or a more closed movement, and some of the guests in this book have picked up on that, rather satisfyingly, especially in regard to *Next*. I'm frustrated by movements that reach their storytelling pose and ruin it with insufficient frames for it to read, or a pose that is not clear enough. On stage a while back, I danced a bit of *Swan Lake* as a *pas de deux* for one – don't ask! While not exactly going for the jumps or the spins, I went for the drama, wringing every ounce of emotion from that sensational music. A ballet teacher in the audience did not exactly rush to sign me up, but did comment that she had seldom seen 'such open and clear upper body extensions'. I hope that was a compliment, and I was chuffed. If only I had the agility and rhythm to go with it … but then that is why I am an animator. Since then, those words have summed up exactly what I try to do with animation.

Making movement flow is a huge trick to master, especially as many animators tend to improvise a shot without totally thinking how the puppet is going to end up. The secret is to make all the movements relate to each other and to plan the shape of a sequence. A well-plotted bar sheet or storyboard can help that. If there's music or dialogue in the scene that is good discipline, but otherwise we need to visualise the structure of the whole sequence.

On the bar sheet or dope sheet, do you draw little stick figures to help you plan the movement in advance, or do you just let the puppet take you with it?

JD – I use bar sheets only for dialogue. In the early days, I sometimes used them when there was difficult sync required between live action and puppet. Gene Warren and George Pal drew little 'animation' miniatures showing eye actions and so on, but I never did that.

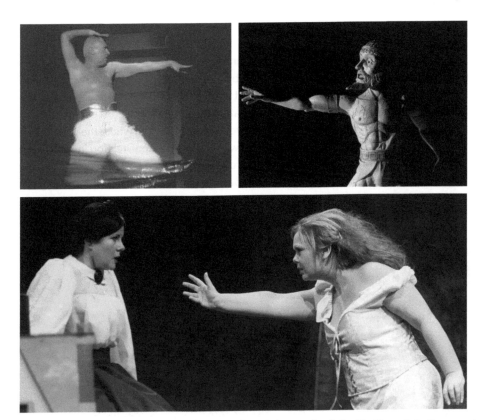

Three strong, clear extensions, me attempting *Swan Lake*, two Ros's in *The Turn of the Screw*, and the chorus from *Achilles*.

TB – I follow the director's intent and storyboards for primary key pose, but I will discuss the performance with the director. In the X-sheet, I will see the dialogue if I'm doing lip-sync, and might jot down a few notes on the sheets (such as if the character says, 'Alas poor Yorick', I might jot in 'Character lifts arm to chest from poor to Yorick', and so on).

DC – I'll write key words of things I want to happen or arrows to remind me of direction and phrasing. This sometimes changes when the puppet doesn't agree, but it's a good guide. Lots of marks and symbols to mark actions and noises, etc.

AW – I prefer to animate instinctively, but I have occasionally used dope sheets for basic planning.

SB – I just go with the flow. I do think up several key poses for most shots.

RH – I make minor notes and 'lines' on bar sheets that remind me where I want to take the puppets and where the 'highs' and 'lows' are in the dialogue. If I feel confident with the shot, I hardly make any notes and just let the puppets take me along.

JC – I roughly plan my action for a shot. This saves time and avoids errors in action and timing – especially if you have to match a movement on the cut. Though I don't draw stick figures I do make notes on the dope sheets that indicate which words are emphasised and the pitch of the dialogue – funny little waves, arrows and syllables underscored, and the odd suggested expression or gesture.

The role of puppets

I try consciously to push the role of the puppet, and in *Next*, in the Macbeth scene, I had Shakespeare (who in effect, was being operated by me) operating the dummy, who in turn was operating a glove puppet of a witch. This seemed to be a suitably Shakespearean nod to fate and animation, with some greater force manipulating us. Some productions of *Macbeth* have portrayed the witches as puppets, although I have seen a production where the witches were puppets operated by Macbeth himself in a somewhat drunken stupor, reinforcing the idea of the necessary change of perspective to see the truth. The puppets were a catalyst for Macbeth's darkest thoughts to be made real. I have always been fond of the original cast recording of *My Fair Lady* that depicted Bernard Shaw operating marionettes of Rex Harrison and Julie Andrews. The *Pygmalion* story is one with many resonances for animators.

Trying to put weight into a lifeless object.

In all my films, characters watch, guide, observe and manipulate others, and may be flirting with something profound. This is a recurring theme for me. I'm not sure it's conscious, but it is comforting to think that as I guide and manipulate a puppet someone may be guiding and manipulating me. With *Screen Play*, the Recitor guides and literally manipulates the story. He in turn uses two figures in black, the Kurago, to animate the characters in his memory. At the start, these figures are seen operating the two main lovers as puppets with rods as my acknowledgement of the art of Bunraku, where exquisite, almost life-size puppets give astonishingly complex performances, more often than not requiring two, or even three, operators. They wear black and with faces usually concealed, and although hugely physical, they are invisible to the audience,

whose eyes only watch the puppets. Each time I've seen Bunraku, I have had the satisfaction of being engrossed with the puppets but also disappointed that I didn't notice the puppeteers. I love those moments when something obvious becomes invisible. There are moments in my films when the animation becomes invisible. I'm pleased that the audience doesn't always notice my black figures in *Screen Play*, nor do they assume that the lifeless characters in *Next* and *Achilles* are actually animated. These characters seem to fall with appropriate weight and react naturally to being picked up. There is one shot of Achilles cradling the dead Patroclus that I clearly did not get right. As Achilles lets his dead lover's head fall, the head bounces back too far and with the wrong timing, suggesting that it was a motivated move rather than a natural reaction. Just one frame can ruin the timing of a gesture, and that's a hard skill to master. To counterbalance the duff shot in *Achilles* there are some decent shots where it looks as though Achilles is lifting a heavy object. Gilda also flops quite naturally in her death in *Rigoletto*. A film I have written features one very much alive puppet, and one very much dead, although both of them have to be animated with equal detail. I like the irony of putting as much effort into making something look lifeless as it does to make it look full of life.

In the major dance treatments of *Romeo and Juliet*, Romeo dances with the supposedly dead Juliet, during which the ballerina is thrown about, limp and lifeless. The reality is very different as the ballerina is working hard to look dead, and all with her eyes shut. I cannot imagine the trust involved and the total complicity between the two dancers. To the audience it just looks natural.

Production

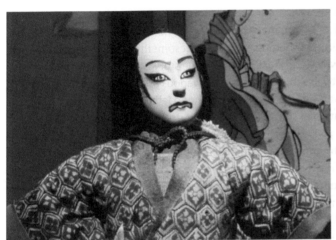

The lovers from *Screen Play* never had the close-up they deserved.

Trying to get a sense of the whole sequence is made difficult by the practicalities of working. Early in the morning you are fresh and it is common to see animators (and here I hold my hand up) putting masses of activity into a shot, and then as the day wears on, it gets hotter under the lights, you realise that the shot may not get finished, and gradually the action becomes just about the central character. When played back the shot is busy at the start and then peters out towards the end. When several shots like this are next to each other, a clunky pattern becomes very clear. Watch a scene in the pub from any bad soap opera and the characters all raise their glasses at the same time. As the scene continues, the actors seem to have done their bit and it quietens down. We must try to find the structure of the shot and the sequence itself, and look at the bigger picture the whole time, which is not easy when you are so focused on a particular frame. Along with the boards and the bar sheets, the role of the director is to make the animator see this bigger picture.

Designing puppets to act

The first satisfying puppet I performed was Mr Toad from Cosgrove Hall's *The Wind in the Willows* (the earlier *Pied Piper* was a beautiful, simpler puppet, but I only spent six months with

him). He was one of my favourite characters, and I never tired of him. He was tiring but never boring. Toad was remarkably complex, and after a while I realised that his still moments were just as effective as his more manic moments, of which there were many. In the book, Toad is not the main character … the book is Mole's journey, but it's hard for Toad not to be the energy, the catalyst, the driving force, the drama and the enthusiasm of the piece. He is carefully balanced with the other three main characters, Badger, Mole and Ratty. They are the four humours, the four elements, and if one takes too big a share, the others suffer. It was easy for Toad to upstage by sheer presence, and many times he did, but I hope we managed to give him a balance of hyperactivity and moody stillness. His mood swings, almost bipolar, were great fun to play, and he was a superb puppet.

The Wind in the Willows

With my involvement in the Thames TV/Cosgrove Hall films of *The Wind in the Willows* it's hard to be objective about their influence, but many people are animating now as a result of these programmes. So indulge me further by letting me talk about something I'm very proud to have been involved with. I wonder why it had such an impact. The story is a brilliant piece of writing, with characters that are instantly likeable. At its heart are various aspects of loyal friendships, existing in an environment that is threatened, like a childhood fading. Both, for many, have gone. It is a satisfying combination of sunshine and shadow, and although it all seems an innocent tale of animals having adventures, something very sad and melancholy is going on underneath, even more so in the context of Kenneth Grahame's tragic life. It's Toad's excitement and enthusiasm for the newfangled that inadvertently push the old ways further away. In terms of animation, the series represents an era of television that seems to have passed. For a teatime animation series, there's seldom been such a consistently high set of production values or such a lovingly crafted series. With a cast of A-list voices, and sets, props and costumes overflowing with meticulous detail, the series set a standard higher than most children's programmes at the time. That, maybe, was its appeal: it wasn't just for children. There were great, literate scripts, and told with warmth and pacing that may today be seem languid. Perhaps audiences have responded to the brilliant puppets, and animation that was about performing and not just wobbling the characters. Maybe it was the detail in all aspects of the production, the sheer lushness and richness of everything that have stayed with people. All in all, it was a generously hearted series, free of product placement or cynicism, made like miniature feature films.

I will admit that that some of the animation now looks rough, and a few decisions turned out to be less successful: photographed painted backgrounds blown up looked exactly that next to the real sets; mixing smaller versions of the puppets with larger ones does not work; a few attempts at backprojection look a bit clunky; but it was quite a feast, and a real joy to work on. The 16 mm looks a bit drab now, and the camera moves are basic. Some of the effects are definitely not special, but six years in the company of Toad was definitely one of the

best friendships I have known. Shooting the series was not without dramas and tensions, but the characters always kept us interested. I would be upset if a day's shooting did not involve Toad. We were aware that these were special puppets, enabling us to do some good performances. I planned days in advance how Toad would behave or react. Oh, to have a chance to work with him again. A surprisingly complex but loveable character, and his inherent physicality and enthusiasm were a gift to any animator.

Why stop motion? – Charlie Hopkins, animator at Cosgrove Hall

Stop motion animation as a style never appealed to me. *Larry the Lamb*, *Trumpton*, *Postman Pat* and *Bagpuss* on Saturday mornings were gap fillers for the 'real cartoons', which for me were the Warner Bros cartoons. Only two stop motion shows could match these cartoons, and they were *Chorlton and the Wheelies* and *Morph*. These had the inventiveness and dynamism of any Chuck Jones cartoon, but I was unaware of the technique being different to cartoons. Aged ten I imagined I'd like to work for the *Beano* one day. I loved 2D animation. I watched and drew Danger Mouse, taping episodes on an old Betamax. My mum told me that *Danger Mouse*, *Cockleshell Bay* and *Pied Piper* were made by Cosgrove Hall, and based in Chorlton, 'over the way'. So, then, I wanted to do *Danger Mouse* and go and work at this Cosgrove Hall ...

... Then *Return of the Jedi* came out and I became a *Star Wars* nut overnight! (And it's a passion that's stayed with me.) I collected the toys and played out many stories of my own with them. I'd build shoddy settings in my front garden using abandoned tiles, stones and twigs, trying to re-create the actual sets from the films in miniature ...

I began writing my own stories, getting gold stars for them as well as reprimands for bad spelling and terrible punctuation (which has also stayed with me!).

Rolf Harris and *Rolf's Cartoon Club* and *Who Framed Roger Rabbit?* turned me back to animation. I was getting earache from my careers advisor to choose a vocation ... so, thrilled at the thought of actually getting paid to draw cartoons and work on films like *Roger Rabbit*, I decided I was going to become an animator. I was fourteen with no real flare for art or any idea of how to become an animator. My art teacher laughed at my plans. My career advisor frowned and told me about the interesting benefits of becoming a warehouse man ... or an HGV driver. I took this on board and, spurred on by negative reactions, pursued my dream ... and kept hitting brick walls every step of the way!

At college I began building models. I had a fine art education so every project I did leant towards the inner workings of one's mind and the internal suffering of oneself. Itching to do my animations I bought a super 8 camera and began my own little films, with the help of the very few animation books around at the time.

The first stop motion was with a bendy Mickey Mouse toy. I was amazed by the immediate feedback it offered me, it was somehow less complex and more instructive than drawing thousands of drawings for a 2D film. I experimented more with stop motion, and with paper cut-outs; I got excited at how I'd gather inanimate objects and move them around ... giving them a life of their own. I began a more in-depth study of stop motion, researching companies, artists, film-makers and films, and found myself hooked and wanting to do more serious stuff. *The Nightmare Before Christmas* came out ... and then I knew what I wanted to do.

Whilst I was on the interactive arts course at university and after being shown around Cosgrove Hall, I had the time, space and know-how to be able to get into this line of work properly.

The thrill of writing, drawing, storyboarding, building your own sets, creating something that was just in your own head, seeing every element come together and watching your first rushes of your crudely built puppet wobbling across a set is a thrill that is still with me to this day, there is no feeling like it. The physical aspects of bringing something to life, a mere model moving, seeing the results ... it's incredible, nothing can match it, and it was this passion, this fun of experimenting and getting results that swung it for me ... maybe I would get lucky Throughout university, I developed my film knowledge, and built upon my experience, and got more and more ambitious, always mucking up along the way, and that thrill stayed with me ... still does to this day.

From my experience, most professional stop motion animators (me included) are a little odd. We tend to be insecure, a little inadequate in certain areas of our lives, battling for control over our lives or feelings. That's why stop motion appeals to me. I can express myself and control every aspect of the medium ... its fair to say I enjoy playing god, with a need to control. I know when life gets a little scary and unpredictable I can release my frustrations acting through a puppet. Some take this further by becoming directors, producers or even setting up their own studios, controlling their own puppets in the form of staff ... This industry attracts its fair share of nutters, who can't cope with real life and hide themselves in the realms of children's television, but saying that as one of these nutters, it's a wonderful environment to be a part of.

As a professional stop motion animator I work in studios on shows with rules and constraints of a world that has been predesigned and developed. There are frustrations, and restrictions, and lazy, difficult and easily threatened staff, but you realise it's like any other job, until you are lucky enough to get on a 'magic crew!', then the studio becomes something else, a wonderful creative environment. You have a group of people, with many of things in common all working towards a certain goal. That's a rare and very special feeling. When it happens that special something is there in the end result.

Stop motion intrigues everyone. Its popularity over the years has made it an acceptable cartoon medium alongside 2D and now CG animation. What it has is something extra, a novelty factor attached to it. The fact that every aspect is manmade, crafted, lit and moved; it's like live action in many ways but on a miniature scale ... and slower. People who watch know it exists for real, that that puppet has been animated by human hands ... For me, anything is possible in stop motion, if a little expensive, but it's all worth it!

Kenneth Grahame does not help stage or film adaptations (but then the book was never written for publication) as the characters change size from page to page, and swing from humanistic to more animalistic just as easily. The original design for Toad had his bottom rather low, and his long legs slightly splayed in a crouching position. This looked fantastic in a drawing and caught the 'toad' element very nicely, and a drawn film could have moved him perfectly, stretching and squashing, cheating on the physical restraints that solid anatomy brings. But with a puppet and its solid mechanics, walking like this would have been absurdly difficult. He couldn't move his legs forward in a parallel manner, but would have had to swing his legs round the outside of his hips. Since both Grahame and the animators had in mind an elegant, if hugely pompous, gentleman, this would have defeated the purpose. Toad's legs were moved from the outside his body to underneath him, making him a somewhat portly man with a big head. This enabled him to walk with some sense of style rather than a lurch. Toad was blessed with beautifully long legs and arms, and I used both to give as much expression as possible. Too often animated characters have large, round bodies and tiny stumpy legs A nightmare, I'm afraid. Short arms are especially a nightmare as we resort to human gestures. The vocabulary becomes limited if the arms cannot reach the face or cross the stomach. Long limbs suit my style of animation.

Oh, but what a puppet Toad was! The armature for this puppet still exists today and is a little marvel. Initially, the sculptors struggled to find the right proportions. A little toad head sitting on a neck atop a human body looked daft, as did the realistic anatomy of a toad head seamlessly joining the body. The distinguishing features of a toad are the large mouth and those eyes, both of which we emphasised. One reason for filming *The Wind in the Willows* in that point of

Cosgrove Hall's history was to develop lip-sync. We had not tried it before … *Chorlton*'s mouth shapes were perfunctory, *Cinderella* only nodded to the music, and the *Pied Piper* just smiled enigmatically, although one rat managed a monologue with an open-and-shut mouth and tongue and plenty of saliva! Toad and his chums had to be convincing speakers, especially as the likes of Sir Michael Hordern, Ian Carmichael, Beryl Reid, David Jason, Richard Pearson and Una Stubbs were voicing such legendary dialogue.

The vocal cast for *Gilbert and Sullivan*: Wyn Davies, Sandra Dugdale, Steven Pimlott, Christopher Gillet, Anna Burford and Roland Wood.

Voices

Vocal performances can really make or break a film. For the *Pied Piper of Hamelin*, before Robert Hardy delivered the narration, another actor had recorded the script, but he was too big and too fruity, and not keen on responding to any direction. If we had proceeded the vocals would simply have been a voice-over, and that is death for an animated film. Everything must be done to integrate a voice into the world of the film. In the 1990s many very literate and very beautiful films were made in the UK, based on various classics, all with high-profile actors delivering pitch-perfect studio performances, which somehow did not connect with the performances of the puppets and the drawings. As with puppets, it's the little improvised vocal moments and the reactions to the physical surroundings from a character that plant it in the imagined world. The more physicality the better. As voices are usually recorded way ahead of any filming, the director needs to help the actors visualise what and where their characters are. Ideally, the whole cast needs to be in the same studio at the same time, bouncing off each other. It is traditional for actors to record their lines in order, leaving a suitable gap, with no overlap, so that the timing can be tightened or loosened. This is great for the editor and director to have freedom in assembling the dialogue track, balancing the sound as necessary, cutting bits that don't work after all, but it takes a very good actor not to anticipate this gap. Often, when a line of dialogue is due to be interrupted, you hear the voice just rising in a small cadenza. I would be very

happy letting the actors naturally interrupt and encourage each other, and for this to be the performance the animators work to, rather than constructing some of the performance in the edit suite. But, swing and roundabouts, one actor may have given a tremendous delivery on one take, while the other actor may not have been on top form, and you are stuck with overlapping lines. Again, I worry about technology separating the performer and the performance. Technology is best used to fine-tune the performance, rather than create it.

Lead, kindly cue-light – David Holt, voice artist

Thanks to our rail service, the producer has arrived late, so now I'm reduced to ten minutes to convince her that I can provide the funny, eccentric yet convincing, vocal characterisation for an animated dog that hypnotises people. How many other people's Monday mornings start like this? No rehearsal, no preparation; just a couple of lines for balance. So I give it a go. Thoughtfully, the producer has some character designs for said hypnotising dog. He's wonderfully canine in an eccentric, cartoony way, with sinister eyes – like the memorable Kaa in the *Jungle Book*. Eastern European? Chinese? Boris Karloff? Terry-Thomas at his most malevolent? All these variations are tried. We settle for Eastern European with a hint of Bela Lugosi. Two complete takes and I'm out the door. 'We'll be seeing you soon'. This sounds hopeful, however, wasn't that a well-known comedy flicking through the script?

I'm sweltering in a tiny booth recording for the xxxxth episode of a co-production. Such series will be animated with Canadian voices and then re-voiced here in England for a native audience: hence my participation (and perspiration). I have several characters, and this time I am working 'to picture' and therefore working to someone else's performance. It's a strait-jacket. 'You're talking to yourself in three different characters in this scene, which do you want to record first?' Hmmm … the one with the most to say, probably; leaving any shouting till last. 'Ooh, there's a song: it's a nice tune and you get to harmonise with yourself. Let's give it a go'. I'm on my own, trying to hit the cues, watch the pictures and remember each line; it becomes a demanding exercise in concentration and vocal stamina. Less an acting job, more a technical exercise, but hopefully the audience won't hear my perspiration. Between takes I slurp draughts of water and slide open the booth door for a snatch of another luxury: oxygen. 'Close the door when we're recording'. 'I'm perfectly well aware of that after twenty years in the business!' I'm tempted to screech, in my best Bette Davis. I manage restraint, pocket the eye-patch, and instead proffer a humble 'Sorry'.

Later, Ermintrude has burst a blood vessel: you can hear her udder creaking under the strain of hitting those high Cs. In response, my Hancockesque Dougal is unimpressed and scuttles off to find a bone, and my nerdy, anorakish Brian is more interested in adding a rare form of carborundum to his ever-expanding gravel collection. No, this is not a nightmare induced by a tropical disease, but bread and butter to those of us in animation. It may look like the ranting of the mentally fragile, but our job as voice artists is to turn this into some sort of reality, so that the directors can walk out of the studio with their lunacy enshrined on tape, ready for animation. 'Oh, Dougal lands in a puddle of mud'. Thanks, that makes a big difference. 'We're rolling!' I do the first of several takes of what must seem like primal scream therapy. 'A bit quicker …' 'Distorted the mic, sorry …' 'More of a thump on the landing …' 'Perfect, thanks David'. My fellow artists, a select group of hideously talented individuals, are reading their scripts, reading the paper, daydreaming, fixing the buckle on a shoe, or (thankfully) giggling at my ravings. There's lots of giggling in the control room too: is this at my dazzling, epoch-defining comic performance, or just something rude on the internet?

'Oh it must be such fun doing all those silly voices', I'm told, but I correct them. Fun: of course, I wouldn't be doing it otherwise. Silly voices: yes occasionally, but not always; a silly voice does not necessarily constitute a character. Being, first and foremost, a trained actor, I try to invest some truth in the characters, Whether on radio, on TV, on stage or in animation, I point out that providing voices for animation is an *acting* job. You have to act the part: act the emotions and action, however heightened and ridiculous; because if you can't act you're heading for trouble. The animators can act very well and they need inspiration from the voice track to manipulate their puppets effectively. It requires an open imagination, a willingness to try things out and suggest ideas. A good voice track should work on its own, without pictures, just like a radio play. The other illusion people are under is that we work to picture all the time: 'It must be terribly difficult fitting the words to all those mouth movements!' Well, yes it damn-well is! But thankfully ninety per cent of the time involves recording before the animation, so one isn't working to the constraints of ready assembled pictures. The voice recordings are then taken away, edited, barsheeted, animated, mixed with music and sound effects, and finally placed back into the finished mix.

Here's a thought for directors out there: when your voice 'talent' is safely sealed into the booth, it's often the case that conversations going on in the control room can't be heard by said talent. Now, we voice artists are a fragile lot. We feed off love and appreciation, and encouragement – however false. Good directors always punctuate the end of a take with words such as 'brilliant', 'excellent', 'fantastic', 'epoch-defining', etc.; or 'Oh b****cks, it's the best we're going to get. Let's go down the pub'. Could I politely request that you continue to do so? It makes us feel good. It convinces us that we are doing well and everybody is happy. This gives us more confidence, which feeds into a better performance, so the momentum keeps building and by the end of the session you've got what you wanted, and we can feel satisfied that we've given of our best. What has the corrosively destructive effect is hearing nothing from the control room and yet seeing lots of mouths moving. Faces are serious, heads in hands; people can be seen on the phone looking tense and fraught. To our febrile imaginations this translates as: 'Oh my God, he's terrible' and 'I thought we'd booked David Jason'. And although that may happen, what they are saying is: 'Do they still do that pastrami on rye here?' or 'I could strangle that nanny!' So please, keep the talkback on now and again. Keep us informed. Treat our fragile egos with kindness and generosity and you will be rewarded.

Oh, I didn't get the part. This was a knockback, for sure, but there'll be other opportunities. Let's face it; I used to be a tractor driver: I was by turn frozen, soaked, deafened and plastered with slurry on a regular basis; so what have I got to grizzle about? It is magical seeing those wonderfully animated models coming to life on the screen, produced by some of the most skilled and creative people in the world, and knowing that you've played a part in that creative process. And there they all are with your voices on the soundtrack.

It could just about be the best job in the world.

Toad's mouth was huge, and if opened too wide it looked like some terrifying wound. I initially made the mistake of raising his head, as well as his jaw, as he spoke. Most ugly. Mole and Ratty had very pert little mouths with pretty malleable lower lips thanks to several inserted paddles, and Badger had flapping whiskers. Unlike the others, Toad did not have a nose, which helped to give those characters expression, formed in part by certain mouth shapes. The puppet-makers gave Toad a suggestion of a front part of a top and lower jaw that could move independently of the rest of his mouth. This made convincing 'O' shapes. 'E' shapes were easy

Sempre Bufo! Always a toad (Richard Haynes).

and the lower jaw managed 'Ms' and 'Vs'. One shape that is always hard to make is a pursed and puckered 'P' shape. This can be done using replacement mouth shapes (as with Jack Skellington, in *The Nightmare before Christmas*) or by replacing the mouth structure, but with Toad such a large expanse of mouth made any form of replacement difficult. But you find a way to convince the audience that the character is doing accurate lip-sync, and this is about not animating every tremble of the mouth. Should an actor say 'Mississippi', there are seven mouth shapes. Watch this on a film and you would probably see a blurred mouth in most of the frames as the jaw and lips raced from one shape to another. With stop motion we do not usually have the luxury of blurred frames, and showing a puppet mouthing every syllable would give a distracting and very flappy action. There is no need to animate the shape exactly as written on the bar sheet, but it's important to listen to the overall shape of the word, and to some extent, you need to be anticipating the shape of the next sound. With so many consonants in ' Mississippi' there are not enough frames to shut the mouth then open it again wide for the vowels, but you can give the suggestion that the mouth is shutting and opening. The word 'oboe' has two big O shapes with a tight closed B in the middle. Both Os are so wide and the B is so brief that I'd only close the mouth a fraction before opening it again. Closing it all the way would look overenunciated. Most puppets have neither teeth nor a tongue, both of which are vital for speech, making exact reproductions of mouth shapes somewhat futile. Thinking of the character, the rhythm, the volume and the geography is far more important.

Mouth shapes: not just an open and shut case – Jo Cameron Brown, dialect coach

The way a character sounds helps to tell the story of who they are. The shape of the mouth matching the voice-over gives the character authenticity, believability and above all character. Try this: stretch your mouth into a letterbox shape: 'eeeeee' what characteristic does that expression convey … hesitancy, apology, surprised resignation? Now bring the lips forward into an 'oooooo': How does that feel? Vowels tend to convey emotion: 'oooooo', 'aaahhh', 'aaww', 'heeeeh'. They are made by the tongue position in the mouth and while no lip movement is required to make a vowel, adding lip-rounding, stretching, jaw dropping lends a character life, and humour. Consonants tend to make sense of these emotive vowels. Try this: back to the letterbox mouth shape, teeth slightly apart and say 'A hard day's night'. Now have a yawn, retain that open jaw and round space in the mouth and say 'A hard day's night'. You will have two very different sounds. The first near a Liverpool sound, the second nearer an RP English sound. Try the oooo shape, lips forward, energy at the front of the mouth 'A hard day's night' now may be making the journey up to Newcastle, or if those lips are softened into a pout our character takes on a French *je ne sais quoi*! Lip shapes can help identify a character, matching the accents and dialects of the voice-over, adding emotion, background, humour. Even a single lip shape can define a character: just consider Elvis' lip-curl.

Rosemary Joshua, the voice of Gilda from *Rigoletto* and Ashley Thorburn, the voice of Sparafucile.

Alasdair Saunders, sound engineer, Hullabaloo, UK

My first animation recording session was for five days with just myself, the series director and one actor. I became fascinated with and how these voices ended up as a television full of talking small, furry animals. The series had four main characters, several smaller roles and a narrator. I was amazed that one actor could switch voice from character to character, having two-, three- and four-way conversations with himself as well as using his natural voice to narrate.

Cosgrove Hall sessions were on a much grander scale. The production team would turn up *en masse*, with as many as nine artists, often famous names; all recorded simultaneously – by far the most complex job I've had. I had no idea that recording sessions could be so demanding.

A new series is always very exciting. The cast is made up of actors, comedians and, in my view, the unsung heroes of animation: voice artists. These incredible individuals specialise in using their one voice to create a plethora of different characters of all ages, accents and gender. An actor new to the world of animation is often taken aback at the skills shown by their fellow voice artists. What ensues is a battle of professional rivalry with each vying to top the other's performance. This results in blisteringly outlandish recordings, perfect ingredients to hand on to the animators. A fine example of this is the BBC's remake of *Bill and Ben*, where the interplay between the two flowerpot men (comedic actor John Thomson and

highly acclaimed voice artist Jimmy Hibbert) is a joy to witness, all delivered in the entirely made-up language of 'Flobadobese'!

On the day of recording, with the cast assembled there will be time for them to relax and chat – an important part of the recording process as everyone needs to feel at ease. Every part of the day is geared towards capturing the best performance possible and so the atmosphere is kept light and jovial.

The recording begins with a read-through of the script. This is a busy time for me as I make a lot of technical adjustments on the console. An artist might be required to deliver a line in the character of an angry giant, followed by delivering a line as a timid doormouse. I scribble down various symbols on my script warning me of line-by-line technical changes.

I always record the read-through, but don't let the cast know. The read-through can result in 'happy accidents' with off-script asides or adlibs.

Once everyone is happy with their scripts and characters, recording commences. Typically the first take is recorded, followed by notes from the director and script alterations. The episode is then recorded for a second time, invariably becoming the backbone of the voice track.

Individual lines may be recorded as alternatives to those scripted.

By the end, all are exhausted, but the excellent performances are well worth the effort.

The next part of the process is the dialogue assembly, where the director and sound editor select the best takes. The aim is to tell the story in an entertaining, clear way. Once complete, the dialogue will be 'fine cut' to a precise length, with the director leaving appropriate gaps for action sequences.

I hear nothing more of this episode until it has been filmed and edited. With the finished film and voice track back in the audio department we can start the process of designing the sound for the series. Usually a series is set in a world far different to our own and we create atmospheres to reflect that. These are layered up from existing sound effects libraries and recordings we make ourselves. I often come to work on a Monday morning armed with various props selected to make up these atmospheres.

The same goes for spot effects. If a character is large and happy, we record footsteps that reflect that. These atmospheres and spot effects become part of a bank of sounds specific to the particular series. Once the bank is complete and approved by the director the track-laying process begins. For each action on film, there is an appropriate sound. A single ten-minute episode contains thousands of spot effects, all carefully laid by the editor. Every location has its own atmospheres, be it day or night, come rain or shine.

After track laying, the director will preview the episode, making adjustments with the editor. All that remains to be done is the final mix.

The incidental music will have been scored appropriately and delivered to us for the final mix. Armed with dialogues, atmospheres, spot effects and music, the final mix can take place. The object is to blend all these sound elements in a way which complements the picture and reinforces the storyline. Modern mixing equipment allows the flexibility to incorporate any last-minute changes almost instantly, making the working day a pleasure for the mixer. Once the director and producer are happy with the final mix it is played back on a domestic television set and one episode is complete and ready for broadcast.

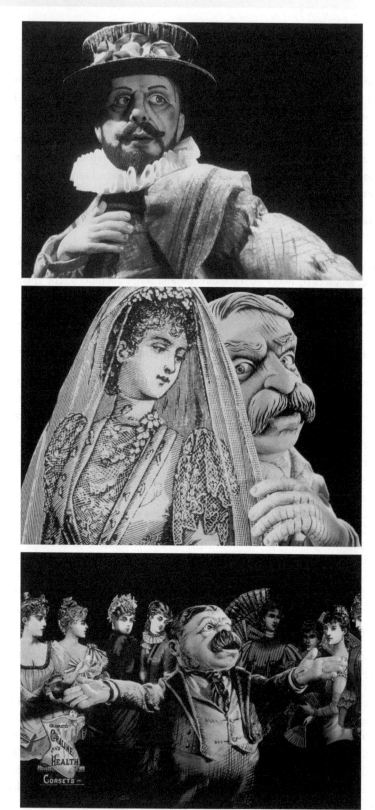

The expressive eyes of D'Oyly Carte, Gilbert and Sullivan.

Eye acting

Toad had extraordinary eyes, made by a maker of genuine glass eyes. We had intended to have removable eyes, swapping large or small pupils according to his mood, but in the end we had one pair of standard marmalade-coloured eyes, with beautiful mechanical hand-adjusted upper and lower lids, a gift to the animator. Too often, closing lids are luxuries the budget can ill afford. Some puppets have painted eyes that you pull out and replace with half-closed or fully closed versions. This gives limited expression, but Toad's eyes were able to close as quickly or as slowly as the animator wanted, and, even more of a luxury, they were independent of each other. He was capable of closing them slowly as if peering, helping some of his more devious moments, and he was capable of opening them in a single frame, aiding his more melodramatic moments. Moving from the closed eye to the vast expanse of open eye was quite shocking, but very Toad! These eyes provided such versatility.

Rigoletto's one eye working overtime.

Only the *Rigoletto* puppets have matched Toad for such potential. Keeping Toad's eyes in focus was enormously hard. With such a tiny iris in such large orbs one millimetre to the side and these eyes lost their focus and the face was dead. Of course that could be used to Toad's advantage … many scenes had Toad being lectured to by Badger, and you could act Toad trying to keep interest but then making a point of his eyes losing focus, as his mind wandered and he literally had a glassy eyed stare. This also enabled him to throw his eyes up with a look of disdain that only needed a tiny move of the head complementing this to work. The same gesture with a character with merely painted eyes would have needed a much larger flick of the head to register and might have ruined the gesture and timing. In addition, since Toad's irises were so small, they were capable of a lot of movement within the eye itself. He could slyly follow a character for a long time before needing to turn his head. Disney's *Pinocchio* uses the same trick of having unfocused staring eyes to suggest his lifelessness, which suddenly becomes very active and focused eyes when he is transformed into a breathing boy. A simple, cheap trick, but a vital one.

The script called for Toad to listen to approaching cars or to sniff wine, being the epicure he was, but without ears or a nose as such we had to find different body language to express this, and inevitably the eyes helped. He could 'listen' with his eyes and his eyes could show whether the wine was good or not. It is often interesting to find a less literal way of expressing things.

I much enjoyed the flicker of focus from one eye to the other between the characters in *The Corpse Bride*. With most puppets just having a tiny pinprick of colour, the eyes could have been dead (even for a dead character this is not helpful), but this flickering helped to suggest something going on in the characters' heads, with real connection and responses going on between the characters. It extended the range of emotions possible: it was clear when a character was agitated or was threatening or challenging. With any clever trick like this, you also make a comment when the characters do not do it. This was a lovely detail and one that would have been impossible for characters with non-moving eyes.

I find it hard working with characters that only have a black dot as an eye. It limits the expression, and forces you into a simpler acting style. Toad was capable of looking at something while his head was pretending not to, literally out of the corner of his eye. To get the characters with painted eyes to look somewhere, you have to turn the whole head. You cannot do anything subtle or with subtext. It is hard for a character to avert his gaze in embarrassment, for example. To do this you would have to turn the whole head, and that reads as a totally different gesture. Invariably, this painted dot is black, which is probably the most unnatural colour to paint an eye, but somehow how its very graphic nature, like a dot in a pen drawing, works. I tried once to give these black shapes a tiny white highlight, but rather than bring the eyes to life, it had the effect of making the eyes look fixed in a particular direction. The white unmoving dot clashed with the natural moving highlights caused by the studio lights. When lighting a puppet, especially in telling close-up, it is always worth trying to get a natural highlight in the eyes from the lights. As portrait painters know, the smallest of highlights makes the difference between a painting being dead and being alive.

Blinking

Blinking is another huge means of expression. Outside the biological need, blinking is a great form of punctuation. You can use blinking as a comma, to pass through linked thoughts and ideas, or use it in a more pronounced way as a full stop, to suggest the end of a gesture or idea. An emphasised blink is a great way of letting the other character know that you have finished, and that it is their turn to respond. The passive partner of a conversation can respond with casual and regular blinks, showing that they are still paying attention. It is important to focus the shot so that the viewer knows exactly who is important and who is listening, for schedules may prevent detailed animation of secondary characters. This can sometimes leave the listening characters a little static, wary of causing any distractions. I would never leave a puppet frozen for too long without blinking them, just to indicate that they are still paying attention.

Many languages have a vocal equivalent. The Japanese have a very strong 'hi' that accompanies the other speaker at regular intervals. The British nod a lot and say 'yes'. I would suggest with animation that we can do this more effectively with blinking. Sadly, I have seen instances where the animator has focused all his attention on the main puppet, and just had the others in a strong pose listening. Forgetting the others, the animator suddenly remembered to move them, by overcompensating and blinking all at the same time. Not a good idea.

The boy from Suzie Templeton's *Dog* (Royal College of Art, 2001).

The most expressive eyes I have seen are in Suzie Templeton's *Dog*. The story of a father and son, and the suffocation of the family dog, is replete with strong silences and looks and pauses and is a testament to less being more. It is hard to say exactly what happens, but the missing mother is clearly recently deceased and the father has a fear of whatever lurks outside. The plot is not necessarily what the film is about. It is only a few minutes long, but I've never seen any film generate such a powerful atmosphere so quickly. The design of the sets is essential to the feel of the film, as you can almost touch the mildew and the brickwork. The texture belies the scale of these puppets and sets, and the film is lit to make the most of these textures. But it's the performances of the three characters, the father, the son and the dog, that amaze. There's very little action as such, save for the brief, violent suffocation of the dog, but the film is full of subtle movements. It's rare to find puppets, especially in a student film, with armatures that allow such movements, let alone being able to animate such minuscule delicate movement. It's as if Suzie has just breathed on the puppets. Some of the gestures are so slow that you are not sure they are even moving. This takes enormous control when animating, as sometimes a move needs to be sufficiently large to register, but then be too big to be appropriate. Such moves may not have been too clear on the video playback, so Suzie must have relied on the tactile nature of the animation. This feeling of the movement is such a skill that can often atrophy with technology. In her half-hour film of *Peter and the Wolf*, Suzie has managed to keep these subtleties, even when working with other animators. There's an astonishing shot of the cat on the grandfather's chest, with a lovely touch of the grandfather twitching briefly in his sleep. An emerging trademark of Suzie's work is the characters' eyes. Their delicate colour makes them stand out,

but she seems to wet the eyes, making them alive. They are clearly focused but, rather than looking static, there are the briefest of hints of movement, suggesting things going on inside the head. Whole shots are constructed around the movement of the eyes. Once again, so much is communicated through the eyes.

A trick I have used is having the blinks out of sync with each other. This can produce an unsettling effect. A character in *Hamilton Mattress*, the egocentric Senor Balustrade, had such a blink as one of his many signature moves, and it had the effect of making him look slightly out of control and a little unpredictable. Even though they are just one frame different, it's enough to give the character oddness.

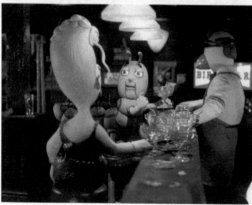

The lively eyes of the *Hamilton Mattress* characters: Senor Balustrade, Feldwick and Hamilton.

I am wary about overdoing the blinks. In most Disney films, the characters are given eyes that are overemphasised in terms of proportion and activity, making the blinks a huge feature of the animation, with the subsequent constant fluttering getting too cute. It's hard to get a balance. Too much and the characters get annoying, too little and the faces become somewhat dead. The physical purpose of a blink is to keep the eyes moist, but the brief closing of the eyes can also stop the vision from getting too blurred in a swift movement of the head, like the black frame in a strip of film. If it wasn't there, things would all melt into each other.

Another new development with dear Mr Toad was having mechanics under the skin operated by turning a key inserted into the skull. At each side of his mouth, Toad had a half ball shape that with a turning thread could raise or lower, giving Toad a fantastic smile or a sulk ... both of which he did aplenty. Initial designs for the puppet had the keyhole carefully disguised in one of many of Toad's warts on

his head. With all the texturing and the positioning of the wart, the audience were unlikely ever to see this hole. However, we would forgotten Toad's all-important sartorial tastes. In every episode he had a new outfit, and this invariably included a hat. We had to animate the first few scenes knowing that Toad could only smile if he took his hat off. This became like some vaudevillian routine. The screw hole was subsequently moved to behind the head, out of the way of most hats. This worked well except for occasions when he leant against something, limiting access to the hole. It's unlikely that you'll ever be able to design such mechanics with 100% access, but it is vital that you think through such practicalities.

Shakespeare

A somewhat different puppet was Shakespeare from *Next*. He was just as physical as Toad, with a deliberately less expressive face, but exquisite eyes. This particular puppet, now nearly eighteen years old, was like working with velvet. Sometimes you can feel a puppet's joints grinding against each other, but these joints were smooth and very sensual. They stayed exactly where you put them. He was so proportioned that I could hold him rigidly round the chest, and with just one finger reach and move an arm independently of the rest. He was a reasonably light puppet, as there were few mechanics and not a huge head, so he was able to balance on a single magnet under a toe. His skin might now be rotting away, but his skeleton would still be able to give a good performance. Acting through him was a pleasure.

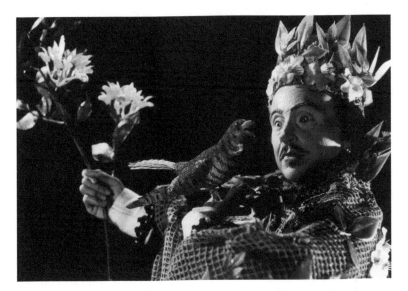

Shakespeare's eyes.

Puppets for *Screen Play*

The puppets for this film have less emotional resonance for me, as they were essentially all about the costume, the make-up and the masks. I'm not sure I got through these façades as I do the other puppets, but they are pretty impressive. There are two versions of the main boy and girl; one with the elaborate Kabuki make-up for the theatrical part of the film, and one for the more real filmic section. For this last section, they had new heads that were free of theatrical make-up,

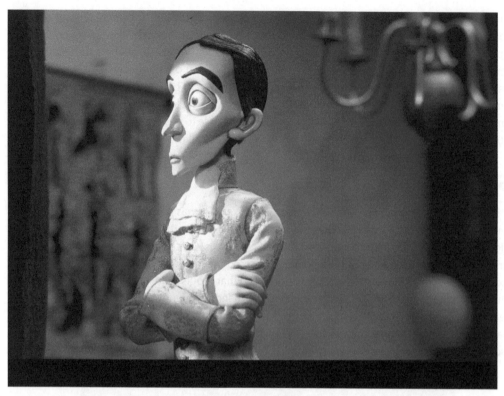

The haunted face of The Periwig Maker (© Ideal Standard Films, Annette and Steffen Schaeffler).

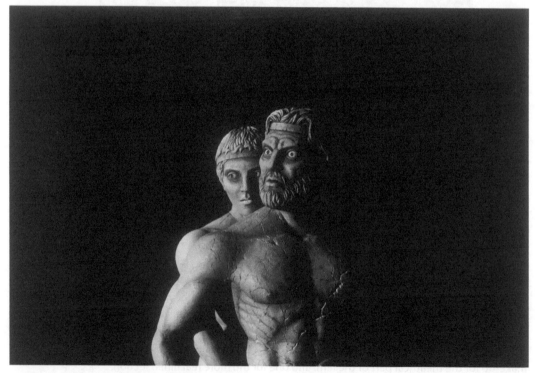

Achilles' direct gaze and Patroclus' averted gaze.

with their costuming similarly naturalistic. Because the puppets had to stand on the revolving set, the size of which was dictated by the length of my arms, the puppets ended up being smaller than preferable. The mechanics involved with the revolving stage meant I could not place magnets under the actual floor surface, so tiny magnets were disguised in the soles of the shoes. This was less than perfect as the magnets were not strong enough to support the puppets, and I could not switch off the magnetism. I was unable then to give the nice peeling-off shape to the feet as they walked, and they all look a bit flat-footed. The small scale of the puppets meant that armatured hands were out of the question (and budget) and their hands had wires in the fingers; after such intense use, these got a bit mangled. Happily, the Recitor (the narrator) was slightly larger, with a pair of beautifully armatured hands. I'm wondering now whether these weren't borrowed from the Shakespeare puppet. Owing to the sign language the Recitor performed, he had to have very articulate hands. The costume was designed around how the character would perform. With the hands being so significant, and most of the film in wide shot, we had to make sure they were clearly visible, so they were very white and stood out against a dark blue costume. Nigel Cornford, the designer, had originally pictured a paler top for his costume, but I was worried that the hands would have got lost against this.

That *Screen Play* is seen as successful still surprises me. I worried it might have been an enjoyable but indulgent exercise on my behalf. That people are moved by it and watch it frequently, and that it is studied in colleges, is a constant source of unexpected pleasure. There were many reasons for wanting to make it, and most of them to do with interesting storytelling, but now I feel there is too much storytelling and no actual story. I would love to revisit it. Another reason for the film was the long, extended shot, as this was the nearest I could get to the adrenaline of performing.

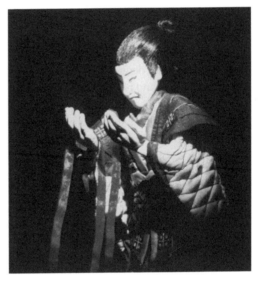

The Recitor's storytelling hands from *Screen Play* and that blood again.

Stop motion is unlike any other performance. Once you've done a shot, you suddenly think of another piece of business, or a different way to have timed it, but you cannot go back. This is both terrifying and hugely exciting, even today after thirty years. *Screen Play* was that recurring dream I mentioned earlier. As I took that first frame, that was it for nine and a half weeks of shooting. That extended period of adrenaline plays with your head, but what an exciting challenge. Whether this was for my selfish benefit, I don't know, but the audience seems to enjoy the constant and lyrical stream of changing imagery. It would not have worked if I had used close-ups, and there would not have been the shock when the film starts to use cinematic grammar. As the title implies, it was all about playing with storytelling … and screens. The first section is a theatrical piece, with the audience, given only one objective viewpoint, being told where to look by lighting, staging, design and the movement of the revolving stage. The second section uses seemingly more naturalistic filmic elements of close-ups, moving cameras, and so on, to guide an audience. This is a bit of a cheat, and probably why

I like theatre so much, as audiences have to work that much harder, and the experience is more involving and satisfying. I never enjoy anything, whether film, opera or ballet, where everything is given to me on a plate. I want things to be dangled and teased in front of me, leaving me wanting to know more.

Puppets for *Rigoletto*

The character of Rigoletto had several problems to solve, as I wanted him literally to have two sides. I gave him one dead, discoloured eye. A rather obvious conceit in hindsight, but I had not reckoned how hard it would be to focus him with only one eye. As he flicked his good eye away in a gesture of emotional embarrassment, it simply read that he was looking elsewhere. His performance was built around this one eye. To emphasise that he was focusing on a character, he had to be as tactile as possible, literally grabbing the character's attention. I love working out these approaches. Rigoletto was a hard, slow film to make, but only having one eye probably saved a few days' shooting. Sticking characters in masks for some scenes also speeded up the shooting. Every little bit helps.

The trio of principal puppets was given fantastic breathing mechanics, as it was important, if not to replicate the act of singing, then to show the effort involved. The puppet designers gave the puppets supple lips that could suitably tremble and vibrate, and mouths able to open a considerable degree. The breathing was important for me, and I went through the singing, breathing and phrasing techniques with the musical director. The designers provided extraordinary devices, operated by small keys, that lifted and separated the chest cavities. Access was through the front of the torso, with the keyholes disguised by jewels or buttons. This worked well in theory, but in practice the more intimate close-up scenes, where it was essential that the breathing was noticed, had the puppets clutching each other in paternal or rather more seedy embraces. Gilda often half turns away from whoever she is with, allowing access to the key. Sometimes, when she is face to face with another, she literally had her breath taken away, as I simply could reach the screw. I wanted to show off this breathing, particularly with Gilda, where it was not just about singing but her heaving chest expressing something about her state of mind. We designed a latticework as part of her costume that enabled us to see her cleavage rise and fall while being suitably modest for the character, and echoing the imagery of cages throughout.

Ah, those ingenious, playful guys at Mackinnon and Saunders …. On the day I received Rigoletto himself, they told me they had fitted a device in the breathing mechanics to prevent overwinding. Engrossed in the scene, worrying about whether the chest was going up or down (and that was a constant worry), I stared into Rigoletto's one good eye, twisting the chest key slowly, when suddenly he started to sing, annoyingly loud. What he was singing was nothing by Verdi. The puppet-makers had fitted the chip from a greetings card that bursts into song all too frequently. Rigoletto continued to sing *Happy Birthday* inappropriately for many hours to come. You could happily strangle a puppet in such moments.

Rigoletto is hardly the first film to using breathing puppets, as many of Ray Harryhausen's creatures can be seen breathing, most memorably in *One Million Years BC*. This, I believe, was achieved using an inflatable bladder in the chest cavity. The results are impeccable and subtle, and must have been enormously tricky to animate. If I had not written the breathing on the score I would have become hideously confused, and I often did. The cat in Suzie Templeton's *Peter*

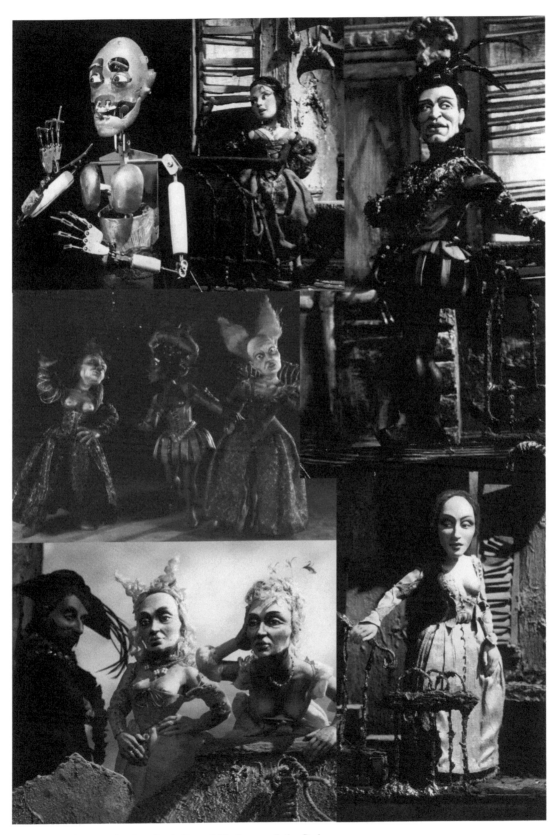

Gilda's breathing mechanics, the ladies of *Rigoletto* and the Duke.

The supremely talented Peter Saunders and Ian Mackinnon, and some of their many creations (photograph courtesy of Matthew Stansfield).

and the Wolf lies on Grandfather's chest, purring away, its chest rising and falling perfectly, with the fur fanning out and contracting. This must be achieved through some internal mechanism, enabling the fur not to be touched.

Staging

Doors

As animators enjoy imbuing inanimate characters with personalities, I try to give the props and set all manner of resonances. Doors are a useful dramatic device both on stage and on film, giving a sudden entrance. (My favourite theatre, the Royal Exchange, is slightly handicapped, being in the round. Actors have to run a good twelve feet before they are actually on stage, and then more to be visible by everyone. The split-second timing of entrances demanded by genres such as farce is trickier to achieve here.) Editing can create a sudden entrance, necessary not only for tension and excitement, but also for moving the plot along. Doors have so many significances, and a thesis could be written about the importance of doors as a dramatic element. They are useful to introduce or say farewell to characters; to suggest something unseen; to suggest a journey, whether real or emotional; to suggest beginnings and endings; or to suggest things kept secret – many possibilities, and a terrifying image is simply a door handle being turned or a character tentatively reaching for a doorknob. Questioning what is on the other side, the potential for suspense is enormous. Films like *The Others* exploit this wonderfully. Doors can represent a moment of decision, a finality or a beginning. Any of us unfortunate to have attended a cremation will know how emotional the sight of a door closing can be. As with the door handle, much can be read into a static shot of a door.

Doors are a great catalyst for expression, as how a character leaves or enters says so much about them, and coming through a door always draws focus. It is instant and immediate. In animation we often deal with alternative worlds and perspectives, where doors provide a link. In Suzie Templeton's *Peter and the Wolf*, Peter starts the film in a cage, needing to break out of a door to experience the adventure with the wolf. By the end, it is Peter who is free but has put the wolf behind a door. Sensing this, he frees the wolf.

I use doors a lot in my work, but animating a character through one is usually incredibly fiddly as there's inevitably a moment when you cannot reach all of the puppet. Usually, the doors of a character's house in a children's TV series reflect the scale and style of the character. This is fine until another character has to walk through. In the whacky world of animation one size seldom fits all. Animating the door itself is hugely satisfying, as even the beginner can make a door slowly creak open or slam shut with the added vibration to show the energy. In real life we would not actually see the door vibrating, but it's a cheap and effective trick.

In my film and stage work I use doors hidden within more illustrative parts of the set. The palace doors behind which the Duke has imprisoned Rigoletto's daughter look like a deceptively pastoral painting. *Screen Play* is all about sliding doors, playing on characters' entrances and exits, and changing perspectives. *Hamilton Mattress* has numerous doors hidden in the jungle panorama of the nightclub. With Hamilton thrown out into the alleyway, the closing of the door, and its fading light, is a moment of desolation. Every stage piece I've designed has hidden doors as a way of making a character instantly appear on stage, often from the least expected of

A scene from *Habeas Corpus*, Altrincham Garrick, 2007.

Exits and entrances from *Hamilton Mattress*.

places. I have directed farces whose staple ingredient is a preponderance of doors. Michael Frayn's dazzling *Noises Off* stipulates almost a dozen doors, and there is something inherently funny about characters running in and out with clockwork precision. Likewise, the lack of doors, or a defining space, can have a decidedly creepy effect. A film is hatching in my head, now, exploiting the significance of doors.

I have thought of developing something based around the opening and closing of elevator doors, each time revealing a new environment. This is not unlike the black frame of a film strip or the black cloak of a magician. Something is concealed from us briefly and has changed.

This long diversion is not so much about doors as about using the space, and letting that be part of the storytelling. In the condensed world of animation, anything can tell the story. Telephones used to have such subtext, but mobiles and the ease of keeping in touch have changed modern scenarios. Stairs have an inbuilt drama, again suggesting a journey, or a mental descent or ascent, as well as a physical one.

Rushes

One pressure that new digital technology has eased is the nightmare of watching rushes. With animation it's a mockery to call them 'dailies' as that would be a few seconds. The early series I worked on saw the film sent off for processing not more than once a week. The most responsible job on a film set then was the camera loader. I have watched many a camera being opened and a week's worth of film shoot across the floor. No-one got angry as there was no point. You cannot roll it all up and shove it back in the camera quickly hoping it didn't see the light, like the photographic equivalent of the three-second rule of dropped food! Sometimes the courier lost the cans as he travelled to the labs across that bleakest of motorways, the M62. Some sheep may at this very second be cogitating over lost footage of *The Wind in the Willows*. There have been occasions when the camera was opened, and there's an echo unlike any other: no film. Terrifying, but not as

All my obsessions in one image: a redrawn detail from a Max Ernst collage.

terrifying as watching a week's rushes with producers or clients unfamiliar with the details of the scene or story, and whose casual comments cut deep. Shooting on digital lets you check a shot immediately, and check it with the sound. You can see it cut into the previz, fitting into the sequence. You can more informally share thoughts with producers and clients. Rushes of yore held no such luxury. We sat in stony silence listening to the flicker of the projector, screening your work in its most naked state. There was no sound to make sense of the gestures, grotesque mouth movements or sudden movements, and without this motivation even the best stop motion looks awful. The shots were likely to be in a random order, depriving some actions of any sense and context. It was hard to sit there and not speak out the dialogue along with the film, or to shout out that a certain gesture was done because it parallels something later in the film. No such joy as the rushes sit there screaming their coldness. Never was an animator more vulnerable or more prone to being destroyed. What you thought was a beautiful piece of acting, in the cold silent light of a projection room always looked absolutely ghastly, and I sweated with fear and nervousness as my performance fell on stony ground. I would lose sleep the night before, being sick with anxiety. It was made worse by being removed from that shot. The shots stand alone. Sometimes an animator filmed some naughty piece of business at the end of the day. How flat it fell the next morning.

In a rehearsal room, if a performance is unsuitable you can try it again, and it's gone. Unfortunately, your work, and your bad work, is up there on the screen to be run and rerun, each time hurting more, your inadequacy growing. For the first week of a production, everyone crams in to watch, and there is polite applause, but schedules take over and interest wanes, and only a few people come. This anguish was all of my own, as the indifference could be caused by everyone else blindly focusing on their bits, the lighting, the costume and the set. I would be happy never to sit through rushes again. It was worse than exam results read out to the class. If I wasn't a perfectionist, didn't care so much and didn't worry about every frame, then rushes would be a doddle. There have been moments, however, when rushes have brought spontaneous rounds of hugely rewarding genuine applause. After all this time, I'm not surprised by my own rushes, as I know exactly what they will look like. It wasn't always so.

Watching rushes: the Pepper's ghost effect from *Gilbert and Sullivan*.

Do the rushes ever surprise you?

JD – Sometimes, unfortunately, but not too often.

TB – When I improvise on the set, and see it in rushes, and it works, that's very satisfying.

KD – Yes, it makes me want to re-do it!

RC – In traditional and CG, no, because they are different in terms of process and refinement. In stop motion, yes, because even when I have 'hit' what I was trying to do, I find that being somewhat of a perfectionist, I wished I could just tweak the timing or pose a bit more.

DC – I've seen the shot a hundred times by then so it's only things like lighting and colour I couldn't see in the grainy black and white monitor image that surprise me.

AW – Very often surprise. I don't like to watch rushes too much as I become too conscious of the shot's flaws.

SB – Yes, sometimes for the better but not usually.

RH – The rushes do surprise me a little, but it's usually because I find that sometimes it is difficult to devote 100% concentration to the job in hand; I may 'lose' it slightly and momentarily. If I notice this while animating, though, I try to 'hide' it, or make up for it with another move with the character that is well timed.

JC – Recently rushes have been a clearer, nicer film version of what already appears on your video assist operating system. The last 'blind' rushes I saw were on *Rockie and the Dodos*, where you'd be filled with excitement and dread. Had the shot come out OK? Were the timings right? Invariably they were but we'd all still be anxious.

The 16 mm Bolex cameras were a good size, enabling the animator to work around and alongside the camera itself, something the big chunky 35 mm cameras made difficult. The cameras also had a satisfying click, so the animator knew exactly when a frame had been taken, allowing them mentally to release all the stored information about that frame and be ready for the next. Most animators, even when working on digital technology, still need a click. In my early days with often two animators working on a shot, one was responsible for clicking the camera; the other would stand back from the set and wait in a quiet Pavlovian trance, focused on the set, until the click released them ready for the next frame. Having video technology to show the previous shot or the whole sequence has made the burden of absolute concentration somewhat lighter. On *The Wind in the Willows* I didn't like to stray too far from the set in the middle of a shot for fear of losing what I was doing. Other than notes on the storyboard, there was very little way of finding your way back into a shot.

It must have been a nightmare for the editors, and it's hard to believe that reasonable-quality images were possible from such a tiny frame, but many people have an affection for 16 mm. The Bolex cameras were user friendly and lenses could be changed in a matter of seconds. Sometimes the cameras were in such a position on the set as to render the viewfinder inaccessible, so the sides of the shot would be marked on set, constructing a mental acting space. It is years since I've looked through an actual viewfinder. The monitor is the instant and possibly lazy way now, but it gives a clear picture. What it does not give you is a muscle and spatial memory of looking at the puppet from behind the real camera. Judging everything by looking at the monitor gives you a very second-hand experience of what is in front of you. I would encourage young animators to look at the puppet and to feel its movement, rather than relying totally on the monitor. The early great animators such as Ladislas Starevitch, Willis O'Brien, Bretislav Pojar, Emile Cohl, Jiri Trnka, Karel Zeman, Hermina Tyrova, Zenon Wasilewski, George Pal and Ray Harryhausen managed to get great performances out of their characters without the aid of complex technology, or any means of seeing what they were animating. Instinct, with the occasional surface gauge, is still the best means of judging a performance. Technology can smooth things out and correct mistakes, but it cannot save a performance that isn't there to begin with. I'm sure those pioneering animators would have embraced any technology that made the process easier, but they probably would have resisted anything that distanced themselves from the performance.

Technology has changed the process, undoubtedly for the better. Time allowing, technology can give us precise animation. There is no 'flying by the seat of your pants' any more. That's both good and bad. Without seeing immediately what you

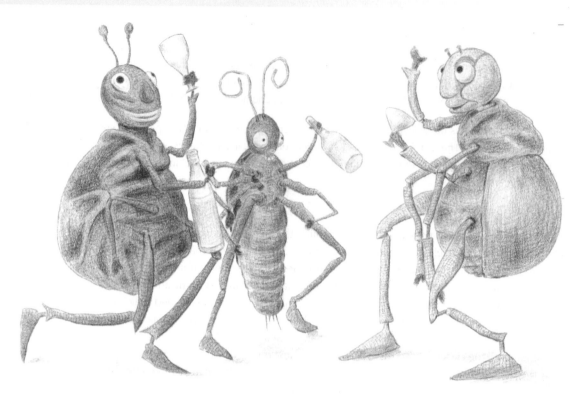

Starewicz's *The Grasshopper and the Ant* (Saemi Takahashi).

have just animated you had to put yourself into the puppet's position more, and you had to know the shot you were shooting and be totally prepared. Animators probably had a more intimate connection. Technology provides an often welcome safety net, and many animators rely on having their performances enhanced or even created in postproduction by clever editors. But it would be a shame to lose that adrenaline of having to get it right first time. One big clunky 35 mm camera I worked with had mechanics that allowed you to look through the viewfinder by sliding a substantial piece of the camera across on a special sliding rig. It was terrifying to see the camera move during a delicate take, but the camera usually returned to the precise position. However, the shots often had to be structured according to the camera, as sometimes the piece that slid across came into contact with the set, prohibiting any access to the viewfinder.

The first video playback system I worked with, probably in about 1986, was a very cumbersome affair. To take a frame you had to drop it on to the sequence that was being built up. The tape had to roll back probably ten seconds and then, with an alarming click, it would drop on the new frame, while denying you access to one frame from earlier. Very frustrating. Usually the

image was poor black and white, and not always taken from down the actual lens, meaning that you were animating with a distorted sense of parallax. Sometimes the image was so poor that a light had to be turned on to take the video playback image, and then turned off to take the real image on film. The extra light was invariably forgotten, giving a length of frame with flash frames: an editor's nightmare. This led to having more people on set than necessary, and animations sets are hideously cluttered at the best of times.

The quality of the film, though, was very kind to stop-frame animation, its grain and general softness giving a very gentle blur to the animation, and in those rough-and-ready days we needed all the help we could get.

Editing

The role of editor has changed enormously with technology. With stop motion, where only a few extra frames were shot, the editor's main role was assembling, trimming and finessing the footage. There was not enough spare footage to restructure or shape the film creatively. In *Next*, there was probably an extra six seconds shot, and *Screen Play* didn't even have that. With tight schedules it is sensible to get the film right in the storyboards; well, I used to think so. With most films now shot digitally, the editor has so much more creativity, not just in correcting mistakes, but in rearranging shots, creating new ones out of existing footage, adjusting the composition of clumsy shots, cloning characters from elsewhere and so on. Usually, editors work side by side with the director, shaping the final film, making sure every necessary element of the story is clear. I confess to have been very precious about each frame, but now I welcome a different informed perspective and am ruthless about cutting stuff if necessary. Working alongside editors such as Nibs Senior of Flix Facilities in Manchester for many years, I have developed a mutual understanding of whether a shot works. Most directors and animators, me included, will defend a shot, explaining all manner of plot, intention and subtext, but an editor has the distance from the intimacy of the shot to see clearly. Even though the storyboard has to be the basis of the film, the editor and director together can reshape the film, emphasising its strengths. With the fragmentary nature of stop motion, it is hard to have an accurate feeling for pacing during shooting. A director animating his own film can feel that rhythm, but an animator locked away on his own sequence of shots is not necessarily aware of the whole film; an editor pulls this all together. Inevitably, this means losing much loved or tricky footage. Learning to let go is hard, but necessary.

During the fine cut are you loath to let the editor cut shots?

JD – I'm a ruthless editor of my work. If it doesn't work, cut it. On other people's movies, I'm disappointed when an animation scene I liked gets cut.

TB – I generally work with an editor, but because stop motion can take so much of one's time and energy, I feel it's important to plan ahead via storyboards. There's nothing worse than spending weeks on a shot, only to have it excised when it wasn't necessary. If shots are planned out, this will minimise the heartache that comes from necessary cutting. The thing I love about stop motion is that one can throw in a degree of improvisation. When clicking away one frame at a time (that can be anywhere from a few seconds to a few minutes between frames), there's plenty of time to reflect on the performance and suddenly find a bit of inspiration.

KD – It's hard to let clips go, especially when they've taken days to do. I enjoyed the surprises of shooting on 16mm, because you didn't know what you were filming. It was amazing when the prints would come back. So exciting.

RC – Animation is an intensely personal art. We want to see *our* work on the screen so we have ownership of that character. That's why most stop motion has more personality ... the individual (or

few) versus the crew of hundreds. There's something about the work coming from one person, as much as possible. Because one can rework a shot in CG (an advantage if used properly), two things can happen. One, nobody puts their soul into the take because they know it's going to be changed. Two, in a large company, too many hands can make too many changes, risking watering down a shot instead of enhancing it.

AW – I'm never happy handing my work over to an editor. Every frame is like my child. It hurts.

SB – Cutting and editing scenes are as important to film-making as animating. I hate reshoots and leaving shots on the cutting-room floor, but if it makes for a better film it has to happen. Learning to let go of something you've lovingly slaved over for hours is a hard lesson.

RH – Editing can be regarded as 'criminality' in animation, so when I made *The Typewriter* every shot was tightly fitted to the music, so we didn't animate too much.

JC – An editor is invaluable to any film. Animated shorts are often one person's vision from conception to delivery. As director/animator you see a shot, perhaps beautifully animated, and find it hard to cut it. A trusted second opinion is extremely useful and can keep a film on target. (Though I have once or twice insisted on keeping a shot.)

DS – For me the film simply has to work in its own right and whatever needs to happen to make that so is justified. Having not done the animation work itself makes it easier for me to play editor, but I've found even the most precious animators eventually realise you have to lose stuff. Jeff Newitt is ruthless with his work when it comes to editing. Having just spent months animating he'd happily chuck out shots to make the edit work.

> Many characters are shot against blue screen, which makes things harder for the animator but easier for the editors; well, there is so much creativity, but we need to be careful that the actual stop motion does not become a series of elements in a kit, like some drawn animation, that can be assembled in postproduction. Some of this is necessary, and has rescued me from tricky situations, but we must not forget that the appeal of stop motion is its existence in a spatial environment, reacting with its surroundings and reacting spontaneously. Editing should not be a safety net.

The sound of silence – Matt Holt, Hullabaloo, UK

An animation sound editor makes sound where naturally, little or no sound occurs, requiring a great deal of creativity, ingenuity and a fair amount of luck. Mainly it's about trial and error.

A new episode means a new challenge. You have to formulate ideas very quickly based on limited visual effects. The process has many layers, all crucial to the finished programme.

Sound editing raises some questions that would never come up in most fields. What sound does an octopus make when it walks? When a magical scooter goes berserk, does the bell ring and when underwater how loud is a trumpet calling a mermaid? I need to answer them all.

When I describe what I do I keep it simple – 'I do the sound effects on the show'. But it's more than that. In most shows like *Rupert Bear* the process is divided into four sections. Firstly, the dialogues for each

character have to be separated onto their individual tracks. Secondly, the atmospheres for all the various scenes have to be added, each location requires different environments. This gives the show 'life' but it's the third element that brings me into Rupert's world – the footsteps. These provide the base element for the final layer, the sound effects. These combine many layers to create believable environments.

The most challenging element is making a show unique. Sound design plays a large part. Most of the day is spent coming up with new sounds to involve the viewer in Rupert's world. Edward runs in a field, up the steps of the tree house, through the front door and stopping inside. I track lay grass footsteps, heavy wooden footsteps, a door closing and lighter wooden footsteps. With some dialogue extras of Edward running a simple scene becomes complex. Detail in the sound, however small, is always key to a good show, whether it's the brushing of clothes or a pencil writing. Sound is crucial to create the illusion that involves the audience.

Children have to believe what they are watching is real to the point they could almost interact with the characters. The sound track helps bring the audience, especially children, into the animated world.

Music

Music, needing a whole book to itself (along with sound), is an underrated element, too often added as an afterthought. It's potentially up there with the visuals, and as integrated. Music added after shooting can make life easier on the set, but tougher for the composers trying to merge haphazard rhythms into a unified whole. I prefer working with music from the start, so that the animation can reflect the music, following the pacing and bring a great discipline. This depends on the function of the music, whether it is background underscoring or a part of the storytelling, as in my films of *Rigoletto* and *Gilbert and Sullivan*. It would have been impossible to have laid a score down afterwards for these, and the score adaptations were done as part of the storyboarding. Working with the musical director, Wyn Davies, we made sure that Verdi's and Sullivan's music flowed dramatically and was respected.

I've said that stop motion is like dance in its celebration of movement and rhythm, and music should be encouraged to be as important as a score for a ballet. One of the most beautiful marriages has to be Michael Dudok de Wit's exquisite *The Monk and the Fish*, set to music by Corelli. It is hard to imagine one without the other. The music adds joy and life, and makes the film flow. Usually a classical orchestral sound needs a suitable richness from the visuals to work (there have been some spectacular duds with orchestras rampaging away to animation that would make Saturday morning fodder blush: Tchaikovsky seems particularly abused), but here the drawings are simple and the music is appropriate.

Nigel Hess' beautiful and apt scores to *Screen Play* and *Achilles* were both, unusually, written to the finished score. Rather than illustrating the scene they are a major part of the story telling, uniting all the elements in an integrated whole. It's a privilege to have such scores.

I would suggest that being able to read music is essential as a score is not very different from our own bar sheets, turning sound and music into a very visual shape full of helpful patterns. On *Rigoletto*, the score became my storyboard and bar sheet all in one.

Would some form of movement notation, like Benesch, help? Is musicality necessary? Do you think like a choreographer?

JD – I can't read music, but I'm very aware of rhythm. I stop myself from listening to music because I get ideas for short films (which I know I won't be able to do) and it hurts. Yes, I'm very aware of key poses.

TB – Yes, I'm musically aware, having grown up with and studied music formally. I can't help being aware of rhythm. The key pose is the heart of the performance. If you study live actors, their movements breaks down into key poses. The application is the same for animation.

KD – Music is such an important tool for the film that I become slightly obsessed with what it I want it to say. If you have someone who you can work with then it's fun when they compose and you can get stuck in.

RC – I appreciate music and the timing in an acting performance. I do thumbnails and frame numbers … that's my notation. I try to work towards the pose in order to make the statement needed. Without that, it could be easy to miss the mark, or drift in terms of timing and performance … much like a computer will do if you give it too many frames and too few keys.

DC – Yes!

AW – I don't read music, but I feel rhythm. I'm always aware of the shape in the camera.

SB – Rhythm is one of my weaker points, but I think strong positions and shapes are very important.

RH – I'm very musical, although I don't play a musical instrument now (I used to play piano). I understand music, though, and have a strong sense of rhythm and timing. When animating I'm always thinking of key positions. I consider negative shapes as well as positive ones, and the silhouettes of the characters in the camera.

JC – Animation uses rhythms, even when there is no music. Poses held play as important a part as the action. I've some musical training but don't use a prescribed notation technique. It's useful to have musical beats marked out and, when there is dialogue, notes on the dope sheets that indicate which words are emphasised and the pitch of the dialogue. I feel you must always be aware of the puppets' position in relation to the camera.

Series

I would encourage every animator to work on a series. There is no better training and discipline. Students come out of college flush with success from a first film, hoping that the next step is directing their own bigger film. It can happen, but the reality is usually working for someone else's studio. This can be hard, relentless work, and not always artistically satisfying, but you learn the craft. Working on a tightly scheduled series teaches you about focus. You instantly get to know how that puppet should perform. You learn do the bare minimum to get the most across. This economy is no bad thing. Animators love to move things, but that doesn't mean that things

A page from the score of *Gilbert and Sullivan* and its corresponding bar sheets.

have to move every frame. Series work teaches you what is important. The sheer mechanics, the timekeeping, working as part of a crew and those responsibilities are invaluable things to learn. Working alone can be extremely indulgent, and most of us have probably imagined animation as a rose-tinted bohemian existence, coming and going as we please, doing a frame here and there. I would hate that, as I thrive on relentless pressure. There is a notion that stop motion is a solitary art, with etiolated geeks pottering away in rooms full of toys. Perhaps there are elements of this, but most people work well when bouncing off others. I didn't always, and saw this as interference, but I now very much welcome other people's informed input. Being challenged is a good way to feel sure about a piece of work. One of the director's roles is to have the answers. As each department focuses on its particular aspect, the director has the vision to see everything, justifying everything.

Series work can be draining, with the same themes coming round again and again. There is seldom progress from episode to episode, but you get to know the characters. Keeping fifty-two episodes fresh is a feat, but I enjoy seeing the characters work in different situations. I got to know my characters such as Shakespeare and Achilles so fleetingly; intensely, but still fleetingly.

There is camaraderie about series work, but with the pressure there is a danger that everyone gets disconnected from what it's all about. This disconnection can be from the story, from decisions and from each other. The producer and director try to keep everyone involved and working to the same end. It is hard work, but important and rewarding. Standing back after a series knowing that you have been partly responsible for seven hours of good-quality television is not bad.

Feature films

If working on feature films is seen as the benchmark of a career I definitely have not made it. My involvement with features has been somewhat haphazard, being limited to short periods on *Mars Attacks*, *King Kong* and a week on *Neverending Story II*, but I have enjoyed being connected with them. The sheer scale and organisational aspects seemed both daunting and exciting, but each film was an adventure, not just learning a totally different way of working, but also learning new technology, and learning it in a different country. I'm sad not to have done more features, and I had hoped I might have been considered to direct one, but maybe I just haven't come up with the goods. Of the short time I was on the features, probably, and I reassure myself here, I may have been there too early in the long process. Most animators' involvement in a feature may last for over a year or so, with an end result of a handful of random shots or a complete sequence, but probably not more than a total of just a few minutes of screen time. This is certainly quality over quantity, as features allow the luxuries of rehearsing, meticulous planning, staging and restaging, and sometimes shooting little more of a second a day of film. To have the chance to make that second absolutely beautiful, well I would snatch it. Some animators thrive on this ultrafine-tuning of performances, but some give their best performance on the first take, with any subsequent takes losing all spark and becoming a mere mechanical repetition. I am somewhere in between. My ideal way of working would be to film a scene in one chunk, and then go back, fine-tuning as necessary. It's hard as most of my career has been spent shooting between nine and ten seconds a day, maybe more, with the mental attitude that reshoots are just not even an option, and that mistakes have to be worked through. This affects how you approach your animation, and keeps you on your toes. This lack of any safety net is thrilling and exhilarating and I'm not sure that I would function so well if I had the luxury of several reshoots. I don't think I would be able to duplicate a performance even remotely for a second take. Some things would be lost, some improved, and new bits of business thought of. I would love the luxury of not having to rush, but I would be wary of rehearsing too much and losing the spontaneity that is stop motion's unique pleasure.

In what acting I've done, I've found it hard to be exactly the same in each performance, but that's the nature of live performances. Anything, from a prop to the audience coughing can change the rhythm, and new pieces of business appear or are dropped or timed differently, and the emphasis changes. This is just the same in stop motion, where it is pretty impossible to repeat an action. This keeps things exciting, but can make the logistics of assembling a film somewhat tricky. When shooting a series the animator only thinks about performing that shot

that day. With your own film, the shots have been in your head for months, and with features that you can discuss and plan. Very different approaches.

Shooting out of sequence and animating your puppets to match an already filmed shot will lose this freshness. You see the puppet working itself into the necessary position rather than letting it flow, and when a movement looks contrived, it's dead. In reality, the schedules of features may seem a luxury, with a whole day to shoot a second or two, but a lot of that time is spent in fine-tuning the lighting or practising a camera move. Production values on a feature are that much higher than for television series, and take more effort and time to get them right. It is common for an animator to be standing by all day while a set is lit, and then come four o'clock, the shot is ready; that is not the best time of day suddenly to give your best.

Is it easy for you to move from the luxury of schedule and detail of a feature to a more commercial TV series? Are you able to maintain a satisfactory standard?

JD – For TV commercials, we always had much more time and money (per unit of screen time) than for any feature with which I was involved.

TB – I don't like the fast pace of a TV stop motion show. It's just too gruelling. Now that I am almost fifty, I want to slow down a bit and have a social life. I enjoy teaching a great deal – it affords me the opportunity to have some time off to work on my own films, sculpt and paint. I would rather work on my own films than someone else's, because I consider myself a storyteller first.

RC – I started in commercials, and that's been the bulk of my work. So, yes, I transition well, and deliver quality work on commercial deadlines.

DC – Yes, I can do whatever the job requires, but I never have freedom from my mortgage and family commitments to pick and choose the job particularly. I view the job for what it is (feature film, series work, advertisement) and who it's for (adult or kids audience) and how much it pays and then look at what they (production) want from me (footage, quality, etc.), then I have to work out what is possible and what I am prepared to produce within all of this and still get home in time to play with my kids' toys before they go to bed!

SB – I probably work better in the commercial bracket, it's what I know best.

RH – I have only worked on TV series so far, and I have become very used to the production methods and timescale of series work. It would be nice to work on a feature and concentrate more on quality, but I have found a balance between quality and quantity on series work and I am comfortable with it.

JC – It is hard to jump between projects with different requirements. A feature has the luxury of time to produce work of a high standard, though there are still time pressures. On features you have a huge support network, teams of riggers and puppet-makers to help. You have to slow down and try to make every frame as perfect as possible. The pressures of series work are different. You have punishing schedules. There are smaller teams to support you; often you have to make do. There is great skill in being a successful series animator; to know when to hold a pose, how to cut corners and still provide a good performance and tell the story.

Apart from the prestige, the budget and the facilities, I would love to direct a feature to be able to develop a more intertwining subplot and more parallels. Short films and series are limited (although this can be their strength as well) as every frame you do has to contribute to the main situation. I hated killing Achilles as there was so much more I wanted to do with him. In shorts there is no time to wander off for a different perspective on the main story, and with series everything has to be self-contained, as little can develop from one episode to another. There's no arc for the characters. But with a ninety-minute feature there is time for much more complex situations and character developments, and more tangential action. I would love to be able to play with rhythm more, teasing the audience, rather than having to dive straight in. With a feature you can digress, spend more time setting up the atmosphere, and have shots that do not always feature the characters. I worry when storyboarding a series shot that does not feature a main character. It is rare to have time to stand back from the plot or the characters. This is all great discipline, and you learn to make absolutely everything count, finding ways to condense two plot points into one shot. My own films probably take this to an extreme and are subsequently very dense, as so much needs to be conveyed. My films take a certain amount of learning to read, but I don't apologise for that. I expect the audience to concentrate as I expect to concentrate when watching a film. I tend to make films that squash a quart into a pint pot, and hope the audience sees enough of what's happening to stay interested, and keep them thinking afterwards. I would not want to make a film where little lingered after the lights came up.

I wish I had the skill of such film-makers as Michael Dudok de Wit, in whose films, especially my favourite, *The Monk and The Fish* (1994), so much is created with so little. A simple shadow creates a credible geography and a black line becomes a horizon. The enigmatic story of a monk catching a fish is superficially no more than that, but because the drawings are so simple and everything is about suggestion, the viewer's mind is full of its own meanings. The action progressively takes on a lyrical surreal quality and the ending is simply uplifting. The animation consists of few in-betweens, relying on stunningly synchronised key drawings. The music, based on Corelli, is as much a dramatic part of the film as the animation and design. Everything works together, but it is its deep simplicity that is so powerful, and I wonder whether that is achievable in stop motion. The very weightiness of the puppets, the pure physicality and texture of them would probably fight with any lightness. To have replicated *The Monk and the Fish* in stop motion, frame by frame, simply would not have worked. The scene where the monk is jumping in great leaps and bounds sees the animation at its most economical, but also its most evocative and moving. Stop motion animators would fight hard not to put in more detail.

My favourite scene: Hoth AT-AT attack from *The Empire Strikes Back* – Paul Campion

After the excitement of *Star Wars*, the anticipation of a second film was huge. By the time *The Empire Strikes Back* came out I'd read everything on special effects (back then special effects were still 'special', the techniques used were much more guarded and less understood by the general public); although I had a basic understanding of how bluescreen shooting and optical compositing worked, the process of stop motion was something this thirteen-year-old was very familiar with, so I was very excited to hear that there was a lot of stop motion animation in *The Empire Strikes Back*.

The start of the film is an effects feast, starting with stop motion Tauntauns, and then ending with the Imperial AT-AT attack. The sequence opens with some wonderful panoramic long shots of the giant four-legged AT-AT walkers in the far distance, a brooding dark menace on the horizon. We mover closer and see them in all their glorious detail, feet adjusting as they place on the snow, hydraulics pistons moving in time with the legs, all framed by the amazing snowy mountain scenic paintings of matte painter Mike Pangrazio. Stop motion works particularly well here, giving the AT-ATs a definite mechanical presence, and one must wonder, if the film had been made recently with digital effects, would their movement now be too fluid and perfect and somewhat lacking in reality? As well as the AT-ATs there's Luke's climb up to the underside of one of the AT-ATs which was also a tiny stop motion puppet, and teasing glimpses of the two-legged stop motion animated imperial 'chickenwalkers', that would later feature in *Return of the Jedi*. This sequence had a huge impact on my desire to work in film special effects. I researched the AT-ATs and snowspeeders, and eventually built my own versions from plastic models.

The AT-AT was meticulously detailed (I had aspirations to work in the film special effects industry as a model-maker) with panels missing to reveal circuitry beneath, battle damage and snow-covered feet. It had tiny lights in the front head turret which lit up a coloured windscreen as in the films, and tiny fibre-optic lights in the cannons, all powered from a battery in the wooden display base of the model. The model won an award at a national model-making competition and I still have both the AT-AT and snowspeeder models gathering dust. The snowspeeder model was later used as reference for my friend Richard Chasemore to illustrate a snowspeeder in the *Star Wars Incredible Cross Sections* books. The talented (and in my mind incredibly lucky to be able to do that for a living) artists who created the sequence were my own personal heroes, and now several decades later I've been lucky enough to have worked for Phil Tippett in San Francisco, and with Mike Pangrazio on the visual effects for several films.

King Kong

Every frame of the 1933 *King Kong* should be essential study for an animation course. Peter Jackson's dazzling remake is, many students' first contact with Kong. Of course, the 1933 film can look technically raw, but more than seven decades later the film is still an amazing, emotional, complex experience. You are swept along by the story and Kong himself is remarkably credible. I was at a screening with a reluctant audience of cynical hi-tech special effects artists, some of whom were about to start work on the remake. Sure enough, there were giggles at the dialogue, at Fay Wray emoting and at Carl Denham barking his orders, but once at Skull Island, there was silence. A hard audience found themselves won over. Why shouldn't they be? The film is a masterpiece.

I cannot believe that this superbly constructed film was as casually put together as history suggests, but that was, perhaps, Cooper being amazingly modest. The tight script has delicious symmetry, split into halves, both involving boat journeys to an island. The first sees Man in Kong's country, and the second sees Kong in Man's country. It is two takes on Nature versus Man. But it is Schoedsack and Cooper's direction and visualisation of these two halves that are beautifully thought through with meticulous detail, and belie the shoot-and-run techniques of their animal documentaries. The parallels and contrasts between the halves are eloquently made, with Kong being part of the natives' show, doing battle with flying creatures and long snake creatures, taking Ann up to the highest point on the island in the first half. In the second he is part of the natives'

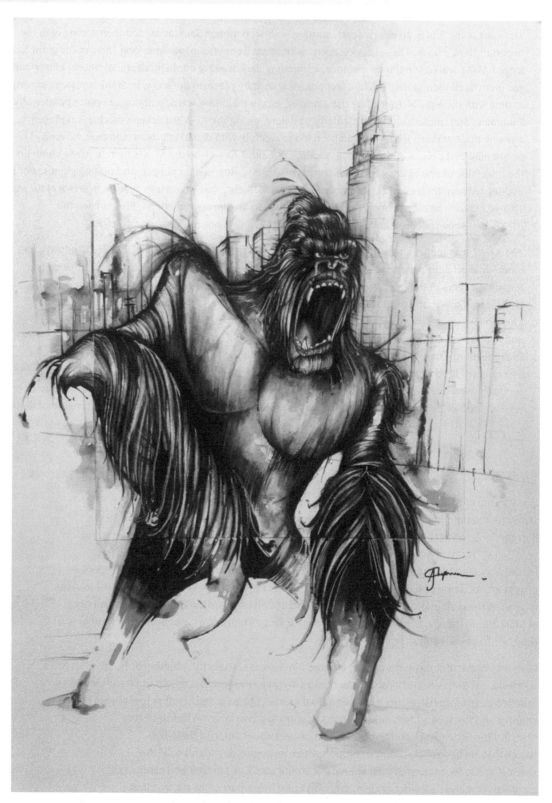

King Kong on the rampage, by Andrew James Chapman.

show; he fights planes, battles with the long snake-like trains, and climbs to the highest point on the island of Manhattan. In the first half it is Ann who is tied between two pillars, and in the second, Kong is thus displayed. There are so many parallels and mirrored situations, all full of potent imagery, that it is hard to believe it was not all planned to the very frame. It is all the more amazing to think of the films being made at the same time. The Depression was still felt, sound was ever more popular, and the public taste was for upbeat musicals and drawing-room comedies. Next to Kong, Ginger Rogers and Fred Astaire were *Flying Down to Rio*, and although nearby Busby Berkeley was in the money from getting his golddiggers to dance as animated eroticised objects. The sight of Kong sniffing his fingers after undressing Ann must have been shocking. Ann in the water revealing a surprising amount of flesh is still provocative, as is the whole story if taken to its logical conclusion. The film has so much sexuality in it, and I'm sure it is no coincidence that the first time we see Ann, she is stealing an apple. Surely all this was thought through in minute detail. As we have seen puppets saying things their manipulators cannot, is this puppet acting out what many couldn't help but think?

Researching for a play about King Kong, it was suggested that Ginger Rogers wanted to play Ann, but the public perception of her as a wisecracking dancer worked against her. How different things might have been. The play focuses on the personalities involved, drawing larger parallels with the film itself, and the whole act of creating. It was full of quirky ironies, and we were pleased how we had envisaged not only putting Kong on stage but theatrically showing the craft of stop motion. The piece plays with the central ironic reversal that first appealed to me, that of Kong being a puppet held in a hand while appearing to be holding a small character in his hand. This flirts with all manner of ideas about animation and the puppet/puppeteer relationship. There are even moments where Kong almost animates Ann, by pushing and shoving her.

THE EIGHTH WONDER

By Emil Wolk & Barry.J.C.Purves

A treatment for a play with music, set behind the scenes of one of the greatest films of all time.

Starring- Merien C Cooper, Ernest Schoedsack, Fay Wray, Willis O'Brien, Ginger Rogers, Charlie Chaplin, Boris Karloff, and a bevy of beautiful dancing girls. With a special appearance by the beast himself, King Kong. Written by Emil Wolk and Barry J. C. Purves

The Eighth Wonder, a yet to be staged play about Kong.

It is hard to underestimate Kong's significance. Watching the film did not make me want to be an animator, as it did for so many, but it did overwhelm me with its perfection. Everything was just right, from the Dore-inspired visuals to the wealth of detail (those beautiful cut-out birds giving so much depth, and which subsequently appear in all my work) and the astonishing use of sound. I only ever felt cheated by the famous publicity still of Kong looming over the cityscape of New York. The film never delivered that, and thankfully, as it would have veered into totally absurd realms.

At the centre of it all was Kong. Aged eight, I didn't exactly understand the process by which Kong was created, but I knew he had been created, and that probably the cast were reacting to something invisible. Today I still marvel how the animation has been seamlessly inserted into the live action, and vice versa, even both at the same time. I love the moments when the alive and kicking Fay Wray is dumped on to the ground, or falls away from the altar, and frames later an animated Fay crawls away. It's done so fluidly and I hope somewhere there are dozens of storyboards detailing this.

But I was confused, confused by being moved by something I knew did not exist, and something that was at once epic and mythical but also intensely intimate. This is Kong's real place in history. Before Kong and O'Brien, animators such as Starewicj were making character-driven narratives, and not just special effects. His *Reynard the Fox* contains some extraordinary character work, but nothing before 1933 matched the moments where Kong tramples the line between special effect and performance. The defining moment is the fight between Kong and the T-rex. This was when stop motion showed that it was not just a charming novelty, but a real art. This fight, just minutes long, is something that reminds me what this is all about. Both Cooper and O'Brien had studied wrestlers in action, and thus Kong and the dinosaur do not just lay into each other, they weigh each other up, reacting to each other. These puppets, especially Kong, appear to be thinking. Sometimes they just pause, looking at each other, working out what to do next. I could see a thought process, giving the illusion of being alive, and yet I knew it was not real. This captured my imagination. The fight is clumsy as they mistime jumps or grab the other awkwardly. It's not slick and it is better for that. The violence is strong, but the telling moments of stillness are still impressive. Young animators often dive into animating dinosaurs as all sound and fury, not giving the action a chance to breathe, or to see the creatures reacting. This sequence is more startling for the use of Max Steiner's music. Up until the fight, the orchestra has been busy, but suddenly, as the two creatures square up to each other, the orchestra stops, and the fight carries on in silence, save for the grunts, roars and Fay Wray. This makes the fight brutal. At the end, Kong famously flicks the dead T-rex's jaw back and forth, always getting a laugh. I initially thought this an inappropriate moment of comedy. Today, though, I'm hoping the audience will laugh, and they do. After the intense fight, this is not just the director allowing the audience a bit of light relief, but a moment to show Kong's complexity. He is not just a killing machine. It suggests that his victory takes him a little by surprise. It gives him a flaw, and a depth that endears him to the audience. Kong is not just a special effect, he is a complex character beautifully performed.

The other great moment is on top of the Empire State Building, when Kong is wounded by the planes. The sequence is paced relentlessly, but amid the action there is a moment of utter tenderness. With the end inevitable, Kong reaches out to Ann, stretching his finger to touch her, and then he falls. Absurdly, just writing this makes the tears well up. It is possibly a ludicrous story, but told so well that this moment of connection is utterly credible and heartbreaking. Even so, knowing that Fay Wray was reacting to nothing and that the mighty ape was eighteen inches of fur and metal skeleton manipulated in another studio, and that an animator managed to imbue an inanimate object with expressions that still work over seventy years later is simply extraordinary and beautiful.

The film's background is just as extraordinary, with the right combination of oddball talents at the right time. The film evolved out of recognition before reaching its final state. At one point a komodo dragon was the central character, presumably before the beauty and the beast theme was introduced. I love the folklore about Kong, especially about leaving a pair of pliers in view on a miniature set. Rather than scrap the shot they were animated out as some sort of creature.

I like the story, as all stop motion animators have left something on the set at one point and you face the same dilemma. In the *Pied Piper of Hamelin* there is a large roll of Sellotape sitting in the background of a crowd scene. It would have been noticeable had it just disappeared.

My favourite anecdote about Kong is that the release of Kong, with its impressive sea serpent scene, is said to have coincided with, and possibly started, the first

Willis O'Brien tenderly holds Kong as Kong tenderly holds Ann (Saemi Takahashi).

rumours about the Loch Ness monster; a happily susceptible public wanting their own monsters. It is great that stop motion can have such an effect. I can't see that happening with an equivalent drawn scene from a film, or even a sophisticated CG creation today. For so many, that serpent was real.

Mention Kong in cynical company and you're likely to get a cheap gag about fur crawling. The fur never once bothered me. I understood why it crawled, but put it down to wind or, rather bizarrely, fleas. The fur was a worry even to the film-makers, until during the film some RKO suits commented on how clever O'Brien had been to get the fur to bristle when Kong was scared. Fur will always be a problem as long as animators need to touch the puppet. Only holding Kong in furless places such as his chest might have helped, as would hairspray. I have worked with characters where a good percentage of the fur has been sculpted, with loose strands laid over the top confusing the appearance.

Sometimes such fur-covered figures are manipulated with rods attached to the various limbs. I would feel disconnected but it does seem to work. Likewise, some puppets are manipulated

Ronnie Burkett with his marionettes, after a performance of *10 Days on Earth*, Manchester, 2007.

by rods connected to a computer. This can make the move itself through various motors, or the animator can move the puppet and its movement is recorded by the computer and can then be reproduced and fine-tuned at will. This has its uses, especially where absolute perfection and reproduction are needed, but I would still like to touch the puppet and feel it moving in my hands. I'm not sure how I would feel if I had to share the manipulation and animation of a single puppet with others.

Live puppetry often involves multiple performers for one character, but then they have probably been rehearsing together for weeks. It amazed me when the puppeteers for the Muppets had their hands high in the air inside the character, but would be looking down on the floor at a monitor. To be able to perform like that, at once intimate and removed, must take some skill. Many of the amazing Henson creatures require several operators, with technology enabling the puppeteers to be removed from the actual character. They manipulate it using sophisticated contraptions as joysticks and gloves that are wired to translate the puppeteers' movements into appropriate movements for the creature. The performance must come from rehearsal and a brilliant overseeing director. I doubt there is total spontaneity. Likewise, I find marionette performers amazing as they, usually, only get to see their characters from above, although they too probably have monitors. A stop motion animator sees the whole of the puppet and can touch it, and from a decent perspective. The point of this, and probably the point of this book, is that whatever technology does to improve the performance of a puppet, and I am surprisingly embracing this technology, we must not be careful not to lose the connection between the human performance and the puppet. Stop motion, in the animation world, has probably the most direct connection to the artist. It is this peculiar relationship between puppet and puppeteer that keeps me enthralled.

Framing

The traditional shape of television screens used to be 3:4, which is probably the ugliest shape possible. Decent compositions are hard in that shape, with landscapes looking squashed and undynamic, but it is a framing perfect for talking heads. There is neither room for other characters nor scope for face-to-face conversations without reducing the scale of the characters. This framing allows for close-ups of characters thinking, but most screens now are at least 9:16, which is a more elegant composition, encouraging movement. Landscapes can look exciting and wide, and are nearer to what our own eyes see. There is more scope for drama with characters reacting face to face, and using foreground and background together. Characters can relate to each other, rather than just cutting back and forth between isolated talking heads. A schedule, though, often needs close-ups of a particular character shot together and by himself, saving time on camera set-ups or allowing other characters to be used elsewhere. This leads to a sequence that does not flow, as there is little action to overlap, or the presence of the other character is missed. It helps to have part of the other character in shot, but if not, then a significant movement can be engineered to motivate the cut back and forth. Ideally, there should always be a reason to change a camera angle. If we are looking over a shoulder of a character about to speak, let the character show some signs of anticipating this, such as straightening the posture or raising a hand. As you cut round to the other angle, carry on the action, and the cut will be invisible, which is always the aim. The sequence will flow so much better than a series of nodding heads if you can overlap the action. I am uncomfortable with news interviews conducted with one camera fixed on the subject, zooming in and out for variety. With the subject later gone, the interviewer blandly reacting to nothing is cut into the interview, killing any spontaneity. Worse still is the shooting of a floor assistant's shoulder as she wears the interviewee's jacket. Very cheap television, as the two people are not seen to relate. An infamous scene in *Just a Gigolo* saw David Bowie supposedly chatting to Marlene Dietrich, except that they were shot in different studios, in different countries. Clever editing and the use of

stand-ins fail to convince us that the actors are there together. In stop motion everything we do is about giving a convincing illusion of characters existing in a real space responding to each other, so it does not help to shoot in ways that destroy this illusion.

Close-ups, etc.

Producers, understandably, like to encourage two, or even more, cameras shooting on complicated shots to maximise the amount of useful footage. Sometimes this works, but most animators are comfortable playing to one specific camera. There is often some rig or other tricks hidden from the camera by the puppet or the framing. This is blown by two cameras running, and no matter how often you are told that the camera is only there 'just in case' or that 'it won't be used', you can guarantee that it will. Playing to one camera is not just for hiding rigs, but animators go to great pains to ensure that the composition and the poses works for that specific viewpoint. Most dance is generally choreographed for the one, slightly general, perspective of the audience out front, where all the patterns and the shapes of the body are seen to read most clearly. Sometimes dance on film has cameras are all over the place with some of the dancing looks a mess, as the shapes do not read. It is the same with animation, particularly with many of the animal characters having a big snout or such, making both eyes visible at once somewhat difficult. An animator will perform the puppet bearing in mind such quirks, making everything read for the camera. Two cameras ignore this, but then there is extra footage and that should not be dismissed.

With two cameras shooting at once, the main camera is shooting a master wide shot while the other covers things in close-up, but there is a great difference between animating in close-up and in long shot. This is not just in terms of performance; an animator will rein in his performance for a close shot and keep most of the storytelling acting to subtle facial expressions that would not read in a wide shot, where broader physical acting is required. We need a different technique for close-up animation. In wide shots, where the character makes up a tiny part of the frame, you can animate a gesture in broad strokes, as the space in the actual frame that a limb travels through is still relatively small. A character can do a large wave in three frames, which when reduced by a large framing may look smooth. With the same gesture in a close-up, the distance these waving arms travels between frames in proportion to the frame can be enormous, making it hard for one frame to relate to another. The gesture falls to pieces, as there just aren't enough frames to tell the story.

I would encourage close-up animation to be more subtle, using many more frames to tell the story; this slows the pace down, but big fast moves in close-up just do not work. However, this is all about finding the appropriate framing for the gesture. It is hopeless trying to contain a large gesture in a tight framing. Remember that the camera should fit the animation, not the animation fit the camera. Today, with digital shooting and high definition, it's best to have the framing a little looser, to be cropped in postproduction. This is more satisfactory than having two cameras shooting, with one camera producing well-structured and well-animated footage, and the other capturing clumsily composed and rough-looking animation that just may be usable.

Framing can be an issue of schedules. Shooting more close-ups means you can get more footage out in a day, which is a vital consideration, but it leads to a very different sort of film, and perhaps one not best suited to movement. Inevitably,

a character has to be passive to be contained within a close-up, which goes against most animation. In Nick Park's brilliant *Creature Comforts*, and the subsequent series, what the characters lack in bodily movement they make up with exceptionally mobile faces, and that is the joyous point of this animation.

It should not be assumed that characters have to move constantly to be animated. Adam Elliot's characters, such as *Harvie Krumpet*, do little more than blink, but they are alive. At a festival, I saw a supposedly innovative dance piece, which featured a solo performer not moving, while the music raced away. This may have challenged how dance and movement are perceived, but I cannot say that the disgruntled audience came away with any satisfaction of an experience or performance. Some members of the audience were screaming for the performer to move, so at least there was a reaction. Maybe the point was to get the audience to move. Some moved out of the theatre very quickly.

Anthony Gormley

One of Anthony Gormley's many figures on Crosby beach, 2007.

On a beach in north-west England Anthony Gormley planted 100 life-size iron casts of his naked body, spread along a mile and half of beach, all with their eyes fixed on one point out at sea. It is a stunningly beautiful sight. Although little more than weathered iron, they have such presence, and being surrounded by the constant movement of the tide ebbing and flowing implies a movement, or lack of it, of their own. They seem to be animated characters acting out their own drama. Watching them drown and emerge twice a day is a complex emotional

experience … but why? They are only statues, but the fact that these lifeless characters have been given a dramatic context, staged and composed in a setting full of resonances and movement gives them a suggestion of life and character. They have been given a story, and even though it's an enigmatic one, it still has a beginning, middle and an end. The water provides the drama and tension, and although these characters are supposedly identical, barnacles and rusting give each one a different personality.

These figures are held in such affection and, along with the expected crude graffiti, are often dressed up for occasions such as Christmas and the World Cup. Clearly, the public has imbued these lumps of iron, very much like the rather innocuous Mannequin Pis in Brussels, with some sort of soul, and visit them regularly as old friends. They bring other friends to meet them. I saw a dog repeatedly dropping a ball at the statues' feet, waiting for some response. These figures have been animated, like animation itself, by the lack of movement. We get paid for doing the same. It may be strange to imbue images or lumps of clay, metal, plastic, latex or wood with personalities, but it has been going on for centuries, and meets some psychological need. I still hesitate before throwing away a photograph, and to cut one up would be downright impossible.

The Wicker Man

Director Robin Hardy's terrifying original *The Wicker Man.* (Richard Haynes)

We can give even the most basic of representations a personality and a spirit. Corn dollies and effigies still carry much weight. The central image in the original unsettling film of *The Wicker Man* is a huge effigy, doll or puppet, simply designed, but no-one can look at it without feeling something close to awe. I gather the production team treated the figure with huge respect, feeling considerably uncomfortable when called upon to burn it. If we imbue these figures with

a life, then we are naturally cautious about destroying that life, especially with such a figure that is seen to consume the major character. It's just a creation of sticks, but with much presence and potential violence, it seems capable of living. The head was initially given a suggestion of a face, but it suddenly looked less hostile and mysterious. By removing any specific features, it became far more sinister. When onlookers couldn't read any expression, they read the worst.

Likewise, the figures at Madame Tussauds may be just wax, but with the best ones it's hard not to imbue sort of presence. It must be harder still to destroy them.

The Nightmare Before Christmas

This is a groundbreaking film in so many respects, but what I love is its energy. Too often with stop motion this energy is due to rather unruly frenetic animation, but here the energy is exquisitely controlled and dance like. The music and the camerawork sweep the audience along, but it's the animation itself that is so lively. Jack's spindly design should strobe from one frame to another, especially as some of the moves are so big, but it does work, wonderfully. He is full of very striking, clear poses held for just long enough, and he snaps into these with audacious speed, but this works because of tiny softening-out moves and gently overlapping actions. The film bursts with all manner of glorious movement and rhythms, and eccentric character walks and tics. It is a stunningly physical film, with every character clearly defined by its movement. Watch and marvel.

I had forgotten how much of the facial expression relied on replacement pieces. You can see how the design of the puppets has had to accommodate this. The replacement mouth shapes have less subtle movements and less variety than were achievable with the Mackinnon Saunders puppets for *Corpse Bride*, where the majority of facial movements relied on internal mechanics. This allows the animator much more freedom for changes of rhythm, very detailed finessing and personal acting.

What amazes me about *Nightmare* are the tiny feet. With all the texturing on the sets and curved surfaces magnets must have been impractical, so the puppets were tied down with various screw devices. This is enormously time consuming, but does allow such small feet to clamber over the variety of surfaces.

But Christmas itself? I wonder why there is so much stop motion associated with Christmas. Is this a time when more stories are told, when more myths are circulated and children are excited by all manner of fantasies? Or is it about toys? There are always more stop motion programmes on at Christmas and it is fascinating that things coming to life are seen to be a special treat.

Directing

My most recent work, directing 52 episodes of Rupert Bear for Entertainment Rights and Cosgrove Hall – 2007.

Directors

There are two types of director: those who assemble and those who direct. Putting a film together is not the same as directing it. The best a director can do is to make every shot interesting and make it count, and the worst is to make a dull film.

Many films comprise a series of shots put next to each other in a pedestrian manner. No director should make his presence felt with an egotistical display of showy tricks and flashy camera angles, but I think that the director should use and combine all the elements of film-making, lighting, colour, design, editing, sound, movement, music, etc., pushing them, well directing them, to illuminate the script, the narrative, the characters and emotions as clearly as possible. Directing is not necessarily about having something profound to say, but more about making whatever you do say interesting. Many films have something interesting to say, but lack

the language to say it. Others (and I wonder whether I include mine here) have nothing particular to say but say it beautifully. Not every film has to be full of subtext, and it takes as much expertise to direct a simple children's films as it does a challenging adult film. Directing is not about showing off, but I do think it is about making everything count and making considered decisions.

It's little wonder that my favourite director always will be Alfred Hitchcock. Today his films can look restrained (there is little blood or actual violence in *Psycho*), his effects unsophisticated (the Birds themselves and much ropey backprojection), his pacing rather too deliberate (it is ages before the birds attack in *The Birds*), but they are brilliant films. Absolutely everything is thought through to reflect the narrative themes of his films. As Shakespeare meticulously, but unnaturally, chooses words for their colour, tones and rhythms to reflect his characters' situations and dilemmas, so Hitchcock uses every element of film-making to say something, however great or small, about his characters. Everything fits in with some grand scheme; nothing appears as a random choice. With stop motion, where we create everything from scratch, it takes no more effort, time or money to create something that has some resonance or significance than it does to create something that will merely do. It's not enough to paint something a certain colour because it is pretty. Painting it a certain colour because it sets a mood, or because it suggests a decision made by a character is far more interesting. A conversation between two people trying to communicate in a room is more interesting if the setting allows a threat of interruption or a ticking clock. Directing is about having a clear vision of the film and how all the elements can give life to the story. Having characters doing things is not the only way to tell a story.

The Birds is my favourite film from Hitchcock, possibly my favourite film full stop (although I see Mary Poppins raising her parrot-headed umbrella at me with a look of betrayal). A brilliantly constructed film, which doesn't give everything away, with every frame tightly constructed, composed and balanced, all working towards the film as a whole. This can make films look too arty, causing critics to spout clichés such as 'style over content', but good direction is about getting this balance right, and Hitchcock does get it right. Some scenes in *The Birds* are self-conscious, such as the succession of shots of a static Tippi Hedren watching the gulls at the gas station. As a child I found this a little clumsy, as I did with Einstein's lion statues in *Battleship Potempkin*. But some sequences in *The Birds* that are so perfectly thought out and appropriate that you do not notice the tricks. The most famous sequence is the attack on the schoolhouse. The arrival of the crows is plotted and choreographed so scrupulously that you want to call out to Tippi Hedren to look behind her. When she does see that single crow that guides her gaze to the bird-covered climbing frame, it is a deliciously shocking moment. It is a set piece, a sequence that clearly has a structure and completeness, and has the audience thinking 'here we go'. It is a self-consciously directed piece, drawing attention to its construction and gimmicks, but it works, and it works because of so many elements. The use of sound is particularly striking. The film is unique as it has no musical score, only the birds providing the majority of the soundtrack. In this sequence, though, Hitchcock has the children, off screen, singing a deliberately innocent, repetitive nursery rhyme. It is haunting and unsettling. Apart

from being a reminder of the children's presence, the repetitions crank up the tension. Tippi Hedren, growing ever more unnerved with each verse, also cranks up the tension by repeatedly flicking her cigarette and looking over her shoulder. Small gestures replete with meaning.

Hitchcock uses colour to define the characters, especially Tippi Hedren. Throughout the film, she is dressed in a rather garish, unsettling and unnatural

Alfred Hitchcock's *The Birds* (Jessica Koppe).

The Bodega Bay schoolhouse, from *The Birds*, today.

green suit. This green looks inappropriate against the natural greens of Bodega Bay, immediately making her look out of place. Hitchcock shows Melanie Daniels, the Hedren character, as a caged bird let loose, a woman breaking free of the usual sexual conventions, and reinforces this through lighting and composition, constantly framing her with shadows or grilles or the shapes made by a phone box. Throughout the film there are visual metaphors of cages being open and shut.

Hitchcock is forever taking standard chases and giving them twists, such as the Mount Rushmore sequence in *North by Northwest*. It's not just enough for him to have his hero and heroine hanging over a cliff, he has them hanging over the huge stone faces of the presidents, who look on placidly (for *Rigoletto* I borrowed the idea and had the huge carved face of the Duke dominating poor Rigoletto), and the juxtaposition makes all manner of comments and subtext. In the same film, another breathtaking sequence has Cary Grant being chased by an innocent-looking crop-dusting plane. He runs to hide but he is in the widest, most barren plain: there is nowhere to hide. Finding these almost surreal settings makes for classic sequences and great direction. Wallace and Gromit giving chase on a toy train set is inspired direction. Another favourite sequence is in Hitchcock's *Strangers on A Train*. Bruno follows handsome tennis champion Guy, to persuade him to murder someone, in return for a murder he has already performed. During a tennis match, another cage from which there is no escape, Guy knows that Bruno is somewhere, and in a stunning shot, Guy spots Bruno in the crowd, a single stationary head among dozens of spectators all flicking their heads back and forth in perfect unison, following the match. Some lesser directors might just have had a clumsy zoom in to Bruno in the crowd, but Hitchcock uses the setting of the tennis match to highlight the tension and the relationship between Guy and Bruno. A feeble scene might have had Bruno approach Guy on the street and remind him about the murder, but this scene visually says it all and more.

Are you good at taking direction from the director or client? Have you ever slipped in a piece of extra business in a fit of pique?

JD – I learnt to tolerate the direction of agency personnel and of my employers. I learned that sometimes they were right (Lucille Ball) and sometimes they were wrong (Gene Warren). I did slip in bits of unrequested business, but usually out of boredom, not pique – I started making all the *Davey and Goliath* characters look heavenward every time they said 'god'. 'God' takes about four frames, and is said a lot on a religious show. I switched a costumed puppet to an uncostumed one of Davey's mother for a couple of frames. ('Mom' without a costume looked like a nude lady.)

TB – I'll generally follow the requests of the client, director, whoever. If I have an opinion, I'll offer it, but if it doesn't fly, then I'll do what is requested without qualms. I'm not spending my own money; somebody else is paying my salary.

KD – What do tutors know? Didn't my idea sound better? Were they always right?

RC – On a commercial, the client pays, so they have the final call. I have told clients that this or that may not look quite as they expect, or would not work. If they insist, I do it as requested. On a film, a director is in charge, and again, my job is to deliver what is asked. I give my best advice. Sometimes you have a director that insists that they want you to do it a certain way, even though you *know* it is not going to work. Ultimately, the choices are, do it their way and let them find out, or be removed from the picture. Usually, you will get to do it the correct way anyway, so it's better to keep working. Then they learn to

trust you and your advice and those situations tend to not crop up again. However, those situations have been few, thankfully.

We did slip in something once, on a commercial for a pizza company whose logo was a frog. It was in a kitchen scene with the puppet being around ten inches high. Terri Wozniak was a traditional animator, and a great seamstress, and all-round artist. She suggested some small tole plates on stands in the kitchen. Sure. When the set was dressed, I thought they looked great. A closer look at the plates showed she'd painted the blue tole pattern ... as a border of flies. It was pretty funny, and appropriate. I decided to leave it in because the image plane was softer there and the film would diffuse it even more. No one ever even said they saw that, but it was there.

But nothing truly objectionable, that would be unprofessional.

DC – I aim to please, it's their film after all and my challenge is to get their vision on screen. I've never put anything in to be spiteful but I have snuck things in for my own amusement. There's a photo of my daughter in *Curse of the Were-Rabbit* and my toy Shrek was in the church for a while. Sometimes background characters do things they're not supposed to!

SB – I'm good at understanding what people want. And no, I tend not to put in little jokes, I find it hard enough just getting what I'm meant to be doing right.

RH – I've got on very well with all the directors I've worked with. I learn a lot from them and, since I aim to work towards directing myself, find I've a good 'one to one' relationship with them. I keep it at a level so that we bounce off ideas with one another.

JC – Generally I take direction well. You need to make sure you are on the same wavelength quickly. It's not always appropriate to do what you think is best, as ultimately the project is the director's vision. I do get into dialogue about shots, questioning the director you for a clearer idea. I will make appropriate suggestions. I've occasionally added my own touch, but never in a situation where there would be hell to pay.

Directing *Gilbert and Sullivan*

In keeping with its subject, I wanted to give this film a very energetic, spontaneous feel, as if we were watching a live performance. I also wanted to nod towards bits of business often incorporated into typical stagings of the operas. I tried to suggest that we were perhaps shooting on multiple cameras, catching the action, rather than the action being played to the camera. There is no awareness of the camera, other than the excerpts played as if to an audience, but the characters do have a general focus of playing to the front of the bed, helping to plant a geography where there was none. Helping the idea of spontaneity, we composed the shots loosely, and not as regimented as in my other films. I endeavoured to let the cutting of the films be dictated by big gestures and significant movements (all rigidly done to the music), so we were following the puppets rather than anticipating them – such an important difference. On a few occasions I let the characters come into focus at the start of a shot, as if the camera almost missed them. Again, what the camera lacks in movement, the characters make up.

In a line from *The Mikado*, 'I can't help it, I was born sneering' seemed to sum up Gilbert's character. He seems to have been a dry, hard man but with the softness to know this, and I animated him with this in mind, keeping him controlled and tight, allowing only a moment of humility at the end with the appreciative letter from Sullivan. His exaggerated height helped him to look down on the other characters. Sullivan I treated as a bit more agitated and less controlled than Gilbert, and being a conductor, he waved his arms more. A gesture Sullivan that has when conducting echoes pretty accurately a gesture of the musical director, Wyn Davies, when he conducts.

Wyn Davies conducting the Welsh National Opera orchestra for *Rigoletto*.

Carte's body language was the most naturalistic of the three. All of them look pretty startled for most of the film, as they could not blink. The budget allowed for either good hands or blinking eyes. The beautiful hands won.

There was no budget for effects. No real issue, as I wanted as much as possible to be done in front of the camera. The spotlight on Carte in bed at the start of the film was digitally added (although a similar effect I used elsewhere lined up some white chalk on the black velvet behind the action, and this chalk was lit. Occasionally touching it also gave a bit of life to it. Oh, I like these cheap effects!). All the transformations into the excerpts were done on set, although I could have found a more imaginative way to change the puppets into their *HMS Pinafore* costumes than literally substituting them between frames. Today a bit of CG pixie dust might help. I tried to give the impression that Gilbert, Sullivan and Carte became those characters as Gilbert drew them (characters coming to life, being animated, are a recurring

theme for me and so many animators). It would be more effective to have a CG pencil line drawing a quick outline as they moved around, and then filling it in with the new costumes. But all these things are dictated by budgets and schedules.

One effect, which was done physically on the set, but for all the effort could have been done in postproduction, was the appearance of the Savoy Theatre as a flickering vision. The flickering was a reference to the innovative electric lights

Carte had installed, but our vision was actually on set as a large Pepper's ghost, with a piece of glass diagonally across the set reflecting a piece of drawn-in reverse artwork. It was fine, but looked like an easy double exposure. I should have related it to the physical space by having a character walk behind it. However, I like the rawness of tricks like Pepper's ghost.

Stop motion shoots seldom go exactly as planned, and the final shot of pulling back from D'Oyly Carte's bed to reveal a montage of all the operas did not work as I had hoped as it was too dark to read. This is again down to schedules and getting one chance. This is a shame as, like the Shakespeare film, I'd referenced every Gilbert and Sullivan collaboration in this montage, something I didn't quite manage in the singing.

I am pleased with the film, especially its musical structure and storytelling, although now I would have done things differently. It's not great animation, but the characters are alive and the film races along. I had hoped to make it even livelier and spectacular, but budgets, schedules, blah blah blah … I'm becoming a stuck record. I'm pleased that the familiar words take on new and fresh meanings about the relationship between the three men, and the relationship between commercial work and art. It captures a good sense of Gilbert and Sullivan, the icons, and gives them, and D'Oyly Carte, the respect they deserve. I am pleased with the people I managed to work with on this film … it boasts an impressive credit list. It was not the easiest film to make as I lost my father during it, thus making the death scene of Sullivan particularly hard to film. An empty bed is such a powerful image: a prop full of implied meaning.

The film did alright, and won many Best Film and Best Director awards in some surprising places like Russia. This has puzzled me, but also pleased me, as if you take away the Gilbert and Sullivan element (and I'm assuming that G&S is not big in Russia), there must have been enough left, about relationships and humour, for them to have enjoyed the film. It took some criticism for being too élitist (which I find not just surprising but depressing) and also for being too British (which I don't find surprising but I do find the notion depressing), and I'm not going to apologise for either of those notions. I dread the idea that something is too British (or French or Italian or American or whatever) and that this is treated as a criticism. Shouldn't animation be celebrated for individual or cultural characteristics, rather than appeal to some dull, vapid lowest common denominator? We have the potential to make different films. Not knowing about certain cultures doesn't make them less interesting. How boring it would be if everything followed the same, albeit winning, formula. A good director can make even the driest of subjects interesting. It would be appalling if films contained nothing new. Every film I've made has required the learning of some new skill or seen me gain a new insight. I would hope to get that whenever I watch a film.

What sort of homework do you do with a new character, and have you ever taken acting classes, studied body language or learnt a new skill for such homework?

JD – I learnt to tango for a Pillsbury doughboy commercial. I've never filmed myself or studied pantomime formally, but I watch a lot of silent films.

TB – Any competent actor would tell you that if they don't do homework for the character they are playing, they might never find the character. I learnt a bit about martial arts when working on *Celebrity*

Deathmatch, but I would have rather learned about tap dance from *Holiday Inn*. I use my body quite a bit, so it's natural for me to act out the character. I took dance lessons when I was in summer music theatre. For my current film, *The Labyrinth*, there is a rather lengthy virginal sacrifice dance using four female dancers and one male dancer wearing a bull's head. Ridiculously ambitious, but if I pull it off, I can retire. For me, body posture is most satisfying, as the human form can say quite a bit in simple gesture.

KD – No, but I know I should. I was nervous about tending acting classes at university, but I forced myself as I knew my animation would benefit, but they got cancelled. Would love to do more, and think about movement, balance, etc.

RC – Yes ... a little dance study, mountain climbing study, etc. I have a good sense of timing, weight and how the body transitions, from years in martial arts and playing soccer. I act out the performance, because there can be so many timing issues that you don't want to leave them to chance. At least I don't, because I want a specific performance to have a specific timing. I enjoy getting expression out of a pose but putting an expression on the face is meaningless if the body pose says something different (unless that's an intentional contrast). I studied jiu-jitsu, karate and tai chi for many years, which was extremely valuable, and started playing soccer.

DC – I research a character to get to know them. Learning new skills isn't necessary; you just have to make it look like he can do it. My skill is as an animator and I act through shots in character and look at video reference where possible. We filmed ourselves on *Curse of the Were-Rabbit*. I like to believe I can animate from my imagination and not have to see it on the monitor first, that's a bit like cheating. It helps to see things sometimes for timing and poise and balance but it's good not to 'need' it.

AW – I don't need to act out for myself, but I use it to communicate with the director.

SB – I've looked at different dance styles for scenes, but sometimes it's best to animate a heightened version or caricature of the movement and not be too real.

RH – I can feel the action, but I do find myself acting out the puppet's actions from time to time. I like the head and face best, although I do like to get expression with the upper body and arms.

JC – I do character research looking at old films, classic performances, even people I know who share character traits. I love theatre and dance. Every animator should go to a performance regularly. There is so much to be learned from watching other people interpretations. I've learnt new skills to aid my animation. On *Hamilton Mattress* a group of us learnt to tango dance for the nightclub sequences. Having video reference is a very useful technique used at Aardman Animations. On *Creature Comforts USA* you and your director would act out the lines you had to animate, sometimes twenty times and then picking one or two for reference, not to 'copy' the action but to give performance clues. It helped you both to be on the same wavelength. This technique is often used on feature films. Though the face can be very expressive, a lot of puppets have limited movement. I like to use whole body language to emote; there is so much to be read from posture and movement.

FL – I like to do the action of the puppet myself during animation. In that precise moment, I find it even more useful than watching another person doing it.

Gilbert and Sullivan has yet to be available on DVD. I'm actually a little surprised and pleased at the favourable reactions from the most fanatical and traditional of Gilbert and Sullivan fans, who see it as a game. They are quick to tell me of the gentle changes from Gilbert's original. Perhaps the subjects themselves, Shakespeare, Greek myths, opera, inspire such devotion, but the audiences who seem to enjoy my films do so with a most agreeable passion, or modified rapture (thank you, Mr Gilbert). Likewise, the audiences who dislike my films do so with a solid indifference.

Since this film, people have suggested a complete Gilbert and Sullivan opera in stop motion, with *The Mikado* and *Iolanthe* being the favoured works. I'd be up for that, and I would do something as refreshing and as innovative as the operas were in their time. Yes, please, but where are the talking animals?

I was pleased, just before the recording, to find a line from a letter that Gilbert wrote to Sullivan, which the latter sadly never received: 'It gives one the chance of shining right through the twentieth century with a reflected light'. That's a very respectful compliment, and I quickly incorporated it into the script, unlike the quote about 'God save the Queen', but there will always be 'what ifs' and 'if onlys' on any film. We never make the film in our head, as our thoughts are always developing, and new ideas just happen as we work. At least in stop motion, the process takes place over such a long period that any new research can usually be accommodated, although this can work against a film. It would be lovely to be so sure of the storyboard, the script and all the production elements that the filming goes as planned, but it never does. Stop motion is, thankfully, an organic beast.

Do you think animation is a tedious process for which you need a lot of patience? Is that the question you have been asked most? What is the dumbest and the most profound question?

JD – No. 'How do you know how far to move it?' The dumbest was by a senior person at an effects company: 'we found that animating in sunlight didn't work because the shadows move'. Perhaps the most profound turns out to be 'how do you know how far to move the puppet?' because that takes in the entire spectrum of mechanics and dramatics.

TB – No, I find animation quite relaxing. There are no dumb questions, only stupid answers, and I've given plenty in the latter category. Most profound? That would be from a pastor who asked me, 'Do you believe that there is a possibility that Jesus actually rose from the dead?'

KD – You do need patience, but maybe that comes with practice. I always get 'ohh, you mean like Wallace and Gromit'!

DC – 'How come you can't see your hand when you take the picture?' (dumb) and 'why do you do it?' (profound but depressing if you soul search too deep). Before an interview on *Hamilton Mattress*, Barry Purves and I joked with the journalist about questions he might ask, like 'bet you're patient?' and 'does it take a long time?', then he held up his microphone in all seriousness, asking 'do you have to be patient because it takes such a long time?'

TA – 'You must have a lot of patience'. This makes me feel like the most impatient man alive! Telling someone you're an animator automatically produces this 'ooh, patience' response. Talking to someone unfamiliar with animation, it seems an unwritten law – you have to answer this comment, before discussing anything further. The next most asked question is 'don't you have to make lots of different pictures for just one second?', followed by the dreaded 'and how many minutes do you make per day?' Not good when it's a two seconds per day project!

JC – I don't think the process of animation is tedious and I have little patience. I can be calm and methodical. 'How do you know how much to move it?' 'Do you have a lot of patience?' 'Do you make the puppets?'

FL – Most people I talk with – the ones who haven't made stop motion ever – think that stop motion is in fact laborious and tedious. I don't think it is tedious at all, and is just as laborious as anything else you do seriously.

DS – Dumbest and almost most asked is 'where do you get you get your ideas from?' Most asked is the Patience Question. I answer it talking about the ceiling of the Sistine Chapel and how long that took, or any great achievement come to that. If you're driven by the idea it'll take as long as it needs and the time will pass quickly. I can't think of the most profound question – 'Can you make a living out of doing animation?', but someone must have asked us about something deep once ….

BP – On seeing the puppets on set: 'yes, but where are the real ones?' 'Where do you put your hands?', even 'but I can't see the strings'.

Favourite films

The one film that stands out more than any other is Zbigniev's *Tango*. This short film of people entering and departing a room (doors again!), becoming more linked as the film progresses, leaves me speechless every time. It's hugely entertaining watching the different stories, wondering exactly what significance links the incidents (I'm sure there is significance, as all aspects of life are there). Watching the film flow so beautifully and easily belies the Herculean task of the meticulous preparation. The stories weaving in and out are just as complex as a piece of Bach or Rossini, where numerous melodies build up and play against each other with a million variations and harmonies, still hearing the individual tunes, while something much larger emerges. *Tango* is an extraordinary film, not just for its bravado, but there is something very moving going on, especially in the last few seconds when the bouncing ball that has been the driving rhythm of the film sits sadly on the floor. That this film was worked out by hand is extraordinary. A computer would have made things easier today and probably given the film a much slicker feel, but it would have robbed the film of its pleasure. The cut-out photos technique shows off the human hand behind the film. It's the dancer battling gravity in thirty-two fouettés, yet making it look easy and sublime at the same time. I get huge pleasure from witnessing such effort disguised as simplicity, and while stop-frame animation may not be as complex, it involves many hours of intricate work for something deceptively simple. This obsession with labour-intensive work is worryingly satisfying.

Similarly, Michael Frayn's play *Noises Off* not only manages to be about the performance of a complicated farce called *Nothing On*, but he throws in an even more complicated backstage farce, and has them overlapping at the same time. Quite how this was planned defeats me.

My most complicated film is *Screen Play*, and I admit that part of the challenge was the stupidly complex but necessary nine-minute take. I enjoyed the months planning every movement of those screens. Originally the screens were to slide from side to side, revealing new vistas, but reading that the Japanese had pioneered the revolving stage, I complicated things by adding not just one but a double revolving stage. The revolve gave me too much imagery for one film, and I later designed a stage production of *Jekyll and Hyde* around a revolve, instantly taking us from outside to inside, from black to white, from order to chaos. The preparations for *Screen Play* involved building a basic revolving stage, endlessly reworking the choreography of the screens. Plotting the interesting shapes to segue neatly into each other was the hard bit; the timing happened as I filmed.

These mental gymnastics are probably something that each stop motion animator secretly enjoys. We have to, don't we? Otherwise how can we spend so long doing such complicated stuff for, in real terms, so little? I've been animating for thirty years, but there's probably no more than twenty hours to show for that. It's probably no surprise that I love jigsaw puzzles (especially doing them without the picture) and doing Suduko puzzles without making any notes. Animation requires an obsessive mind set.

Tim Burton's *Vincent* (Saemi Takahashi).

Can you list your five favourite animated films, and is there one particular moment that stands out?

JD – Can't do just one. The scene in *A Midsummer Night's Dream* with the rustics rehearsing and the script getting edited with a meat cleaver – an unexpected pragmatic solution.

The stegosaurus sequence in *Kong* because of the 'naturalistic' way it is staged, the grotto-fight close-ups in *King Kong* because I feel a real struggle going on; the scene in *Son of Kong* in which the styracosaurus chases the adventurers along the stream.

The skeleton fight in *The Seventh Voyage of Sinbad* because it's dynamic, and presents something that couldn't be shown satisfactorily by any other means than stop motion.

Many moments in the Pal Puppetoons and Joe Young getting drunk, showing how well stop motion can depict 'acting'.

Rosina Rubylips in *Hansel and Gretel*, but that's due largely to Anna Russell's voicing.

Five favourite films: *A Midsummer Night's Dream*, *Song of the Prairie*, *King Kong*, *Mighty Joe Young*. I'd put *Next* here, but I've only seen it once or twice.

Joe Young would be my favourite character, but some from *Corpse Bride* give him competition.

TB – The Talos scene from *Jason and the Argonauts*. A giant bronze statue coming to life is about the most surreal thing I've ever seen. The animation is flawless.

Jason and the Argonauts (Ray Harryhausen), one of the greatest fantasy adventures ever lensed; *Next* (Barry Purves), possibly one of the best examples of key pose I've ever seen; *The Black Scorpion* (Willis O'Brien), the nightmarish quality of the animation; *The Mascot* (Ladislav Starevitch), outstanding examples of different types of material to use for animation; *Pas de Deux* (Norman McClaren), not necessarily a stop motion film, but a film of exquisite, haunting beauty.

KD – Favourite scene – Nowhere Man in *Yellow Submarine*, for some reason it gives me goosebumps, he just looks so lonely.

Favourites: *Nightmare before Christmas* – I love the design of the film; *Cousin* – all of Adam Elliot – the script, and the narrator and simplistic style of the film, E is for Eat … so touching; *Next* – I love the golden wings and the tapping of the chin; *Secret Joy of Fallen Angels* – because I don't get it and it looks amazing; *Vincent* – it makes me laugh.

DC – The slow-motion Hammy towards the end of *Over the Hedge* because it's so simple and not like anything I've seen before. I expect we'll see loads of it now. Hammy is so hyper fast you couldn't imagine him any faster so they went the extreme opposite and time stood still in comparison to how mega super hyper fast he was! The Mime Frog cell phone section of *Flushed Away* seems very fresh and original and gets a huge laugh every time.

Top five:

1. *Balloon* by Ken Lidster: first stop-frame piece that totally enthralled and mesmerised me. Beautifully animated with a simple little story of nastiness getting its comeuppance! Only one colour and a very minimal soundtrack. Beautiful.

Two stills from *Balloon* by Ken Lidster (© NTFTS).

2. *Who Framed Roger Rabbit?* The amazing mix of live action and animation swept you up in the whole story and you believed they were all there interacting. Brilliant slapstick Disney style, total overacting too.

3. *Father and Daughter*, no, *Monk and Fish*, no, *Father and Daughter* by Michael due Dot due Witt: a selection of simple and beautiful drawings that made me cry. *Monk and Fish* – light, airy and fun. *Father and Daughter* – heartbreaking!

4. *Monsters Inc* by Pixar: because it's so well put together. Everything means something to the story later on. It comes together perfectly at the end with no wasted detail or superfluous story. Great timing

and acting. Well-detailed drama and emotion. A superb colourful cast with only one human which is good because people are still the weak part of any CG movie.

5. Wallace and Gromit in *The Wrong Trousers*: brilliant story, brilliantly told. It opened my eyes to what you could do with Plasticine and made me think, 'that would be better than getting a proper job! ' and three feature films later I've decided it is!

Favourite puppet: Animal from the Muppets, the Clangers and the Wombles and Windy Miller and his friends and The Magic Roundabout were all inspirations and big influences, but Yoda from *Star Wars* is cool, the new all-action kickass CG Yoda!!!

Oh, oh, oh! And of course *Hamilton Mattress*! He's so 'anty'!

AW – My favourite puppet is the small furry creature in the Russian *Chiburashka*, by R. Kachanov, 1972.

SB – *The Incredibles; Toy Story; My Neighbour Totoro; The Iron Giant; Pinocchio*. But the skeleton swordfight in *Jason and the Argonauts* takes it for best scene.

KP – The 'Poor Jack' sequence from *Nightmare before Christmas*, for the emotional arc Anthony Scott's animation brings forth. Will Vinton's *Closed Mondays*, for its variety of techniques, funny character animation and ground-breaking historical importance. Every frame of Nick Park's *Creature Comforts*, for the masterful character animation. Ladislas Starewicz's *The Mascot*, for its simultaneous charm and creepiness. Ray Harryhausen's skeleton fight with the Argonauts, for its technical and cinematic brilliance. Len Lye's unreleased *Peanut Vendor*, because it's creepy. And a student film by Jim Pinard called *Crosspaths*, for its simplicity and spiritual significance.

BP – The Talos scene from *Jason and the Argonauts*. Favourite animated films are: *Tango, The Monk and the Fish, The Sandman, Overtime* and *Harvie Krumpet*.

RH – *The Wind in the Willows*, 'May Day' episode.

JC – A very short film by Paul Driessen that had a little black spider in a white square bouncing on a web string. All you can hear is a 'boinging' noise and a little giggle. As the bouncing becomes more vigorous the spider hits the bottom of the frame. Instead of bouncing back it appears its legs are stuck. Gradually the legs stretch then, one by one, ping off. The spider shoots up and as it hits the top of frame, a red splat appears. So simple but very funny, everyone laughed (poor spider).

Favourite films: *Rargh*, a charming drawn animation about a world that exists only when a man is sleeping. I loved its quirkiness *Nightmare before Christmas*, for its dark story and wonderful design.

The Sandman (© Berry Batty Mackinnon).

Screen Play, simply a beautifully told story – some gore and a shock ending. *The Sandman*, atmospheric, dark tale, beautifully animated and great design. *Shrek*, funny script, some good animation (some appalling) ... I loved donkey!

DS – I found *Tales of Tales* to be a very moving film when I first saw it and at the time I hadn't seen many films of this quality. It made me realise that complex emotional issues can be handled in subtle ways through animation. The others are the classic clichés, *Jason and Argonauts*, *Clangers*, some of the work of George Pal.

AC – *Next* – the audacity of trying to 'do' Shakespeare in five minutes, but it works wonderfully – the character himself is so human and although silent speaks volumes; he's also very Barry! Also you, the audience, have to work hard to see how many plays you can recognise. *Bambi*, one of the first films I can remember, it was totally real and I wept buckets. *The Cat Came Back*, very funny, lively, annoying and simple. *Hill Farm*, beautifully drawn, wonderfully visual and lots of humour. *Screen Play*, visually stunning, highly complicated from many points of view – story, animation techniques, symbolism, sign language, etc., lots of theatre but again makes the audience work hard.

PRW/MG – Favourite moment in all animation has to be the wolf singing to the baby as he rocks it in the cradle in Norstein's *Tale of Tales*.

Top five animated films:

1. *Tale of Tales* (Yuri Norstein) because it captures the essence of Russia and of Norstein.

2. *The Public Choice* (Lejf Marcussen) for its totally original concept – I almost stop breathing now that I know (and wait for) the very surprising ending.

3. *Father and Daughter* (Michael Dudok de Wit). My love of this film has a lot to do with my own relationship with my father. But the beautiful drawing, the shadows, the passing of time all contribute to this masterpiece (Margot says her favourite moment in animation is almost this entire film).

4. *The Big Snit* (Richard Condie): we both love this because it is hilariously funny while carrying a message that is so subtle. If you have ever played Scrabble, or loved anybody for their idiosyncrasies, you have to love this.

5. *A Grand Day Out* (Nick Park) for Gromit because in spite of some of things he does (knitting for example) he is a real dog. And he is cleverer than his master – and he knows it! This is my favourite Nick Park film because it has a rough-edged look but is a masterpiece of detail and so British!

Others: *Screen Play* – we both love this because it relates to Japanese culture (which we love) and because we worked with a mime company and studied mime and movement which gave us understanding of movement and stillness. *Next* – for our love of Shakespeare. I love the films of the Brothers Quay, particularly the *Street of Crocodiles*. This had a very profound effect on me – I loved the mystery, the strange sounds and the broken dolls. They were some of my dreams brought to life. I told the Quays this and they said I was mad! Early TV series we both loved: *Clangers* and *The Magic Roundabout*. We loved these before we even knew what stop motion was. The most recent addition to the stop motion greats is Suzie Templeton's *Peter and the Wolf*. We have always loved her work, especially *Dog*, but this latest

production is nothing less than superb and proves that stop motion is still one of the most amazing media in animation.

Not all animated characters live, but with drawn animation and stop motion they do. Stop motion characters become real – take *Dog, Wallace and Gromit, Creature Comforts*. And all Barry's films and *Nightmare before Christmas*.

Possibly the most loved animated sequence, the skeleton fight from *Jason and the Argonauts*, animated by Ray Harryhausen (Paul Flannery).

Widening the Scope

Animation in a bubble

I have had my share of being ribbed for my reasonably conservative cultural ambitions and pretensions. That's confused me, as I assumed that animation belongs with the other arts, where innovation, imagination and the like are applauded and encouraged, but for many people it does not. It does for me, and I know it can and should. I want to burst the bubble that separates animation from the other arts. Nothing would please me more than to work with leading designers, composers, choreographers or writers, but on the rare occasion where I've been in such company, the conversation stops dead. Some do not understand that our skills are much the same but applied differently, although more slowly. We're sometimes looked on as a quaint cottage industry. We're not. Any cross-over has to be beneficial to us both. The look of incomprehension as I asked a respected theatre company about directing was priceless, and yet they employ people with less experience. I'll admit to admiration coloured with jealousy of animators who have crossed over, such as the brilliant Brothers Quay. Their stage productions have left me dazzled, excited and energised many a time, as do their animated films.

My eureka moment was the Royal Shakespeare Company's nine-hour *Nicholas Nickleby* in 1980. Seeing this, I became aware of great direction, great storytelling, and the unrivalled thrill of the relationship between an audience and the cast. *Nickleby* was also the first production I'd seen where the focus was on the performer as storyteller. It wasn't about pretty sets and costumes, but about the performer sharing an imagination with the audience. I was never the same after this production. True, the stage wasn't genuinely bare, and the hundreds of costumes were splendid, but it was the rawness of the cast using their bodies as the narrative and set that was so powerful. One minute they conjured up the image of a stagecoach, the next they grouped as if round a gambling table, and then they were walls closing in on Ralph Nickleby, all just using no more than their bodies. One of the final scenes, and probably the most emotionally shattering I shall ever witness, was poor Smike's death. Just Nickleby and Smike alone on stage, both actors far from their teens, and Smike too tall and substantial for a malnourished boy, but none of this mattered. The performances were so utterly convincing that we saw all we needed to see, and I was reduced to tears, feeling an intruder in such a heartbreaking scene. Ever since I've been a sucker for a performer standing alone on a practically empty stage; certainly I love spectacle and great design, but somehow the whole experience is more satisfying when you have to fill in a lot of the details. It seems as though you are participating with the actor rather than watching him. An awful cliché, but you are sharing something. Spectacle can become

animated wallpaper, but with a single actor in front of you, you are rewardingly forced to join in and concentrate. By totally throwing the emphasis onto the puppets I've tried similarly to break down the barrier between performer and audience, even if I cannot help throwing in some telling visuals.

I strive to make a moment in stop motion that matches the sheer emotion of Smike's death, or the finale of *Swan Lake*. Risible drawn versions of both *Nickleby* and *Swan Lake*, found on markets next to DVDs hoodwinking innocent parents that they are buying a premature release of the latest Disney or Pixar, do not help my case.

Name ten of your greatest cultural experiences, or creative artists, alive or dead.

JD – Willis O'Brien; John Singer Sergeant; Albert Whitlock; Ray Harryhausen; Frank Frazetta; N.C. Wyeth; Art Clokey; Rimsky Korsakov; Ivan Bilibin; Victor Herbert; Rudolph Friml – okay, it's eleven, sue me.

Probably *the* most influential cultural experience was my father taking me to the theatre arts department at Michigan State University when I was five and I saw marionettes up close for the first time. There was no performance; no-one else was there, only the behind-the-stage sets and the marionettes hanging motionless. It wasn't even a fantasy subject, just uniformed WWII soldiers and their sweethearts, plus a large troop train set, but I never forgot the 'magic' of it all. Strange that my dad would have even been aware of the puppet theatre, since he was involved with the sciences and was teaching aerial terrain recognition to air corps cadets.

TB – John Huston; John Singer Sargent; Frederick Remington; Augustus Rodin; Igor Stravinsky; Bernard Herrmann; Dante; Michelango Bounarotti; Jan Van Meer; Ray Harryhausen.

KD –

1. Paul Berry – after seeing *Sandman*, the next day I made the tutor play it in the large lecture theatre and everyone was speechless.

2. Audrey Hepburn – pure style and beauty.

3. Dick Van Dyke – for my childhood.

4. Paul Weller – guidance.

5. Tim Burton – for biting.

6. Baz Lurhmann – for making everything sparkle.

7. Paul Wells – for making me believe and suggesting I cross the bridge.

8. Barry Purves – *Screen Play* – repeated watching and tears at the end.

9. Suzie Templeton – I can remember exactly where I was when I first saw *Stanley* and being told it was a student film. Kept me going through my degree!

DC –

1. *Star Wars*: models, matte painting, music, monsters, far away fairytale, fantasytastic!

2. *The Muppets*: the music, the fun, the laughter, the imagination, makes me happy.

3. Egypt: seeing the sun come up where Moses got his instruction book leaves its mark!

4. Wagner's *Ride of the Valkyrie*: goosepimpletastic! The power of music!

5. *The Lord of the Rings*: a big book of somewhere else. It took me on a journey.

6. Rodin's *Thinker*: makes you want to think. Surprisingly small in real life.

7. Tony Hart's gallery: made me think I could do creative imaginative things. Lovely piece of music too.

8. Johnny Morris' animal voices: made me wonder, what do they think?

9. *Pete's Dragon*: animated character in the real world, fantasy? Reality.

10. Gerry Mulligan (baritone saxophone): what one man can do with some complex plumbing is simply gorgeous.

SB – Nick Park; John Kricfalusi; Terry Gilliam; Tim Burton; Barry Purves.

BP – Only ten? Who wrote this question? RSC's *Nicholas Nickleby*, David Bintley's ballet *Still Life at the Penguin Café*, Matthew Bourne's *Swan Lake*, Stephen Sondheim's *Sunday in the Park with George*, Prokofiev's *Romeo and Juliet*, Disney's *Mary Poppins*, Handel's *Xerxes*, Kenneth Grahame's *The Wind in the Willows*, Hitchcock's *The Birds*, and of course *King Kong*.

RH –

1. Leroy Anderson (composer the music for some of the films I want to make)

2. Gilbert and Sullivan

3. Walt Disney

4. Ray Harryhausen

5. Claude Monet

6. The Sherman Brothers

7. Rodgers and Hammerstein

8. Al Hirschfeld

9. Brian Cosgrove and Mark Hall

10. Will Hannah and Joseph Barbera ... and of course, Barry Purves!

JC –

- Ballet of *Edward II* – the first time I'd seen ballet as a masculine, sexy, raunchy, tutu-less thing.

- *Harvey* with Ben Keaton, Royal Exchange. I love the film, and this production, especially Ben's performance, equalled it.

- Halle Orchestra playing Bond themes.

- *Amélie* – restored my faith in cinema. Loved its oddness, romance and fantasy.

- John Irvine – *A prayer for Owen Meany*, my favourite book.

- Preservation Hall Jazz, New Orleans. I went backpacking, ending in this tatty but famous little venue. Sat on the floor and had my socks knocked off by the gig.

- Frank Lloyd Wright.

- Gaudi, for his incredible vision verging on folly.

DS – I was overwhelmed by seeing *Lawrence of Arabia* as child. It had a profound influence on me because of its scope, scale and emotional power. I didn't understand the role of the director at the time (or for many years afterwards) or indeed the scriptwriter but what I *saw* made me want to know more about cinematography and how these things were shot. Freddie Young was a hero; I never got to meet him.

AC –

- *Othello* – Ian McKellen as Iago, the Other Place – McKellen was totally mesmerising.

- *The Tempest* at the Rollright stones at midnight, just because it was so weird, Mark Rylance.

- *Twelfth Night*, The Globe, Mark Rylance – Rylance again being astonishing, full dramatic performance on stage (music dancing, frocks); full dramatic performance offstage, standing, eating, talking, sore backs!

- The Stones, Knebworth House – pure drama, spectacle, comradeship.

- Warhol exhibition, Tate Modern.

- Visit to the pyramids and National Museum, Cairo.

- Philoctetes – *Cheek by Jowl*.

- *Hamlet*, the Roundhouse – Marianne Faithful.

- Pasolini – *Oedipus*, *Medea*, films.

Festivals

Thirty or so years ago the idea of a film festival devoted solely to animation, getting your film shown and discussed and meeting fellow film-makers, was extraordinary, but there are now festivals around the world, all operating differently. Originally, most festivals happened every two years as there was neither the new material nor the audience to be annual events, but that has by and large changed. Each festival has its own theme and criteria about the films they want to show. Some show a whole range, others specialise in a technique, while some prefer genres such as science fiction, or specific audiences of, perhaps children, or a particular message. If a film is rejected by a festival, it doesn't mean necessarily that they don't like it. It may simply not fit their scheme of things. But there is nothing to rival the first screening of your latest film at a festival. Terrifying and exciting in equal measures. Festival audiences usually adore animation with real fervour. There's always a buzz, an openness and a willingness to swap stories.

The perks of this job: the lake at Annecy

Most festivals offer awards, some are which are a fancy piece of sculpture, others a certificate, while some offer substantial cash awards. Most awards are decided during the week by hardworking juries who spend their week locked away in a room watching unimaginable hours of films, while usually battling half a dozen different languages and customs, and trying to avoid the accusatory and flirtatious looks of hopeful film-makers. Discussions are rarely less than heated and passionate, and all manner of reasons are offered for wanting particular films to win. I've been on many juries and usually the discussions are very rational, although I can't pretend that a bottle of vodka, or more, has not been waved in my direction as gentle, bribe is too strong, persuasion. As a non-drinker and in spite of tears from a jury member pleading for her favoured film to win, that was a lost cause on me.

It's hard to say what makes an award-winning film. A certain standard and clear innovation impress straight away, but it's probably more about a film achieving what it set out to do, and doing it well. It's not always about saying something deeply moving or significant, as small, simple films about the most trivial of incidents, but which are beautifully told, can still win. It's probably about exploiting the language of animation, to tell some story that other mediums cannot. The big

blockbusting comedy will invariably win the audience vote. Audiences want to be entertained, and many festival audiences are particularly quick to show their appreciation, or lack of it. The packed auditoriums of Annecy ring with boos and slow hand claps just as often as the audiences cheer to the rafters. There's no surer or more raw way of finding out whether your film works. Annecy is an amazing experience and has grown to huge proportions. As with any festival, you are overwhelmed with trying to work out how to see as many programmes as possible, as well as trying to decode the booking system. Annecy usually has several auditoriums scattered over the gorgeous town, but its strength is also its weakness; namely, the lake itself. The town has such a stunning setting and after too many hours of watching films that lake is a magnet. By day three you find the film-makers in a flotilla of boats, capsizing with picnics, or skinny-dipping in the mountain fresh water, but all having overdosed on films or questions from journalists. With animators being cooped up for most of the year, this is a tremendous location to meet other film-makers, and Annecy treats the films with huge respect, with countless meetings and workshops, and usually a breathtaking party on the lake or in a chateau. I have great memories of Annecy, especially sitting out on the lawns giving a masterclass to twenty or so animators, being unable to concentrate because of the distracting scenery, and the gourmet picnic. Stuttgart also holds a great festival, and a very intense one, with all the activities focused in the same area, complete with a wonderful old wooden circus tent as a meeting place. Hiroshima, Espinho, Bradford, Liepzig ... oh, too many great festivals and tremendous fellow animators and excited audiences. Festivals are a great perk of this business, and a massive release after the intense process of making a film.

I have often taken puppets with me, or festivals have hosted an exhibition. Nothing draws the crowds like a collection of puppets. Their physicality has provoked some genuinely rewarding conversations, usually from people coming up to me in the street, away from the screenings. They often appear clutching a bag which contains their puppet, desperate for any practical help and appreciation. I'm happy to talk about puppets for hours, especially when accompanied by some of Annecy's unbelievably delicious pastries. The immediate reaction is to touch the puppets, to move them, to be part of the tactile experience that we enjoy as animators. This reaching out and touching is often out of curiosity, but it's also about wanting a direct connection with the puppet or character. With a stop motion puppet, especially for short films, there is generally only one version of the character, making it unique. Audiences often struggle to relate this lifeless object they are prodding to what they've seen living on screen. There is some melancholy as well, as there is the puppet, its work done, spent, but still containing all that experience. Puppets have life, but they must also have death.

Unlike the marionettes, the glove puppets, the animatronic puppets, and to some extent the clay puppet with its visible fingerprints, stop motion puppets sit there with no obvious intervention. There is still a mystery about them, about how they move and perform. A frequent comment is 'yes, but where is the real one?' Etiquette stops some people, but most just want to touch, hold and photograph, smiling in response to a physical experience that

I don't think a keyboard, under similar circumstances, can produce. A drawing on a previously blank sheet of paper of a recognisable character can raise the same smile. From nothing, there is now a character, and a unique personalised one.

Festivals unite all manner of people through the shared passion of animation. I love watching homemade puppets being delicately unwrapped, but I'm often saddened that people's resources do not match their obvious enthusiasm. The

Some of the extended animation family around the world.

fact that they have built one at all is encouraging, and more than I've done, but the pride with which these puppets are brought out as some sort of offering says something about our need for puppets. Festivals are certainly the place to be refreshed about our craft.

I cannot pretend that festivals and the sixty awards for the films have brought me work (most are a celebration, not a market), but they have brought a lot of satisfaction and a stuffed address book. I'm not one for working a room. Naively, I hope the films will sell themselves, without the liquid-fuelled promises made in the early hours at some foreign hotel. I may well have lost out, as I cannot do the essential networking, but I would feel that I'd cheated if I got a contract through turning the uninvited charm on some unsuspecting broadcaster. What awards do mean is a certain undeniable respect and credibility from your peers, and that is priceless. On several occasions a film of mine has been up for an award, and in the aftermath of the production I could not afford to go. One occasion, where a film was winning a Grand Prix, saw me slumped on the sofa back home, in less than buoyant spirits about not working. I made an acceptance speech down the phone. Possibly festivals without the pressure of awards and competitions are more friendly.

Festivals, and film schools, have been supremely generous to me and have taken me to places I would never have otherwise gone. Animation does seem to travel, not just geographically, but across class and cultures. I can count on one hand the true holidays I've taken, but stop motion has filled my passport with interesting stamps. Only Russia doesn't have any pins on my wallchart, although I nearly got to Moscow to direct a play, in Russian, about a great Russian violinist, with one of Russia's great actors. It took some thinking before I said yes (fears of being exposed or out of one's depth haunt us all), but the woman who had invited me suffered a bereavement, and the project ran out of steam. The fact that I am a stop motion animator and someone saw something in my work that made me suitable for such a project was flattering indeed. Such calls should be savoured. At the risk of sounding Chekhovian, one day I'll get to Moscow. I can't complain about lack of places I have been to, and often giggle to think that a peculiar and generally rather useless ability to communicate something through inanimate objects has taken me round the world and introduced me to some truly exotic places and equally exotic people. A shared passion goes a long way.

Theatre work

While writing this book I have been involved with several plays at my local non-professional theatre, the amazing Garrick Playhouse. I say amazing as the company put on twelve productions a year, each in just five weeks of evenings, and invariably the standard is pretty extraordinary. Working there has allowed me some considerable creativity that I may not otherwise have had. I usually direct and design my own productions, and have a pretty well-supplied workshop at hand, with a comprehensive wardrobe.

I approach each play with the same detail and preparation as I would animation. Although the environment and the audience are different, I set out to tell the story in the most interesting way I can. I'm not a director who will duplicate another production, nor just put a show on, but I will go back to the core of the piece and try to find something fresh. I have never done a literal production, with an architecturally solid set. I don't have the draughtsmanship skills necessary, and I am

Montage of images from *Communicating Doors, The Ritz, Snake in the Grass, The Turn of the Screw, Jekyll and Hyde, Lady Windermere's Fan, Habeas Corpus* and *One Flew Over the Cuckoo's Nest,* Altrincham Garrick.

not interested in reproducing a living room on stage. Some of the audience was disappointed not to see a beautifully detailed gothic interior for our *The Turn of the Screw*. This is hardly a literal piece, with most of the cast unbalanced one way or the other. What the audience saw was a huge dolls' house doubling as a bed, a table, a garden, a tower, well everything. It seemed to embody perfectly a fractured childhood. Around this dolls' house lay broken toys, unused toys, unread books, empty birdcages, all covered in dead leaves. Vast cloudy gauzes fluttered to the ground, progressively making the stage even more insubstantial, and allowing the figures of the ghosts to be half glimpsed. Everything became less and less solid, echoing the state of Miss Grey's mind. Not a realistic approach, but that's not my strength. This lies in coming up with concepts, conventions and visual metaphors that provide a gloriously theatrical space for the actors to play in. I try not to upstage the actors with the design, instead making them stand out, using the design to set the mood and atmosphere, and to make a statement. My heart sinks when a curtain goes up revealing a very literal representation, with no design idea or a point of view, much as my heart sinks with rotoscoping in animation. It's seems a waste of the potential of such artifice as theatre and animation. There's always room for some interesting stylisation.

In anything I do, I like to read through the script a couple of times, and note down my gut reaction, or what themes leapt off the page, and usually try to keep hold of these. As with my animation, it's important for me to find the central image that will best serve the play before I even think of any staging ideas.

Colours often appear first. If the piece strikes me as somewhat farcical, I will probably start to rule out sombre colours. I would probably have a hard time directing a farce in a black box, or *Macbeth* in bright primary colours. As colours and brightness seem appropriate for comedy, so darker colours and shadows seem appropriate for tragedy. Many a book has been written about the emotional qualities of colour, and it's essential that I use them as another dramatic element. Most things I do have a journey plotted by colour and design. The tone and the rhythm of the piece also need to be found straight away.

Habeas Corpus

I need discipline and parameters in any form of creative activity. At the Garrick, this discipline is time, facilities and the sheer feat of getting it all done, while coping with day jobs and real lives. *Next* worked as I had only one main puppet. Alan Bennett asks for an empty stage for his *Habeas Corpus*, but our audiences appreciate something to look at and an empty stage might be too challenging. With our crew busy on bigger productions, necessitating simplicity, I kept reading the script, trying to find a clue to a striking but economic image. The dialogue was full of innuendo and risqué puns, and couples swapped partners with earthy, dance-like energy. The play is a farce with some scenes a mere two lines in total, giving a clue to the pacing required. I wanted to include dance, especially the tango mentioned in the script, but that is a

hard dance to perfect in so short a time and it seemed too overtly sexual for the more naughty comic sexuality of the play. Farce is essentially about the promise or threat of sex, rather than sex itself. Suddenly the maypole popped up, and that satisfied everything. It's clearly a sexual innuendo in itself, and involves simple, effective dancing. It is also colourful and comical. The maypole generates a circular shape, and leads to men and women swapping partners quite naturally, and the knotting ribbons are a fitting visualisation of the plot.

The cast of *Habeas Corpus* at the Altrincham Garrick.

Add some Morris dancing, whose cheerful English absurdity always raises a smile, and everything fell into shape with a satisfying clunk. When the imagery works for the piece I get excited. A maypole set in a country green seemed perfect, allowing space for the cast to run round, and it would be easy for a stretched crew to build. A maypole led me to think of garden fêtes, and the general buccolic atmosphere worked well for the play. With fêtes come bunting and balloons, and with balloons come more sexual innuendo, and since the play is obsessed with breasts, this was all making sense. I disciplined myself to make everything work with either balloons or the maypole. A character tries to hang himself, and initially the idea was for him to swing right across the stage, but getting the necessary harness and safety issues sorted out well in advance would have been time consuming. Hanging from the maypole might be messy with the ribbons, but ribbons got me thinking about ribbons attached to balloons. If the character entered clutching a balloon, and let it float up, jerking appropriately, then that seemed a good visual comic moment, expressing the hanging within the context of the design and the production, and without any safety issues. It was original and got a huge laugh. Likewise, a long-awaited arrival of a much discussed pair of false breasts became a round box that split in two, revealing two very pink balloons. This got a laugh bigger than if we'd used a literal appliance. Their very fakeness was much more revealing about the absurdity that something literal. I found a million uses for balloons and the maypole, all the while keeping things utterly simple.

The show-stopping false breasts of *Habeas Corpus*.

Most satisfactory when it happens, but of course it doesn't always happen. I can get stuck with an image that is so beautiful, but I cannot make it work. My inner voice tells me: it's a great image, but what is it saying? Nothing, the other voice says. Well why have it? Because it's nice, and I'm showing off. So the conversation goes on, with Gollum and Sméagol overtones, and if I can't find a justification for it in the scheme of the piece, then it has to go. My scrapbooks and scripts are full of images that could have been startling, but, they just weren't right. But for *Habeas Corpus* everything clicked with the maypole. For *Next* it was the single puppet, *Screen Play* the revolving stage, *Rigoletto* the bird masks, *Achilles* the stone arena, and for *Gilbert and Sullivan* the bed. Each a discipline forcing creativity. Within each piece, I try to work with strong shapes that also differentiate the locations. *Hamilton Mattress*, in particular, had verticals, horizontals, circles or triangles prescribing each location.

Hamilton Mattress' location-defining triangles.

I love finding resonances with props, and in *Habeas Corpus* brightly coloured umbrellas became weapons, sexual metaphors and places of concealment. The show was a riot of colour. The main four doors, hidden in the set, were each painted off stage a bright solid colour. This emphasised a sudden entrance with a flash of savage primary red, but also helped the cast to remember which door they were racing through. I had wanted a distinct pattern made by the interweaving maypole ribbons, by limiting the colours, but twelve dancers grabbing their particular ribbon on a sudden cue needed the security of individual colours.

The Ritz

Likewise, *The Ritz*, a farce, needs a couple of dozen rooms on stage, each with a bed in, but I designed a set with one large open white space with just two beds doubling for every location, with my ubiquitous hidden doors. This led to split-second timing with beds vacated by one couple and occupied instantly by another, seemingly as another space. This extra element of theatricality increased the physical mayhem far more effectively than if we'd had a literal set. In practical terms it meant clear sightlines as well. A very happy production.

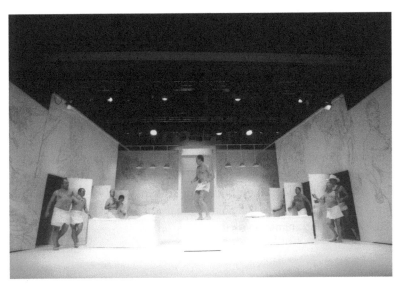

More doors and more flesh in *The Ritz* at the Altrincham Garrick.

Effect on people's lives

Through many of the arts, people's lives can often be literally transformed, sometimes when used as therapy (which seems such an inadequate word), or when participating brings people out of their shells. Simply talking about it has huge cathartic powers. Just by witnessing art (another inadequate word), lives can actually be changed, and if not changed then enriched. A recent series, Channel 4's *Ballethoo!*, followed a group of nearly 200 teenagers as they were offered the chance to perform in a production of *Romeo and Juliet* with Birmingham Royal Ballet. These teenagers came from the most troubled, difficult and violent of backgrounds, and for most the idea of ballet and the discipline that goes with it, let alone the rarefied cultural qualities, was incomprehensibly alien. Just getting them into a rehearsal room together on time without fights was difficult enough, but the programme followed them over eighteen months. Many fell by the wayside, unwilling to commit for many complex and tragic reasons, but for those who stayed the course, their life has truly been transformed, their eyes opened. It could have been opera, or theatre, or sport or music, but as soon as they started to work together, to contribute, and win respect from each other and the teachers, things started to change. Smiles where there clearly had never been smiles appeared as the students realised they were working together and producing something special. The violence, sex and warring families of *Romeo and Juliet* had deep resonances for most. For students and performers alike it was an incredible journey. Lives were enriched, confidence was found, respect was won and culture was appreciated. Another very public television series featured a community from a troubled housing estate being given the chance to sing at the Royal Albert Hall, and in most cities less publicised events like this happen, using 'art' to bring people together, building and shaping often shapeless lives.

The question is, could such a programme, with animation instead of ballet, change and enrich people's lives? I have been very touched and transported by watching animation, but has a film actually changed me? Animation does not have the

immediacy and directness of a live performance, or the common perception that individual personalities are involved, nor does it have any glamour or sexiness that film or live arts have. Animation can have an image problem, and the process of animation, while having some mystery, is often as interesting as watching paint dry. Documentaries about animation struggle to find a more interesting way to say 'so you move it a bit at a time'. I'm not sure whether a programme about giving the public the chance to work on an animated film would serve as great television, as the emotions involved would be low key or negligible, the dramas likely to be less dynamic than an actress having a monumental attack of nerves or a dancer breaking a leg, and the clash of personalities somewhat internalised. All the same, I would like to make a passionate programme where animation is used to inspire, to excite, to transform. Not a programme that was about a workshop, but a large scale-national event, involving all manner of arts groups coming together, speaking directly to the public and making some change for the good. Basically, making animation exciting.

Extreme puppets

I love the fact that there is an irony-free Dolls' Hospital in New York, run by Irving Chais, and his pride in restoring his patients is enormous. It's clearly not about just repairing mechanical things. Likewise, a sign outside the Mackinnon Saunders workshops reads 'Mackinnon and Saunders Hospital', and its witty acronym of MASH seems perfectly apt.

At the other extreme from our puppets are the life-size, astonishingly realistic puppets, well dolls, sold not just for sexual purposes, but for company. This is taking the already far-fetched idea of *Coppelia* to its darkest conclusion. A recent documentary from Channel Five, called *Guys and Dolls*, showed with surprising tenderness, the extent that such dolls played in some men's lives, and not exclusively men. These dolls are created using special effects technology to be fully poseable, articulate and, yes, animatable. The skeletons inside are bigger versions of our animated puppets, and the silicone is much the same, and can be custom-made to whatever measurement, colour and age. The sexual side plays a big part in the life of these dolls, and one man quoted in the documentary genuinely worried that he might get his friend pregnant. I'm not qualified to analyse the psychology here, but the extent of the assimilation of these puppets into people's lives is comprehensible. These dolls have identities, share holidays and are photographed in everyday domestic situations as if proving a full life, or a relationship, where there is none. Talk of ownership was disconcerting, as was the idea of the owner being jealous of the workers repairing a doll, but then I'm twitchy if someone touches a puppet of mine. Another man wanted to be buried alongside his companion, raising confusing issues. If this doll is alive in the man's eyes, must he then somehow kill her, or let her die? A further comment seems to explain the whole business of animation very succinctly. The man clearly didn't want to come home to find his 'partner' staring into space or collapsed in an ungainly

way on the floor, so he made sure they were neatly posed as if 'their attention was directed'. That's pretty much what I tell new animators. It's essential to make sure that a puppet appears to be thinking about something, that their 'attention' is directed. I try to ensure that an animator poses puppets for publicity stills, otherwise a puppet staring into space, however beautifully lit and shot, is a dead puppet, and a dead puppet is a doll. I wonder whether that is the distinction between the two. Are puppets designed for a life or a performance, and dolls just

decoration? I wonder how many degrees of separation there are between me sitting Toad down in a comfortable position, chatting to him, and these sex dolls.

Another unsettling trend is dolls for grieving parents who have lost a new baby. These dolls are made with precise accuracy from photographs. I cannot imagine the grief of losing a child, but I can relate to wanting to keep the memory alive. A replica doll, though, seems an uncomfortable way of dealing with the grief, as it raises the question of, having imbued this doll with a personality and a life of sorts, how do you cope with the doll not growing, and when and how do you put it to one side? I'm not sure I can understand taxidermy either. My head reels with all this, as though I can too easily give things a personality, and even get huge comfort from this; but in extreme circumstances, who knows what you would do?

Situations like this reinforce the idea that puppets and dolls are there to help some people hide away from the real world, and to help maintain the illusion that all is alright. So often the puppet world is safer than the real world, or the puppet provides something that is lacking. Sometimes, distressingly, they can be given too much imbued life.

Transference

I am sure that any puppet animator experiences attention when he has his puppets with him, but I seem to have encountered many people who have confused my puppets' personalities with mine. I appreciate it, no, I love it, when people can enthusiastically identify with the puppets, but it's unsettling for an outsider to project something from the film onto me. I have talked of the two-way relationship between the animator and the animated, and the ease of projecting emotions onto inanimate things, and I put myself into everything I do, but there does seem to be something about puppet animation that attracts people who cross a line. I'm gingerly skirting the issue of having had some obsessive fans and, once, a stalker. It is flattering, but difficult and confusing, as it was, to some extent, the characters that were being stalked. I was the next best thing. I questioned how that could have happened, and I blame the puppets for acting with unrestrained passion, emoting grand enviable emotions. Animators are not celebrities in the way that opera singers, dancers and actors, whose talent is inseparable from their physical persona, can be. You see the craft of the dancer and it's physical and undoubtedly sexual, but animation doesn't have much sex appeal about it. Actors who have played Bond are themselves seen as being sexy and tough. Actors who've played Jesus or characters in long-running soap operas are similarly confused. This is odd but understandable. Something does linger over, but to confuse an animator with a puppet is certainly interesting. I don't think what we do is particularly unusual, but there is some mystery about it, something not understood.

A great film that succinctly sums up the experience of being an animator is *Overtime*, in which a dead puppeteer is given a heart-warming and unbearably touching send-off by his creations. As he manipulated them in life, they manipulate him in death. Only a few minutes long, in exquisite black-and-white computer graphics, the film captures accurately the complex but very real relationship between animators and their creations. It is a perfect film in so many ways; it's execution; it's rhythm; it's choice of music; it's glorious movement; but above all it's celebration of a relationship. We may be gone, but hopefully we've created something that lingers; a small legacy.

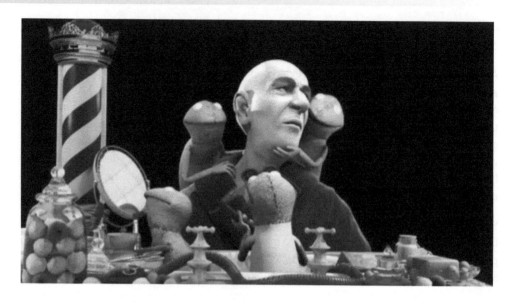

Overtime, directed by Oury Atlan, Damien Ferrie and Thibaut Berland, France, 2004.

Finale

I'm aware that my career stretching out ahead is measured in years, not decades, and that causes panic as I haven't done enough. Here I become my Shakespeare puppet standing in front of a producer being judged. I've still got films to make, but I want to make the one that will inspire, make a difference, and some sort of impact. I know animation can do it. I know I can do it. I'm just scared that my ideas will atrophy.

Saint Peter / Sir Peter waits to pronounce judgement on a career, from *Next*.

Finishing *Next*, I felt I had botched the ending and wanted to suggest the wings full of artists ready to audition. That might have made the difference between a decent film, and, well, I'll never know. Mozart was one of the figures, but Mozart and I have an uneasy relationship. Most pieces I find sublime, especially *Cosi Fan Tutti*. My difficulty with Mozart is the relationship with Salieri in Shaffer's *Amadeus*. Professional jealousy can eat away dangerously. Well perhaps not jealousy, but more the feeling of being second rate; being the understudy waiting to show what they can do. With more talented, more prolific, more public, more favoured, more commercial and frankly, more successful Mozarts around, there will always be Salieries skulking in their shadows. It's a terrible admission. I feel like screaming at the radio to give Salieri more airtime, but then perhaps his music isn't interesting enough. Ouch!

The lesson is to do the homework thoroughly when preparing a film. In *Next* I obstinately punned Sir Peter Hall with St Peter, hoping to give the audition more gravitas. Nineteen years on, I accept that it's a decent enough film, but one which does not need another layer which a five-minute film cannot support. The trouble with stop motion is that it takes so long, with everything as a rehearsal. Having done it, it could be better next time, but there's no next time, and you're stuck looking at that shot for a long time. Watching one's films becomes not unlike toothache, getting worse the more you fret. I am proud of some things, but watching them I feel sick knowing how I could do better, or equally feeling satisfied, but I wish I could do more of it. Oh, the dubious joys of being an insecure perfectionist. Make sure that you're happy with the storyboard; otherwise you will come to regret it. I doubt there is any animator who can honestly sit back and think 'that's great!' Thank goodness.

What's the most useful advice you would give to a student?

JD – Contrive a way to enter the business as near to the capacity in which you want to work, instead of planning to work your way up to that position.

TB – Don't get discouraged; hang on to your dream; work hard.

KD – Question everything and be open to it all.

DC – Don't believe anyone who says 'you can't do it'. Listen and think why they said it and ask *yourself* 'why not?'

SB – Trust your gut feelings; do what you think best.

RH – If you have the passion, ambition and dedication you will get there.

JC – Work hard, don't complain, be loyal to those who help you, try to improve and don't get bigheaded – it's not always the best animator who gets the job.

DS – Don't believe anything that anyone tells you! Work out what you're passionate about, what excites you, what drives you and go for that. If you don't, other people will fill that space ahead of you.

BP – Give the animation time to read!

Career

To talk of disappointments is to admit to ambition and belief in one's abilities, but I can't say that there has been the continuity of creativity that I might have hoped for. My days working outweigh the days I didn't, but there's not the output I would have wished. Piles of scripts and storyboards gather dust. Shame. I stalled in the late 1990s without a constant producer, at a time when the big television channels were losing interest in the short film and the specials. This combination resulted in my floundering, working in spurts; but then no-one ever said that animation was a constant job. Perhaps I was just out of step with what commissioners were looking

Animators from colleges I have talked at: the future is safe.

for. I had hoped that I might have developed, challenged, experimented and pushed stop motion into areas I know it can go. I was spoilt with the creative period of Channel 4, getting a taste of what stop motion is capable of. We are only scratching the surface of its potential, and have yet to guide it into unlikely genres, pushing different emotional buttons. I want puppets to express an intensity of emotion to match opera performers, the darkest tragedy, and all with the grace of dancers.

A colourful and bizarre career, certainly, with a flurry of winning awards, but still the word 'potential' haunts me. For the most part it's been about making a living doing something I love, hoping the creative moments outnumber the pedestrian, and trying to make those pedestrian moments interesting and classy.

The question of winning the lottery crops up daily and, yes, I would indulge in something creative, pushing boundaries and exciting audiences with things that have excited me. It's fine giving audiences the familiar and what they want, but how are any of us to grow like this? I'm all for taking chances and seeing things of which I've little knowledge and experience, but it seems that animation has yet to take that risk. The numerous talking animal CG films made in 2006 and 2007, mostly with similar themes and central smart buddy/stupid buddy relationships, all started to blur into one furry wisecracking celebrity-voiced jumble. There are formulaic and they work well, but what happens when that formula grows too familiar? We must constantly find new, fresh perspectives and stimulate audiences.

In spite of everything, I'm often found giddy with the excitement of watching a puppet perform. When the work is interesting, it's not work. It's what I do, and what I love. Some days I can't wait to shoot a scene and give a character life. There are days, for us all, when a lazily written project, with a patronising message, a story more to do with merchandise than character and, worst of all, which is unforgivably dull, makes us question what we can contribute. But then there are good days. I feel, after thirty years of working with puppets, that I can coax all manner of sophisticated performances out of them. It's not all about making 'artistic' projects or 'culture' (why should I have to apologise for mentioning those words?), but it is about making interesting pieces that inspire, entertain, inform, tantalise and excite the audience. We have a duty to make the most of this extraordinary craft.

My fear is that people will look at my work and wonder whether that is all that I could come up with. 'Have you any ideas?' is the most insulting thing someone can say to me. It's easy for others to suggest 'why don't you do such and such?' I wish. Film is a huge team affair, seldom the result of one man's effort, and however much I holler, there need to be others with the same enthusiasm to move a project along … that and an enormous amount of equipment, facilities, a considerable budget and a passion. Stop frame is simply not cheap. It's not always the director who can kickstart something, and maybe my cornucopia of ideas doesn't meet a perceived commerciality. I've always been one to try something new.

The portrait on page 342 by Sandro Kopp seems expressive of both my career and how I see stop motion. This toucan is a rather exotic, eccentric and essentially useless creature that has yet to fly. Even though I've not tapped my potential, I'm still lucky enough to have done a job I've loved for thirty years; a relatively stress-free job; a sublimely silly one; I just want to make more of it.

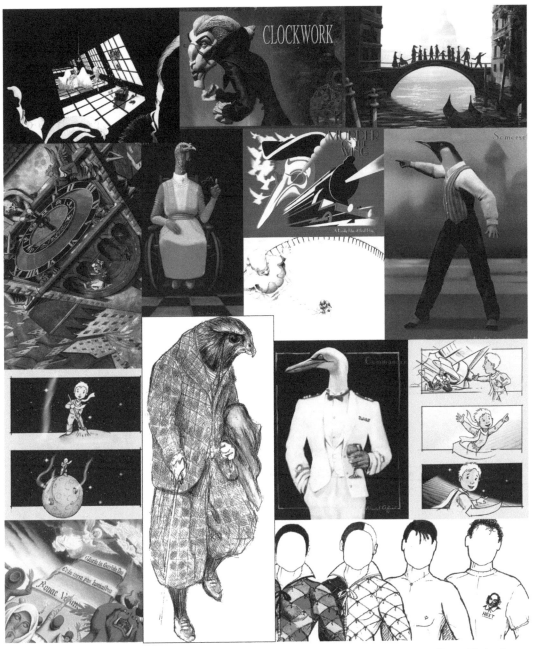

Just a few of the many that got away: images from *Noye's Fludde, Clockwork, Hitch, As If ... , Harlequintessence* and *Toucan Tango*.

And, finally, what ambitions do you have? Where would you like to see stop motion in ten years?

JD – To renew my skills as a painter and to earn money, selling paintings. I would like to see stop motion continue as a personal art form as well as a corporate art form. The attraction of stop motion when I started was that it provided a low-cost method for telling stories that could be handled by one person. I wouldn't want that possibility to disappear, although the idea of one person entirely creating animation sequences for a live-action film is probably dead for all time in mainstream production. If I thought I had twenty more productive years ahead of me, I would try to make some animated shorts in my garage, but gearing up to do that and mastering the new digital technologies would consume so much time and money that I know it would be unrealistic.

TB – I'd like to be remembered as a good storyteller of film, stop motion and music to tell those stories. I'd like to see stop-frame animation last forever. I just hope it lasts for a long, long time, long after I'm gone. Thanks!

KD – With an academy award on my mantelpiece! I would like to see British stop motion leading the way, with our own country funding features and supporting more short films.

DC – I'd like to be directing. You get to ask for stuff that's difficult to do, without being the one who has to struggle to do it. I'd like stop motion to still be a viable option and not just a quirky underground cult medium employed only by the eccentric and self-funded recluses who have no need of public opinion. More successful stop-frame movies will bring the public around to acknowledging it as a very respectable film technique. I hope people don't forget how to draw and make things … it's not a virtual world, it's a real world!

SB – I want to make more films and carry on making a living from stop-frame work. I'd like to see stop frame more involved with the computer work so that special effects are more than just a computer image.

KP – I have ideas for more books and short films, and would love to teach more. I'd like to see more stop motion programmes being offered by schools, colleges or high schools, as an accessible alternative to only focusing on CG. There are too many high-school computer courses masquerading as 'animation courses' which are being taught by shop teachers instead of artists. It would be nice to see more stop motion filmmaking presented at an early age as a tool for creative expression. The myth that animation is 'all done with computers' needs to be clarified, and it needs to be emphasised that the computer is just one of the many tools that can used, and can ultimately be complemented by these traditional skills of stop motion or hand-drawn animation which provided the foundation in the first place.

RH – I'd love to see stop motion return to the detailed realism that was so beautifully done in *The Wind in the Willows*. There's enough colourful and 'wacky' series, and there's more room for realism, with a hint of anarchy. It would also be great to see stop motion take a completely opposite turn, into extreme wackiness. The stop motion versions of Chuck Jones and Tex Avery would be a refreshing new era for the medium.

JC – I'd like to be a better animator making my own films. In ten years' time I'd like to see animation just about where it is right now. I hope that no one form will dominate and I hope to see more mingling of styles.

FL – I want to be a professional artist, a professional animator, maybe have my own little studio … It sounds like an unoriginal dream perhaps; but my personal wish is to transform art from a hobby to a way to make a living.

DS – I don't think it's going to go away, in fact we will find the audience will want it to play to its strengths, looking crafted, slightly jerky, quirky, and presenting fantasy worlds that we feel we could step into.

Sandro Kopp's portrait about potential, Wellington, 2004.

I'm sure that stop motion has a good life ahead. I can't see that I'll ever get bored of it, but it's up to us to exploit, to push, to explore and to challenge this glorious technique with real passion. Dullness and complacency have no place in a frame-by-frame world.

So, thanks to Toad, Shakespeare, Verdi, Achilles, Gilbert, Sullivan and all the many others, you've been great company.

I'll leave the last word to Mr Gilbert, which would surely please him.

How purely fragrant
How earnestly precious.
-Well it seems to me to be nonsense.
Nonsense, yes perhaps, but, oh, what precious nonsense.

W.S. Gilbert, Patience

Att ... air ... nn ... shun

All right you lot !!!

70 shots by lunch time

... that would be awfully nice

Andy Cadzow's sketch of me at work in New Zealand, 2003.

Index

T - #0073 - 071024 - C370 - 254/178/20 - PB - 9780240520605 - Gloss Lamination